A Concise History of American Architecture

A Concise History of American Architecture

Leland M. Roth

ICON EDITIONS
HARPER & ROW, PUBLISHERS
New York, Hagerstown, San Francisco, London

Reprinted with corrections 1980.

Designed by Janice Stern

Library of Congress Cataloging in Publication Data

Roth, Leland M
 A concise history of American architecture.

 (Icon editions)
 Bibliography: p.
 Includes index.
 1. Architecture—United States. I. Title.
NA705.R67 1979 720′.973 78-2169
ISBN 0-06-438490-X 80 81 10 9 8 7 6 5 4 3
ISBN 0-06-430086-2 pbk. 80 81 10 9 8 7 6 5 4 3

to Amanda

and those who will grow with her;
in the hope that their environment will be
cleaner, brighter, and ever more humane

Contents

List of Illustrations

Preface

Building, like politics, is based on the fine art of compromise, and every building represents a judicious balance between conflicting needs and aspirations on the part of the client and architect and builder. Americans, perhaps somewhat more than other builders, have been caught between divergent needs and desires, between the impulse to build pragmatically and efficiently and the wish to realize a conceptual ideal. They came to the New World in the beginning to find a measure of perfection and found they had to shelter themselves in the most rudimentary manner; the conflict between the ideal and real has continued from that time to the present. Perhaps now it is being resolved in some small way, but time alone will show whether it is a synthesis or the emergence of a new orthodoxy.

This short history of American architecture is concerned, in part, with this dualism, and it is written to introduce the student and the interested observer to the major developments that have shaped the American-built environment from the arrival of the Europeans to the present. It sketches the impact of interrelated changes in conceptual imagery, style, building technology, and town planning theory. It cannot treat every major building or every prominent architect, and hence some readers may be disappointed because a favorite is not included. What this history does seek to explore is the pluralism that has complicated and enriched American architecture from the beginning and the energy and vitality this pluralism has inevitably brought.

This study was begun in 1973 as a part of a much larger historical survey of all the visual arts in America, a collaborative effort by several authors. When that project was halted due to a change in ownership of the original publishing house, Cass Canfield, Jr.,

of Harper & Row expressed special interest in publishing the architecture section separately. It was decided not to rewrite the material extensively in an attempt to create something more encyclopedic; indeed, both the author and Mr. Canfield believed that a strength of the original manuscript was its brevity enforced by the original project. These foreordained constraints suggested that buildings be selected for discussion because they illustrated particularly important conceptual or technological changes, and not because they exemplified stylistic changes alone. It is my hope, however, and the publisher's belief, that the central developments have been sketched out and clarified.

The text is divided into sections marked by particular coherence in building technique and expression; often these are delineated by economic or political cycles. The last sections are longer by design and are consciously more subjective in character than the earlier sections, as the proximity of events prevents true objectivity. Time will make more correct the relative weight of things. Accordingly, the closing section is presented as an epilogue or a critical essay presenting some of the problems of the 1970s.

A bibliography and glossary follow the text, as does a synoptic table showing the duration and overlap of the successive building modes.

A great debt is owed to Brenda Gilchrist who supervised the original project and gave me complete freedom in the organization and content of the material. Even more, however, is owed to Cass Canfield, Jr., my editor, to whom Ms. Gilchrist passed the original manuscript. It was Mr. Canfield's subsequent unflagging enthusiasm which surmounted technical difficulties and has made this book possible. He has been the most supportive, patient, and helpful of editors. I am greatly indebted to Joyce Schiller who handled much of the correspondence concerning the illustrations and who prepared large sections of the manuscript in its latter phases. I must thank too the many students in American architecture classes who indicated what they felt would be most helpful in the glossary and who in general helped me see again what puzzles, pleases, and captivates those learning to see and understand the environment around them. To Carol belongs the lion's share of thanks for she has never begrudged the evening hours spent in the study, the long and tedious editing and typing, nor the many requests to comment or simply to listen; her constant support has been indispensable.

Leland M. Roth
Eugene, 1978

1.

The Land and First Homes

Shaping the environment for utilitarian or symbolic ends is architecture in its broadest sense. To build well involves a synthesis of optimum function, sound construction, and sensory stimulation, a formula first elaborated by the Roman architect Vitruvius. Yet the way in which these elements are combined and the relative weight given to each are determined by many factors—by the values and objectives of the builder and his culture, by economic resources, by technical capacity, and by climatic forces. Of all of these influences, perhaps natural forces make the most insistent demands on a building, for it must withstand the incessant pull of gravity and the attrition of weather.

Culture, technology, and climate together helped to shape the first shelters and ceremonial enclosures made by the first men in the New World. As the various building types were gradually developed and refined, they paralleled the wide differences in climate and landscape found across the broad North American continent. The land in which the aborigines made their home, the area which is now the United States, stretches three and a half thousand miles from the Atlantic to the Pacific Ocean, and it is twelve hundred miles wide between Canada and Mexico. It is a vast and fruitful land of great geographical and climatic contrasts. To the north are the fanning fingers of the Great Lakes; to the south project the triangle of southern Texas and the peninsula of Florida. In the middle lies an immense fertile valley, the basin of the Mississippi River and its tributaries, the Ohio and the Missouri rivers. The eastern edge of this basin is framed by the diagonal corrugations of the Appalachian Mountains. Toward the west the prairie rises gently to the dry steppes of the high plains, where it eventually reaches the western boundary, the high jagged Rocky Mountains. West of this irregular chain is a high desert plateau,

hemmed in between the Rockies on its eastern edge and the Sierra Nevada and Cascade ranges on its western edge. On the west and windward side of the Sierra Nevada lies the warm Pacific coast, the northern half of which is forever green as winds from the Pacific are forced to drop their burden of moisture as they are pushed up and over the mountains. Far to the east lies another coastal plain which tumbles down gently from the Appalachians to the Atlantic, here and there its outline deeply indented by great tidewater inlets. The northern stretch of this coastal plain is hilly and entrenched by the parallel channels of the Hudson and Connecticut rivers and by numerous meandering rivers which empty into the Atlantic, while to the south the coastal plain is much smoother and wider. Each of these areas has its own character, and from one geographical zone to the next the climate differs in extremes, going from the relative moderation of New England to the draining humidity of New Orleans, from the deep winters and steaming summers of the plains to the searing midday heat and dry freezing cold nights on the high southwest desert.

Into this outstretched land entered the ancestors of the American Indian. They crossed into the New World, perhaps as early as 40,000 B.C., in the first of several waves of emigration from the central Siberian plateau over a land bridge that was periodically opened and then closed by advancing glacial sheets. A second influx occurred around 20,000 to 15,000 B.C., and by 12,000 B.C. in the mid-continental valley was established a Big Game Hunting tradition identifiable, as is each of the successive cultural traditions, by its distinctive tool types. As the hunters diffused to the east and west, they adapted to the regions into which they moved. A modified Desert tradition was developed in the great basin and in the Southwest by about 8000 B.C., and by about A.D. 500 this had evolved into the various cultures of the Southwestern tradition to which belonged the Pueblo cultures discovered by the Spanish. To the east different traditions developed following their own timetables, beginning with the Archaic tradition which lasted from about 8000 B.C. to about 1000 B.C. This was transformed into the Woodland tradition which continued from about 1000 B.C. to A.D. 1000. Depending on the specific geographical area under discussion, this can be subdivided into various component cultures, none of which developed in all regions simultaneously. Of these the most extensive and best known are the successive Adena and Hopewell cultures, which can be dated around 1000 B.C. to around 100 B.C., and 100 B.C. to A.D. 1000, respectively. The Woodland tradition was in turn replaced by the Mississippian

tradition which originated in the lower Mississippi Valley about A.D. 1000 and spread northward, forming the basis of the various tribal cultures discovered by the French, Dutch, and English.

Although the Woodland tradition of the eastern half of the continent was technologically simple, using tools of chipped flint, polished stone, and beaten copper, it had a complex ceremonial life centered around a cult of the dead. This is apparent in the care taken in earthworks built by both the Adena and Hopewell peoples, for besides purely defensive fortifications they built thousands of burial mounds, effigy mounds, and extensive ceremonial enclosures. These earthworks were built up of thousands of basketsful of earth, carried by hand, for there was no domesticated animal other than the dog. The social organization and dedication of purpose can be gauged by looking at the complex at what later became Newark, Ohio, built sometime between 300 B.C. and A.D. 700. The entire complex, shown in a plan surveyed by E. G. Squire and E. H. Davis in the 1840s before much was obliterated, covered an area measuring nearly 2-by-2½ miles (Fig. 1). Best preserved of this complex now is the large circular ring about 1,200 feet in diameter with a low-profile bird effigy mound at its center, its head pointing toward the opening of the enclosure.

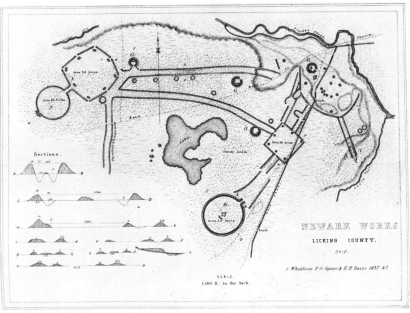

1. Hopewell Culture, Newark Earthworks, Newark, Ohio, 300 B.C.–A.D. 700.

2. Adena Culture, Serpent Mound, near Locust Grove, Ohio,
A.D. 900–1200.

The bird is one of the thousands of effigy mounds once found throughout the Ohio-Mississippi Valley, such as the well-known Serpent Mount near Locust Grove, Ohio (Fig. 2), built about A.D. 900–1200, in which a serpentine earth sculpture was placed atop a natural rocky bluff.

The significance of the geometrical formations is unknown, although the orientation of many toward summer solstice and the rising of significant stars suggests astronomical functions. Other constructions were on naturally defensible bluffs, and their elaborate gates indicate that they were forts. Among such strongholds are "Fort Hill," in Highland County, Ohio, and "Fort Ancient," in Warren County, Ohio. All these large constructions, ceremonial, effigy, and defensive, were far outnumbered by free-standing domical or conical burial mounds, ranging from modest swells to large imposing artificial hills such as the mound at Cave Creek, West Virginia, which originally rose over 70 feet and measured 1000 feet in circumference at its base. As was typical of such mounds, at the center were elaborate inhumations in wooden burial chambers, while the outer surface was covered with scores of deposits of cremated remains.

Many implements of the Adena and Hopewell cultures have been removed from these mounds, for tools and items of jewelry were often included with the remains. Commonly found objects include delicately carved stone pipe bowls or silhouettes cut from Appalachian sheet mica. Such grave items reveal a widespread trade network maintained by the Eastern Woodland Indians, for the copper was brought down from the upper Great Lakes, the grizzly bear teeth and obsidian came from the Rocky Mountains, the conch shells and carved plaques came from the Gulf Coast, and other materials came from points equally remote.

Soil studies indicate that no buildings were erected atop these Adena or Hopewell mounds, but this clearly *was* the practice dur-

ing the Temple Mound culture which followed, constituting the first phase of the Mississippian tradition. The mounds of this Mississippian tradition were rectangular (or in some way geometrically shaped) in plan, with flat terraces at the top. On them temples and other sacred enclosures were built. The largest of them all is the pyramidal mound at Cahokia, Illinois, originally about 790 by 1,050 feet at the base and nearly 100 feet high, built in several stages around A.D. 900–1100. Cahokia was the center of nearly twenty towns, and here lived perhaps thirty thousand people; there were as many as two hundred other smaller mounds and earth forms, including an astronomical observatory circle of wood. This was the largest settlement north of Mexico City, but other major centers, somewhat smaller, were located at Aztalan, Wisconsin; Moundville, Alabama; and at Macon, Etowah, and Lamar, Georgia.

Mound building began to decline after A.D. 1000, and successive cultural changes and population migrations gradually erased the knowledge of the mounds' specific purpose. By the time of European settlement the Indian population was perhaps twelve million or more in the area north of Mexico, divided into eight major cultural groups corresponding almost exactly to the major geographic regions: the northwest coast, the California coast, the Columbia River plateau, the great basin of Nevada and Utah, the Southwest, the high plains, the central prairie, and the eastern woodlands. When the Spanish moved into New Mexico in 1539, they encountered the Anazazi culture which had established itself in the Four Corners region of Utah, Colorado, Arizona, and New Mexico about A.D. 1000–1100. Basket makers and potters, they were a people rooted to the soil, deriving their entire sustenance from farming. Of all the aborigines, these were the most attached to their place. Their architecture, like that of all the Indians, had its origin in the primeval semi-subterranean Siberian house, variations on which are found across the North American continent. The archetypal house was circular in plan and so the Anazazi houses started, but as they were pushed together to form tight clusters, the plans became rectilinear. Initially, for protection, the large multiple-unit residences were built into the recesses of river canyon walls, or in the sides of mesas, with the apartments built of dry stone masonry. In southwestern Colorado, in the hollows along the sides of Mesa Verde, are several well-developed pueblos (so-called by the Spanish because they were villages), particularly Spruce Tree House and the Cliff Palace, built about 1100. Even more spectacular because of its setting is the Casa Blanca in the

Canyon de Chelly, Arizona, built during the eleventh century and remodeled during the fourteenth century. Its position high in the canyon wall and its forthright masonry construction exemplify the unity of house and land that so often appears in Indian building.

Later pueblos were built directly on the fertile plains below the cliffs, closer to the fields and water supply. Along the valley of the Rio Chaco in northern New Mexico still stand the ruins of eleven pueblos built during the tenth century. Although the plans vary, each has a general plan in the shape of a large D or E. Pueblo Chetro Ketl, begun around around 1000, one of the biggest, was five stories high at the rear and contained 506 rooms. Even larger was Pueblo Bonito, begun about 920, laid out in the shape of a D, with the multiple levels along the curved side and a single story along the front straight side, thus forming an enclosed courtyard. Altogether it was nearly thirteen hundred feet around, four stories high at the back, and able to house as many as twelve hundred people.

Still inhabited, though now modified, is the Taos Pueblo, Taos, New Mexico (Fig. 3), begun before the sixteenth century but showing the traditional method of adobe construction. The pueblo consists of two clusters of houses, each built of sun-dried mud brick, with walls ranging from two feet thick at the bottom to about one foot thick at the top. Each year the walls are still refinished with a new coat of adobe plaster as part of a village ceremony. The rooms are stepped back so that the roofs of the lower units form terraces for those above. The units at ground level and some of those above are entered by doors that originally were quite small and low; access to the upper units is by ladders through holes in the roof. The living quarters are on the top and outside, while the rooms deep within the structure were used for storage of grain. The roofs are made of cedar logs, their ends protruding through the walls; on the logs are mats of branches on which are laid grasses covered with a thick layer of mud and a finishing coat of adobe plaster. It is a massive system of construction but one well suited to the rigors of the climate, for the thick structure, whether stone or adobe, absorbs the midday heat and during the night slowly suffuses heat to the rooms within so that the internal temperature remains relatively constant over a range of about ten degrees Fahrenheit, while the outside temperature varies over more than forty degrees. Drafts were originally kept to a minimum by the low narrow doors and minuscule windows, though the openings are now larger due to the use of standardized modern openings.

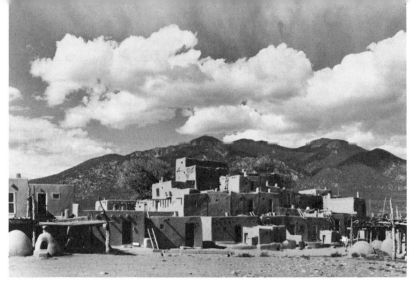

3. Taos Pueblo, Taos, New Mexico, 16th century with successive rebuilding.

When Santa Fe was set up as the administrative center of New Mexico in 1609, a blend of Indian and Spanish building techniques was used for the Palace of the Governors, begun in 1610 (Fig. 4). Indeed, the Spanish readily employed local construction because it was so similar to familiar vernacular traditions at home. As in other *presidios*, the palace was a large rectangular building, and incorporated a traditional Spanish colonnade (with wooden columns) along the front, and an enclosed patio to the rear.

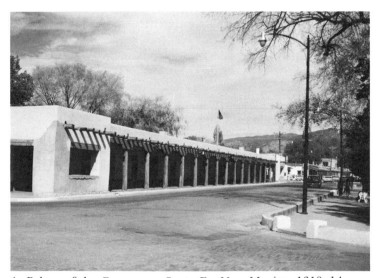

4. Palace of the Governors, Santa Fe, New Mexico, 1610–14.

Though the construction was carried out by local Indians in their own fashion, they used wooden molds provided by the Spanish to produce standardized bricks. Priests too adapted Indian building techniques to the building of churches, making the buildings taller and including twin towers at the west fronts, but the severe cubic masses punctuated by the protruding log ends bespeak a long Indian building tradition. Good examples of early churches are San Estéban del Rey at the Ácoma Pueblo, New Mexico, about 1630, and San Francisco at Taos, New Mexico, about 1772.

Although the Indians of the Southwest had radically transformed the archetypal house in their pueblos, in their *kivas,* subterranean circular ceremonial chambers, the old form survived nearly intact. Similarly other cultures in other climates modified the house to suit local conditions, retaining vestiges of the original form. The Indians of the eastern woodlands developed a quite different house type adapted to the forest. Algonquin villages of the Northeast contained free-standing houses for fifty or more families (some large towns being as large as five hundred families); these were invariably on high ground near fresh water. The basic house type common to all Algonquin-speaking tribes was the *wigwam* which continued to be constructed by the Ojibwa (Chippewa) around Lake Superior through the nineteenth century (Fig. 5). This consisted of a domical frame of saplings lashed together and covered with sheets of bark, hides, or woven mats of rushes depending on the material most readily available. There was a single door, protected by a skin, and usually a hole at the top through which the smoke of the central fire might escape. The wigwam varied from ten to sixteen feet in diameter and was up to ten feet in height; it housed two or three families. The principal variation was the elongation of the wigwam into a long rectangular house whose wooden frame was closely covered with available materials such as birch bark, elm bark, skins, or rush mats. Such long houses were found by the first European explorers all along the Atlantic coast, but the largest of all were built by the Iroquois in central New York who took one of their names, *hodenosote,* from the name of their long houses. Iroquois long houses ranged up to one hundred feet in length by eighteen feet in width, with a gable or bowed roof; in such houses lived as many as fourteen families with space for their stores of maize, squash, dried meats, and other food stuffs in the end chambers. One such Onondaga house was described by Pennsylvania naturalist John Bartram in 1743.

Bartram was fortunate in being one of the last white men to see

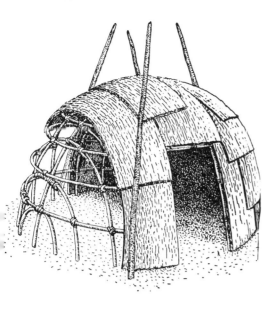

5. Ojibwa (Chippewa) wigwam; drawing.

a thriving aboriginal village whose houses were still being built in the traditional manner. There are much earlier descriptions of Algonquin villages, including the accounts of John White and Captain John Smith. White was one of the leaders of the expedition sent out by Sir Walter Raleigh in 1584 in an attempt to establish a colony on Roanoke Island off northeast North Carolina. He was skilled as an artist, and on visits to the Indian towns of Pamlico, Secotan, and Pomeiock he made detailed sketches of village layout and house types. His drawing of Pomeiock shows it to have been a cluster of eighteen long houses arranged around a central open space and surrounded by a circular wooden palisade, the ends of which were overlapped slightly, forming a defensible gate. This kind of arrangement was typical of the palisaded Indian towns among Algonquin and Iroquoian tribes, but Secotan, the chief town of the Powhatan Indians, was more open and lacked a defensive wall. Its buildings were scattered in clusters among fields of maize and tobacco (Fig. 6). In the labels and inscriptions on his drawings, White said the Powhatan houses were "constructed of poles fixed in the ground, bound together and covered with mats, which are thrown off at pleasure, to admit as much light and air as they may require." About thirty years later, Captain John Smith wrote in his *Generall Historie of Virginia* (1624) that the houses were "so close covered with mats, or the bark of trees, very handsomely, that notwithstanding either wind, rain, or weather, they are as warm as stoves." In the late fall entire villages usually moved to winter quarters deep in the forests where, in the midst of the thicket, they would be protected from cold winds and have ready access to game.

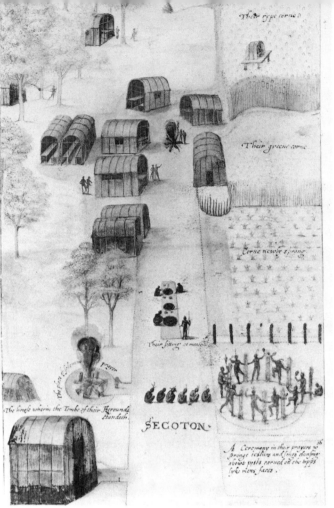

6. John White, *Indian Village of Secotan*, c. 1577–90; watercolor.

The Mandan and related tribes who lived along the Missouri River were much more sedentary and built large villages of thirty to fifty houses, sometimes surrounded by palisades, along the river banks. Mandan houses were large squat conical structures about forty feet in diameter, depressed about a foot below grade; inside was a heavy wooden frame of radiating rafter poles resting on an outer circumferential frame which stood about six feet high and rising to center supports about twelve to fifteen feet high. Against this frame woven mats were placed and earth piled to a thickness of a foot and a half at the top and several feet at the base. In time this covering became hard and often became one with the turf of surrounding prairie grass. The entrance was a small tunnel through the thick earth cover. In such houses five or six families lived, secure against the howling winds of plains win-

ters; in the summer the thick blanket of earth kept the midday heat from penetrating, maintaining a relatively constant temperature inside.

The more nomadic tribes to the north and west had conical houses as well, but these *tipis* were fully portable. The *tipi* (a Sioux word for "dwelling place") had a frame of about fifteen long poles of cedar or pine on which was stretched a conical skin fashioned of buffalo hides. Originally the tipi was moved by dog *travois* (as the French called it), but when the horse was domesticated by the Plains Indians, after it had been introduced by the Spanish to the south, the tipi became larger, heavier, and more elaborate. In plan the tipi was not circular but oval, with the entrance on one of the narrow sides, usually facing easterly so as to be downwind (Fig. 7). Above the entrance, where the skin was fastened together, were two long flaps held out by movable poles and guy ropes. The tipi was an aerodynamic shape positioned to give least resistance to prevailing winds, and with flaps which could be easily repositioned to correspond to shifts in wind direction to maintain an upward draft through the tent to carry off smoke. Clusters of tipis were usually set up (by the women of the tribe) on the lee side of low hills or copses of trees to gain additional shelter during the winter. Such placement, combined with an inner lining of the tipi fastened to the inside of the poles and kept tight against the ground, made this seemingly fragile dwelling comfortable in summer and winter alike. Of all Indian building types, only the tipi was dependent on outside sources of heat energy.

The forms of Indian village plans and dwellings were the result of long trial and error in adjusting to the nature of each individ-

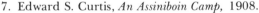

7. Edward S. Curtis, *An Assiniboin Camp,* 1908.

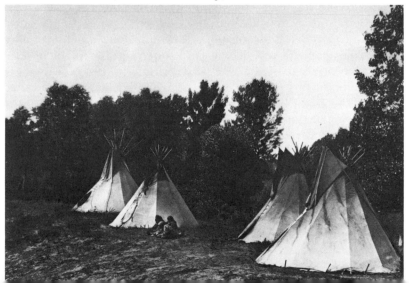

ual regional climate. Still, because of the common Asiatic heritage, the houses of all North American Indians were derived from a basic archaic type—the circular semi-subterranean earth lodge. This was modified by each group according to need and climatic conditions. Where great extremes of temperature prevailed, the walls became thick to retard heat loss and gain; where humidity was high the walls were demountable to make ventilation easy.

It may appear that there was great homogeneity among the disparate Indian tribes, when in fact there were great differences in culture, language, and custom, just as there was great diversity in their house types. Nonetheless, there were important common precepts which ran through all Indian cultures, whatever the tribe or language, and which shaped the conduct of Indian life and, consequently, the form of their villages and houses. Most important were the code of hospitality, the practice of communal living, and the communal ownership of land. The code of hospitality required that food be prepared at all times so that each visitor might be greeted amicably and be offered nourishment while an appropriate feast was prepared for a subsequent ceremony. It also meant that there could be no starvation in one section of a village while there was food in any other section, for food was shared in times of stress. No Indian before the sixteenth century owned his own home, as Europeans defined "ownership." Though it was the men who usually obtained the building materials, it was the women who fabricated the buildings (except the pueblos which were built by the men, although the annual replastering was and is still done by the women), and "ownership" most often resided in them. The extended families who occupied the houses were most often related along matrilineal lines, and utensils and furnishings of the house were shared in common. Land was also held in common by the tribe as a whole, and cleared portions were allotted to the women for cultivation; usually only the chief or his wife had authority to trade land use or goods with outsiders. Land was never considered a commodity by the Indian; one might have the privilege of the use of the land, one might even be able to trade such privilege of use, so that individuals might exchange the use of plots with the consent of the tribal leaders (the so-called right of disposal), but seldom if ever did an individual have the right of destruction of land or things on the land, for all but the most intimate personal property, such as a medicine man's utensils, belonged to the group. There was no conception of fixed boundary lines or of speculation in land or of exclusive rights to timber, game, or water. The land and the flora and fauna found

on it were the free gifts of the Great Spirit which the code of hospitality dictated be accessible to all.

From the perspective of the Europeans, the Indians were savages—noble, perhaps—but possessed of virtues so remote from European culture as to be indiscernible. Faced with the hardships of establishing footholds in the New World, the European settlers had little time to ponder the merits of Indian culture. It countered all their traditions, and Indian building along the Atlantic seaboard in no way provided the immigrants with the emotional and symbolic security needed in what was to them an alien land. Indian building represented a heathen culture which the Europeans fervently set about reshaping into a Christian culture; where Indian patterns of living were not actively suppressed, they were simply ignored. The benefits of aboriginal social practices, the provision of multifamily housing and its concomitant savings in energy, and most especially the adjustment of building type to regional climate were all largely rejected. Ironically most of this would have to be painfully rediscovered over the next five centuries. Alone in a strange land, the colonists did a most natural thing—they began to build as they had in the lands from which they came, trying to recreate the best of their homelands. They shaped their vision of a new society in the accustomed fabric of their European traditions, and then their transplanted architecture in turn shaped them.

In truth, the English who settled in Massachusetts Bay did learn many things from the Indians whose land they bought. Maize (corn), pumpkin, and wild turkeys were added to the diet, and, in time, the colonists adopted the Indian practice of placing a herring with maize seed during planting. Desperate for immediate shelter, the colonists shoveled dugouts in hillsides and threw up wigwams very much resembling the houses of the natives, but actually based on English shepherds' and charcoal burners' huts (Fig. 8). These first homes disappeared long ago, but modern reconstructions based on early descriptions show that, except for framed doors, windows, and the chimney at the end built of twigs lined with clay (wattle and daub), these wigwams did indeed look like Algonquin houses. As quickly as conditions allowed, however, the wigwams were replaced by cottages built according to English vernacular traditions, using a heavy hewn wooden frame, with the spaces filled with interwoven twigs (wattle) and covered with mud plaster (daub), with a roof of thatch. These usually consisted of a single room, with few windows, a large masonry fireplace mass at

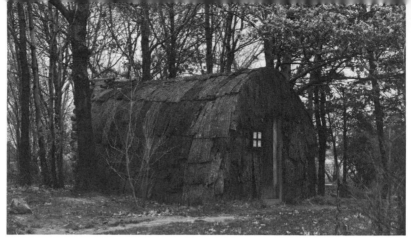

8. English wigwam, Salem, Massachusetts, reconstruction,
as built in 1620.

one end, with the door next to it. Such half-timbered cottages
proved much too sensitive to the extremes of New England
weather, for temperatures ranged a good thirty degrees more in
Massachusetts than in the West Country or East Anglia where
most of the settlers originated. The exposed frame moved too
much through thermal expansion and contraction; cracks opened
up between the frame and the wattle and daub panels. The solu-
tion was to cover the frame with a wind-tight skin of narrow clap-
boards or split shingles. Since thatch too reacted poorly to the
climate, tending to rot, the roof likewise became a skin of shingles.

By the latter half of the seventeenth century the Massachusetts
Bay colonists had developed a unique house type derived from
traditional English sources but adapted to the New England cli-
mate. The Parson Capen house, Topsfield, Massachusetts, is a
good example (Figs. 9, 10, 11). It sits atop a gentle knoll next to
the Topsfield Common, close to the town meetinghouse, conve-
nient for the Reverend Joseph Capen for whom the community
built the house. According to the date carved on one of the roof
rafters, the frame was raised June 8, 1683. As was customary with
such houses, the upper floors project beyond the lower floors, and
the windows are pushed outward, tight against the clapboard skin.
Carved brackets beside the door help to transmit the weight of the
upper frame to the posts below, but at the corners the upper posts
hang below the projecting second story in the form of carved
pendills. The plan consists of two rooms on either side of a cen-
tral masonry mass containing fireplaces back to back (Fig. 10). In
front of the masonry core is a narrow hall, opposite the entrance
door, with a cramped winding stair leading to the rooms above.
Such an arrangement was economical of fuel, for during the
winter the huge bulk of stone and mortar at the center of the

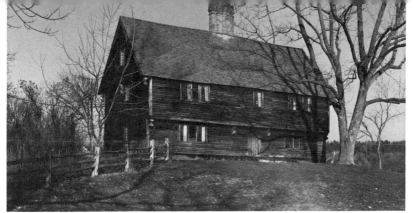

9. Parson Joseph Capen house, Topsfield, Massachusetts, 1683.

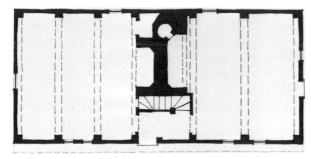

10. Parson Capen house, plan.

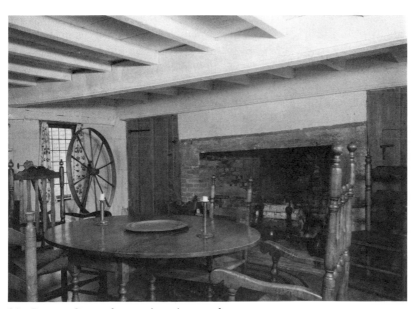

11. Parson Capen house, interior, parlor.

house absorbed and stored the heat of the wood fires during the day, gently radiating it back during the long night.

From the outside, houses such as the Capen house often appear stark and imposing, but inside they are subdivided into close, snug, intimately scaled rooms. This came about partly because of the short hardwood timbers of the stout frames and partly because of the need to minimize the air space to be heated in winter. The intimate scale is reinforced by the framing members left exposed in the low ceiling and walls, as in the parlor of the Capen house (Fig. 11), or the parlor of the Thomas Hart house of Ipswich, Massachusetts (Fig. 12), built about 1640. Both rooms show well the huge focal fireplaces and the simplicity of the handcrafted furniture, based on Elizabethan and Jacobean models, ornamented chiefly with lathe-turned supports.

The typical enlarged version of this house type was the "saltbox," exemplified by the Whitman house, Farmington, Connecticut (Fig. 13), built in 1664. The basic front portion of the house is nearly identical to the Parson Capen house, but to the rear the roof is continued down with only a slight change in slope to cover a story and a half lean-to addition. Usually the back room was a large new kitchen with pantries or bedrooms to either side and additional bed chambers in the loft above. In order to add the kitchen, of course, it was necessary to enlarge the chimney mass at the back to house a new hearth and oven.

Particularly in Massachusetts the town functioned as a religious commune (at least in the early seventeenth century), and was a theocracy of God's elect. The houses were solidly built and plain, but emblems nonetheless of God's manifest approval of their owners as evident in their material increase. The center of each town, both figuratively and literally, was the meetinghouse in the town common. This was an innovative building, for the Separatists and Puritans who turned their backs on the liturgy of the established English church wanted a building whose directness and appropriateness would strengthen the impact of the spoken word. Moreover, the meetinghouse was more than a church, for it housed political gatherings such as the annual town meeting and served as a haven in times of adversity. At a time when religion and daily life were nearly one, the meetinghouse was the communal assembly hall. Few of these seventeenth century structures survive, since most were replaced by larger buildings during the next century, but still extant is the excellently restored meetinghouse in Hingham, Massachusetts (Figs. 14, 15), built in 1681 with additions of 1731 and 1755. Typical of most of the early

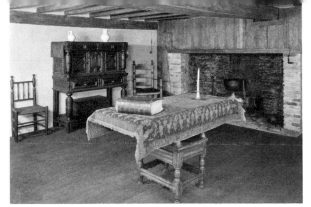

12. Thomas Hart house, Ipswich, Massachusetts, interior, parlor, c.1640 (now installed in the Metropolitan Museum of Art, New York).

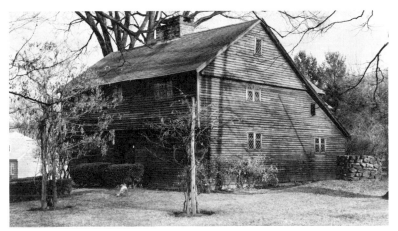

13. Samuel Whitman house, Farmington, Connecticut, 1664.

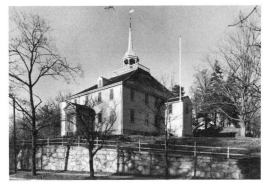

14. Old Ship Meetinghouse, Hingham, Massachusetts, 1681 with additions of 1731 and 1755.

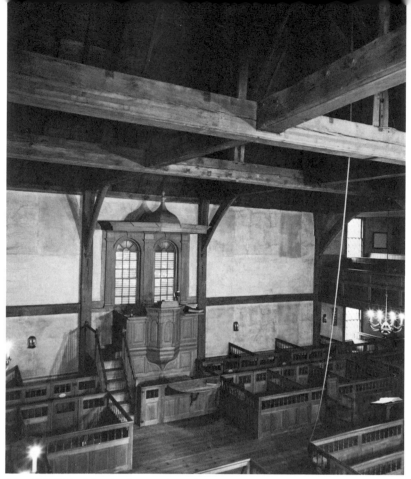

15. Old Ship Meetinghouse, interior.

churches, it is a relatively large hipped-roof barn-like structure, covered with clapboards. As were most of the early meeting-houses, it was originally nearly square in plan, enclosing one large room with the roof supported by three enormous king-post trusses (Fig. 15) which, because of their resemblance to naval con-struction, gave rise to the popular name "Old Ship Church."

The Capen house and "Old Ship Church" typify private and public building in New England during the seventeenth century, but elsewhere along the Atlantic seaboard, where different ethnic traditions were momentarily strong, other architectural expres-sions flourished briefly. Along the Hudson River, where the Dutch had established settlements, and where the climate was more moderate, Netherlandish traditions were adapted to the New World. At the mouth of the Hudson in New Amsterdam ap-peared brick buildings with crow-stepped gables turned toward the street (Fig. 16). In addition to these Flemish-gabled urban buildings, a distinctive rural type developed among the farms in

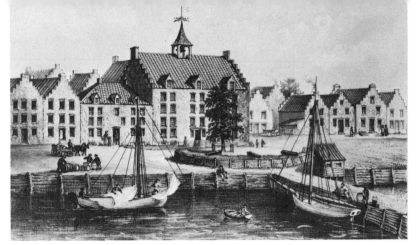

16. Stadt Huys (City Hall), New Amsterdam (New York), 1641–42; lithograph, 1869.

Long Island and northeastern New Jersey. This was based on the traditional domestic architecture of the Walloon settlers who came from Belgium and northern France. An example is the Pieter Wyckoff house (Fig. 17) in Flatlands, Bruecklen (Brooklyn), built in 1639 in what was then a rich farming belt around New Amsterdam. The low roof, sweeping out along the side to form a canopy over windows and entrance, is characteristic, as is the double-pitched gambrel roof which gave the name to a domestic type revived in the late nineteenth century—"Dutch Colonial." Significant too are the separate fireplaces at each end of the house, the use of shingles to cover both roof and wall surfaces, and the way in which successive additions were placed at the sides of the original unit rather than to the rear as was done to form the New England "saltbox."

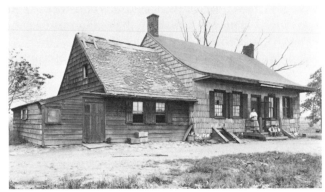

17. Pieter Wyckoff house, Flatlands, Brooklyn, New York, 1639.

The gambrel roof was also used extensively in the region around Philadelphia by the Swedes who first settled there, but its outline was higher, more balloon-like, and the irregular ashlar masonry of fieldstone used by the Swedes was particular to that area; it was later further developed by Germans and Welsh who settled in the region. Of all the local building traditions, the fieldstone construction around Philadelphia proved to be the strongest and influenced design through the eighteenth century. The ethnic character of the other smaller Swedish settlement in Delaware, however, was rapidly supplanted by the English who took the colony over, so that by the end of the seventeenth century the building traditions there were virtually the same as in the region around Philadelphia including Chester County.

There was to the seventeenth century New England village, such as Hingham, Massachusetts, a great unity of expression just as there was a great unity of purpose among the early builders and settlers. Of a type and sharing a common late medieval architectural tradition, the buildings grew according to the needs and circumstances of the owners, sprouting gables, dormers, ells, wings, sheds in ordered confusion. Often they turned silver and beige as sun and sea worked on the wood. Later, in the eighteenth century, as tastes and styles changed, houses might be replaced by new ones painted in pastel shades with crisp white trim, but the placement of the houses on the land had been fixed. The houses spaced themselves along curved and bending roads that followed the contours of the land and led as convenience dictated. But always near the center of the cluster, at the nexus of the paths, was the village common and the meetinghouse. In rural areas of New Hampshire, Vermont, Massachusetts, and Connecticut, such villages survive, their plans virtually intact though the individual buildings periodically have been replaced. Woodstock, Fair Haven, and Strafford, Vermont; Lebanon, New Hampshire; or Ipswich, Massachusetts, are all good examples.

This strong village pattern demonstrates how much life in the northern colonies was town-oriented, even in the rural areas. The urban focus was stronger still in the large cities, such as Boston and Philadelphia. In 1630, when lack of adequate fresh water necessitated building a new seat for the Massachusetts Bay colony, the neck of land protruding into the middle of the bay was selected. The main thoroughfares of this new Boston, named for the city in Lincolnshire, followed the ridges and hollows across the then rugged peninsula, along paths trod by the Indians and the first English settlers. A map of Boston in 1722 (Fig. 18) shows the

seemingly random network of streets and the patchwork of fields behind the scattered houses. On the east shore, around the harbor cove, was the town's center, with two open squares dominated by business houses, an open market, the meetinghouse, and a town hall. Here, over the next two generations, wharfs began to push out into the harbor as trade grew. The town common was a large undivided area on the west side of the peninsula, stretching below Beacon Hill, so-called because on its heights navigation lights were set up. Boston was, from the beginning, conceived as a center of cultural and economic activity—the fire on the hill was the signal to shipping that soon made Boston the chief city of New England, surpassing Salem and Newport. Though it had been viewed from the start as a major city, Boston was given the tight web-like street pattern of a village, and there was little thought given to the effect this might have on future growth

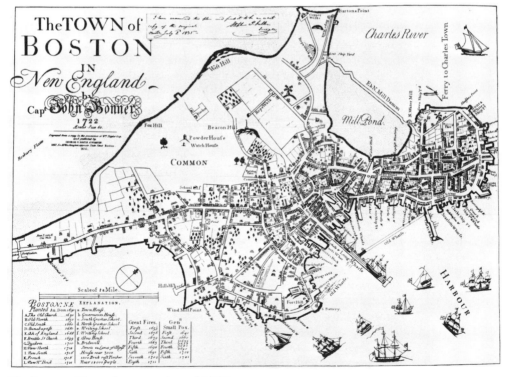

18. Boston, Massachusetts, plan of 1722.

Much the same turned out to be true of New Amsterdam (New York), though originally it had been planned on paper by the Dutch West India Company as an orderly series of rectangular subdivisions behind the defenses of a strong fort. When it was actually settled by Flemish Walloons in 1625, however, the layout of the settlement was considerably changed. A much smaller fort was built at the tip of Manhattan Island and behind it streets were extended as need and convenience dictated, following the contours of the land.

There were, however, several cities laid out in the seventeenth century with formal geometric plans, the first of which was New Haven, Connecticut. The plan was based on a large square, subdivided into nine equal squares the center one of which was the town common. It was platted by surveyor John Brockett in 1638, but may have been planned by John Davenport. While it seems to follow the planning precepts laid down by the Roman architect Vitruvius, even to having the grid turned at an angle to the points of the compass, it seems more likely that the geometric grid was based on the plan of the New Jerusalem described in the Revelation of Saint John. A larger and much more ambitious urban venture was Philadelphia. When it was begun as Penn's Woods (Pennsylvania) in 1682, proprietor William Penn took care to establish a spacious city with ample provisions for future health and growth. In his written instructions to his agents he specified that the town be situated on the Delaware River so that it have deep water access to the Atlantic for shipping, but it was also to be near water connections with the hinterland. Moreover, the location was to be high, dry, with supplies of good water. Because Penn knew at first hand how the congestion of medieval London had magnified effects of the fire and plague of 1665 and 1666, he was determined to do better in Pennsylvania. He had sketched out a plan that called for widely spaced perpendicular streets (Fig. 19). Laid out on a grid on a neck of land between the Delaware and Schuylkill rivers, Philadelphia was divided into four quadrants by dominant north-south and east-west thoroughfares (Broad Street and Market Street). Their intersection was marked by a large open square reserved for public buildings, and each of the four quadrants, in turn, was further apportioned, roughly at its center, a separate square for public convenience. So that neither fire nor contagion could sweep his "green country town," as had happened in London, Penn stipulated that the large city blocks be subdivided into wide deep lots with the individual houses set in the middle of each and surrounded by formal and kitchen gardens.

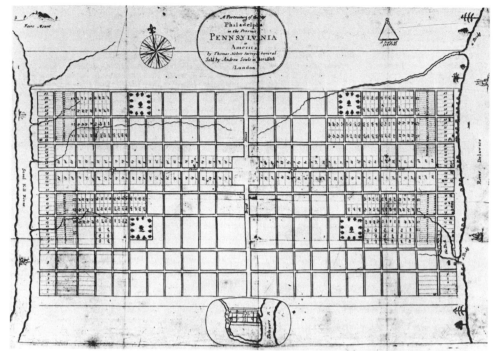

19. Philadelphia, Pennsylvania, plan as laid out by Thomas Holme according to instructions from William Penn, 1682.

South of Maryland there was no urban focus as intense as that in the northern colonies, and during the eighteenth century relatively few new commercial centers developed with the important exception of Charleston, South Carolina. This was partly so because of geography and partly because of economic determinants. After the unsuccessful attempts of Raleigh to establish a colony during 1584–90, a permanent settlement was made in Virginia in 1607. It set the pattern for settlement in the South, for it was populated not by religious dissidents who sought isolation from interference of crown or church, but rather by agents of the mercantile Virginia Company. Many of those who came to Virginia were sons of peers and landed gentry who, denied fortunes at home because of primogeniture, sailed to the New World to build their own estates. In comparison with Massachusetts' Plymouth Company, the group that settled Virginia was commercial and from the start maintained strong economic and cultural ties with the mother country. Economic ties were made all the easier by the fortuitous geography of the Chesapeake Bay in Virginia and the Albemarle and Pamlico sounds in North Carolina, for the many

deep inlets, sheltered from the ocean and its uncertain weather, made it possible for ships to load at a thousand tidewater wharfs. Hence the southern economy quickly came to be based on large plantations specializing in single bulk crops—tobacco, cotton, indigo, rice, and other raw materials—to be shipped out for processing elsewhere. This meant that every plantation on tidewater could ship from its own wharf and receive manufactures from England without going through a regional seaport. Each land owner was his own exporter, importer, and wholesaler. This was also true to a lesser extent in the Carolinas, but even Charlestown, begun in 1672 as a regional center and port, was never quite the same focal point of activity as were the cities of the North, perhaps because its most influential citizens were summer residents only, living at their inland plantations during the winter months. The fifth largest city in the nation at the time of the first national census in 1790, Charlestown rapidly fell to a very minor position thereafter.

Because of the influence of economics and geography, the story of architecture in the southern colonies in the seventeenth and eighteenth centuries is largely that of isolated country houses identified by county rather than by city. In contrast to the first New England homes which were based on English vernacular village houses, the earliest Virginian houses were often modeled after English country houses, and they were adapted to a much milder climate. The educated gentry who came to Virginia had more experience with "high style" domestic architecture in England and aspired to bring some of its developed character to their new homes, as can be seen in one of the earliest surviving houses, the Adam Thoroughgood house, Princess Anne County, near Norfolk, Virginia, built between 1636 and 1640 (Fig. 20). Thoroughgood arrived in the New World in 1621, an indentured servant, but by the time he had worked out his contract in 1629 he sat in the House of Burgesses and by 1636, when his house may well have been underway, he had amassed an estate of 5,250 acres. His house celebrates his position by referring to contemporary English traditions in brick masonry, making use of the local sources of good clay and oyster shells for lime. The house is one and a half stories, and while from certain angles it has a vertical emphasis, from other vantage points it has a horizontal emphasis that suggests a desire for classical repose, a debt perhaps to the influence of Renaissance architecture just beginning to be seen in England in the work of Inigo Jones. The near bilateral symmetry of the front, masking the asymmetry of two rooms of unequal size inside, and the subtle brick stringcourse at the eave line recall the

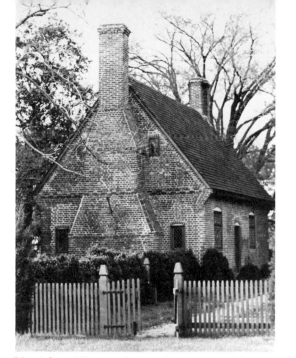

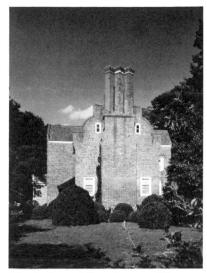

21. Arthur Allen house, "Bacon's Castle," Surrey County, Virginia, c.1655.

20. Adam Thoroughgood house, Norfolk, Princess Anne County, Virginia, 1636–40.

classical elements in Elizabethan and Jacobean architecture. The massive stepped-back chimney at the end, however, is medieval. There are separate fireplaces at each end of the house, one for each of the rooms, for in Virginia it was unnecessary and undesirable to cluster the chimneys in the center of the house. Indeed, it was necessary to throw off as much heat as possible during the spring and fall months.

An attempt at true "high style" is evident in the design of "Bacon's Castle," the home of Arthur Allen, Surrey County, Virginia, built about 1655 (Fig. 21). It is a full two stories high, with two large rooms on the ground floor, projected towers front and rear housing entrance porch and stairs, and huge chimney stacks at the ends. The entrance tower originally had a simple pediment over the door which helped to emphasize the classical aspects of the façade suggested by the correspondence of parts and the stringcourse between floors. Internally, the main rooms are unequal in size, belying the external symmetry, and this medieval aspect is especially fully developed in the Flemish gables and massive chimneys at the ends of the house. In fact, the composition of the ends is so strong that they overpower the rest of the house, indicative of the work of a sincere but unpracticed designer. Still, there is a masterful play of light and shadow and of solid and void

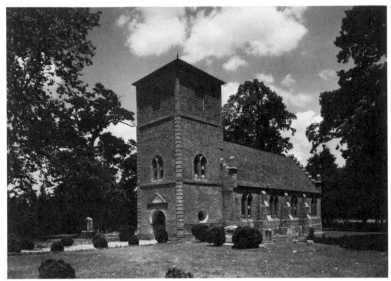

22. St. Luke's, the Newport Parish Church, Smithfield, Isle of Wight County, Virginia, 1632–c.1675.

in the chimneys. The massive base rises two and a half stories with a small setback at the top; from this rise three slender, free-standing chimney stacks which are joined at the top by a continuous corbeled cap. In all, the house is a mixture of European traditions; "a transplanted cultural symbol," wrote Professor William Pierson, "which took nothing architectural from its environment except its materials."

Most of the earliest churches in Virginia were of wood construction and have disappeared. Generally they were quite different in character from northern churches since they housed Anglican congregations; indeed, it was mandatory in the charter of the Virginia Company that the Church of England be established in that colony. It was only natural then that these colonists built in a way that recalled the parish churches of rural England, such as those of Atcham in Shropshire or Woodham Walter in Essex, which were of a generalized vernacular Gothic. The only surviving seventeenth century Virginia church is the Gothic St. Luke's, the Newport parish church, in Isle of Wight County, begun in 1632 (Fig. 22). Like the Virginia houses, it is of brick with traces of medieval tradition in its lancet Gothic windows in the sanctuary and tower, and the crow-stepped Flemish gables. Also Gothic are the open heavy wooden roof trusses (now carefully restored to their original appearance). By the time the church was near completion, the fashionable mode had changed in England and so, ac-

cordingly, various Jacobean classical touches were added to the tower, such as the stylized pediment over the round-arched entrance, and the quoins at the corners. As in the earliest Virginian houses, there is a mixture of medieval vernacular traditions of the sixteenth century and bits and pieces of the new classicism of the seventeenth century in buildings which were in truth homes away from home.

All things considered, the English colonists learned relatively little as they built on the American continent, using crude wigwams and dugout houses only long enough to build more traditional structures in a vernacular Gothic that recalled the familiar architecture of their homeland. In time, however, most unsuitable aspects of the transplanted English Gothic forms were modified to weather regional variations in climate. The colonists perpetuated the English system of land tenure and use, laying the foundation of the American myth of the private house standing on its own grounds. Even the few medieval practices of communal municipal ownership gradually disappeared in the face of assertive individual enterprise in the eighteenth century. Indian culture went underground, to be rediscovered centuries later; increasingly the Atlantic colonies became genteel and urbane, their eyes fixed on the model of London society.

2.

Transplantations in the New World: 1600–1785

The European immigrants of the seventeenth century generally built on the basis of tradition using materials at hand in response to local environmental conditions. In the eighteenth century, however, this practice changed markedly in favor of building more in accordance with developments in England. Very quickly the pluralism of building that had characterized the seventeenth century was replaced by a conscious emulation of current fashion in England, no matter what the original ethnic basis of the colony. By 1710 both the Dutch holdings on the Hudson and the Swedish settlements on the Delaware had been added to the British empire, and by about 1725 a uniform English culture was well established from Maine to Georgia. Thus, in place of many cultures, there developed one, beginning a recurrent theme in American life and architecture—the impulse to superimpose a uniform culture and a uniform building mode on a people and landscape characterized by great multiplicity of tradition and character.

Consciously trying to emulate England, planters and merchants shed the provincialism of their forebears and aspired to enter more into the mainstream of English life, looking on London as the arbiter of fashion. The medieval aspects of vernacular architecture of the seventeenth century gave way to a variant of late English Baroque architecture. English culture and the architecture of the English court and the wealthy upper class became the model not simply because of the preponderance of English settlers in the colonies but also because of the restrictions of the Navigation Acts which sought to enforce the mercantile system in the American colonies; England was the only country with which the colonies could legally trade.

American building of the eighteenth century shares with English architecture of the period the name Georgian after the monarchs who sat on the throne during that century, but American buildings are identified as Georgian Colonial to make a clear distinction. Generally American architecture during the eighteenth century falls into two chronological periods. The first from 1700 to 1750 shows the influence of Inigo Jones and more especially of Sir Christopher Wren. The second period begins about 1750 and shows the decided influence of James Gibbs and the Neo-Palladian movement centered around the Earl of Burlington and William Kent. Though both these influences came about through more frequent travel and the increasing awareness among the wealthy of what their English counterparts were doing, they were also due to commercial publication of architectural treatises in English, undertaken in earnest at the beginning of the eighteenth century. The first of the fourteen editions of Palladio's *Four Books of Architecture* appeared in England in 1663, but most popular was the edition of 1715 edited by Giacomo Leoni and sponsored by Lord Burlington. This was followed by William Kent's *Designs of Inigo Jones,* 1727, which illustrated the work of the first English Renaissance architect. Extremely important were the five volumes of Colen Campbell's *Vitruvius Britannicus,* 1715–25, and William Adam's *Vitruvius Scotius,* 1750. In addition to these were the two folios by Isaac Ware. Far and away the most important book in the colonies during the last half of the century, however, was James Gibbs's *A Book of Architecture,* 1728.

Such books, aimed at the gentleman-scholar, were large in format, expensive, and largely theoretical. Particularly popular in the colonies were numerous carpenter's handbooks such as William Salmon's *Palladio Londinensis,* 1734, or the books by William Halfpenny, Abraham Swan, and Robert Morris. Especially useful was Batty Langley's *The City and Country Builder's and Workman's Treasury of Designs* which appeared in 1740, went through more than eleven editions up to 1808, and traveled to the farthest reaches of the English-speaking world. Langley's *The Builder's Jewel* of 1741 was nearly as popular.

The eighteenth century was a period of urbanization in the colonies, through concentration and development of the centers already established, for during the century relatively few new cities were established with the notable exceptions of Savannah, Georgia, in 1733, Pittsburgh, Pennsylvania, in 1784, and Louisville, Kentucky, during the Revolutionary War in 1778. For the coastal cities it was a period of great growth, as centers of com-

merce and as centers of culture. For some, such as Charlestown, Salem, and Newport, it was their finest period; they never again enjoyed such influence or creative power. In two other cities, New York and Williamsburg, developments occurred which were to have repercussions for centuries.

By 1674 New Amsterdam had been secured by the English. Renamed New York, it grew fairly slowly, with each addition extrapolating existing tracts (Fig. 23), the roads following worn paths across the hilly terrain ("Manhattan," the Indian term for the island, meant "island of hills"). The Ratzen plan of 1767 shows the irregular pattern of the Dutch settlement at the tip of the island and irregular English additions to the northeast. Later additions, such as the subdivision of Trinity Church lands along the Hudson, or the tracts on either side of Bowery Lane, were divided into regular grids, and the divisions east of the Bowery even had a large public square set aside in the manner of London parks. The other park in the city was a small triangle east of Broadway below City Hall. To the north, beyond these additions, stretched the rolling and varied landscape of Manhattan Island. What is significant about New York, as restructured by the English, is the corporate legislation similar to that enacted for other cities. All land between low and high water belonged to the city, giving rise to the exploitation of the shoreline for municipal wharfs. All land not already in private hands when the corporation was modified in 1696 became municipal property; because of this the park land in the division east of the Bowery, originally privately held, eventually became city property after the Revolution and was cut up and sold. All land used for streets, alleys, and lanes also became municipal property. Such legislation was to form the background for the later speculative subdivision of the entire island.

While New York grew in stages northward from the Dutch nucleus, Williamsburg, Virginia, was laid out as a new town. The original capital at Jamestown had never been a good location, and when the Virginia capitol burned in 1698, newly appointed Governor Nicholson lost no time in having the General Assembly move the seat of government to Middle Plantation, a village on higher ground. In 1694, as the governor of Maryland, Nicholson had sketched out the plan for its new capital city, Annapolis, along French Baroque lines. He was also instrumental in laying out the plan for the new Virginia capital which was renamed Williamsburg. Surveying began in May 1699 for a city of two thousand people (Fig. 24). One reason for relocating in Middle

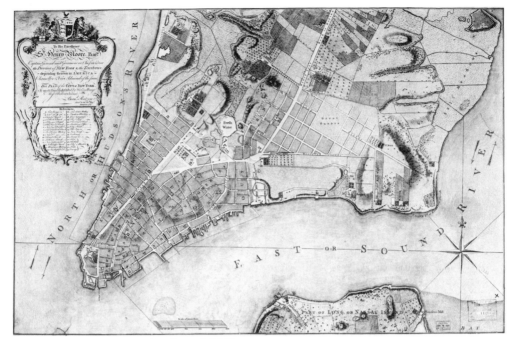

23. New York, New York, plan of 1767.

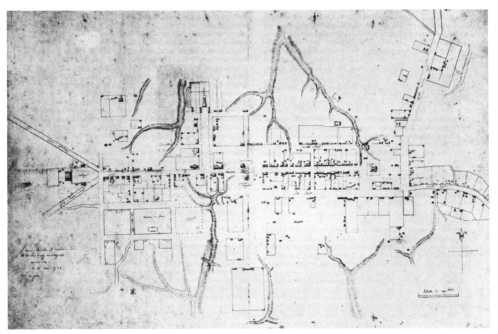

24. Williamsburg, Virginia, plan as laid out by Francis Nicholson, 1699.

Plantation was that four years earlier the College of William and Mary had been located there and it would make a good adjunct to the capital (see Fig. 44). The new college building, then under construction, was selected as one terminus of a broad boulevard, running east and west, that formed the major axis of the town. Named Duke of Gloucester Street, it was a mall ninety-nine feet wide and nearly four thousand feet long. So that it could be laid out several houses had been removed and the materials returned to their owners in one of the earliest instances of the exercise of eminent domain in the English colonies. The legislation establishing Williamsburg was exacting, stipulating that the houses along Duke of Gloucester Street should be of a certain size and all set back six feet. At the east end of the new street the capitol was built in an open square. Midway along the boulevard were the market square, the Bruton Parish Church, and the Powder Magazine. Just to the west of the market square was a perpendicular axis extending to the north, the palace green, two hundred feet by one thousand feet, which terminated in the Governor's Palace begun in 1706. The palace, the most elaborate and finely finished house in the colonies at that time, was built directly on the axis of the green, with rooms balanced around a central hall. The axis then continued beyond the house as the basis of the formal gardens to the north. In addition to the marked sumptuousness of detail of the palace, this organization about a predetermined axis initiated a significant change in domestic design in the colonies; for during the remainder of the century private houses were invariably axially planned.

The typical Georgian house, of which the Governor's Palace, Williamsburg, was one of the first examples, is based on a body of normative abstract principles. It is bilaterally symmetrical about a center axis, both in plan and façade. This axis is marked by a central hall which runs the full depth of the house. The house is cubical and restrained, divided into horizontal ranges by the use of low hipped roofs, balustrades, prominent cornices, stringcourses between each floor, and a water table where the building rests on the foundation. It is disposed so as to have careful proportional relationships among elements; it is ornamented with selected devices derived from antiquity; and it is clearly articulated in its parts so that edges, windows, and the center entrance are all elaborated. Derived from Renaissance and Baroque architecture, such houses and public buildings are boldly rectangular, though in the last half of the century, due to the influence of the work of James Gibbs, entrances were marked by projecting pedimented pavilions.

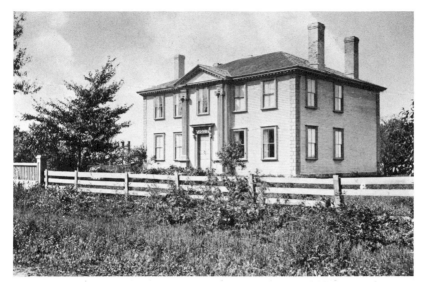

25. Lady Pepperrell house, Kittery Point, Maine, c.1760.

As a result of building practice based on universal principles, the Georgian Colonial houses of the Atlantic seaboard have a far greater uniformity than do the varied expressions of the seventeenth century. It is possible to view examples from Maine to the Carolinas as one family of buildings. At the northern limits of this range is the Lady Pepperrell house at Kittery Point, Maine (Fig. 25), which was built about 1760 by the widow of the first colonial baronet, Sir William Pepperrell who had been honored for service to the king. Typical of the northern houses, it is built completely of wood with wooden quoins at the corners. Smooth plank construction, based on Gibbs, was used in the center pavilion, which was emphasized by the colossal Ionic pilasters on pedestals and by the richly embellished door with its cornice carried on consoles. Nevertheless, the main cornice is rather weakly proportioned for the house as a whole, and it sits directly on top of the windows of the second floor.

To the south is the Wentworth-Gardner house of Portsmouth, New Hampshire (Fig. 26), built in 1760. It is basically similar to the Pepperrell house but without the center pavilion and thus more in the tradition of the first part of the century. Instead the center axis is stressed by a very elaborate entrance; the door is framed by richly carved Corinthian pilasters which carry a full entablature and a swelling broken scroll pediment ending in large rosettes. Plank sheathing is used here also but the chamfered joints suggest rusticated masonry. The horizontal emphasis of the

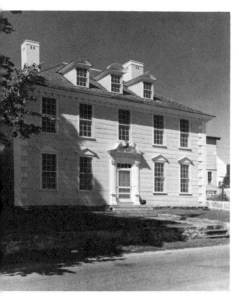

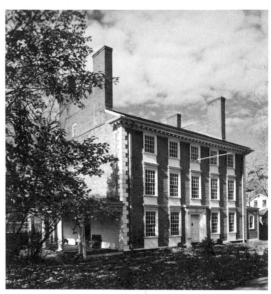

26. Wentworth-Gardner house, Portsmouth, New Hampshire, 1760.

27. Isaac Royall house, Medford, Massachusetts, 1733–37 and 1747–50; east facade completed 1737.

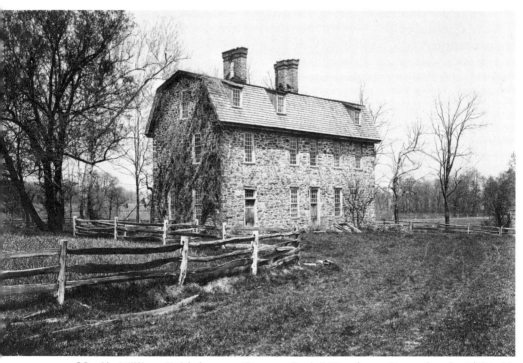

28. Sir William Keith house, "Graeme Park," Horsham, Pennsylvania, 1721–22.

first floor is maintained by the pedimented caps over the windows. As in the Pepperrell house, however, the cornice of the roof is narrow and it too sits tightly on the tops of the second floor windows. Even in black and white reproduction, the difference in color of the wall surfaces and the trim elements is noticeable. Generally these frame houses were painted in colors intended to suggest masonry, with dull yellow for the walls (as here) or tan or light brown, with white used for the details and trim. Often sand was mixed with the paint to give the surface the texture of stone.

The Isaac Royal house, Medford, Massachusetts (Fig. 27), is a good example of the fully developed Massachusetts house. It is a more complex building begun in 1733 as a two-and-a-half-story house, one room deep, with brick end walls and frame façades. Beginning in 1747 Isaac Royal enlarged it to three full stories, two rooms deep. The prominent brick end walls and the tall chimneys are illustrative of the radical change in planning in these northern houses; the fireplaces are now found on the outer walls or flanking the center hall. They are no longer nestled at the center of the house. On the east façade the usual ornamental devices are present: quoins at the corners, cornice, and entrance framed in Roman Doric pilasters and entablature. Here, however, the windows are connected by spandrel panels between floors, adding a vertical accent to the basically horizontal conception. The interiors of the house, begun about 1750, are well executed and well express the wealth young Isaac Royal had accumulated in the rum trade.

There were, however, strong local traditions which still contributed much to Georgian architecture during the eighteenth century. A good example is Graeme Park, built at Horsham, Montgomery County, Pennsylvania, 1721–22 (Fig. 28). The exterior is intentionally severe, with walls built of rubble fieldstone, openings unframed and seemingly randomly placed. The random ashlar masonry and gambrel roof carry on Swedish, German, and Welsh Quaker traditions, and seem to show no great change from what had gone before. Inside, however, are exceptionally well-designed and -executed interiors of carved pine paneling. The framed and pedimented doorways, remarkable in view of the early date, are appropriate inasmuch as this was the country home of Sir William Keith, governor of Pennsylvania.

More comparable to the New England houses is the home of the privateer and sea captain John MacPherson, "Mount Pleasant," in Fairmount Park, Philadelphia, then a suburb of the city (Fig. 29). Built in 1761–62, it is a good example of the full influ-

ence of James Gibbs, and well represents the characteristics of the typical Georgian house. In plan (Fig. 30) the main rooms lie on either side of a central hall running through the house, expressed externally by the projecting center pavilion. Because of this the stairs are tucked into a corner where they ascend and cut in front of one of the windows, indicating one of the problems of fitting functions into a priori formal conceptions. The flat-topped hipped roof is crowned by a balustrade which continues the horizontal stretch of the house; this is reiterated by the strong cornice line, the brick stringcourse between floors, and by the swelling water table at the base. The wide-spaced windows are capped by heavy flat arches, but most elaborate is the Palladian window in the upper level of the center pavilion and the richly embellished entrance consisting of an arcaded door surrounded by a Roman Doric frame and pediment. Contributing to the solid appearance of the house are the two massive chimney clusters; in each are four free-standing flues rising from a square base and tied at the top by arches, somewhat like those in Vanbrugh's Blenheim Palace, Oxfordshire, begun 1705. The construction is of masonry, indicated by the brick quoining, stringcourses, and other details, but the rubble masonry walls (in the tradition of buildings like Graeme Park) are covered by a smooth coat of stucco. The influence of Gibbs is seen in the placement of the out-buildings forward of the house at the ends of quadrants, creating an entrance forecourt. This comes directly from the plates in Gibbs's book, and is remarkable because few northern houses show this degree of formality in the planning of their dependencies and grounds.

During the third quarter of the eighteenth century, Philadelphia became one of the most urbane cities in the colonies and its craftsmen turned out most accomplished pieces, as can be seen in the interiors of Mount Pleasant or the parlor from the Blackwell house of Philadelphia, built about 1764 (Fig. 31). The change in scale from the low, intimate confines of the seventeenth century saltbox is immediately evident. Ceilings in Georgian houses up and down the coast were uniformly high. The pervasive formality of planning is revealed in such details as the way the fireplace is centered between the doors. Each part is richly embellished, the doors heavily framed and topped with broken pediments, the fireplace capped by a mantel carried on carved consoles. Above this, the over-mantel contains a painting within a broad carved frame which in turn is surrounded by carved plaster foliate reliefs. A full and heavy cornice marks the meeting of wall and ceiling. Because of the increased height, suspended crystal chandeliers became common in the more prestigious homes.

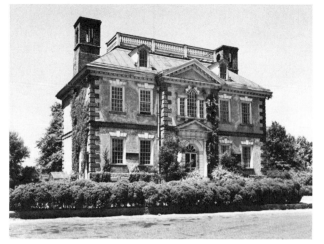

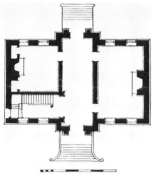

30. "Mount Pleasant," plan.

29. John MacPherson house, "Mount Pleasant," Philadelphia, Pennsylvania, 1761–62.

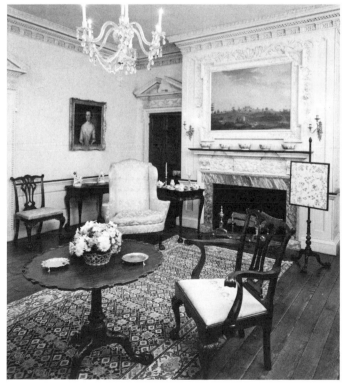

31. Blackwell house, Philadelphia, parlor, c.1764 (now installed in the Henry Francis du Pont Winterthur Museum, Winterthur, Delaware).

Fine furniture was made in several centers. Salem and Newport became well known for finely wrought furnishings, particularly Newport through the work of John Goddard and John and Edmund Townsend. Philadelphia especially had large numbers of artisans who produced furniture based on designs by Thomas Chippendale. Like the houses in which they stood, these pieces are marked by rich three-dimensional carved embellishment. There is throughout both the houses and furniture an interest in antiquity that was becoming more exacting, blended with the play of curve and countercurve of the Rococo. High chests indicate the level of craftsmanship colonial artisans had attained by the middle of the century; indeed, Philadelphia pieces compare very favorably with their English counterparts.

High chests generally stood seven and a half feet tall. When one compares them to the five-foot height of seventeenth century court cupboards, one can readily see that drastic changes occurred in the scale of domestic design in the eighteenth century; ceilings for example were about three feet higher. While severe climatic conditions forced the early houses to be compact, under the same conditions Georgian houses could be larger in size, partly due to improved fireplace design with air ducts allowing more heat to be obtained from burning fuel, but mainly because of the simple use of grates to raise the fire, and the use of coal as fuel in the seaboard towns. There was also more money for fuel, candles, and whale oil; rooms therefore could be bigger with ceilings higher, and still be heated and illuminated. All of this was brought about by the growing economic base, fed ironically by goods produced largely in defiance of English mercantile law. The cast iron stove perfected by Benjamin Franklin in 1742 is one example of this; manufactured illegally, it was designed to produce significantly more heat from a given amount of fuel, and thus helped to increase the volume of usable space.

Many of the great Georgian Colonial houses in Virginia were built in the first half of the century and are therefore based more on the work of Sir Christopher Wren and the published illustrations of Palladio's work than on Gibbs's book. As in the preceding century, the houses stand in isolation along the banks of the Chesapeake Bay estuaries. One of the earliest and best is the home of William Byrd II, "Westover," in Charles City County, Virginia (Fig. 32). It was built in 1730–34 and may well have been partially designed by Byrd, a highly successful planter who gathered one of the best libraries of his day—four thousand volumes,

many of them on architecture. Active in colonial affairs, Byrd spent much of his time in England and knew well the trends in domestic architecture there. It is likely that Richard Taliaferro also contributed to the design of "Westover", and his name is connected with many other tidewater houses as well. "Westover" has a very steep roof, in the manner of the Governor's Palace in Williamsburg. Below this and its pedimented dormers, however, the house is more fully Georgian with broad window bays, stringcourses between floors, and an embellished central entrance. Auxiliary buildings, built on either side of the house, were later connected to the main house by "hyphen" extensions. As had been typical of the Virginia houses for over a century, "Westover" is of red brick, and, like earlier houses, has a rather irregular internal room arrangement, in contrast to the insistent external symmetry.

The interiors of "Westover" are perhaps not so sophisticated as the exterior, but a fine example is found in the central hall of "Carter's Grove," James City County, Virginia, said to be by carpen-

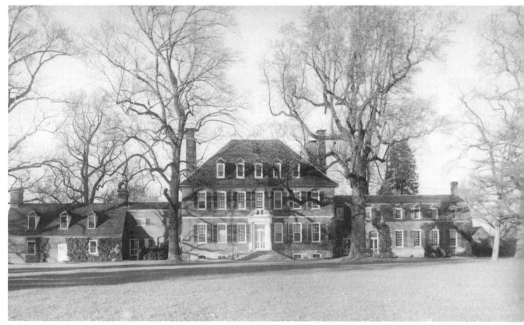

32. William Byrd house, "Westover," Charles City County, Virginia, 1730–34.

ter Richard Bayliss (Fig. 33). The paneling of the walls, the Ionic pilasters which divide it into sections, and the full entablature they carry, are all carved from pine, while the stairs and balustrade are of walnut. The workmanship is among the finest in the colonies, with details of paneling and woodwork derived from the pattern books of the day such as Salmon's *Palladio Londinensis*.

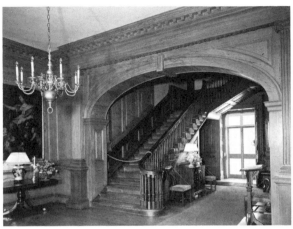

33. "Carter's Grove," James City County, Virginia, interior, stair hall, 1750–53.

As in the seventeenth century, the southern planters attempted to emulate the high style of English country seats, and this continued with increasing suavity and attention to current standards in the mother country. This is already evident in the early house built by Thomas Lee about 1725–30, "Stratford," in Westmoreland County, Virginia (Fig. 34). Because of the austerity of the design, the scale of the house is somewhat deceiving, and there is little overt impression that this was the center of an estate of sixteen thousand acres. The brick construction is typical but the H-shaped plan is unique and transforms the house into a sculptural mass. This, plus the great clusters of four chimneys connected by arcades at their tops, suggests that the unknown designer of the house may have had in mind Vanbrugh's Blenheim Palace. Also atypical for this area was the elevated single floor of the house, consisting of two four-room apartments on either side of the central hall. The ten-foot base which carries the main floor is of special oversized brick, laid in a bold Flemish bond with glazed headers, thus creating a distinctive pattern in the masonry of the base.

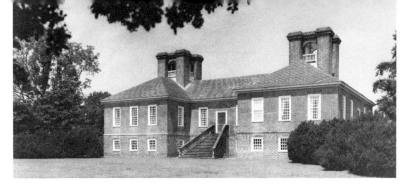

34. Thomas Lee house, "Stratford," Westmoreland County, Virginia, 1725–30.

Southern houses, set in landscaped grounds, were somewhat more extensive than northern counterparts, and required large separate kitchens and service facilities. In perusing Palladio and Gibbs, the planter gentlemen-scholars found suggestions for planning such large formal houses, and in fact the spreading villas designed by Palladio for the Veneto were indeed rather similar to the Virginia plantations in function and social life. One house which clearly shows this Palladian-Gibbs influence is "Mount Airy," in Richmond County, Virginia, built in 1758–62 (Figs. 35, 36). It is believed that the architect was John Ariss, who had been trained in England and was familiar with Gibbs's work. The plan and elevation of Mount Airy are based closely on plate 58 of Gibbs's *Book of Architecture,* and in many ways are similar to Mount Pleasant, Philadelphia. The house consists of a two-story rectangular block with a pedimented central pavilion; an entrance forecourt is formed by dependencies at the end of quadrants connected to the main block by curved covered passageways. Less typical for the colonies is the construction of brown sandstone with light limestone used for the central pavilion, but even this is based on suggestions from Gibbs's plates.

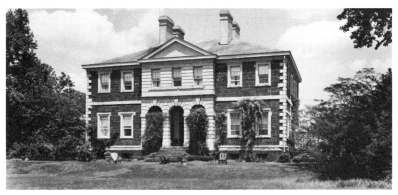

35. John Ariss(?), Col. John Tayloe house, "Mount Airy," Richmond County, Virginia.

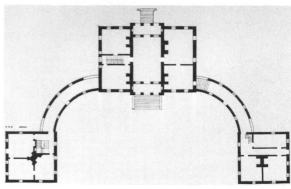

36. "Mount Airy," plan.

A few Virginia tidewater houses and a few northern buildings can be attributed to designers or architects. More often, however, the designer is unknown even when the reference to a Gibbs or Salmon design is clear. The professional architect, as we know him today, had not yet come into existence in the colonies. The major houses and public buildings of the eighteenth century were designed by well-to-do gentlemen with the leisure to read and pursue private study in architectural theory. That their designs blend together well is due to their common reliance on a coherent body of knowledge based on Renaissance principles, usually derived ultimately from Palladio. There were a few who received some training in England before moving to the colonies, such as James Porteus (in Philadelphia), John Hawks (North Carolina), James McBean, a pupil of Gibbs (New York City), and John Ariss (Virginia). Most designers, however, were amateurs, having been trained in medicine or law, or as carpenters and cabinetmakers. Richard Munday, for example, designer of Trinity Church, Newport, 1725–26, and the Old Colony House, Newport, 1739–41, was a carpenter. William Buckland started as a woodcarver but trained himself in other trades, came to the colonies as an indentured servant, and built one of the finest houses in Annapolis, the Hammond-Harwood house, 1773–74 (Fig. 37). Among the gentlemen-architects were Joseph Brown of Providence, a professor at Rhode Island College (Brown University) and a merchant; Dr. John Kearsley, a physician active in Philadelphia; and Andrew Hamilton, a lawyer active in politics in Pennsylvania. Richard Taliaferro of Williamsburg was a well-to-do planter. Moreover, painters such as John Smibert and John Trumbull often drew up designs for buildings, for example, Smibert's Faneuil Hall, Boston, 1740–42 (see Fig. 77), or Trumbull's modifications to Connecticut Hall at Yale University, 1797. Such amateurs were responsible for much creditable work because building practice at the time left much of the detail and ornamentation to the builder

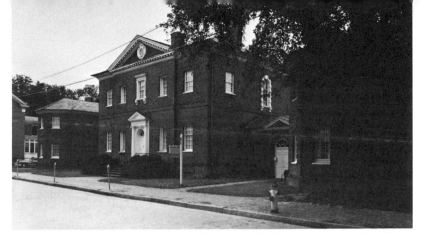

37. William Buckland, Hammond-Harwood house, Annapolis, Maryland, 1773–74.

who in turn referred to the standard details in handbooks.

Perhaps the most erudite and accomplished of the gentlemen-architects of the century was Peter Harrison (1716–1775) of Newport, a native of Yorkshire, who became a merchant, quickly accumulated a fortune, and married a woman of position and wealth. Thus situated, he had the time and means to pursue his hobby—architecture. He pored through the books in his growing library for models suited to his task. His first building, the Redwood Library, 1748–50 (Fig. 38), is based on an illustration by Edward Hoppus for the fourth book of *Andrea Palladio's Architecture,* (London, 1736). Harrison's library consists of a Tuscan Doric temple front superimposed on a broader lower gable-ended block. Although the side wings appear to have rusticated ma-

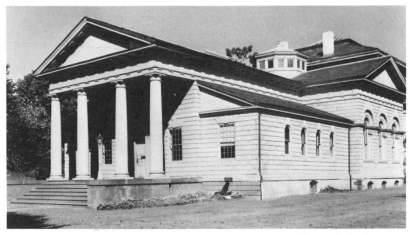

38. Peter Harrison, Redwood Library, Newport, Rhode Island, 1748–50.

sonry, the entire building is of wood, painted a chocolate brown with sand mixed in the paint to give the illusion of stone. For the details throughout, Harrison was totally dependent on his books.

One can begin to see this dependency more clearly in the interior of the Touro Synagogue, Newport, built in 1759–63 (Fig. 39). It is drawn from books, but it is exquisitely done. Harrison's problem here was compounded since he had no sectarian architectural heritage upon which to draw. He was designing a house for Sephardic Jews who had been attracted to Newport because of religious toleration in Rhode Island. Indeed the colony itself had been established by dissenting Baptists from Massachusetts led by Roger Williams. Having no type to emulate, Harrison used the simplest, most direct Georgian forms. Externally the building is a cube with the main embellishment a portico supported by freestanding columns. Within is a large space framed on three

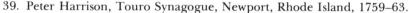

39. Peter Harrison, Touro Synagogue, Newport, Rhode Island, 1759–63.

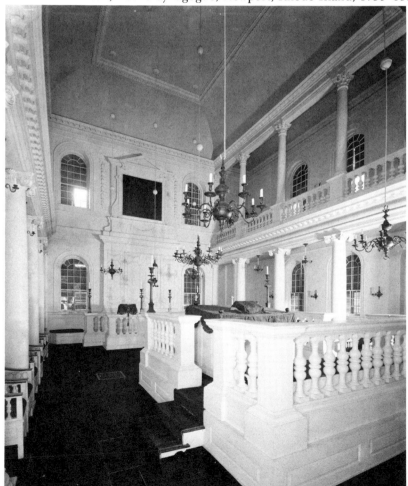

sides by balconies for women, carried on twelve columns representing the twelve tribes. Altogether it is an exercise in lightness and refinement seldom equaled in the eighteenth century.

Harrison was a staunch conservative, and throughout his life remained loyal to the crown; he eventually ended his career as collector of customs for His Majesty's Government in New Haven, Connecticut, where his extensive library and collection of drawings unfortunately were destroyed by an irate revolutionary mob. His innate conservatism can be seen in the Brick Market, Newport, 1761–62 (Fig. 40), one of his last designs. This was to house market stalls on the ground floor with various chambers above.

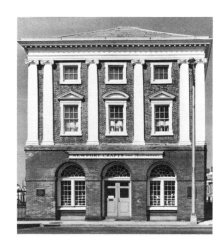

40. Peter Harrison, Brick Market, Newport, Rhode Island, 1761–62.

For his solution Harrison turned to a plate in the first volume of Campbell's *Vitruvius Britannicus* (1715) showing the Great Gallery at Somerset House, London, by Inigo Jones and John Webb. Subtle modifications were required since the Newport building was to be brick with wood trim, but the proportions were retained as was the emphasis on the corners through widened arcade piers and double pilasters. The massiveness of the corner piers would have been visually necessary when the ground floor was an open arcade (the openings have since been glazed and the area enclosed). Like the synagogue interior, the Brick Market is a very sophisticated and correct design, with a trace of the dryness to which academicism is prone.

As with the houses, the public buildings of the first half of the eighteenth century were based closely on the work of Wren;

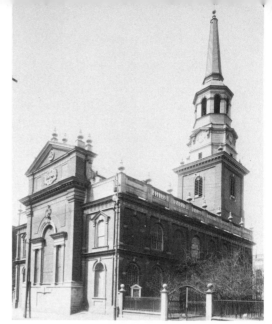

41. Dr. John Kearsley, Christ Church, Philadelphia, Pennsylvania, 1727–54.

churches in particular drew their motifs from Wren's London city churches built to replace those destroyed in the great fire of 1666. But after about 1730 the main source, as in domestic design, was Gibbs's work; most churches built in the colonies between 1730 and 1770 emulated his St.-Martin's-in-the-Fields, London (1721–26). One of the first was Christ Church, Philadelphia, built in 1727–54 (Figs. 41, 42). The body of the church was based on

42. Christ Church, interior.

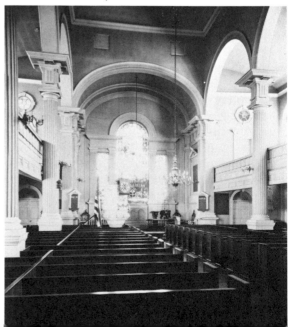

designs by Dr. John Kearsley. The tower was finished later, and though probably not designed by Kearsley, it is clearly based on Gibbs's plates. The body of the red brick church is divided by a stringcourse into two stories with windows heavily framed and pedimented. The ornamental trim elements, such as the balustrade atop the wall and its bulbous finials, are slightly overscaled for the bulk of the building but are balanced by the chancel wall with its large Palladian window framed between colossal pilasters. The interior (see Fig. 42) is also patterned after Gibbs's St.-Martin's-in-the-Fields, and consists of three wide bays carried by free-standing Roman Doric columns with full entablature blocks. As in Saint-Martin's, galleries are carried midway up the columns. Kearsley simplified the interior by keeping a flat ceiling, avoiding the intricacies of the suspended elliptical plaster vaulting of Gibbs. It is an interior suffused with light through the many windows (originally the Palladian chancel was glazed with clear glass), helping to alleviate the heavy scale of the embellishment.

The First Baptist Meetinghouse of Providence, Rhode Island, built 1774–75 (Fig. 43), was also designed by an amateur, Joseph Brown, who had acquired wealth as a merchant, had devoted

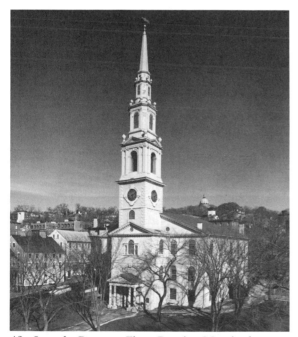

43. Joseph Brown, First Baptist Meetinghouse, Providence, Rhode Island, 1774–75.

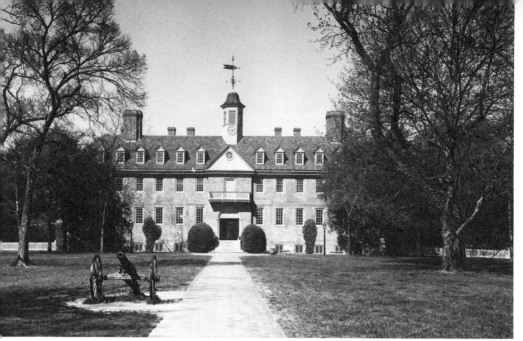

44. College of William and Mary ("Wren Building"), Williamsburg, Virginia, 1695–1702.

himself to the study of mechanics and astronomy, and had become a professor at Rhode Island College (Brown University). As had Harrison, Brown found his solution for this nonconformist congregation among his architectural folios. For the meetinghouse Brown designed a large three-story frame cube, originally eighty feet to a side, with entrances on each side, the main entrance surmounted by a tower of 185 feet copied directly from an unexecuted design for Gibbs's St.-Martin's. To carry it out, Brown had master carpenter James Sumner brought down from Boston; Sumner deleted only minor details intended to have been done in cut stone in the original. In contrast, the free-standing entrance portico, derived from another Gibbs design, is much too small for the tower and indicates Brown's desire for correct details and his lack of formal training. Where Christ Church, Philadelphia, is of brick with wood trim, the First Baptist Meetinghouse, like other New England structures, is entirely frame, with clapboard siding and quoined corners.

One relatively new building type of the eighteenth century was the college hall. The first frame building for Harvard is a good example; it was a multipurpose structure containing rooms for professors and students, classrooms, dining hall, library, and chapel. Whether at Harvard, Brown, Yale, or Dartmouth, the Georgian buildings which replaced the first frame structures fol-

lowed a basic pattern established by the "Wren" Building for the newly established College of William and Mary in Williamsburg, Virginia, in 1695–1702 (Fig. 44). That building, said at the time to have been designed by Sir Christopher Wren himself, consists of a tall four-story U-shaped block. One of the first Georgian Colonial buildings, it is formally planned about an axis that runs through the central arched door and rear court. This focus is emphasized by the central pavilion which breaks slightly forward, crowned by a steep gable, and the tall cupola atop the hipped roof. Through the rest of the century other college buildings at Harvard, Yale, and King's College (later Columbia University) followed this pattern, though roofs became lower, central pavilions wider, pediments broader, and horizontal emphasis stronger.

For the other large public buildings, such as colonial governmental meetinghouses, designers simply sketched out large residential buildings. Richard Munday's Old Colony House, Newport, 1739–41, is one, and possesses a certain vigor in its awkwardly proportioned gable and ornamental details. More academically correct is the Old State House, Philadelphia, now known as Independence Hall (Fig. 45). Built between 1731–53, it was designed by the prominent Philadelphia lawyer Andrew Hamilton. It is a two-story rectangular brick block, with the end walls rising to chimney banks. Between the chimneys run balustrades

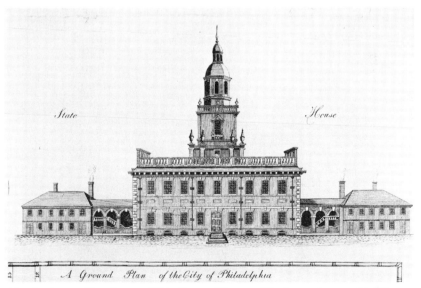

45. Andrew Hamilton, Old State House ("Independence Hall"), Philadelphia, Pennsylvania, 1731–53.

whose horizontal line is reinforced by stringcourses and water table. The corners are quoined. Dependencies were later added to either side, connected to the central block by arcaded passages, but all kept in line with the main building in the manner of early Georgian Colonial houses. The south façade is dominated by the massive tower, based on typical church designs, but set along the side of the building instead of at the end (the wooden upper stages, closely approximating the original, were restored first by William Strickland in 1828 and then again in the 1890s).

While the English colonies were consolidating their cultural positions during the eighteenth century, significant building was going on in the Spanish and French colonies as well. French activity in lower North America was focused on New Orleans which had been surveyed as an orderly grid by Adiren de Pauger in 1722 and to which additional sections were added between 1803 and 1817. Perhaps most impressive is the Cabildo, on the Place d'Armes, New Orleans, built in 1795, a two-story masonry building with an open arcaded ground floor which incorporates the latest French Baroque elements. The Cahokia Courthouse, Cahokia, Illinois, originally built about 1737 as the home of a French trader (Fig. 46), is an example of the more numerous rural buildings and illustrates a type once familiar all along the length of the Mississippi. Its surrounding *galerie* supported by wooden posts has a double-pitched saddleback roof extended to provide protection for the traditional French exposed frame and infill construction. In the southernmost regions, raised up on an airy basement, such a configuration provided a breezy veranda.

In the Southwest the Spanish quest for souls resulted in a number of splendidly elaborated churches built during the eighteenth century. Architecturally less ambitious but more pious in

46. Cahokia Courthouse, Cahokia, Illinois, 1737.

origin was the string of twenty-one missions in California. Nearly all were established by Father Junípero Serra. While the simplest were designed by Padre Serra himself or the Franciscan priests he installed, the construction was supervised by masons brought up from Mexico since the California Indians had no traditions of building in permanent materials as did the Pueblo Indians of the Southwest. Consequently the designs were extremely simple, with a rather plain church block with a domestic and educational quadrangle to the side. More ambitious was the second mission church at San Juan Capistrano, 1797–1806, of solid cut stone, built by master mason Isidorio Aguilar; unfortunately its domical masonry vaults collapsed in the earthquake of 1812. Perhaps the mission which today best conveys the spirit of Padre Serra is San Carlos de Borromeo at Carmel, 1793–97, which has been restored (Fig. 47). The façade is a rather primitive and naive evocation of High Baroque churches of Mexico and Spain. Construction, especially the interior, was supervised by Manuel Ruiz, a mason from Catalonia, and the parabolic transverse arches of the sanctuary, the only ones of their kind in North America at this time, reflect a Catalan influence.

The missions of Texas, New Mexico, and Arizona show more

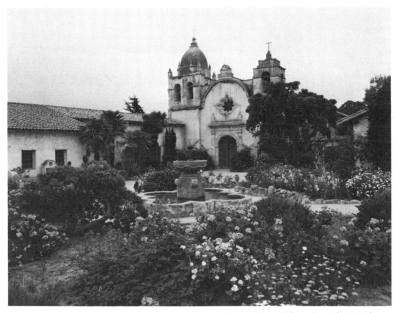

47. Mission San Carlos de Borromeo, Carmel, California, 1793–97.

familiarity with late Spanish Baroque models and a desire to emulate the mother houses of Mexico and Spain more nearly matched by construction skill and economic means. Representative of such missions is San José y San Miguel de Aguayo, San Antonio, Texas, built in 1768–77 (Fig. 48). In many of its details it is the most authentic Spanish Baroque in the United States, although the carving of its tufa masonry is necessarily rough. The walls originally were stuccoed and painted with brilliant quatrefoil patterns. Its dome vaults also merit special attention since most of the missions had flat framed ceilings. Most striking are the intricate elaborate portal sculpture and baptistry window carved by Pedro Huizar, a trained stone-cutter. Although the bold frontispiece of San Xavier del Bac near Tuscon, Arizona (1784–97), is more untutored in design and execution than that of San José y San Miguel, the matching towers with their large oversized diagonal flying buttresses well exemplify the vigor and plastic inventiveness of the provincial builders. Yet as beautiful as such stone carving at San José y San Miguel was, it meant little to the many transplanted English-speaking settlers who began to arrive in Spanish territories in increasing numbers during the nineteenth century, and while some building practices were maintained, such stone carving gradually came to an end.

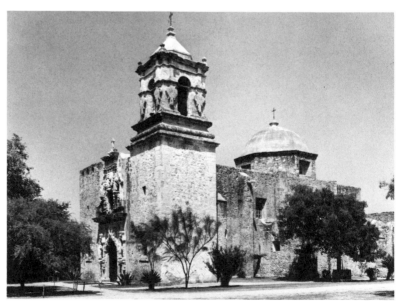

48. Mission San José y San Miguel de Aguayo, San Antonio, Texas, 1768–77.

3.

Building a New
Nation: 1785–1820

During the Revolutionary War building activity came to a virtual halt. When building resumed with improved economic conditions after the Peace of Paris, architecture in the new United States of America began to change as architects came to feel that it should be symbolic of the new nation.

The constitutional government was an experiment in applied Enlightenment philosophy which rejected monarchical absolutism and attempted to recreate the natural society in which it was believed men were meant to live. Thus architects correspondingly rejected Baroque-Rococo complication of form in search of a simpler architecture suggestive of the first civilized state of primal man. The most radical architects, such as Ledoux in France and Jefferson and Latrobe in the United States, even suggested that architecture should be an instrument of social reform, a tool to reshape men's minds and to enhance civil intercourse.

This new architecture, drawn from the purer past, developed as part of an increasingly critical, scientific, and analytical view of history which arose during the eighteenth century. According to this new perception of history, the past consisted of consecutive evolutionary periods. Once the period in which the democratic and republican state arose had been identified, it became theoretically possible to recreate its architecture. Moreover, since the new nation borrowed so heavily from the form and terminology of the Roman republican government, it was natural that Roman architectural forms should have been among the first used by American architects.

In addition, American architecture in the period from 1785 to

1820 lost its distinctly provincial status and began to enter the mainstream of Western romantic eclecticism which proposed that a building was good because of its associations with a period in history whose image was instructive or enlightening. The sensations evoked by these associations might include pleasure and idyllic charm or even fear, awe, and terror. Forms could be drawn from all phases of human history, from any time or place, past or present, near or distant. This associationalism first appeared in mid-eighteenth-century Europe in landscaped gardens where free-standing isolated pavilions recreated Roman gates, Chinese pagodas, Greek temples, or ruined Gothic abbeys as objects of contemplation. Eventually this led to increasingly accurate revivals of specific styles whose images were historically and symbolically associated with the function of the new building—Gothic for churches, Roman for governmental structures, or Egyptian for mortuary structures, for example. A few architects extrapolated lessons of structure and elemental form from such study of past architecture and fashioned wholly new buildings, employing a truly synthetic eclecticism. Then, too, there were always some designers who, knowing the styles, attempted to demonstrate them all in a single building, combining elements in a show of erudition, exemplifying a different form of synthetic eclecticism. Most architecture of the period from 1785 to 1820 belongs to this synthetic phase, while archaeological revivals became dominant in the subsequent romantic period from 1820 to 1865. A final resurgence of symbolic eclecticism from 1880 to 1930 was marked by such a finely developed historic and stylistic sense among most architects that they could, in fact, use Roman, Renaissance, or Gothic elements as if they lived in those periods. Consequently this last phase can be called creative eclecticism, for the buildings of that period were carefully designed to accommodate historic styles with modern functions. To mention all these phases of eclecticism at this point is to get ahead of the story, but it is important to recognize that *all* of the architecture of the period from 1785 to 1890 (and even much of it up to 1930) adapted historic styles to create associations in the mind of the user or observer which would strengthen and enhance the functional purpose of the building.

In their search for associational enrichment, architects were greatly aided by the flood of publications that appeared in the eighteenth century illustrating classical antiquity. The excavations of Herculaneum, started in 1738, and of Pompeii, begun ten

years later, mark the beginning of modern archaeology, and were followed by publications of the architecture and artifacts uncovered there. Numerous expeditions set out to measure and record ancient building sites—those of Robert Wood to Palmyra, Robert Adam to Spalato, James Stuart and Nicholas Revett to Athens, are but a few of the English ventures. All of these resulted in illustrated folios which for the first time put into the hands of architects accurate records of antiquity. Furthermore, there was a new focus on the structural logic of ancient architecture, initiated by the French Jesuit priest Marc-Antoine Laugier in his *Essai sur l'architecture* (1753), in which he argued for a truthful expression of shelter based on a hypothetical "primitive hut." Structure, he said, consisted basically of wall, column, and entablature; buildings should be formed of simple geometric units such as spheres, cubes, and pyramids. Treatises such as Laugier's led to the development of an architecture that was rational, clearly articulated, and that attempted to show in its parts how it was put together and how it worked.

American architecture began to express all of these emerging ideas. Latrobe best exemplifies the rationalist attitude, while Jefferson is a good example of the idealist who sought to translate classical architecture to the New World because of its beneficial associational lessons. In New England especially, after the Revolution, there were more traditionally minded architects who evolved a new national style based on Roman sources as interpreted by the English architects Sir William Chambers and Robert Adam. Thus American architecture from 1780 to 1820 was a combination of many expressions; it was a period of searching, combining ideas both conservative and radical, old and new.

The establishment of the capital city for the new nation is a good demonstration of the way in which many artistic sources were combined. The site along the Potomac River between Maryland and Virginia, selected by George Washington to appease factions in the North and South, was convenient to sea vessels and yet had water connections to the uplands. The planning of the city, with suggestions by Washington and Jefferson, was entrusted to one of Washington's aides during the war, a French architect and military engineer, Major Pierre Charles L'Enfant (1754–1825). As L'Enfant surveyed the site in the spring of 1791 he fixed upon the two highest ridges in the tidal plain as the locations of the two centers of the government, the house of the Executive and the house of Congress. Around these two nodes the en-

tire plan for the District of Columbia was established (Fig. 49). From the Federal House (or Capitol, as it was later called) a wide esplanade was projected westward to the river; it was to be framed on either side by residences of ambassadors and public buildings. Intersecting it at right angles was another lawn stretching southward from the President's House, making an arrangement much like that of Williamsburg. Directly connecting the two centers, L'Enfant projected a bold diagonal street, Pennsylvania Avenue, providing ease of access and "reciprocity of sight" which he believed very important. Using this diagonal as a starting point, L'Enfant then sketched out complementary diagonals radiating from the two centers and over this web of diagonals he threw a rectilinear grid of streets. Where the diagonals met in great *rond points*, L'Enfant provided places for public buildings and monuments. Essentially the conception of Washington, D.C., is based on axial and radial Baroque planning, which L'Enfant had seen in Versailles, and in the Garden of the Tuileries, combined with the

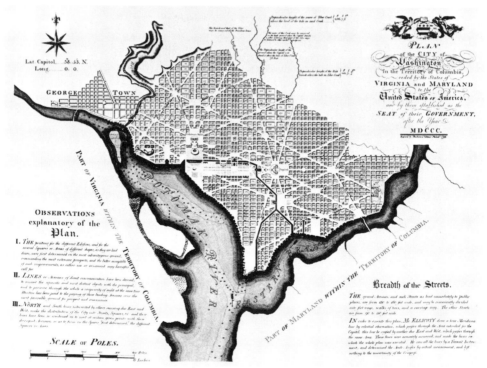

49. Charles Pierre L'Enfant, Washington, D.C., plan, 1791.

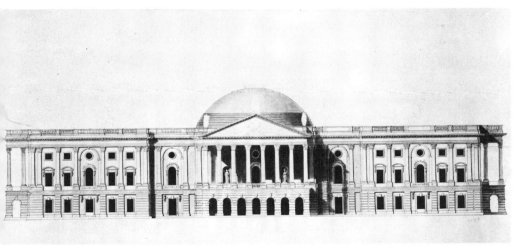

50. Dr. William Thornton, United States Capitol, Washington, D.C., east elevation, 1792; watercolor and ink.

standard, rectilinear grid. Far in advance of the time was the vast scale on which L'Enfant planned, for only in the twentieth century was the district fully developed.

At the two foci of his plan, L'Enfant positioned grand monumental buildings, but when the competition for the House of Congress was held in 1792, the submissions proved that native designers were simply not yet sufficiently trained to handle such large compositions. The design eventually awarded first prize (Fig. 50) was submitted after the deadline by Dr. William Thornton (1759–1828), a physician, born in the West Indies and trained in Edinburgh and Paris. His scheme was basically late Georgian in conception, consisting of wings for the House of Representatives and the Senate flanking a center block with the temple front capped by a low saucer dome. The smooth low dome and the temple front show Thornton's study of antiquity, but the pilasters and other detail show his traditional roots in Georgian architecture. Construction proceeded slowly, and when the government officially occupied the new city in 1800, the two wings stood on either side of a void where the rotunda was intended to be. Subsequently under Latrobe, from 1803 to 1817, and then Bulfinch, 1817 to 1830, the exterior of the building was slowly carried to completion, essentially according to Thornton's plan.

The premium for the design for the President's House went to an architect who had European training, the Irishman James Hoban, whose design drew heavily from plate 51 in Gibbs's *Book*

of Architecture and which also greatly resembled Leinster House, Dublin, Ireland. It was a dignified sedate block, punctuated solely by a projecting bay containing an oval office, the most distinguished feature of the design. Construction, supervised by Hoban, who unlike Thornton was specifically trained as an architect, started in 1793 and continued through 1801 when President Adams moved into the still unfinished house. At the same time Hoban supervised construction of the Capitol as well, and designed porticoes for the President's House which were eventually carried out in 1824 and 1829. Though Hoban's work was more restrained and sophisticated than Thornton's, no one seemed to note the irony that the two most important and symbolic government buildings were highly conservative in design and adhered closely to the traditions of Georgian architecture.

In New England too architecture remained particularly conservative during the period. Because of the resulting association with the ruling mercantile aristocracy in and around Boston, the term *Federalist* (or sometimes simply *Federal*) has been given to the architecture there during the years 1785–1820. Although this term poses problems when applied to the more innovative neoclassical work further south, it is very apt in describing the work of McIntire in Salem and even Bulfinch in Boston, both of whom were conservative in approach and made modifications on traditional models, moving away gradually from colonial and English prototypes. Samuel McIntire (1757–1811) was born and lived in Salem, Massachusetts; he was the son of a woodcarver and a woodcarver himself. Because of this, his buildings have an assured tightness of ornament which is distinctive. An early example is the house he designed for Jerathmeel Pierce in Salem in 1782, which is based on Georgian types such as the Major John Vassal house in Cambridge, Massachusetts (1759) or the Isaac Royal house in Medford. Like them the Pierce house has a compact rectangular plan with central hall, central entrance, and clapboarded walls with colossal pilasters at the corners in place of quoins. Unlike them, however, it has a balustrade directly atop the main cornice, so that the low hipped roof is entirely obscured and the house has a sharper, more cubic probity.

This cubic severity is even more pronounced in McIntire's masterpiece, the John Gardner (Pingree) house, Salem, 1805 (Fig. 51). Actually the house extends well to the rear and its plan is more irregular than the façade suggests, but the front is austere to the point of starkness and gains its particular distinction through the arrangement of proportioned parts and the position

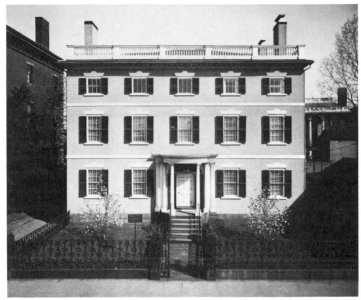

51. Samuel McIntire, John Gardner (Pingree) house, Salem, Massachusetts, 1805.

of windows and stringcourses. The central entrance is the clear focal point, and the thin white Corinthian columns are in sharp contrast to the brick walls. This portico is characteristic of much New England Federalist work, with its attenuated, wiry, taut, linear details, forms meant for stone but translated into delicately carved wood.

The same crisp linearity appears in the ornamental devices of the interior, all designed and in part carved by McIntire himself. In a sense, this is a furniture-maker's aesthetic, for the same refinement of component parts appears in the chests designed and carved by McIntire, most particularly the chest-on-chest built by William Lemon in 1796 (now in the Boston Museum of Fine Arts). This too has elegantly severe and elongated forms, particularly the reed-like Ionic colonnettes at the corners which are so much like the colonnettes supporting entablature-mantelpieces in the rooms of the Gardner house.

McIntire was self-taught but not possessed of a particularly inquiring mind and was content to repeat himself in his work. Charles Bulfinch (1763–1844) was more probing and reflective, and his work underwent a greater degree of stylistic evolution. Bulfinch was born of a well-to-do Boston family, had a thorough

education in the classics, graduated from Harvard, and made the Grand Tour of Europe. His chief interest was architecture, and when reverses in family fortunes forced him to develop a source of income, he made his living from designing buildings. His only fixed income was the small salary he drew as superintendent of police of Boston, and the fact that he held this post is a measure of his concern for the welfare of his city. Bulfinch was elected to the Board of Selectmen when he was twenty-one and he served continuously, except for four years, until he went to Washington, D.C., in 1817; perhaps no American architect since Bulfinch has been so politically active.

His exposure to the great cities of Europe had made it clear to Bulfinch that Boston in the 1780s was still basically medieval; and so Bulfinch devoted himself to reshaping his home city. One of his first designs shows the scope of Bulfinch's thinking; this was the Tontine Crescent planned in 1793. It consisted of two curving arcs of town houses, facing each other and enclosing an elliptical park (Fig. 52). Only the southern crescent was completed. Construction was of brick with delicate decorative devices, but ornament was so restrained that there were no frames around the

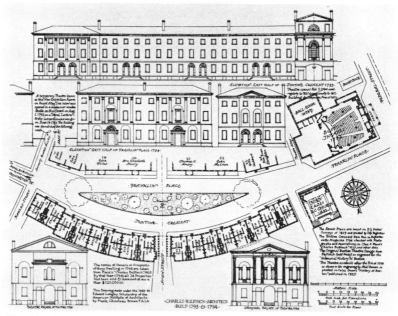

52. Charles Bulfinch, Tontine Crescent (Franklin Place), Boston, Massachusetts, plan below, half elevation above; planned 1793.

windows. In the center of each arc was a raised pavilion penetrated at ground level by a passage leading to a street behind. The ends of the arcs were emphasized by bringing the houses slightly forward and embellishing them with engaged colossal columns. While the sources of this group were Adam's Adelphi Terrace in in London, and the Circus and Crescent in Bath by the John Woodses, father and son, in comparison to these Bulfinch's work was very Spartan and severe, relying for visual enrichment on the proportions of solid and void.

Bulfinch completed an impressive number of fine houses on or near Beacon Hill, especially the three large houses built in succession for Harrison Gray Otis (1796–97, 1800, and 1806), and several house rows or terraces, continuing the theme introduced in the Tontine Crescent, beginning with a group of eight town houses (1804) on Park Street across from the new State House, and then the larger Colonnade Row of nineteen units (1811) on the south side of the Common. These and other houses by Bulfinch on Chestnut and Mt. Vernon streets on Beacon Hill set the pattern for later development, leading to Louisburg Square (Fig. 53), 1826–40, one of the best adaptations of the London residential square in the United States. More fortunate than the demolished Tontine Crescent and Colonnade Row, Louisburg Square

53. S. P. Fuller, builder, Louisburg Square, Boston, Massachusetts, 1826–40.

survives nearly intact, a rectangular court planned by S. P. Fuller, with about thirty adjoining houses enclosing a private fenced park. The houses, particularly those lining the south side, have the bowed fronts which became characteristic of this area of Boston, and though they have Greek Doric porticoes characteristic of the 1840s, the severity of solids and voids and the plain brick construction show the pervasive influence of Bulfinch which eventually shaped the architectural character of the whole of Boston.

The residential development of the Beacon Hill area had been spurred by another Bulfinch building, the new Massachusetts State House, 1795–98 (Fig. 54). As early as 1787 Bulfinch had made a proposal for a new building, but it was eight years before action was begun. Again the architect referred to a recent English building in his design, here to Sir William Chambers's Somerset House (1776–86), but he avoided Chambers's heavy carved ornament and stressed instead lightness and attenuation, using brick with stone and wood trim. Set near the top of Beacon Hill at a time when only fields lay to the south, the new State House was to command the Common, and to accomplish this Bulfinch employed a broad portico on a high arcaded base in front of the rectangular building. Furthermore he called for a tall smooth hemispherical dome, framed in wood, and covered with gold leaf. It was a bold and heraldic solution to the new architectural problem

54. Charles Bulfinch, Massachusetts State House, Boston, Massachusetts, 1795–98; lithograph after a drawing by A. J. Davis.

of what a state governmental building should be. It also defined the character of the Common, and when, soon after, Bulfinch designed the town houses that lined the Common to the northeast and southeast, the urban character of the hill was clearly determined.

In the State House and the Tontine Crescent, both early designs by Bulfinch, the debt to English sources is clear, but in his Lancaster Meetinghouse, 1815–17 (Fig. 55), stylistic maturity is evident. The direct quotations are gone, and in their place is a marked concern for visual clarity and bold geometric forms. Each element of the meetinghouse—auditorium, tower base, belfry, portico—has its own distinct form but is related in turn to adjacent elements. The portico is a simple arcaded block in brick, embellished with Doric pilasters supporting a full entablature, the cornice of which continues around the entire building, tying all parts together. The belfry in particular shows study of ancient Greek architecture. While the general configuration of the meetinghouse refers back to the Wren-Gibbs tradition of New England meetinghouses, the overall sharpness of form and the reduction in ornament reveal the increasing innovative simplicity and unity of Bulfinch's work.

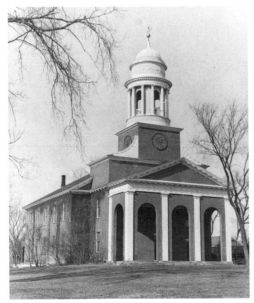

55. Charles Bulfinch, Lancaster Meetinghouse, Lancaster, Massachusetts, 1815–17.

When this church is compared to the Congregational Church in New Haven, Connecticut, by Asher Benjamin, 1812–14 (Fig. 56), it is clear how much Bulfinch had moved away from his sources and how relatively conservative Benjamin was at this time. Asher Benjamin (1771–1845) had been an assistant to Bulfinch and had helped in supervising construction of Bulfinch's new Connecticut State Capitol at Hartford, 1796, building the circular staircase after designs in Peter Nicholson's *The Carpenter's New Guide,* published in London, 1792. But even as the New Haven church was under construction, Benjamin himself was beginning to exert an enormous influence on rural architecture in New England through the publication of his own books patterned after those of Nicholson.

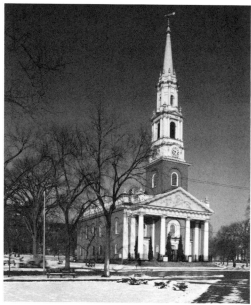

56. Asher Benjamin (with Ithiel Town), First Congregational Church (Center Church), New Haven, Connecticut, 1812–14.

The Center Church as it is called (for it stands in the center of the New Haven Green) is heavily indebted to the Georgian Wren-Gibbs type and is in fact the last and final flower of that model. Such quality of design—well studied, well proportioned, well detailed, but rather conservative—appeared throughout the seven books by Benjamin, beginning in 1797 with *The Country Builder's Assistant* (usually considered the first American pattern book) and

followed by the enormously popular *The American Builder's Companion,* 1806, which ran through six editions up to 1827. Benjamin made special emphasis of the word *American* in the title, indicating that building needs and solutions on this side of the Atlantic had begun to differ significantly from practice in England. His subsequent building manuals—*The Builder's Guide,* 1839; *Elements of Architecture,* 1843; *The Practical House Carpenter,* 1830; *Practice of Architecture,* 1830; and *The Rudiments of Architecture,* 1814—appeared in numerous new editions through 1857, and, together with copies of his first books, were carried by settlers throughout the Northwest Territory, and even to Utah, Oregon, and California.

Variations on the traditional meetinghouse design presented in *The Country Builder's Assistant* (Fig. 57) appeared throughout New England. An early example by Lavius Filmore once credited to Benjamin himself, is the Congregational Church of Bennington, Vermont, 1806. More refined examples, closer in feeling to the Center Church and worthy derivatives of Gibbs's St.-Martin's-in-the-Fields, are Samuel Belcher's Congregational Church at Old

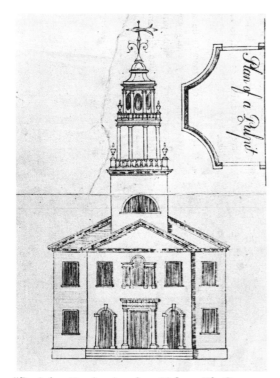

57. Asher Benjamin, plate 33 from *The Country Builder's Assistant,* 2nd ed., 1798.

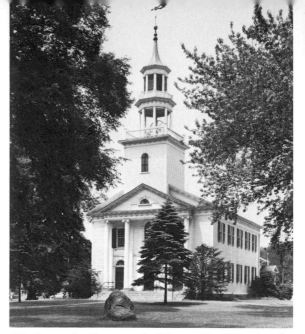

58. Lemuel Porter, builder, Congregational Church, Tallmadge, Ohio, 1822–25.

Lyme, Connecticut, 1816–17; or David Hoadley's Congregational Church at Milford, Connecticut, 1823; or L. Newall's Congregational Church at Litchfield, Connecticut, 1828–29. The dissemination of Benjamin's influence, however, is well illustrated in the Congregational Church at Tallmadge, Ohio, 1822–25 (Fig. 58) by Lemuel Porter, a master builder who came to the Western Reserve from Waterbury, Connecticut. Even the Kirtland Temple, at Kirtland, Ohio, designed by Joseph Smith in 1833, shows the adaptation of Benjamin's designs to serve the needs of the fledgling Mormon church, and Benjamin's manuals were taken by the Mormons to Illinois and from there to Utah. Extremely practical books, aimed at the carpenter and mechanic rather than the gentleman-amateur, filled with plates showing moldings, profiles, windows, staircases, and other details, the first volumes established a refined New England Federalist style as the style of the newly opened West, especially in Connecticut's Western Reserve (later northeast Ohio). Later volumes, with their new plates showing the Greek and Roman orders, helped spread the influence of the classic revival after 1820.

If such work as McIntire's and Bulfinch's is taken as the norm of Federalist, it becomes difficult then to apply this term to the work of Benjamin Henry Latrobe, for he rejected conventional English sources and attempted to fashion an architecture of nearly pure geometry. He was an ardent student of classic architecture and often used classic elements; in this he was a neoclas-

sicist, but he combined modern inspiration with numerous prece-
dents from the past, making a truly synthetic architecture. Born
in England and schooled in Germany, he trained in England with
engineer John Smeaton and with the architect S. P. Cockerell.
He knew well the work of George Dance, Sir John Soane,
and C-N. Ledoux. While he began practice in England, because
of his radical inclinations, financial reverses, and the death of
his first wife, he determined to start anew in the United States.
Of all the individuals discussed so far, he was the first to attempt
to derive his sustenance solely from designing buildings; his en-
tire energy was focused on the study of architectural problems,
and his solutions accordingly departed radically from traditional
forms. He supervised construction and insisted that his working
drawings be followed explicitly, causing innumerable difficulties
with the established and traditionally conservative carpenters'
companies. Yet through his work, his example, and the influence
of his students, he established the American architect as a profes-
sional.

Latrobe's radical leanings and concern for social improvement
are seen in one of the first buildings he completed in his new
homeland, the State Penitentiary in Richmond, Virginia, 1797–98
(Fig. 59). The penal reform promoted by Latrobe and Jefferson
incorporated a number of new ideas such as cells arranged in a
semicircle for easy surveillance from the center, improved ventila-
tion and sanitary facilities, and cells for groups of reformed con-
victs. Externally the building was striking; the walls of brick
formed unadorned massive superimposed blind arcades with win-
dows sharply cut inside them. The entrance was formed by a huge
semicircular arch springing directly from the foundation.

59. Benjamin Henry Latrobe, Virginia State Penitentiary,
Richmond, Virginia, 1797–98; watercolor.

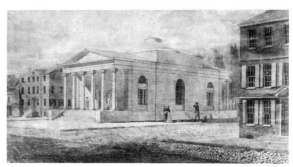

60. Benjamin Henry Latrobe, Bank of Pennsylvania, Philadelphia, Pennsylvania, 1798–1800; perspective by Latrobe.

Through the expressive power of the masonry itself, the building indicated its purpose; it was an American example of *l'architecture parlant* (literally, speaking architecture), functionally expressive architecture in the manner of Ledoux or Boullée.

The Bank of Pennsylvania in Philadelphia, which soon followed, carried these expressive ideas further but with greater refinement of form (Fig. 60). Built in 1798–1800, the building appears at first glance to be a Roman temple on a podium, but the building combines many elements, each of which is used to create a space designed for use. The bank consists essentially of a large circular banking room flanked by offices and chambers. Externally this can be seen in the cubical block which forms the center unit, with extensions front and rear which end in Ionic colonnades and pediments. Each of the rooms is vaulted in masonry; the banking room is covered by a saucer dome in brick, visible from the exterior, and lighted by a lantern over a central oculus. Each of the elements is thoroughly studied and combined in a way that the parts reinforce one another and make one harmonious whole. In addition to the architectonic unity, the image of Roman republican probity and civic virtue is clear.

Latrobe's largest commission, the Baltimore Cathedral, is also Roman, but in preparing the designs in 1804, Latrobe drew up a Gothic design because of the long association of Catholicism with Gothic architecture. He felt the diocese should have a choice. Happily the decision was in favor of the classic mode which Latrobe preferred and in which he was much more proficient. This incident reveals Latrobe's professional ability, for no earlier American architects had the historical knowledge to draw up two radically different proposals. In his classical design Latrobe broke away from the Wren-Gibbs tradition, using Soufflot's Pantheon in Paris and the Hadrian Pantheon in Rome as his points of depar-

ture (Figs. 61, 62, 63). The focus of the church is a large masonry dome on a drum penetrated by four large segmental arches; these lead to the apse, arms, and nave, with four smaller arches on the diagonals. All portions of the church are vaulted in masonry; the section drawing by Latrobe (Fig. 62) shows the saucer dome on pendentives over the nave. Entry to the church was through a very correctly detailed Corinthian portico. Each of the internal spaces was indicated externally as a separate mass; crisp moldings and a single modified entablature encircling the building form the sole enrichment of the stone walls. Beyond this only two severe tower belfries flanking the portico add embellishment. Latrobe's

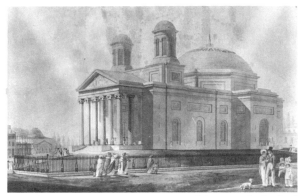

61. Benjamin Henry Latrobe, Baltimore Cathedral (Cathedral of the Assumption of the Blessed Virgin Mary), Baltimore, Maryland, 1804–21; perspective by Latrobe, 1818. The Unitarian church is visible in the background (left).

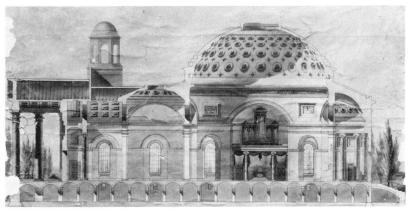

62. Baltimore Cathedral, longitudinal section by Latrobe, 1805.

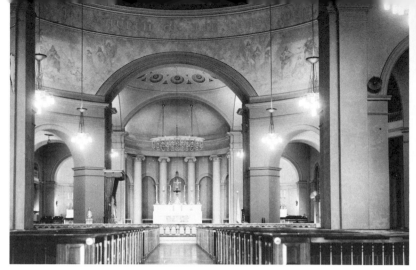

63. Baltimore Cathedral, crossing and choir as built, finished 1821.

painstaking and beautiful drawings again indicate his professional stature. He steadfastly refused to have workmen question his artistic authority; and when, during his absence, the builder of the cathedral changed some of the features following standard eighteenth century practice, Latrobe threatened to resign if his drawings were not absolutely adhered to, and he won his point when the diocese supported him.

Latrobe's views concerning the professional prerogatives of the architect were well developed. In 1806 he admonished his pupil Robert Mills, then starting his own practice, for not insisting on his professional rights. Mills, like most of the early professional architects, struggled against the prevailing public attitude that "if you are paid for your designs and directions, he that expends his money on the building has an undoubted right to build what he pleases," as Latrobe put it in his letter. Against this Latrobe countered that the architect must adhere to the Latin proverb *in sua arte credendum* (he must believe in his own work), and that he should take specific precautions: do nothing gratuitously, make certain that the drawings are clearly understood by the client and that all changes are agreed to mutually, supervise all construction, authorize all payments, and retain the drawings.

Yet Latrobe was more than artist-idealist; he was an engineer as well and understood the physical nature of materials and mechanics. He designed several canal improvements in England and the United States, as well as a steam engine for the Navy Yard in Washington. His water system for Philadelphia, planned in 1798 and built in 1799–1801, securely established his reputation. His scheme called for a dammed settling basin on the Schuylkill northwest of the city at what is now Fairmount Park. Here water was to be pumped by steam to an elevated reservoir and fed by

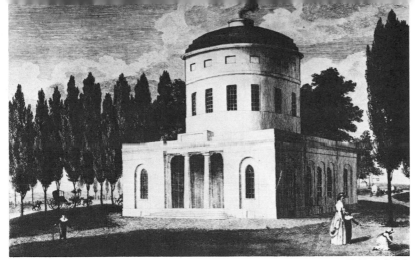

64. Benjamin Henry Latrobe, Center Square Pumphouse, Philadelphia Waterworks, Philadelphia, Pennsylvania, 1798–1801.

gravity to hydrants throughout the city. One of his most abstractly geometric buildings was the pumphouse at Center Square (Fig. 64), consisting of a cubical block at the base, housing the pumps and offices, with a cylinder rising above it in which was located the water tank. Through the center of the cylinder ran a flue for engine smoke. All trim was eliminated with the sole ornament consisting of Greek Doric columns at the entrance carrying a geometricized entablature that circled the lower block. It is highly significant that Latrobe's pumphouse, so like Ledoux's Barrière de la Villette in Paris, uses correct Greek Doric, the heaviest and most severe of all the orders. Appearing here first in the United States, it became the hallmark of the Greek Revival, elaborated and spread later by Latrobe's pupils William Strickland and Robert Mills.

In addition to his private commissions following the cathedral, Latrobe also served as architect for federal buildings during Jefferson's administration. It was he who brought the interiors of the Capitol to completion, and his Spartan geometric clarity appears in the vaulted basement carried on stout Doric columns, in the maize and tobacco capitals he designed for the columns in the Senate anterooms, and in the dome of the old Senate rotunda.

Latrobe's activity in Philadelphia is illustrative of the advanced cultural and architectural position of that city at the turn of the century. Another building there, "Woodlands," the home of William Hamilton, is characterized by a special interest in the shaping of interior spaces that is close to that of Latrobe, but the house (begun in 1770) was completely remodeled in 1786–89 according to plans which Hamilton had perfected in England. The intricacies of the plan (Fig. 65), in which each room is given a distinct geometric shape, suggest the work of Sir John Soane. The

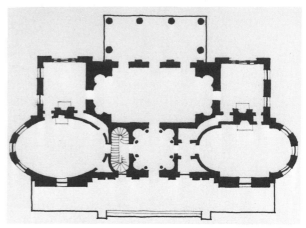

65. William Hamilton house, "Woodlands," Philadelphia, Pennsylvania, plan, 1786–89.

exterior, which incorporates an engaged as well as a projecting portico prefiguring those of Hoban's President's House, has walls built of rough fieldstone, carrying on a local tradition nearly a century and a half old.

Philadelphia also had the distinction of having an early example of a house type that became exceedingly popular after the Civil War. Pierre L'Enfant designed there a large suburban house for Robert Morris, using the double-pitched mansard roof, with projecting end pavilions whose walls were partially curved. Under construction from 1793 to 1801, it was not finished, and this particular mode was not to be emulated for half a century.

If French traditions were not adopted for residential design, they were used by a few architects for public buildings, particularly for municipal governmental buildings. In part this was the result of an admiration of aspects of French culture, and of the art of a political ally, and in some instances the result of the work of an émigré French architect. Such was the case in the design of the New York City Hall, won in competition in 1802 by Joseph F. Mangin who had been trained in France and John McComb, Jr. Reduced in size by both designers in 1802–4 and built under McComb's supervision in 1804–11 (Fig. 66), the building owed much of its clear articulation of parts, and its lightness of feeling to the work of J.-H. Mansart. Something of the clear but light-handed articulation can be seen in the work of Philip Hooker in Albany, perhaps best in his Albany Academy, 1815–18, which seems to owe much to Mangin and McComb's City Hall. Another prominent émigré was Maximilian Godefroy, who came to the United States in 1805 and settled in Baltimore where he taught drawing and engineering at the College of Baltimore (later St. Mary's Seminary). His first completed building was the semi-

nary chapel, 1807, which used Gothic motifs in the first conscious revival in the United States, but the building which best shows his training is the Unitarian Church, Baltimore, 1817–18, contained in a cube with a domed sanctuary (see Fig. 61); there are none of the standard neoclassic clichés but a compactness and probity that are classic in the best sense.

66. Joseph F. Mangin and John McComb, Jr., New York City Hall, New York, New York, 1802–11.

Latrobe was a rationalist, clarifying structure to serve an expressive end, but his friend and admirer Thomas Jefferson was an idealist to whom architecture was a means of effecting social reform, education, and enlightenment. Although he did move in the direction of more abstract design, and introduced the use of graph paper to study proportion in his preliminary designs, Jefferson was nonetheless the last and best of the gentlemen architects. Because of his political convictions he rejected English architectural influences outright, turning instead first to Palladio and then to ancient Rome. When in 1770 as a young man he began his own home, he placed it atop the hill he called Monticello (Fig. 67), not at the river's edge in the colonial manner, for he wanted to see the full sweep of the Blue Ridge Mountains. In contrast to the emphasis on auxiliary buildings in most colonial and English country houses, Jefferson pushed the dependencies at Monticello into the earth so as to preserve the view; only at the ends of the arms did he place small cubical pavilions for a library and guest room. The plan of the complex in the shape of a broad U, with the house standing free at the center and arms stretching and hugging the hill, was based on plans published by Palladio

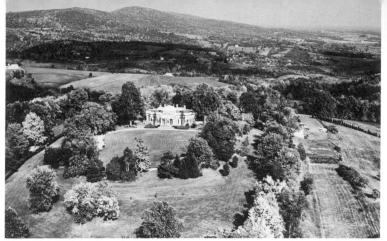

67. Thomas Jefferson, Monticello, near Charlottesville, Virginia, 1770–82, 1796–1809.

and Robert Morris. The façade of the house also derives from these sources. Built section by section during 1769–82, it stood with a two-story central pavilion until 1796 when Jefferson returned from France and began a second building campaign which continued until 1809, changing the proportions of the house so that it presented *one* story under a heavy Doric entablature which ran around the house. Inspired by the Hôtel de Salm in Paris, he added a low dome to the garden front of the house. The effect of all these modifications was to press the house further into the hill and to stretch and emphasize its horizontal dimension. It became a personal expression incorporating contemporary French and neoclassic elements; it is abstract, complex, and highly adapted to living.

Jefferson fervently believed in architecture as a symbol and wrote candidly of the buildings of Williamsburg which he despised because of their association with colonial exploitation. In 1776 he was one of the first to suggest that the state capitol be moved to Richmond, nearer the center of the state. New buildings should be erected, he advised, one for each branch of the state government. Action was slow; the state legislature moved in 1780 but it was not until 1784 that Jefferson was asked to procure a design for a single building which the legislature insisted should contain all services. By this time Jefferson was in Paris as minister to the French court and had established a close working relationship with Charles-Louis Clérisseau, a French architect prominent in the French neoclassic movement and author of *Monuments de Nîmes* (1778). Jefferson selected the Maison Carrée, Nîmes, as his model, since it had all the abstract visual symbolic properties he felt were urgently needed in Virginia. Mistakenly, he believed it to be a product of the Roman republic, erected by self-governing free men. It was simple and pure in form and

would instruct his countrymen in the art of building. It had associations with Rome, not with colonial rule under England. Jefferson and Clérisseau prepared drawings forcing the functions into the rectangular shell, and had a plaster model sent back to Virginia with drawings (Fig. 68); the building was constructed 1785–89 under the supervision of Samuel Dobie with subtle modifications from the original model (Fig. 69). The Virginia State Capitol is significant for being the first building of the neoclassical movement in either the United States or Europe to be a literal reinterpretation of the classical temple, for while there had been temple pavilions on English estates, none had been full-scale, inhabitable buildings. The Virginia capitol filled exceedingly well the didactic role Jefferson had envisioned. The lofty cultural associations were obvious. It was easy to copy a building from the measured drawings increasingly available in architectural books, while the subtle and more architectonic lessons in Latrobe's architecture were much harder to grasp; so, through Jefferson, official sanction was given to revivalism—the Greek Revival was inevitable.

68. Thomas Jefferson (with C.-L. Clérisseau), Virginia State Capitol, plaster model, 1785.

69. Virginia State Capitol, Richmond, Virginia, 1785–89.

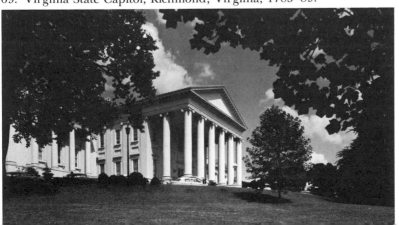

The associations Jefferson intended were always elevated ones, exercises in scholarship meant to sensitize the eye to proportion, scale, and rhythm. Architecture to him was a form of visual education in support of the democratic ideal. Hence practical academic education itself was crucial to Jefferson for he believed only an enlightened educated people could govern their affairs. To this end he pressed for a state university with instruction grounded in natural sciences and modern subjects. Beginning with the curriculum, he designed a program of study based on ten major divisions of learning. Around this he then designed the physical form of the school, conceiving it as an "academical village," a community of students and scholars. Remembering perhaps the arrangement of the Château de Marly by J.-H. Mansart (begun 1679), with its ranks of small buildings framing a court leading from the main house, Jefferson arranged two rows of five pavilions facing each other across a grassy lawn. At their head was the library. In this arrangement Jefferson paralleled Union College, Schenectady, New York, laid out by Jean-Jacques Ramée, a French émigré architect who moved into upper New York to develop lands for the Ogdens. While there in 1812, Ramée planned the college for Eliphalet Nott (Fig. 70) following planning princi-

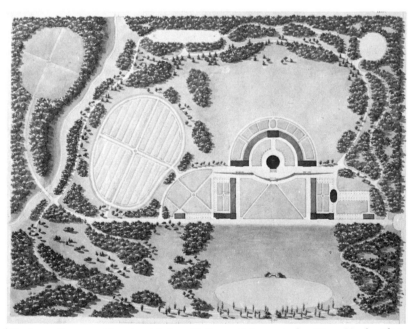

70. Jean Jacques Ramée, Union College, Schenectady, New York, plan for buildings and grounds, 1812.

ples taught in the École des Beaux-Arts, Paris, with the buildings grouped in expanding ranks around an axial court and focusing on a central building, here, as at Charlottesville, a centrally planned library. Jefferson's University of Virginia combines classic form with romantic associational ideals, and so does Ramée's Union College, but the grounds at Schenectady combined an unusual amount of romantic picturesque freedom in their curving irregular paths and clumps of trees; the ordered buildings and geometric courts were to be contrasted with the planned "natural" irregularity of the landscape.

Unfortunately only a few of Ramée's buildings were constructed and the plan was altered in the course of the next century, but at Charlottesville Jefferson carefully supervised the construction of the University of Virginia beginning in 1817 (Figs. 71, 72). Each of the ten large pavilions on the Lawn (as the Quadrangle is called) was to house a different department of learning providing both living quarters for the professor and lecture rooms. No two were alike but rather each one exemplified a specific architectural order. Some of the pedimented façades were pure inventions, and one was based on Ledoux's Paris gates and his Hôtel Guimard, 1770, thus giving an example of the kind of modern French architecture which Jefferson thought worthy of study. Appropriately, the library, the largest of all the buildings, was based on the Roman Pantheon. The pavilions, "specimens for the architectural lecturer," as Jefferson described them, were connected by low colonnaded rows of student rooms thus bringing

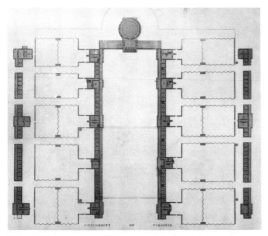

71a. Thomas Jefferson, University of Virginia, plan of the buildings, 1817; engraving, 1825.

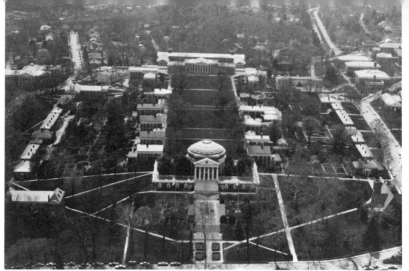

71b. University of Virginia as built, 1817–26, with later modifications, aerial view. New construction at the rear of the Rotunda and buildings at the south end of the lawn by McKim, Mead & White, 1896–98.

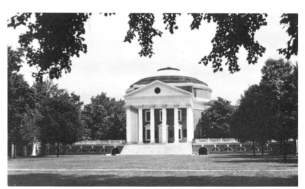

72. University of Virginia, Rotunda, 1823–27, as restored by McKim, Mead & White, 1896–98.

dormitories and classroom together. Behind each row of pavilions, separated by gardens enclosed by low serpentine brick walls, were parallel ranges of student rooms and refectory pavilions.

Jefferson used local brick with white wooden trim, thus necessitating some modifications from the classic models for his buildings. This is especially true of the library rotunda with its porch of six instead of eight columns, its rows of windows cut into the wall of the drum, and most notably the large entablature which encircles the building like a hoop suggesting both visual compression and horizontal continuity. What might have become a sterile grid is subtly relieved, for as the ground drops away from the rotunda, the connected pavilions descend in three terraces, and as they

move away from the rotunda, the intervals between them become greater, enhancing the perspective and teasing the eye. Combining nature and geometry, clarity and reasoned tension, classic temples and Virginia brick, the University of Virginia is Jefferson's didactic philosophy tangibly realized.

While the architects sought to formulate an American architecture, the major business of the country was to establish its own industries and develop its economy so as to be less dependent on foreign production and imports. Chief promoter of this industrialization was Secretary of the Treasury Alexander Hamilton, and in his *Report on Manufactures* submitted to Congress in December 1791, he concluded that "everything tending to establish substantial and permanent order in the affairs of a country, to increase the total mass of industry and opulence, is ultimately beneficial to every part of it." At the same time that Hamilton prepared these recommendations, a small textile mill was opened by Samuel Slater in Pawtucket, Rhode Island. There was no need to build workers' housing in Pawtucket, much less to plan or build an entire town, for the workers lived nearby, but soon these would become necessary. Hamilton among others, was directly involved in developing such an early industrial town which, if it had succeeded, might have had a significant influence on the development of American industry and industrial towns. Unfortunately, it was not to be.

This experiment in industrial town planning was Paterson, New Jersey, begun in 1791. Eager to see American manufacturers develop on a large scale, Alexander Hamilton personally supported the venture which was underwritten by a group of New Jersey businessmen and investors. At the falls of the Passaic River land was acquired and a large mill town was proposed in which a variety of goods were to be produced, including paper, cotton fabric, and brass wire. The planning of the town was put in the hands of Pierre L'Enfant who was assisted by Nehemiah Hubbard. Unfortunately all drawings of the plan were destroyed, but the brief written description that did survive indicates that here too L'Enfant proposed to use diagnonal thoroughfares but with the important difference that at Paterson the radial streets were to follow the general contours of the land. What was so important in this venture, even though nothing came of it at all because of lack of managerial skills among the organizers, was that for the first time a new industrial city was planned according to a grand comprehensive scheme.

Another venture was quite successful and established a pattern for industrial town planning and management that continued in

New England for more than a half century; This was Lowell, Massachusetts. Most textile factories, beginning with the Slater mill at Pawtucket, in 1791, were quite small (thus avoiding the organizational problems that scuttled the Patterson project) and were built near villages thus ensuring a steady supply for the small requisite labor force. Francis Cabot Lowell desired to build a larger more efficient enterprise at Waltham, Massachusetts. When the War of 1812 seriously reduced the number of young men to operate the power looms, Lowell developed a system that made available an entirely untapped source of labor. He set up a series of boarding-houses run by matrons and instituted a social program so specific and blameless that families in the area were quite willing to send their young women to run the machinery. Indeed the situation was made to order for young women eager to enlarge their dowry by working for a few years before marriage.

Lowell than began to think about an even larger textile plant, and in the years before his death in 1817 he worked out a physical arrangement which incorporated the lessons learned at Waltham. In 1821 Lowell's Boston Manufacturing Company acquired tracts of land at the Falls of the Merrimack River north of Boston and proceeded to lay out the industrial town that the founder had visualized; the actual planning of the new town was done by Kirk Boott (Fig. 73). The factories were placed along the power canal looking out over the river; behind them ran streets at right angles along which were the boardinghouses for single employees and row houses and tenements for married workers. Simple in the extreme, this was a scheme which allowed for gradual expansion, efficient operation, and almost inevitable profits for company owners. In 1826 there were thirty dwellings built for the employees in a village of 2,500; by 1836 the total population was 17,633; and in 1865 the population had risen to 30,990. So effective and attractive was the physical and social organization of Lowell, Massachusetts (as the new town was called in honor of the founder) that nearly a score of other major manufacturing towns were patterned after it, including Chicopee, Lawrence, and Holyoke, Massachusetts, and Manchester, New Hampshire. Perhaps the most important lessons of Lowell and its descendants were that an industrial town could be built according to a rational plan and that it was good business for the employer to build attractive substantial housing so as to discourage transience among skilled workers.

Such a view was not widely held in 1814 when Francis Cabot Lowell and the Boston Manufacturing Company began operations at Waltham. In fact a strong current of anti-urban feeling touched many influential people, particularly Jefferson whose views char-

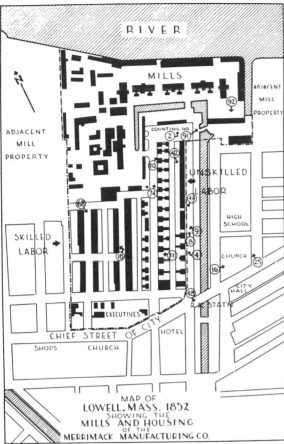

RIVER

MILLS

ADJACENT MILL PROPERTY

ADJACENT MILL PROPERTY

COUNTING HO.

UNSKILLED LABOR

HIGH SCHOOL

SKILLED LABOR

CHURCH

CITY HALL

R.R.STAT'N

EXECUTIVES

CHIEF STREET OF CITY

HOTEL

SHOPS CHURCH

MAP OF
LOWELL, MASS. 1852
SHOWING THE
MILLS AND HOUSING
OF THE
MERRIMACK MANUFACTURING CO.

73. Kirk Boott, original development of Lowell, Massachusetts, plan for the Merrimack Manufacturing Company, 1821.

acterized those of many. In his *Notes on the State of Virginia,* published in 1785, he wrote that "the mobs of great cities add just so much to the support of pure government as sores do to the strength of the human body," while in contrast he asserted that "those who labour in the earth are the chosen people of God." Though his opinion softened slightly in the following years, he remained intellectually opposed to the idea of great cities. To James Madison he wrote in 1787 that "when they [the populace] get piled upon one another in large cities, as in Europe, they will become corrupt as in Europe." With such views prevalent it is understandable why Patterson failed so precipitously. By 1816, however, events in Europe brought Jefferson to admit to Benjamin Austin in a letter that "we must now place the manufacturer

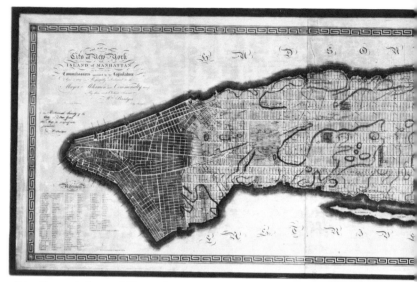

74. Commissioners' Plan of New York, New York, 1807–11.

by the side of the agriculturalist" for the development of industry
was essential if the United States was to be able to remain politi-
cally and economically disentangled. But by 1816 it was in large
measure too late for Jefferson to write this, for the most prosper-
ous commercial center in the nation had been replanned in a way
that was to set the pattern for the remainder of the country there-
after. Urban planners and like-minded architects could not prac-
tice in an atmosphere conditioned by Jeffersonian anti-urbanism,
and into the void stepped the businessman and commercial
booster, and the city where this was manifest was New York.

By the end of the eighteenth century New York had expanded
northward only about thirteen blocks beyond the boundary at the
time of the Revolution. The outcome of the war had dramatically
changed the shape of the city, for, according to state law, all land
belonging to Tory loyalists on Manhattan Island was now forfeit
and became city and state property. In an effort to provide for
the orderly growth of the city, the state established a commission
in 1807 to devise a plan for subdividing the newly acquired lands;
the commissioners appointed were Simeon DeWitt, Gouverneur
Morris, and John Rutherford, financiers and businessmen. In
their report which appeared four years later the commissioners
indicated that one of their chief concerns "was the form and man-
ner in which the business should be conducted." Briefly they had
considered radial avenues, ovals, stars, and other planning em-
bellishments, but eventually decided that "since right-angled

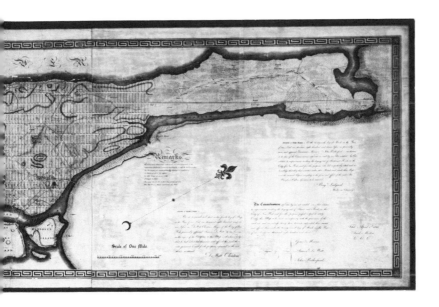

houses are the most cheap to build, and the most convenient to live in," the plan of the city should be strictly rectilinear. Thus arose the famous Commissioners' Plan for New York of 1811 (Fig. 74), consisting of thirteen broad north-south avenues running parallel to the axis of the island and intended as the major traffic arteries. These were to be crossed by 155 narrower east-west streets beginning at the northern edge of Washington Square. As far as the potential growth of the city was concerned, it was a far-sighted plan, but as for the realities of traffic circulation, it was tragically myopic; no consideration was even given to the existing thoroughfares and only one of them, Broadway, was sufficiently popular to assert itself into the grid. Absolutely no recognition was given to topography, and, insofar as possible, the "Island of Hills" was flattened out; only in portions of Central Park, set aside much later, does any suggestion of the original rugged landscape remain. It was a plan which, visually, had very little to offer the resident of the city, but to the commissioners it seemed certain of financial success.

The grid seemed so practical that it was adopted as a system of regional subdivision in the Northwest Territory, as a plat of southwestern Ohio, said to have been drawn up by Manasseh Cutler in 1785, clearly shows. In this all the land between the Ohio and the Scioto Rivers is divided into six-mile squares in accordance with the Congressional Land Ordinance of 1785, but it proved impossible to lay out the grid on so mountainous a region.

Further west, in the flat lands of western Ohio, Indiana, Illinois, Michigan, and Wisconsin, the township grid could be employed easily. In the planning of selected cities, there was some interest in using radiating diagonals such as L'Enfant had laid down in Washington, D.C., and had suggested for Patterson. An early example was the new plan for Detroit, Michigan, prepared by Augustus B. Woodward in 1805 and based on the hexagon; in time only one of the foci of Woodward's plan survived the pressure to use the more conventional grid. Indianapolis, laid out in 1821 by Alexander Ralston who had worked under L'Enfant at Washington, had two major diagonal streets cutting through the grid, as did Madison, Wisconsin, laid out in 1836, but the grid was far more widely employed in building the new cities of the Northwest Territory.

The first thirty-five years of nationhood saw important advances in city and building design. American artists, architects, and planners were eager to occupy an important place in the fashionable and symbolic rediscovery of the art of antiquity. Just as classic architecture came to be associated with classic virtues, so too, as L'Enfant indicated, the larger form of a city such as Washington, D.C., could be symbolic of its special function. L'Enfant's example of the conscious planning of cities, like that of William Penn a century before, had almost no influence as commercial expediency was made the basis of territorial and town planning. The individual buildings of the period were not marked by the same degree of homogeneity as had prevailed before the Revolution. For the most part architects and designers still looked to England as the model but France became a source of ideas as well. Most important, however, in creating the individual character of buildings were the increasing education and professional aspirations of the architects. Despite their varying backgrounds and predispositions a common cultural vision inspired these architects so that each—Bulfinch through his refinement of form, Latrobe through structural expression, and Jefferson through historical association—helped in defining a new era, and through their professional dedication the search for a truly national architecture was set in motion.

4.

The Lure of the Past, the Promise of the Future: 1820–1865

The years between 1820 and 1865 saw the emergence of a broad popular culture. As the authority of the cultural standards of the Federalist and Virginian aristocracies began to wane, they were replaced by the more homespun values associated with the popular western folk-hero Andrew Jackson, elected president in 1828. In several ways, however, changes first began to appear a decade earlier. There were many causes, inextricably linked, one of which was the rise of a strong capitalist economy fueled by many sources: rapid expansion in the territory of the nation, the concurrent acquisition of bountiful raw materials, rapid improvements in the transportation of goods and people by canals, steamboats, and then railroads. Similar improvements in agriculture, such as McCormick's reaper, greatly increased grain production, now more easily shipped. Altogether, this period witnessed the beginning of an industrialized system of mass production and mass distribution, geared to an expanding popular market.

This industrialization, bred of an unshakable faith in material and physical progress, also created a broad middle class, the new patrons of the arts, who took progress as their creed. Many of these parvenu patrons were well educated or well read and acquired fixed convictions about what they felt appropriate to build, paint, or carve. For a brief time in the 1840s and 1850s, the promise of an egalitarian American art was offered in the establishment of the American Art Union and its wide distribution of lithographs. More architectural handbooks and builder's manuals began to appear, some in smaller, almost pocket-sized form; these became increasingly popular, making household words of the names of such authors as Benjamin, Lafever, and Downing.

This was also a period in which social, humanitarian ideals were wedded to fervent romantic feelings of individualism and a nostalgia for cultures far removed in time or place. The associationalism developed in the previous half century came to full flower, and selected historic styles became firmly linked with certain building functions. At the same time industrialization produced new materials and techniques—iron, plate glass, wire nails, and mass-produced machine-sawn lumber—which enterprising architects endeavored to exploit in their romantic creations. Consequently the struggle between abstract universalities and the vagaries of regional adaptation, between the ideal and real, continued unabated with only minor shifts in the accuracy or association of specific historic styles.

Neoclassic architecture, having for the moment a head start, moved first into increasing archaeological exactitude. To some extent this can be seen in the work of Robert Mills (1781–1855), the first native-trained American architect, who for five years was an assistant in Latrobe's office. His Monumental Church, Richmond, Virginia, 1812, employs severe, even archaic Greek Doric columns, revealing an academic side, while his State Record Office (the "Fireproof" Building) of Charleston, South Carolina, 1822, reveals a rational side, using more abstracted orders combined with masonry vaulting for fire safety. Mills use solid masonry vaulting for similar reasons in his United States Treasury Building, Washington, D.C., 1836–42, while the exterior is graced by a beautifully proportioned and detailed Greek Ionic order. Clearly Mills knew historical types well and how to reproduce them when suitable.

From Latrobe Mills learned the need for visual clarity and rational, structural form while his fellow in Latrobe's office, William Strickland, developed an absorbing interest in archaeology and the picturesque use of ancient architecture. This can be seen in an early building, the Second National Bank of the United States, in Philadelphia, which Strickland designed in 1818 (Fig. 75). It is particularly significant that the bank directors stipulated in the competition program that submissions be Greek in design and that they were to be built in marble. Strickland went straight to the folios of Stuart and Revett, basing his entry directly on the Parthenon, making it one of the earliest "copies" of that temple in America. While it is true that Latrobe had already built a classic bank, the Ionic order he used was not specifically drawn from a book, and the form of the building expressed internal spaces; Strickland's bank followed measured drawings of the original

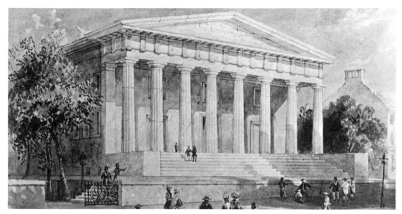

75. William Strickland, Second National Bank of the United States, Philadelphia, Pennsylvania, 1818–24; lithograph.

(though he did eliminate the side colonnades) and kept the unbroken roof line of the temple intact, hiding any indication of the barrel-vaulted banking room within. In its strict adherence to the model Strickland's bank marks the beginning of a true Greek Revival in America.

In the same year as the bank competition, John Haviland (1792–1852) published *The Builder's Assistant* in three volumes, presenting for the first time in an American publication all five Greek and Roman orders (Benjamin added these to the sixth edition of his *American Builder's Companion* in 1827). Haviland had been born and trained in England, coming to Philadelphia in 1816. While his elaborate publication gives him special distinction, his major influence came through his prison designs which are discussed later in this section.

Of the various styles revived in this period, classic Greek at first seemed to be most adaptable to a variety of new uses. In some instances columns might not be used at all, for general severity of form was one of the attributes of the Greek Revival; indeed, the unadorned bare wall was one of the lasting contributions to American architecture made by the Greek Revival (the other important contribution of historicism was the open plan inspired by the Gothic Revival). An example of such severity is the Sears House, Boston, 1816, by Alexander Parris (Fig. 76); the original portion is the left half of the house. Restrained Grecian details appear in the columnar portico and the carved panels above the windows, but otherwise there is utmost severity in the smooth curve of the bowed wall and the crisp incisions of the windows.

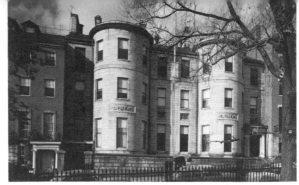

76. Alexander Parris, David Sears house, Boston, Massachusetts, 1816 (original portion to the left).

This austerity is Grecian in sentiment showing a desire for basic geometrical shapes, but at the same time the design honors the tradition of Boston's bowed façades. Also Grecian in feeling is the color, in which granite approximates classic marble. It is possible that the intractability of this stone helps to account for the severe lines and lack of ornament.

Parris also used granite for the long warehouse and wholesale block he built on the Boston waterfront in 1825, the Quincy Market (Fig. 77). The extended building is divided by a center block capped with a low saucer dome; each end is treated as a temple block with five pilasters along the sides and a prostyle porch of four unfluted archaic Doric columns. Behind the temple fronts, under the continuous gable roof, the walls are formed of large granite piers and lintels, making a simple lithic frame. In comparing the white Quincy Market with Smibert's delicate red brick Georgian Faneuil Hall directly behind it (even in its enlargement by Bulfinch), one can see the massive assertiveness of the Greek Revival, a quality that made this style all the more appealing to an increasingly self-conscious nation.

The very fact that so many buildings in New England were built of hard Quincy granite is also illustrative of the industrialization of the building industry, for this material was made available throughout the East by the ingenuity of Solomon Willard (1788–1862) who was carpenter, sculptor, architect, and inventor. Willard opened the granite quarry at Quincy and developed an ingenious integrated system of stone-cutting and handling machinery, rail transport, and deep water berth, which permitted him to cut and ship blocks of granite on a scale unknown for nearly fifteen hundred years. He used this granite for his own buildings, for example, the Bunker Hill Monument, 1825, and the Suffolk County Courthouse, Boston, 1845. Soon buildings all along the coast were built not of local materials but of Quincy granite, partly because it was durable and partly because it was readily available from a commercial source. With the gradual ex-

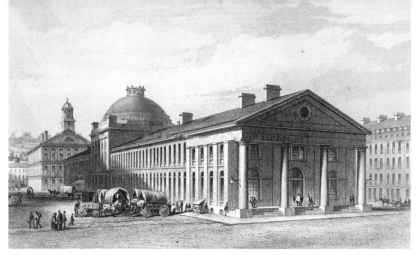

77. Alexander Parris, Quincy Market, Boston, Massachusetts, 1825–26.
Behind the Quincy Market is Faneuil Hall, designed by John Smibert,
1740–42, and enlarged by Bulfinch, 1805–06; engraving, 1852.

tension of the railroad system in the East the replacement of in-
digenous materials by cheaper commercial substitutes was greatly
expanded.

Of the many new building types which appeared in this roman-
tic period, one of the first was the state capitol building. Many of
the legislatures who had sat in eighteenth century chambers after
independence needed new quarters early in the following century
as governments expanded. What these state houses should be and
what they should look like were knotty questions. Jefferson's
Virginia capitol furnished a good model; and New York architects
Town and Davis drew upon this in their severely templar Con-
necticut State Capitol at New Haven, 1827–31 (for a time Con-
necticut had *two* capitals where the legislature met alternately),
and again later for their Indiana State Capitol, at Indianapolis,
1831–35, also generally templar but elongated, with a tower rising
through the center. This in turn may have served as a model
for William Strickland's Tennessee State Capitol in Nashville,
1845–59 (Fig. 78). The enrichment of Greek details is perhaps
even finer in this example. Following Jefferson's example, Strick-
land devised a large Ionic temple, placed on a hilltop, but he
made significant departures from the original Virginian source.
To insure proper proportions in the Ionic columns, the temple
fronts at each end were made octastyle (eight columns). Un-
pedimented hexastyle (six column) colonnades for entrances were
added to the otherwise unmodulated long side walls. Finally, the
whole block was raised on a tall rusticated base. Strickland's Ionic
order was carefully scaled and proportioned after Greek sources,
and for the tower he used another well-known model, the
Choragic Monument of Lysicrates, Athens. The ungainly combi-

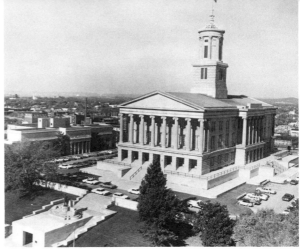

78. William Strickland, Tennessee State Capitol, Nashville, Tennessee, 1845–59.

nation with the tower base thrusting through the temple roof is most un-Greek, despite the individually accurate motifs, but what Strickland wanted was a building that would not only recall the national Capitol, with its wings flanking a domed central hall, but would likewise employ Greek elements with their connotation of democracy. Despite the mixed success of this experiment, the details reveal Strickland's love of elegant form and graceful embellishment.

Of the many Grecian state capitols erected during the romantic period perhaps none was bolder or more assertive than the Ohio State Capitol, Columbus, 1838–61 (Fig. 79). In the competition for the design, the first prize was won by Cincinnati architect Henry Walters, and the third prize was awarded to landscape

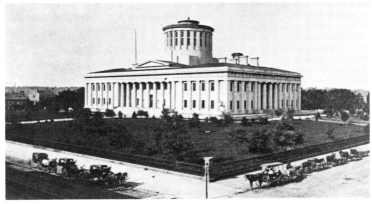

79. Henry Walters et al., Ohio State Capitol, Columbus, Ohio, 1838–61.

painter Thomas Cole. To combine the best features of all these designs the New York architect Alexander Jackson Davis was brought in as consultant. Out of this "collaboration" came the final design—bold, massive, austere, masculine (as the nineteenth century used this term), in contrast to Strickland's more "feminine" solution. This austerity results from keeping intact the rectangular pilastered block of the building, and forming entrance porches in recesses cut into the block behind screens of stout Greek Doric columns. Thus the heavy overscaled Doric entablature runs unbroken around the building; even the low pediments on the long sides are isolated and slightly recessed. Internally the plan resembles that of the national Capitol with the legislative chambers on either side of a central rotunda. In an effort to retain the austere character of the exterior, the rotunda dome is contained in a tall pilastered drum which was to be capped by a very low saucer dome. This capping dome was never built, unintentionally reinforcing the austerity of the silhouette, but its intended appearance is given by the dome-topped drum in the middleground of Cole's *The Architect's Dream,* painted in 1840 for Davis's partner, Ithiel Town (Fig. 80). This was painted after the competition but it shows the essence of Cole's proposal for the capitol. In part the austerity of the heavily scaled unfluted columns may be due to the large-grained local limestone which was used and the employment of convicts from the state prison as laborers. As a result the exterior is one of the most forceful and unadulterated among the Greek state capitols.

80. Thomas Cole, *The Architect's Dream,* 1840; oil on canvas.

The Greek Revival was championed by such well-to-do educated Hellenophiles as Nicholas Biddle, who, as president of the Second National Bank of Philadelphia, occupied Strickland's Doric building. A student of classical literature at Princeton, Biddle traveled to Greece in 1806 to see the buildings for himself. It became increasingly imperative to Biddle that his family home, "Andalusia," north of Philadelphia, be made Greek, so in 1836 he engaged Thomas Ustick Walter of Philadelphia to wrap a Doric colonnade patterned after that of the Hephaisteion, Athens, around the house (Fig. 81). As a result there is no correspondence between the columns and the windows and doors, and the heavy entablature throws the upper windows into deep shadow. But the Doric colonnade is archaeologically correct; Biddle knew exactly what he wanted and he knew that Walter could provide it, for Walter had been in Strickland's office and thus was heir to the rich professional tradition of Latrobe.

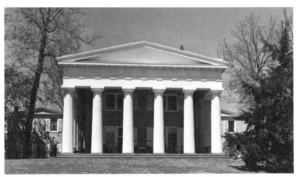

81. Thomas Ustick Walter, Nicolas Biddle house, "Andalusia," nr. Philadelphia, Pennsylvania, remodeling of 1836.

Biddle knew Walter well for in 1833 he had been instrumental in selecting Walter from among other competitors as architect for Girard College, Philadelphia. The school was being built through the bequest of a wealthy Philadelphia banker whose will specifically stipulated the dimensions of the buildings for the proposed college; it may have been Biddle who suggested its Corinthian temple form to Walter. Founder's Hall, the main building, is a peripteral temple (columns all around) with four rooms on each of three floors (Fig. 82). This arrangement, necessitated by the will, results in skylighted rooms on the third floor. Throughout, the rooms are vaulted in masonry, in the manner of Latrobe and Mills. Although the building is not a copy of a temple in the literal

sense (because it is too short for its width) its detailing has a grace and authority that suggests the best Athenian work. Flanking the main building, two to a side, are four dormitories, each a separate pedimented astylar block (with no columns or pilasters). Walter kept each of the buildings isolated, in a row, so that instead of enclosing a Roman forum, as at Charlottesville, the buildings stand free as Greek temples do.

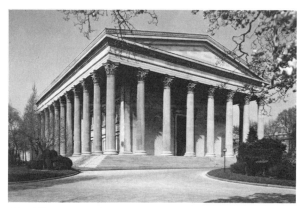

82. Thomas Ustick Walter, Girard College, Founder's Hall, Philadelphia, Pennsylvania, 1833–47.

The major work of Walter's later years was the enlargement of the United States Capitol, Washington, D.C., begun in 1851. By that date eighteen new states had entered the union and the population of the country had grown to nearly nine times what it had been when Thornton had designed the Capitol. Services were hampered by lack of space, and the chambers were hopelessly crowded. A competition was held for extensions of the building and of the entries President Millard Fillmore selected four, giving Walter instructions to design new wings on the basis of these plans. Walter's final design provided for identical wings to the north and south of Thornton's building, employing the same rusticated base and colossal Corinthian order of the original section, but with the classical details both more Grecian and yet florid (Fig. 83). Each wing, with its projecting pedimented portico echoing the center section, was built of white Massachusetts marble, subtly different in hue from the Virginia sandstone of the original section. Internally, all major parts are of iron, the result of Walter's decision to prevent fires like the one which damaged part of the Capitol late in 1851. Wrought iron was used for the roof trusses, while cast iron was used for all other sections, including ceiling

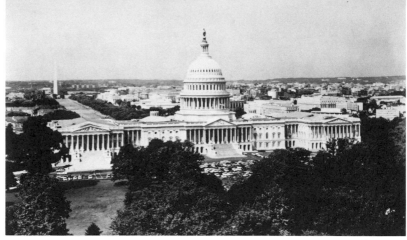

83. Thomas Ustick Walter, United States Capitol, Senate and House Wings, 1851–55; Dome, 1855–64. In the distance is the Washington Monument by Robert Mills, 1836. The Mall is shown restored generally according to the Senate Park Commission's Report of 1902.

and wall panels, window moldings, and trim—it was the largest use of iron in any public building in the United States up to that time, and roughly contemporary to the new Houses of Parliament in London which also made extensive use of iron for fire safety.

The addition of the wings, however, destroyed the relationship of Bulfinch's timber-framed dome to the whole, so in 1854–55, as the wings neared completion, Walter drew up plans for a huge dome over the central rotunda big enough to balance and control the new length of the building. This construction would also remove the last major wooden portion of the Capitol's fabric, reducing the likelihood of a castastrophic fire. For such a dome there were no precedents in Greek or even Roman architecture, and since Walter needed a steep profile (he had to stay within the diameter of Thornton's dome), he turned to the Renaissance domes of Michelangelo and Wren, one indication that by 1855 the force of the Greek Revival was in decline. To set such a towering new work on existing walls and foundations, Walter had to use a trussed iron frame carrying internal and externals shells of cast iron panels; the result was lighter than traditional solid masonry construction. Work on the dome started in 1855 but was not completed until early 1864 largely because the war effort interrupted supplies of iron and passage of appropriations. Yet the fact that the dome was pushed to completion during the war illustrates the compelling force formal aesthetics and symbolism exerted on Walter, President Lincoln, and the Congress. Lincoln, replying to a question as to why construction continued while the nation was split in war and material was so dear, said that construction on the

dome was "a sign we intend the Union to go on." Here restated was Jefferson's belief in the power of architecture to mold the minds of men and to direct their action.

This belief in symbolism was advanced by professional architects whose numbers were steadily growing; they often had some college education or engineering experience, sometimes both, and collected extensive libraries. The firm of Town and Davis exemplifies this new generation of highly educated architects without whom the romantic archaeological revivals would have been impossible. Ithiel Town (1784–1844), born in Connecticut, received his architectural training in the Boston school of Asher Benjamin. He opened his own practice in New Haven in 1810, and while designing buildings investigated the use of iron, wrote on mathematics and navigation, read in the arts, and traveled. Much of his travel was occasioned by installations of his wooden truss bridge patented in 1820 and widely used throughout the eastern states. The royalties on the bridge truss made Town wealthy and enabled him to amass one of the largest and finest architectural libraries of his day (it was sold in 1843). He tended toward clear, rational compositions and, predictably, because of his interest in mathematics, favored classic Greek. An example is the Connecticut State Capitol, on the New Haven Green, which he designed in 1827 (with the assistance of Davis); it is a Greek Doric temple with a hexastyle porch and side walls so deeply pilastered as to suggest a peripteral colonnade. Town was also guided by other ideals, for in 1814, immediately next to Benjamin's Center Church on the New Haven Green, he built a dark brownstone Gothic church for an Episcopalian congregation—the style chosen in recognition of traditional churches in England.

Because his growing practice called him away from the New York office he had established in 1825, Town took on a young partner in 1829, Alexander Jackson Davis (1803–1892). The complement of Town, Davis had spent a large part of his youth reading and devising theater sets for his own amusement. He attended the American Academy of Fine Arts in New York and aspired to become an artist. To support his studies Davis began making drawings of public buildings for translation in popular engraved views (see Fig. 54); eventually he became one of the foremost draftsmen and watercolorists of his day, but he always remained an "architectural composer" in his own words. He was a scenographic designer who provided exotic backdrops for stylized activity rather than shaping space or structure. Nevertheless he appreciated simple rational design as his later work shows. His strong

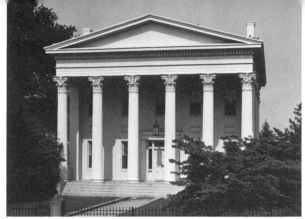

84. Ithiel Town and Alexander Jackson Davis, Russell house, Middletown, Connecticut, 1828–30.

commitment to professional ideals led him, in 1837, to join with Town, Strickland, Haviland, Walter, and others (including Minard Lafever, Isaiah Rogers, Benjamin, Parris, and Ammi B. Young), in an attempt to found a professional society, but this venture came to naught.

The early works of Town and Davis were largely Greek Revival; they were solid, carefully planned, with consummate detailing by Davis. A good example is the Russell house, Middletown, Connecticut, 1828–30 (Fig. 84). A pure cube with a Corinthian hexastyle porch, it is characterized by formally arranged rooms, elegantly refined proportions, and careful alignment of the wall openings with the colonnade (compare this precision with the irregularities of "Andalusia"). The entrance door with its framing Doric pilasters, entablature, and glazed side lights is exemplary of similar entrances soon popular throughout the country in sophisticated houses. The interiors of such houses were equally well or-

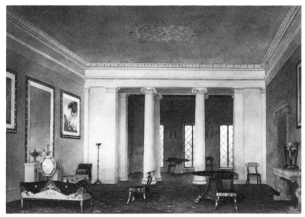

85. Alexander Jackson Davis, study for a Greek Revival double parlor, perhaps for the John Cox Stevens house, New York, c.1830–45.

namented, and a good example is given in the rendering by Davis, possibly for the John Cox Stevens residence, New York, 1845 (Fig. 85). The walls are left plain, with ornamentation reserved for the ceiling entablature molding, the Ionic columns of the passway, and the door with its Greek frame. The furniture is based on pieces shown on Greek vases and resembles the late work of Duncan Phyfe.

Because of its use of repeated elements, the classic revival lent itself well to urban town houses (contiguous houses with party walls). Excellent, highly conservative examples can be found on Beacon Hill, Boston, or on the north edge of Washington Square, New York; in both cases the houses are of brick with restrained Greek entrances. More elaborate, and more characteristic of the fully developed Greek Revival of the 1830s, is La Grange Terrace, New York (Fig. 86), a group of nine houses built in 1830–33 by developer Seth Geer on Lafayette Place, and named after Lafayette's country home. It is possible that the block-long group was designed by Davis, though fragmentary evidence suggests the designer may have been Robert Hingham of Albany. The colossal Corinthian colonnade shelters two full stories, while the rusticated base contains the entrances. Recessing the column-framed entrances so that no projecting elements could break up the stretch of the terrace allowed the march of the colonnade and the flow of the street to continue smoothly. Where a suburban free-standing house, such as the Russell house of Middletown, could be expressed as an isolated unit in the landscape, La Grange Terrace, like the townhouses of Bath or London from which it derives, recognizes the continuity of the street and reinforces its urban character.

86. Alexander Jackson Davis or Seth Geer?, La Grange Terrace ("Colonnade Row"), Lafayette Street, New York, New York, 1830–33.

Such buildings as the Russell house and La Grange Terrace represent "high style" in the cities and were the work of trained professional architects. As yet, however, the United States was not an urban nation. The great majority of people lived in rural areas where building was largely in the hands of carpenters and mechanics who relied on books. Thus it was through pattern books that the Greek Revival spread across the nation and became for nearly forty years the national style. The later editions of Asher Benjamin's books, modified by replacing the Georgian-Federalist plates with new illustrations of Greek Revival forms, were important sources for this Greek Revival. Haviland's book was perhaps less so. While Benjamin's many books were most popular in New England and Connecticut's Western Reserve which by now was part of Ohio, a new author appeared who made the Greek Revival his particular cause and whose books enjoyed special influence in the territory not already won by Benjamin.

Minard Lafever (1798–1854) was a self-trained designer and builder from the Finger Lakes region of upstate New York. His first book appeared in 1829, but it was his second and third titles which exerted the most profound influence. *The Modern Builder's Guide* appeared in 1833 and ran through five editions until 1855; *The Beauties of Modern Architecture* came out in 1835 and went through four editions until 1855. Though no later editions appeared, it should be remembered that in outlying regions such books continued to be used for another decade or more. While Lafever reproduced many accurate Greek details, he also provided a Grecian house design with details more suitable for construction with board lumber and more easily realizable by untrained mechanics. His country villa, the frontispiece for *The Modern Builder's Guide* (Fig. 87), shows a standard popular house type, the penetrated temple—a two-story center block "penetrated" or flanked by wings on either side. In this, however, the columns of porch and wings were converted to square piers with simple geometric capital blocks. All of this could be built of sawn lumber. Houses of this type soon began to appear all across the Northwest Territory, each varied according to the ability of local craftsmen and the aspirations of the client, although several examples demonstrated particular suavity of detail. Some of the more sophisticated examples are the Boody house, "Rose Hill," Geneva, New York, about 1835; the De Zeng house, Skaneateles, New York, 1839; and the Sidney T. Smith house, Grass Lake, Michigan, 1840.

An example of Lafever's influence, perhaps, can be seen in a small house at Eastham, Massachusetts, on the Cape, built about

89. George Swainey, Alexander Roman house, "Oak Alley" (originally called "Beau Sejour"), St. James's Parish, near Vacherie, Louisiana, 1836.

next book, *Cottage Residences,* 1842, was even more popular and went through thirteen editions up to 1887. This was concerned solely with rural houses, their construction, conveniences, appointments, and furnishings. Nothing escaped his attention. The approach to the house, he suggested, should meander through the surrounding planting so as alternately to expose and hide the house, providing different aspects of the building. In his last book, *The Architecture of Country Houses,* 1850, with nine editions to 1866, he expanded various ideas and published house designs by various architects extrapolated from suggestions in his previous book. Part of the reason for the great popularity of Downing's work was the profusion of wood block illustrations showing simple house types (Fig. 90), details, interiors, and landscape plans. In every instance, however, he reminded the reader that these were only suggestions and that the builder should adapt such designs to his own needs and site.

Many of the house designs were supplied by A. J. Davis and were based on houses actually being erected by Town and Davis. Some were Gothic or based on Italian villas, while others were simply conjectural designs in various picturesque modes. Seem-

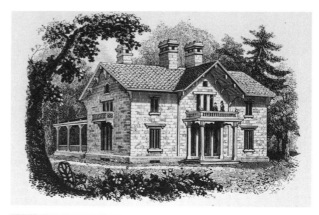

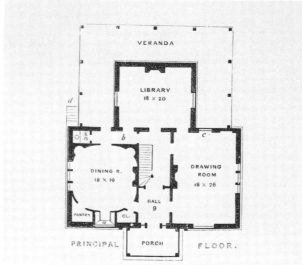

90. Andrew Jackson Downing, Design V, "A Cottage Villa in the Bracketed Mode," from *Cottage Residences*, 1842.

ingly digressing from his earlier classicism, Davis became a staunch advocate of the Gothic style after Town's death, his work ranging from complex country houses to simple cottage designs. This work, published in many of Downing's books, inspired countless cottages across the central states; for some of these Davis actually drew up plans or sent preliminary designs to local builders who made final drawings and supervised construction. One of those he personally supervised was the cottage for the landscape painter Edward W. Nicholls, in Llewellyn Park in Orange, New Jersey, 1858–59 (Fig. 91). Characteristic of these

houses are the steeply pitched roofs and gables often trimmed with carved barge (or verge) boards along the eaves, pointed lancet windows with diamond-shaped glass panes, clustered elongated chimney pots, Tudor-detailed porches, varied window shapes, and, frequently, vertical board and batten siding which Downing agreed to when masonry was beyond the client's means. In plan many of these houses were cross-shaped, with the façade centered on the tall central gable, but irregularity in the plan and massing was common and encouraged by Downing.

The influence of this house type was extensive, because Davis himself built many in scattered locations, among them the Henry Delameter house in Rhinebeck, New York, 1844; the C. B Sedgwick house in Syracuse, New York, 1845; and the W. J. Rotch house in New Bedford, Massachusetts, 1850. The details and structural materials varied, but the general configuration was the same. Derivatives, closely imitating Davis's own work, include many richly embellished examples such as the Neff cottage in Gambier, Ohio, 1845; the Bonner-Belk house in Holly Springs, Mississippi, 1858; the Mann-Foster house in Marshall, Michigan, 1861, the "Lace House" in Blackhawk, Colorado, of about 1860; and the Tea House of Lachrymae Montis in Sonoma, California, of about 1850.

When circumstances allowed, Town and Davis built larger, more elaborate, and more archaeologically correct Gothic villas, such as "Glenellen" outside Baltimore for Robert Gilmore in 1832, or the even larger "Belmead" for Philip St. George Cocke in

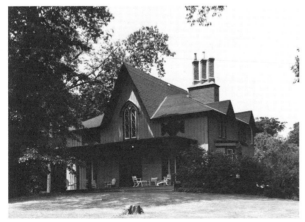

91. Alexander Jackson Davis, Edward W. Nicholls house, Llewellyn Park, Orange, New Jersey, 1858–59.

Powhatan County, Virginia, 1845. Destined to be even larger and more elaborate was "Lyndhurst" near Tarrytown, New York, begun in 1838 for merchant William Paulding (Fig. 92). Inspired by Lowthar Castle, it is a carefully calculated asymmetrical mass in stone, surrounded by clusters of shrubbery and trees which alternately frame and obscure views of the house. Davis's rendering shows his accomplished technique and the rich ornamentation he intended for the house. The plan has an order and clarity that reveals Davis's neoclassical debt to Town, but the silhouette is the essense of picturesque irregularity. The interiors designed by Davis were lavishly executed by Richard H. Byrnes. In 1864, when the new owner George Merritt built an addition to the house, this too was designed by Davis, further enriching the irregularity and complexity of the house.

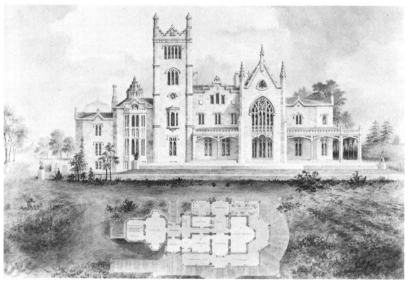

92. Alexander Jackson Davis, William Paulding house, "Lyndhurst," near Tarrytown, New York, 1838–65; watercolor, 18³/₄″ by 26³/₄″.

As Davis's rendering shows, different elements from the medieval period were combined in any single building, and the same is true of the interiors of such houses. An example is the entry hall in "Kingscote" for Noble Jones, Newport, Rhode Island, begun in 1841 after designs by Richard Upjohn (Fig. 93). Early English and Tudor Gothic are mixed with pure invention to create complex visual effects, and the medieval aspect is intensified by deep earth colors, dark stained wood, and stained glass.

The Nicholls house is important not only as an example of the

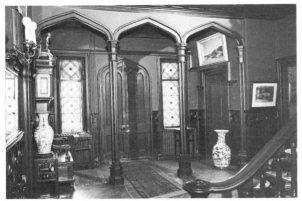

93. Richard Upjohn, Noble Jones house, "Kingscote," Newport, Rhode Island, entrance hall, 1841.

Downing-Davis cottage by Davis himself, but also as the last surviving original residence in a group of about fifty houses that were built in Llewellyn Park. Developed by Llewellyn Haskell, a chemical and drug manufacturer, this was an ideal suburban community amid a landscaped garden, situated on a commuter rail line in New Jersey, west of New York City. The plan was devised by Haskell himself (according to tradition), perhaps with Davis's advice and following suggestions previously made by Downing (Fig. 94). The first streets were laid in 1852–53, and construction

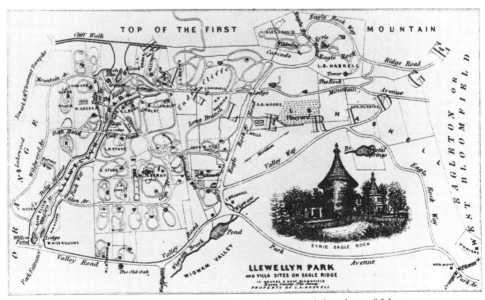

94. Llewellyn Haskell with E. A. Baumann and H. Daniels, plan of Llewellyn Park, Orange, New Jersey, 1852–69.

continued over the next seventeen years. Some of the later extensions were designed by landscape architects Eugene A. Baumann and Howard Daniels. The streets generally followed the topography, and the uncommonly large lots were sold with covenants which prevented the introduction of hedges or fences separating the houses to avoid breaking the continuity of the landscape. The original buildings, all designed by Davis, varied in style from the fanciful rubble masonry gatehouse (Fig. 95) and the similar large Haskell residence, to the simpler cottage for Nicholls. Davis's own house was here was well. The view of the gatehouse indicates the importance of planting in the overall plan. In fact, through the center of the complex ran a communal park strip leading to the pond and gatehouse at the bottom of the hill.

Llewellyn Park marked a radical change in urban planning in the nineteenth century because of its comprehensive plan and the great importance given to landscape elements and parkland. It laid an important foundation for the work of Frederick Law Olmsted in Central Park, New York, and Riverside, Illinois. Imbued with Jeffersonian anti-urbanism and agrarianism, Llewellyn Park was, like all romantic conceptions, a retreat from reality, from the increasing squalor of the industrial city. In 1852 New York had no adequate provision for recreation land, and since it was rapidly filling to bursting with new arrivals from Europe, it is understandable that Haskell should imagine creating a romantic

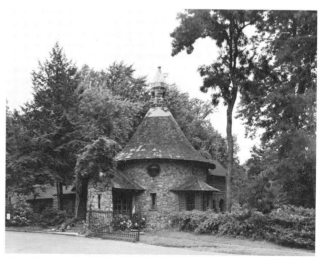

95. Alexander Jackson Davis, Llewellyn Park, Orange, New Jersey, gatehouse, 1853.

landscaped suburb, free of the city's noise, stench, and congestion. Nevertheless, Haskell's suburb was developed as a profitable investment, and what was demonstrated in Llewellyn Park was that it was possible to make planning pay.

Hygeia, Kentucky, if it had prospered, might have given this idea early additional support. A purely speculative land scheme for a new town on the Ohio River opposite Cincinnati, it was the project of William Bullock, laid out by John B. Papworth in 1827 (Fig. 96). Features of many English villages and London's residential squares appeared in the plan; the varied housing included detached villas, semidetached houses (duplexes), town houses, and residential squares. There were provisions for gardens, parks, and promenades, and features of the terrain were reflected to a degree in the street pattern. The design for circulation was perhaps not the best, and there was no clear communal center, but the plan showed imagination. Unfortunately, because of poor financial support, Hygeia never became more than a city on paper.

Without question Llewellyn Park and Hygeia were the exceptions to the rule of city planning by the grid which spread throughout the country. There was money to be had in city building and, as the New York commissioners had recognized early,

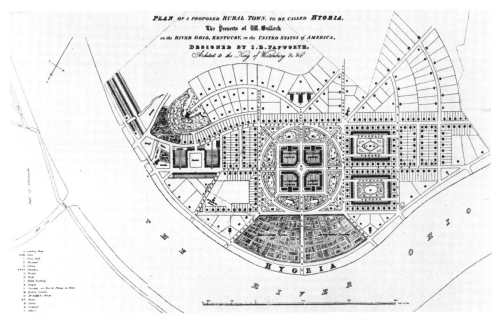

96. John B. Papworth, planner, plan of Hygeia, Kentucky, 1827.

the way to stimulate growth was to use an uncomplicated grid plan, for it is easy to buy and sell parcels of land when they are described by a conventional Cartesian grid. Many cities were laid out in this way, among them Columbus, Ohio, 1815; Wisconsin City, Wisconsin, 1836; San Francisco, 1839, and Sacramento, California, 1848; as well as the many towns platted by the railroads such as Mattoon, Kankakee, and Natrona, Illinois, all 1851 to 1857. Perhaps the most typical and telling example is Chicago. The building of a city at the base of Lake Michigan, in hindsight, was inevitable, for here was a flat four-and-a-half mile portage between the Great Lakes watershed (through the St. Lawrence River to the Atlantic) and the Mississippi watershed (via the Des Plaines and Illinois rivers to the Gulf of Mexico). Because of its strategic importance, the site was bitterly contested by the Indians, the French, the English, and finally the United States. Even before the city existed, in 1829, the state legislature set up a canal commission to develop a scheme for connecting the two water systems, and in 1830 the first plat was drawn up of the proposed city by James Thompson. It was an unmodulated grid; alternate squares were set aside for public sale with the proceeds to be used to build the canal. Even before the canal was started, speculation in buying and selling lots began; indeed many of the early leaders of the city came to Chicago to handle transactions for others and then decided to stay and make their own fortunes. So, in ways more pronounced than in any other city, Chicago came into being on the crest of a speculative bubble. Land became a commodity to be bought in anticipation of appreciation in value, like futures in wheat, corn, or hog-bellies, relatively irrespective of any inherent value. It was a practice which, in Chicago as in other cities, was to accelerate growth and yet destroy the cohesiveness of the city at the same time. The city, as Chicago and other developments suggested, was not, like Llewellyn Park, a haven for civil intercourse, but solely a generator of revenue.

The alternative was to reject capitalism and individual enterprise altogether and build a utopia, and a number of these appeared in the United States during the 1840s as industrialization began to make itself felt. Among these were the small but celebrated Brook Farm near West Roxbury, Massachusetts, which prospered from 1841 to 1846; Hopedale, Massachusetts, 1841–52; the Fourieresque North American Phalanx at Red Bank, New Jersey, 1843–55; and the Oneida Community in upstate New York which survived longest, 1847–79. For the most part all of these adapted existing building conventions to radically new social patterns. One community in which a new architectural

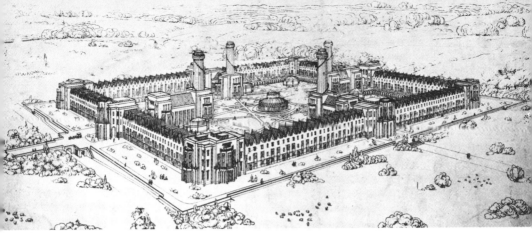

97. Stedman Whitwell (with Robert Owen?), aerial view of New Harmony, proposed community building, c.1825; lithograph.

model was suggested was that established by Robert Owen at New Harmony, Indiana, in 1825 (Fig. 97). The town had already been settled by George Rapp and his followers in 1814 as a religious commune. When the Rappists decided to return to Pennsylvania in 1825 they sold the entire town to Owen who hoped to establish there a model industrial city based on the theories of social reorganization he had developed at New Lanark, Scotland. Owen's New Harmony was to consist of about twelve hundred people living in a large rectangular enclosure containing all communal facilities, with the stables and industrial mills spaced around the housing block in the countryside. The whole complex was then to be surrounded by farm lands providing a rudimentary green belt. The drawing of the ideal residential block, prepared by Stedman Whitwell, was only a dream, and no such structure was ever built, for by 1830 Owen's project had begun to disintegrate. Nevertheless, Owen's ideals of communal ownership of services, centralization, and preservation of open space in a surrounding green belt were important concepts and nearly a century later were incorporated in the first garden city proposals.

The "Gothic" Downing-Davis cottages of Llewellyn Park did not introduce the Gothic style in American architecture, for as we have seen the Newport Parish Church in Virginia was begun in a late variant of vernacular Gothic still very much alive in rural England in the early seventeenth century. As the interest in Gothic novels burgeoned in the eighteenth century (an example is Horace Walpole's *The Castle of Otranto* of 1756), so did an interest in Gothic ornament, particularly in rather fanciful garden "follies." A major impetus was the appearance of Batty Langley's *Gothic Architecture Improved by Rules and Proportions in Many Grand*

Designs in 1742. This earliest phase of "Gothick" (to use the eighteenth century spelling) was not concerned with archaeological accuracy and served largely for garden ornaments and interior details, such as Josiah Brady's pointed windows and finials on what was a basically Georgian-Federalist building for Trinity Church, New York, 1788–94. Even Jefferson proposed using Gothic in one of the many pavilions he planned for the landscaped grounds around Monticello, and in 1771 he wrote in his notes that in the center of the burial plot he wanted to put up "a small Gothic temple of antique appearance." It was not carried out, but this does illustrate the flexibility of Jefferson's associationalism, for while Roman classic was appropriate for seats of government, Gothic was more properly evocative for places of interment.

As we have noted, Latrobe proposed a detailed Gothic solution for the Baltimore Cathedral in 1804, and even before this, in 1799, he built for William Crammond, "Sedgeley," a "Gothick" country house outside Philadelphia. Other "Gothick" buildings soon followed, but the building most often credited with ushering in a more correct Gothic idiom is the small chapel for the Sulpician Academy of St. Mary's Seminary, Baltimore, 1806–8, by the architect then teaching drawing there, Maximilian Godefroy. Gothic, thereafter, was increasingly used for churches and also for new collegiate buildings, beginning with Old Kenyon, for Kenyon College, Gambier, Ohio, 1827–29, designed by the Rev. Norman Nash and slightly modified by Charles Bulfinch.

By 1835 to 1840 Gothic was nearly as well established as Greek as a major style, as evident in Cole's painting for Ithiel Town, for in *The Architect's Dream* (Fig. 80) the brightly illuminated classical modes on the right half of the canvas are balanced by the darker, more mysterious, Gothic building on the left. Indeed, the church shown there may refer specifically to the Gothic work already done by Town and Davis, such as the new building for New York University at Washington Square, New York, 1832–37 (Fig. 98). Unlike Old Kenyon, this was much more archaeologically correct, with a raised central chapel clearly based on King's College Chapel, Cambridge, England, and interior vaulting patterned after Chapel Royal at Hampton Court. The exterior, however, was clad in white marble, an un-Gothic holdover from the firm's more prevalent neoclassicism. A later building, the Yale Library (now Dwight Chapel) by Henry Austin, 1842–46, was even more like King's College Chapel, but with greater emphasis in the vertical line, and was built of dark brownstone.

In church design the shift toward correct Gothic was in large measure the result of the revival in interest in liturgy pro-

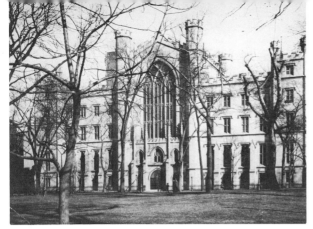

98. Alexander Jackson Davis, New York University, Washington Square, New York, New York, 1832–37.

mulgated by the Cambridge Camden Society in England, and *The Ecclesiologist* which it published, as well as by branch societies in the United States. The professed objective of fidelity to original architectural sources was unwittingly realized far beyond expectations in a small church in Philadelphia, St. James the Less, 1846–47 (Fig. 99). The congregation wrote to the parent group in Cambridge asking for a set of approved plans for their proposed church and, inadvertently, were provided with a set of measured drawings of St. Michael's Long Staunton, Cambridgeshire, built early in the thirteenth century, which the congregation followed

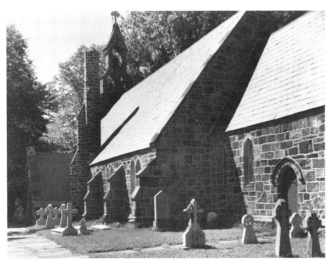

99. St. James the Less, Philadelphia, Pennsylvania, 1846–49; supervisory architect, John E. Carver. Adapted by G. G. Place from St. Michael's, Long Stanton, Cambridgeshire, c.1230.

to the letter unwittingly. This replication of a thirteenth century model was the exception. Most churches were designed by architects according to the needs of a particular parish, and three churches which set the example were all built in greater New York and were all started, coincidentally, between 1839 and 1844. These were James Renwick's Grace Church, New York, 1843–46, Minard Lafever's somewhat more ornate Church of the Saviour, Brooklyn, 1842–44, but most especially Richard Upjohn's Trinity Church, New York, 1839–46. All of these architects benefited from the number of publications on Gothic architecture which had appeared during the preceding decade, most especially Augustus Charles Pugin's *Examples of Gothic Architecture,* London, 1831 (as well as the subsequent books by his more famous son, A. W. N. Pugin), and also the *Essay on Gothic Architecture: Designed Chiefly for the Use of the Clergy,* Burlington, Vermont, 1836, by the Rev. John Henry Hopkins.

Richard Upjohn (1802–1878), born in England and trained as a cabinetmaker, emigrated in 1829, set himself up in architectural practice, and spent periods in New Bedford and Boston before settling in New York. His main concern was ecclesiastical building (though he built many important urban and country houses), and it is significant for his architecture that he was an Episcopalian who happened to be an architect rather than the reverse. His masterwork is Trinity Church, New York, 1839–46 (Fig. 100), which, like a medieval master mason, he personally supervised from a shed on the grounds. While the design for this brownstone church is synthetic in that it draws from a number of English Gothic sources, Upjohn was careful to restrict himself primarily to fourteenth century prototypes, relying heavily on the publications of A. C. Pugin. Upjohn firmly believed in high church ritual, so one finds in Trinity Church a deep chancel (though it does not have a lower roof as in A. W. N. Pugin's churches). Deviating from the purism of the younger Pugin, Upjohn was more interested in the symbolic forms, and used suspended plaster vaults to give the appropriate Gothic effect; such sham construction Pugin deplored. Nevertheless, in such intricate and consummate details as the pulpit (Fig. 101), Upjohn more than compensated for his deceptive vaults, for the total visual effect is controlled and absolutely convincing, enhanced by the high quality of material and workmanship.

Upjohn's shed in the work yard suggests he was not the professional stipulated by Latrobe, but in fact Upjohn was very much the professional architect, and it was at his invitation and in his of-

100. Richard Upjohn, Trinity, Church, New York, New York, 1839–46; lithograph, 1847.

101. Trinity Church, New York, pulpit.

fice, in 1857, that the American Institute of Architects was formed. Moreover he helped establish the legal right for the architect to receive payment for his preliminary designs, after he took the town of Taunton, Massachusetts, to court in 1850 when he received no fee for drawings he had been engaged to make for a new town hall.

Although Upjohn built several important large urban churches in New York City, he was also called upon to design many smaller churches, such as St. Mary's, Burlington, New Jersey, 1846–54, which was patterned after St. John the Baptist, Shottesbrook, Berkshire. In addition he also drew up plans for small frame churches, on the average of about one a year. Among these are St. Paul's, Brunswick, Maine, 1845; St. Thomas's, Hamilton, New York, 1847; Trinity Church, Warsaw, New York, 1853–54; and St. Luke's, Charleston, New Hampshire, 1863. Some of these he published in *Upjohn's Rural Architecture*, 1852, which he hoped would help meet the need for good, properly designed, rural churches. One of the simpler designs is St. Luke's, Clermont, New York, 1857 (Fig. 102). It combines a concern for plan based on liturgy with Downing's simplicity of construction, using vertical board and batten siding and intricately carved bargeboard trim. In the steeple there is a particular emphasis on expression of the structural skeleton, especially the diagonals, and these aspects of frame building were to be more fully exploited after the Civil War in what became the Stick Style.

102. Richard Upjohn, St. Luke's, Clermont, New York, 1857.

103. James Renwick, The Smithsonian Institution, Washington, D.C., 1846–55; lithograph.

Used somewhat less frequently during this period was a kind of free Romanesque style, best represented perhaps in the Smithsonian Institution, Washington, D.C., 1846–55, by James Renwick (Fig. 103). The suggestion of regularity in the plan is played against a capricious irregularity in the silhouette. Every tower is different in shape, and the variety of projections breaks the red sandstone surface into splinters of light and shadow. One of the most scenographic designs of the period, it is a mixture of Lombard, Norman, and Byzantine devices, interlaced with pure Renwick invention. It demonstrates Renwick's broad knowledge of historic architecture, shown also in his more archaeologically correct Gothic churches in New York, Grace Church and St. Patrick's Cathedral.

With a capriciousness equal to that of the outline, the Smithsonian Institution was placed close to the middle of L'Enfant's mall, breaking the open sweep of the space westward from the Capitol. This clearly indicated that by 1846 the expansive continuities of L'Enfant's grand design were no longer appreciated nor understood. To many people, even Downing, this vacant land seemed to invite development. In 1850 President Buchanan engaged Downing to relandscape the Capitol and White House mall. This was a natural choice since by this time Downing had es-

tablished his reputation as the most prominent landscape gardener in the country. Downing proposed to break up the spaces of the malls with copses of trees and winding paths, shaping a landscape in which Renwick's craggy Smithsonian would have been the perfect picturesque ornament. Work proceeded very slowly and only the circle south of the White House, the most formal part of the whole scheme, was carried out.

Since the historical associations of Romanesque were not so rigidly fixed as were those of Gothic, it could be used for new building types whose functions suggested no clear associations. The railroad station was one. As a building type, the station had developed in New England during the 1830s and by the late 1840s had become one of the largest of nineteenth century buildings. Yet what it should look like and what it should express were perplexing problems, and architects trained to think in historical terms attempted to use expressions whose connotations were not already fixed. Henry Austin used a highly inventive expression in his station in New Haven, Connecticut, 1848–49, which has been variously described as Moorish or Oriental. A somewhat more conventional approach was to use Romanesque as was done by Thomas Tefft in his Union Depot, Providence, Rhode Island, 1848 (Fig. 104). The masses were large and simple, with twelfth century Lombard ornament. The arcaded wings were angled back, following the curve of the tracks, and the covered areas proved to be advantageous for sheltering passengers and baggage.

104. Thomas Tefft, Union Passenger Depot, Providence, Rhode Island, 1848.

105. John Haviland, Eastern State Penitentiary of Pennsylvania, Philadelphia, Pennsylvania, 1823–25; engraving.

There were many architectural expressions besides those basically Greek or Gothic. The massive density of castellated early medieval architecture was especially suitable for prison building and helped to convey the image of confinement as well as penal reform being attempted early in the century. Egyptian forms, in their massiveness, also suggested solidity, but usually connoted rehabilitation in contrast to the dungeon-like castellated medieval. Both modes were used effectively by John Haviland. His Eastern State Penitentiary of Pennsylvania in Philadelphia, 1823–25 (Fig. 105) was castellated medieval, and following this example many later prisons across the country used the windowless castellated medieval masonry. Even more influential, however, was the plan arrangement devised by Haviland (and thereafter given his name), consisting of seven cell block buildings arranged radially around a central control station. Prisoners were assigned to individual cells with small exterior balcony courts; they were never removed since solitary confinement was then believed to be reformatory. It was the radial arrangement of the cell blocks and the resultant ease of control that attracted most attention, and Haviland's plan was studied by French penal experts who published a report that was to redirect the planning of important French prisons. Thus Haviland's prison was one of the first American buildings to influence the design of European buildings, reversing a trend in which American architecture followed European models. Especially in the areas of planning, building technology, and

106. John Haviland, Halls of Justice ("The Tombs"), New York, New York, 1836–38.

mechanical equipment, European architects now began to study American developments closely.

Haviland's best known Egyptian prison was the Halls of Justice, New York, 1836–38 (Fig. 106), known locally by the name, "The Tombs," partly because of its funerary appearance and partly because those who entered were said never more to be seen. Egyptian motifs were occasionally used for churches, one example of which was Strickland's First Presbyterian Church, Nashville, Tennessee, 1848–51, but their use was more common in funerary structures. A good example is the massive gate to the Grove Street Cemetery, New Haven, 1845–48, where the obvious relationship to Egyptian mortuary architecture is embroidered by the inscription over the entrance: "The Dead Shall Be Raised."

A simplified Italian Renaissance palazzo mode was well adapted for use in urban houses, such as Upjohn's Pierrepont residence in Brooklyn, 1856–57, and even for mercantile and office blocks, for which again Upjohn provided a model in his Corn Exchange Bank, New York, 1854. One of the earliest instances of the more correct use of the palazzo mode was John Notman's Philadelphia Athenaeum, 1845–47, at a time when such buildings were usually designed as Greek temples. Notman's Athenaeum is important for its accuracy and restraint of detail, for most Renaissance adaptations at this time were at a stage Gothic had been nearly a half century before. A more intuitive and inventive Renaissance mode was popular for suburban and country houses; this, the so-called Italian villa, with its irregular massing and off-center tower, was also advocated by Downing, thereby inspiring thousands of adaptations. In *Cottage Residences* he reproduced an example that inspired Henry Austin's John P. Norton house, New Haven, 1848–49, and in *The Architecture of Country Houses* he illustrated the Edward King villa in Newport by Upjohn, 1845–47. A later representative example is Henry Austin's Morse-Libby house, Portland, Maine, 1859 (Fig. 107). Enriched with elaborate and heavily

107. Henry Austin, Morse house, Portland, Maine, 1859.

scaled ornament at the cornices, windows, door, and porch, it is based on an asymmetrical L-shaped plan. Just as the exterior embellishment became larger and more bulbous during the late 1850s, so too did interiors. Furniture became more convoluted and extravagant in form and material. Compare the fullness of the parlor from the Milligan house of Saratoga, New York, of about 1850 (Fig. 108) to the spare elegance of the parlor designed by Davis only a few years before (Fig. 85). Unassimilated decorative elements abound in the carved fireplace, the gilt frame of the mantel mirror, and the carved valences above the draperies. Such opulence came to characterize the interiors of the next two decades, and if it was sometimes tasteless and blatant, it boldly demonstrated the new wealth of the broadening middle class.

108. Col. Robert J. Milligan house of Saratoga Springs, New York, parlor, c.1850 (now in the Brooklyn Museum).

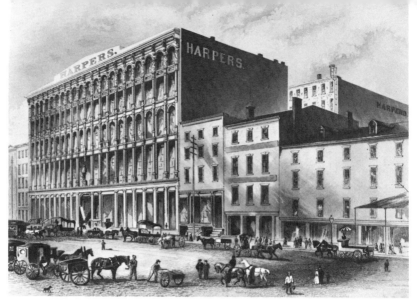

109. John B. Corlies, designer; James Bogardus, manufacturer, Harper and Brothers Building, New York, New York, 1854.

This middle class was created by burgeoning industrial growth and the commerce it generated. With mass production and mass distribution of goods came the department store, a new concept in merchandising based on impulse buying. To meet the demand for retail stores and the warehouses which supplied them, architects and builders turned to the use of iron cast in small, identical, easily assembled parts. Whole stores could be built of prefabricated cast iron panels and sheets of glass in as short a time as two months, as James Bogardus demonstrated in the Laing stores, New York, in 1849. Although cast iron and wrought iron members had been used for some time, by Strickland for columns and by John Haviland for the façade of the Miners' Bank in Pottsville, Pennsylvania, 1829–30, what Bogardus did in the late 1840s was to systematize mass production, enabling him to fabricate whole buildings, including both exterior shell and interior framing, and ship them around the world where the parts could be bolted together. Besides the Laing stores and his own offices in New York, Bogardus also manufactured the frame for the Harper brothers' building, New York, 1854 (Fig. 109). Bogardus, like most iron manufacturers, was not a designer, nor was his contemporary Daniel Badger, also of New York, who cast the members of the Haughwout Building, New York, 1857, a department store designed by John P. Gaynor (Fig. 110). Gaynor used a simple bay unit of Corinthian columns framing an arcade repeated throughout the building except on the ground floor where a simpler treatment permitted larger show windows. The Renais-

sance style, whether relatively restrained, as here, or even more highly elaborated, lent itself readily to iron construction since the repetition of arcades satisfied mass production economics, and the sharp details were easily cast. Though only five stories high, the Haugwaut store presaged important developments for American commercial architecture, for in it was installed the first practical steam-driven passenger elevator. Thus the Haugwaut store contained in embryonic form all the necessary elements of the skyscraper: metal frame, glass walls, and the elevator.

Analogous technical changes were to change domestic construction radically as well. Mass production of machine-cut lumber introduced the standardized stud, the 2 by 4 which could be quickly assembled into frames using cheap wire-cut nails instead of the more expensive hand-forged spikes. Thus freed of the complicated joinery of the traditional heavy timber frame, a mechanic of the mid-century, using a handbook, could assemble a house frame in a day. Such houses were said to have "balloon frames" because of the speed with which they went up. Traditionally St. Mary's Church in Chicago, built in the summer of 1833 by Augustine D. Taylor, is credited with being the first balloon-framed structure. It is certain that, without the balloon frame, Chicago could not have experienced the phenomenal growth it underwent in that decade. Thereafter use of the balloon frame spread quickly. In 1855 Gervase Wheeler published *Homes for the People in Suburb and Country*, showing construction details of the frame, followed three years later by William E. Bell's *Carpentry Made Easy* with its

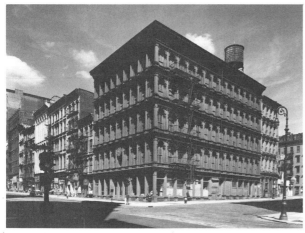

110. John P. Gaynor, architect; Daniel Badger, manufacturer, Haughwout Building, New York, New York, 1857.

straightforward diagrams (Fig. 111). Through the continued re-editions of such manuals and handbooks, the balloon frame almost completely replaced the hewn frame for domestic construction by the time of the Civil War.

The net effect of this growing industrialization was to bring "good" building within the reach of greater numbers of people. There was one other development which had a similar aim; had it been similarly industrialized it too might have had a profound effect—this was the octagon mode. Buildings with hexagonal or octagonal shapes had been built in the United States since the eighteenth century. Jefferson had favored this form, and Dr. William Thornton had designed "The Octagon" to fit one of the angled corners in L'Enfant's Washington. In 1844 Joseph Goodrich built a hexagonal house for himself in Milton, Wisconsin, but for the walls he used a rudimentary form of poured concrete. This came to the attention of lecturer and phrenologist Orson Squire Fowler and so impressed him that he built an octagonal concrete house for himself in Fishkill, New York, in 1848–53 (Fig. 112) and thereafter devoted himself to proselytizing for what he believed to be the home of the future. The octagon was a most efficient form and the materials for concrete could be found everywhere. In 1848 he also published *A Home for All: or, The Gravel Wall and Octagon Mode of Building* which was successful enough to warrant a new edition every year thereafter through 1857. Octagons began to appear throughout the country, in San Francisco, Maine, Vermont, upstate New York, and particularly in Wisconsin where the John Richards house was built in Watertown in 1854–56. Most used the geometric form but fewer employed concrete since the binding cement was still expensive. The grandest octagon of them all was "Longwood" designed by architect Samuel Sloan of Philadelphia for Dr. Haller Nutt of Natchez, Mississippi. Begun in 1861 and left unfinished at the start of the Civil War, it was three full stories high, surmounted by a central tower carrying a bulbous onion dome. Even if Fowler's octagon mode proved to be only a fad, his advocacy of concrete was prophetic and a number of architects began to use the material for foundation work. In 1864, just eleven years after Fowler's house was finished, Peter B. Wight used concrete for the foundations of Street Hall, erected to house the newly organized art department at Yale University.

Meanwhile, industrial and economic growth was beginning to change the face of the American city; commercial buildings pushed ever higher as the most valuable land in the city centers became built up and as the introduction of the passenger elevator

111. William E. Bell, *Carpentry Made Easy,* plate 6, 1858, showing balloon frame construction.

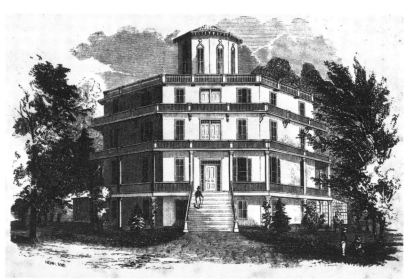

112. Orson Squire Fowler house, Fishkill, New York, 1848.

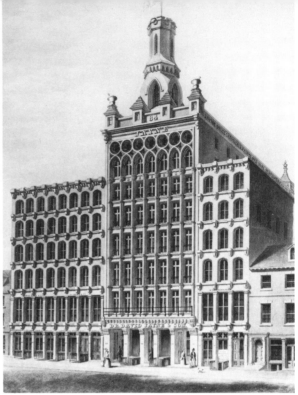

113. William Johnston and Thomas Ustick Walter,
Jayne Building, Philadelphia, Pennsylvania,
1849–51.

made increasing height practical. An early instance in organizing
the exterior of such a tall commercial building was the Jayne
Building, Philadelphia, designed by William Johnston in 1849 and
finished by Thomas Ustick Walter (Fig. 113). Particularly impor-
tant was the skeletonized granite frame of the seven-story façade,
for it was expressed not as separate floors stacked one atop the
other, with strong horizontals separating each floor, but rather as
continuous verticals, with details based on Venetian Gothic sour-
ces. Here appeared the tripartite formula later developed by Sulli-
van and Burnham; the building is divided into functionally and
visually significant parts consisting of base with its stout piers,
midsection with its shaft of closely spaced piers, and top with its
interlaced Venetian arches and cornice.

Gothic verticality may have been one way of handling extremely
tall buildings, but there is a drawing by A. J. Davis, showing that
classical forms had potential for commercial buildings as well.
This is a project of about 1860 for an exchange (Fig. 114). The
elevation shows a building of five tall stories, counting the shops

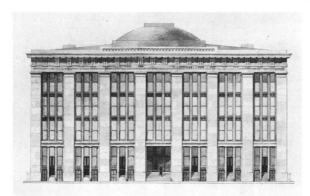

114. Alexander Jackson Davis, project for a Commercial Exchange, c. 1860?

in the depressed English basement. The structural scheme consists of eight tall piers carrying a proportionately large Doric entablature, all of this in masonry. The wall between the piers is divided into large windows held in frames so thin that they must have been conceived in iron. What Davis designed was in effect a curtain wall between the piers. He too has a tripartite arrangement with the articulated base at the ground floor, midsection of repeated floors, and terminating entablature with cornice.

The period from 1820 to 1865 was one of great architectural activity and ingenuity, for during these years the transition was auspiciously begun from an agrarian to an industrialized nation. Scores of new architectural problems were confronted and solutions attempted—large hotels, prisons, stores, warehouses, railroad stations, courthouses, statehouses, even urban town houses. As this coincided with the outburst of American romanticism and its fascination with things rendered exotic by being distant in space or time, the buildings, both traditional types and new types, were cast in those forms whose emotional and historical associations enhanced their meanings. Certainly if the romantic architects could not find immediate original solutions to the flood of problems confronting them, they demonstrated no lack of imagination, nor any ignorance of the rich and varied history of man's building and art. Looking back over the history of architecture, they attempted to isolate ideograms, conventionalized images, that would bring a sense of familiarity and meaning into an increasingly complex world.

5.

Age of Enterprise: 1865–1885

Building activity slowed considerably after a depression in 1857 and did not fully resume until 1866. During the hiatus numerous changes had been effected in architectural theory, in the technology of building, and in architectural developments in Europe. Thus, when building resumed, there were significant differences between what was done around 1856 and what was deemed current and fashionable around 1866.

What distinguishes the period from 1865 to 1885 in particular is the boundless energy that pervaded all aspects of American culture. The general enthusiasm and the attitude that change was possible, desirable, and imminent were genuinely invigorating. Indeed, historian Howard Mumford Jones has called this era "The Age of Energy," and novelist Horatio Alger summed up the spirit of the period when he wrote in 1867, "There's always room at the top." In architecture there was a particular intensity of exploration of many new possibilities in structure and in various modes of building—public, commercial, religious, and domestic. This was also a period of most vigorous economic growth and exploitation; most of the great American fortunes were started in these twenty years. It was also a period that saw the final stages of the full democratization of industry and marketplace as manufactured goods were distributed to the far corners of the country. The mail order catalog and the mail order business with its networks of warehouses at the nodes of rail transportation are the symbols of this democracy in the marketplace. In business and government, *laissez-faire* and social Darwinist policies enjoyed an authority from 1865 through the rest of the century they were not to have afterward; as a result, material utilitarianism gained a solid grip on

the public mind, so that functional utility and income potential slowly came to be more important in a building than psychological or artistic considerations.

Because of the rapidly accelerating pace of technological change, colleges developed curricula concentrating on the sciences. The Massachusetts Institute of Technology, 1861, was the first to be opened, but was followed by several private institutions and by land grant colleges beginning in 1862. Many of the new engineering departments began to offer classes in architectural drafting, design, and structural methods (M.I.T. in 1868, the University of Illinois in 1870, Cornell in 1871, Syracuse University in 1873, the University of Pennsylvania in 1874, and Columbia University in 1881), and while this added to the professional position of the architect, for the remainder of the century his primary role was that of the artist rather than the engineer. By the 1880s many of the schools had appointed design instructors trained at the École des Beaux-Arts to assure that their pupils had sound compositional theory and classical design instruction.

The unbridled energy of the age, its confident enthusiasm, and brash parvenu taste resulted in an architecture that consciously attempted to be modern, vigorous, and more energetic than the previous expressions. The organization of plans became more attuned to specialized functional requirements, and the exteriors became increasingly intricate and overlaid—a roof line was never simple. Seldom in the United States has there been a profession or a clientele that better understood multiplicity of form. The variety of shapes and outlines was further enriched by a use of natural polychromy through contrasting building materials of different colors. At the same time, however, there was a growing divergence between public architecture and domestic architecture. Previously a Greek Revival house (Andalusia) and a Greek Revival bank (the Second National Bank) could appear to be interchangeable, but in the 1870s and 1880s they became two very different expressions.

Just as a utilitarianism fostering standardization emerged in business and industry, so too did a wish for common standards appear among architects during the 1870s. The Centennial of 1876 and the focus on the national heritage revealed anew to architects the order and restraint of Georgian-Federalist architecture. This interest in adapting colonial elements and returning to classical decorum first appeared in domestic architecture, especially in the design of country houses. It was the beginning of a widspread return to a classical idiom which came to full force after 1885.

During the two decades after the Civil War, public and private architecture alike were dominated by two major styles, one generically classical and the other generically Gothic. The classical mode was a consciously "modern" expression on the part of both architect and patron, based on contemporary work in Paris, specifically on the additions to the Louvre, 1852–57, done for Louis Napoleon by architects Visconti and Lefuel. In their attempt to integrate the new portions with the original sections of the Louvre, the architects devised a florid expression that was not merely a revival of French Baroque but a new style, hence the name now given it, "Second Empire Baroque," due to its popularity in the Paris of Napoleon III. Second Empire Baroque was rich in horizontal layering, division into dominant pavilions flanked by end pavilions, separate mansard roofs atop each section, and overlays of elaborate classical ornament and sculptural enrichment.

Since the Louvre functioned as government house, palace, art gallery, and museum, all at once, it became the prototype for specialized buildings with any of these functions in France, England, Germany, the United States, and elsewhere. Just prior to the Civil War a few houses with mansard roofs had been built by European-trained architects Lemoulnier and Lienau in Boston and New York. Detlef Lienau's Hart M. Shiff house, New York, 1850, was perhaps the first, followed by two buildings by James Renwick, his Charity Hospital on Blackwell's Island, New York, 1854–57, and the main building for Vassar College, Poughkeepsie, 1860. The real impact of Second Empire Baroque in the United States did not occur until after 1865. One reason for its wide popularity was that Alfred B. Mullett (1834–1890), supervising architect for the federal government, used it for the numerous governmental buildings he had erected across the country. One of the first was the State, War, and Navy Building (now the Executive Office Building), west of the White House, Washington, D.C., 1871–75 (Fig. 115). The repetitious detail, some cut by machine, is extremely sharp, partly because of the use of dense granite and partly because of the mechanized process. Due to mechanization Mullett was able to achieve an incredible profusion of column upon column and molding upon molding that makes Second Empire Baroque distinctive. In few other examples is multiplicity so well demonstrated. Post offices, like those in St. Louis or New York by Mullett, spread this style to every major city; other architects took it up as well so that it became the "official" style of civic and municipal buildings.

It was also used for railroad terminals, for example, Grand

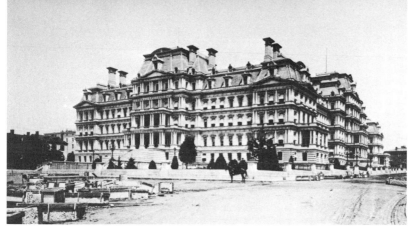

115. Alfred B. Mullett, State, War, and Navy Building (Executive Office Building), Washington, D.C., 1871–75.

Central Depot, New York, 1869–71, by Snook and Buckhout (Fig. 116). The building of this station for Cornelius Vanderbilt marked his amalgamation of several rail lines serving Michigan, New York, and the suburban traffic of New York and Connecticut. Though centralized, the service was strictly segregated on different tracks, and, as if to emphasize this, the architect of the head house, John B. Snook (1815–1901), kept each pavilion of the building isolated, requiring through-passengers to exit and reenter the station through another door to continue their journey. For this the compartmentalized Second Empire Baroque was well suited. Surviving photographs show the bulbous curved roofs and the polychromy of window frames contrasted with darker walls. Behind the elaborate head house was

116. John B. Snook, architect; Isaac Buckhout, engineer, Grand Central Depot, New York, New York, 1869–71.

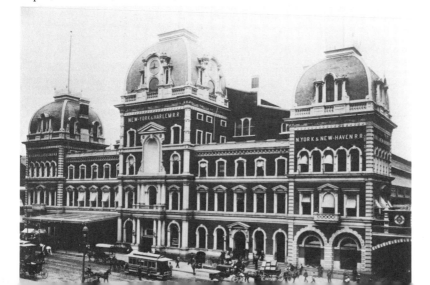

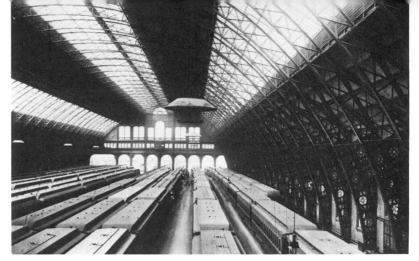

117. Isaac Buckhout, engineer, Grand Central Depot train shed.

one of the most outstanding American train sheds (Fig. 117). Designed by engineer Isaac Buckhout, it was a vast barrel-vaulted space six hundred feet long, roofed by arched iron trusses spanning two hundred feet, covering twelve tracks, carrying a light sheet iron and glass roof. Between head house and shed there was absolute dichotomy, for while the shed covered a large space with the simplest most economical and utilitarian means available, the terminal house spoke the language not of science but of symbolic aesthetics. Because it was meant to convey a "corporate" image there was no expense spared nor any effort to minimize material. There was evident here an impending split between architecture and structure, between symbolic ideogram and the skeletonized shed. Though architect and engineer were often trained in the same engineering schools, there soon developed a gulf between them that persisted for nearly a century.

Among the multitude of public buildings that employed Second Empire Baroque were a number of city halls, beginning with the Boston City Hall, 1862–65, by Bryant and Gilman. One splendidly elaborated example is the Philadelphia City Hall by John MacArthur (1823–1890), built 1871–1901 (Fig. 118). The building is in the form of a huge square with a large court at the center; rising from one of the sides is a tower of 548 feet. Placed in the centermost public square of Penn's plan, the building covers about fourteen acres. The great bulk is emphasized by the doubling or trebling of motifs, as in the paired columns in the pavilions, and the telescoped sections of the central pavilions with their multiple mansard roofs. Since the Louvre was part art museum, galleries too were designed in the Second Empire Baroque mode, and in this Renwick was first with his Corcoran Gallery, Washing-

ton, D.C., 1859, just as he had been among the first to imitate this mode for collegiate buildings at Vassar. For a time all new collegiate buildings were in this mode, and there was hardly a college or university that did not boast a mansarded "Old Main" or "University Hall," now inexplicably nearly all demolished.

Sharing dominance with the fanciful Baroque was High Victorian Gothic, derived from English sources. The major physical impetus came from the work of William Butterfield, especially his All Saints' Church, Margaret Street, London, 1849–59, significant for its unorthodox plan and the extremely rich polychromy of its brickwork and interior finishing. The theoretical basis was provided by John Ruskin in his books *The Seven Lamps of Architecture,* first edition 1849, and *The Stones of Venice,* first edition 1851–53. Ruskin stipulated seven conditions or "lamps" essential to great architecture: "Sacrifice" through the creation of extensive didactic ornament, "Truth" through the exclusion of sham construction in

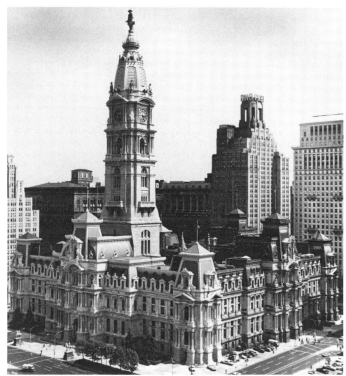

118. John MacArthur, Philadelphia City Hall, Philadelphia, Pennsylvania, 1871–1901.

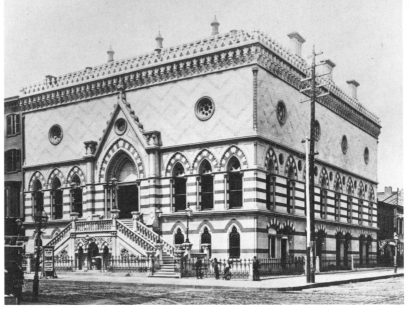

119. Peter Bonnett Wight, National Academy of Design, New York, New York, 1863–65.

favor of the expression of materials, "Power" through massing of forms, "Beauty" through observation of laws of nature, "Life" through expression of complex human activity, "Memory" through building for posterity, and "Obedience" through adherence to various Gothic styles which manifested all the preceding six characteristics. All of these injunctions were studied by American architects and architectural enthusiasts and taken very much to heart; to a large extent they influenced subsequent architecture, whether Gothic-inspired or classically derived, up to the present, though the first, sixth, and seventh lamps now flicker dimly if at all. In his book on Venice Ruskin argued that of all the Gothic forms, Venetian had the most to offer to the nineteenth century. He also argued that Gothic was good because Gothic workmen had been both Christians and contented workmen, building with their hearts as well as with their hands. Their work gave them pleasure and so it was done beautifully. Ruskin, along with the examples of Butterfield's work, helped to establish a free Gothic, elaborately composed and stridently polychromatic, as a strong counterpart to Second Empire.

One of the first buildings in the United States to take up the cause of Ruskin's High Victorian Gothic was the National Academy of Design, New York, by Peter Bonnett Wight, designed in 1861 and built 1863–65 (Fig. 119). It was a small but literal interpretation of Ruskin's theory, for it was a virtual copy of portions of the Palace of the Doges, Venice. The polychromy was

particularly vivid. Wight followed this with the simple but colorful Mercantile Library in Brooklyn, 1867, which is a good example of Ruskinian Gothic. The various buildings which Wight did alone or in collaboration with his partner Russell Sturgis have almost all disappeared except for his Street Hall at Yale University, 1864–66, and Sturgis's Battell Chapel, 1874–76, and adjoining dormitories at Yale which show a severe, simplified, and functionally composed Gothic. In their later years both men individually curtailed active practice, turning toward criticism and writing. Both exerted great influence on the development of modern architecture though they always remained in the background. In this they represented the best of the Ruskinian tradition.

One of the most resplendent High Victorian Gothic buildings in America is Memorial Hall, Harvard University, Cambridge, Massachusetts, by Ware and Van Brunt, 1870–78 (Fig. 120), built as a memorial to Harvard graduates who had died in the Civil War. Its external appearance is that of a church but actually the exterior clearly reflects interior functions. To the west is a large rectangular hall for dining, assemblies, and other large functions, in the center the memorial hall capped by a tall tower, and to the east a large semicircular auditorium which has the appearance of an apse. Inside and out the various materials are openly expressed: the dark wooden members of the large roof trusses, dark-stained

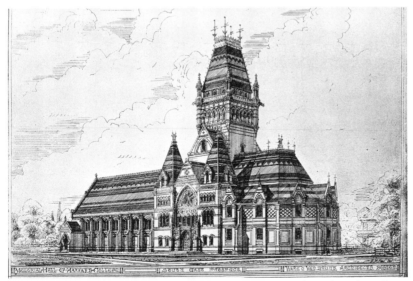

120. Ware & Van Brunt, Memorial Hall, Harvard University, Cambridge, Massachusetts, 1870–78.

wood paneling and interior trim, bright red brick with horizontal courses of black brick at salient levels, bands of light stone, alternated voussoirs of dark and light stone in the pointed arches, and bands of red, green, gray, and black slate which pattern the huge flat roof surfaces into small visual units. Today Memorial Hall lacks the steeple which was an integral part of the tower. Rising high above the square base was a tall truncated pyramid, bristling with crockets and finials, with gables on each side containing large circular clock faces. The flattened top terminated in an elaborate metal filigree cresting, with tall metal masts at each corner. As this and the various buildings at Yale by Wight and Sturgis indicate, High Victorian Gothic was eminently adaptable to collegiate structures, especially since it carried on the earlier Gothic tradition of the 1840s. Like Second Empire Baroque, it was adaptable to and expressive of a wide variety of uses. A good, even classic example of High Victorian Gothic is the Syracuse Savings Bank, Syracuse, New York, 1876 (Fig. 121), by James Lyman Silsbee who a few years later resettled in Chicago. It is colorful but not strident, tall and vigorous without being splintered into over-assertive details, bold and sharp. Hundreds of churches were also built during this period. One of the best, because of its vigorous massing and the polychromy of its stone and slate-work, is the new Old South Church, on Copley Square, Boston, by Cummings and Sears, 1874–75.

121. James Lyman Silsbee, Syracuse Savings Bank, Syracuse, New York, 1876.

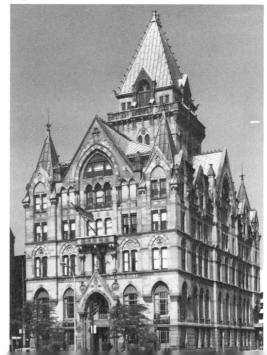

Unique to this volatile period was Frank Furness of Philadel-phia (1839–1912), who might be termed a High Victorian Gothic architect were it not for the fact that his mature work follows no canonical style but is the product of a vigorous imagination com-bined with a profound understanding of the physical and psycho-logical functions of architecture. In part this discipline was learned from Richard Morris Hunt (1827–1895) with whom Furness studied from 1859 to 1861. Hunt's atelier or studio in New York was the first of its kind in the United States and offered systematic instruction in architecture; gathered there were Fur-ness, Henry Van Brunt, and George B. Post, among others, nearly all of whom were to play significant roles in their profes-sion during the next third of a century.

Hunt himself had spent nearly nine years at the École des Beaux-Arts, Paris, the first American to do so and one who stayed there longest; through him and the students of his atelier, the im-pact of mid-nineteenth century French rationalism on American architecture was felt. Among Hunt's early works which show a decidedly rational approach to design, the Lenox Library, New York, 1870–75, is gone, but the base of the Statue of Liberty, New York, 1881–86, remains. Although Hunt's palatial French châteaux for the Vanderbilts—such as the William Kissam Van-derbilt house in New York, 1879–81, and "Biltmore" in Asheville, North Carolina, 1890–95—are better known today, it was struc-tural clarity and bold geometrical ornamental enhancement of logical form as found in the Statue of Liberty base that influenced architects such as Furness.

The structural expression of bearing members, in the form of stout compressed columns and flattened segmental arches and their exaggeration by means of bold inventive geometric or-nament had been essayed in France about 1840 by such architects as Henri Labrouste and E.-E. Viollet-le-Duc, who called this ap-proach "néo-grec" because it attempted to follow the simple direct logic of the trabeated, bearing-wall construction of the Greeks.

It was such "néo-grec" structural expressionism, together with the strong influence of Viollet-le-Duc's writing, a firm conviction in the powerful visual role of architectural ornament derived from Ruskin, and a love of the complex contrasts of color and tex-ture of High Victorian Gothic that combined to make the amalgam of Frank Furness's architecture. His Academy of Fine Arts in Philadelphia, 1871–76, demonstrates all of this (Fig. 122). There is in the façade something of the symmetry and formal order of the pavilions of Second Empire Baroque, but the open-

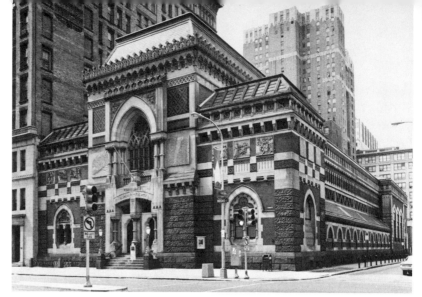

122. Frank Furness, Pennsylvania Academy of Fine Arts, Philadelphia, Pennsylvania, 1871–76.

ings employ pointed arches. There is a rich, even raw polychromy of red brick, brownstone, light limestone, and black brick. Some of the ornament, such as the tympanum panels in the arches, have foliate motifs of a highly stylized angular character, while other elements are sharp and geometrical, like machine parts. The polished columns, especially, look more like pistons than traditional supports.

Furness was especially adept at handling buildings whose functions resulted in irregular, asymmetrical exteriors. The Thomas Hockley house, on Twenty-first Street, Philadelphia, 1875–76, is a good example, with its recessed entrance at one corner played off against a projecting second story bay window on the opposite side. The National Bank of the Republic, Philadelphia, 1883–84 (demolished), was also a good small example, its narrow façade a collision of ramped and semicircular arches, various windows, and opposing roof lines, all jostling around an off-center turret. The much larger Library for the University of Pennsylvania, 1888–91, clearly reflects in its dissimilar forms the functional areas within, all of this heightened by acid-red brick and matching terra cotta trim boldly overscaled. Other of Furness's buildings were more balanced and symmetrical in composition, such as the equally boldly scaled Guarantee Trust and Safe Deposit Company, Philadelphia, 1873–75 (demolished), which somewhat resembled the Academy in character except that it had two projecting pavilions flanking the entrance. Another compact bank which typified Furness's work was the Provident Life and Trust Company, Philadelphia, 1876–79 (demolished, Fig. 123). In this the sharp angularity

of the Academy was further emphasized, the foliate ornament further abstracted, and the supporting columns even more compressed. The plans of these buildings were carefully studied, and interior finishing had the same geometric and boldly overscaled quality, but it was the exteriors with their compressed, interpenetrating elements that spoke to later generations of architects of tough creative power.

An interesting parallel to Furness's hard rationalism can be found in the work of English architect Charles Locke Eastlake and in the design principles he advanced in *Hints on Household Taste,* first published in London in 1868 and then in an even more popular American edition in 1872. Eastlake decried the heavy bloated mid-century furniture, providing designs of lighter pieces fashioned of straight wooden members, often somewhat mechanical in appearance, with scroll-sawn decoration and relatively delicate incised linear ornamental motifs. Eastlake's plea for the expression of the natural color and texture of materials and for form following function is a direct counterpart to what theorists and architects were attempting at this time, and, in fact, some architects and builders enlarged Eastlake's lathe-turned spindles, straight

123. Frank Furness, Provident Life and Trust Company, Philadelphia, Pennsylvania, 1876–79.

flat structural members, and engraved ornament to true architectural scale and an Eastlake variant of domestic design was created.

In the writing of Ruskin there is a strong current of morality, and it is significant that in the years following the Civil War, the years of the "Robber Barons," there emerged a distinct interest in building good housing for workers and wage earners. In New England, especially, a number of industrial villages were either started on new ground or older towns were enlarged. Hopedale, Massachusetts, having collapsed as a Socialist commune, was purchased by the Draper Company, and by 1856 a loom-manufacturing business was established there. During the 1870s a number of row houses were put up by the company for skilled workers, but a decade later duplexes were being built. In other company towns duplexes or single family houses (instead of the previously favored row houses) were built between 1865 and 1870; important housing was built at Cumberland Mills, Maine, by the S. D. Warren Company, "Oakgrove" at Willimantic, Connecticut, by the Willimantic Linen Company (Fig. 124), and at Ludlow, Massachusetts, by the Ludlow Manufacturing Company. This shift away from tenement blocks and row houses common earlier in the century reflects the efforts of industry to satisfy the desires of employees who wanted individual homes. Although the various housing groups were built to provide some income for the company, the principal purpose was to induce skilled labor to stay put,

124. "Oakgrove," workers' housing, Willimantic Linen Company, Willimantic, Connecticut, 1865.

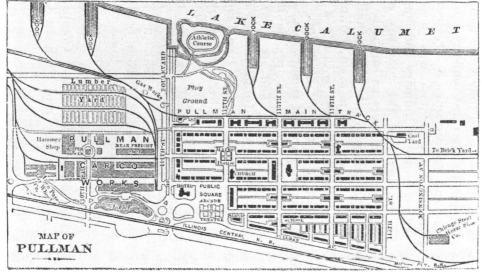

125. Solon S. Beman and Nathan F. Barrett, Pullman (now part of Chicago), Illinois, 1879–80 to 1895.

to reduce the transience in the skilled work force; hence attention was given to good design, sound construction, and to the provision of extensive utilities. In general the workers' housing reflected current vernacular building practices rather than avant garde experiments, and as a rule it was not designed by noted architects before about 1885. Rents were kept relatively low and profits to the company were small; workers customarily paid less than 15 percent of their wages for rent in these better housing developments, and the companies realized $2^{1}/_{2}$ to $3^{1}/_{2}$ percent on their investments.

Certainly the best known company-built town of this period is Pullman, twelve miles south of Chicago on Lake Calumet. There, in 1879–80, at a strategic junction of rail and water transport, George M. Pullman had built new shops in which were assembled his famous palatial railroad sleeping cars. In addition to this, however, Pullman built an entire city for the workers in his plants, providing housing, parks, recreational space, shopping and worship facilities, and cultural amenities such as a library and music hall. A firm believer in the civilizing effect of beauty, Pullman engaged landscape architect Nathan F. Barrett and architect Solon S. Beman to design the entire complex (Fig. 125). Work started on the town early in 1880, and by 1884 it was nearly complete; its population then was 8,500 and by 1893 had grown to 12,600. The factories were on the north side of town, above

111th Street, the dividing line between shops and housing. Immediately to the south of 111th Street was a large hotel for visitors. Next to this was a small park which was fronted on the west by the Arcade, a multi-use building containing various shops, offices, the library, and the music hall. South of this were the town stable and the Methodist Church. Farther to the east, roughly in the center of the residential area as initially built, was the Market House where meat and produce were sold, much of it raised on farms south of the town which received treated sewage from the town as fertilizer. The row houses offered a variety of plans and façade designs, and the units were separated at intervals so as to mitigate the spread of contagious diseases and fire. For permanence and reduced maintenance, Pullman stipulated that all buildings be made of brick.

Since the town was begun as a speculative venture, Pullman owned everything and rented space both to shopkeepers in the Arcade and to workers in the row houses. He even attempted to rent the church to the congregation, but, as the rent was too high, the building often stood empty. Similarly, to prevent indolence and disruption Pullman allowed no taverns in his town. Much of what later troubled the town grew out of this well-intentioned paternalism, for workers had no say whatever in running the town. During the depression of the mid-1880s rents were reduced in several eastern textile mill towns to match cuts in wages, but in 1893 when Pullman was forced to reduce wages he retained rents at their inordinately high level. Workers' protestations went unheeded; the workers went on strike; the strike was joined by railroad workers, bringing movement of the mail to a halt. This, in turn, led to the intervention of federal troops at the order of President Cleveland, and the Pullman riot ensued, bringing with it the stigma which soon attached to every company town. The bloodshed and the invective of the riot clouded the significant achievements of G. M. Pullman and his designers, for as a planned town Pullman was well designed; it was a self-generating community, containing industrial, commercial, and residential facilities, and all the basic attendant services; what it lacked was self-government.

While this concern for good housing was becoming more evident in remote industrial locations, a similar concern for good economically productive housing was arising in the cities, most notably in New York where the problem was particularly acute. Though sincere concern over poor living conditions in the increasingly crowded New York slums had first been voiced in 1834, no steps were taken to alleviate unhealthy conditions. Even caustic

essays such as Walt Whitman's "Wicked Architecture," in *Life Illustrated* in July 1856, with its sharp indictment of tenement slums, spurred little action. In 1876, however, Alfred T. White formed a company to undertake the construction and management of model tenements which would provide open space and sanitary conditions. The first unit built, the "Home Building" on Hicks Street, Brooklyn, was erected in 1877 from designs by William Field and Sons. In 1884 this was followed by the "Tower Apartments" on adjacent Baltic Street. The last and largest were the "Riverside Apartments," 1890 (Fig. 126). Also designed by William Field and Sons, they covered a full block along Hicks Street between Baltic and Warren streets. Behind the U-shaped block of apartments was an enclosed park with play lots for children and a garden for older residents. Though there had been earlier similar ventures by philanthropists and municipal authorities in England and on the Continent, this was one of the earliest efforts toward good "public housing" in the United States. White's experiment, though inspired by social concern, was nevertheless a capitalist venture intended to return a profit to its investors. Always well maintained and well occupied, the Home, Tower, and Riverside Apartments repaid from 5 to 7$\frac{1}{2}$ percent from the beginning, indicating that such housing, when well designed and maintained, was not necessarily a drain on the communal purse.

Spurred by the example of Alfred White's Improved Dwellings Company, investors formed other companies and the city and state legislatures began to give serious attention to the slum prob-

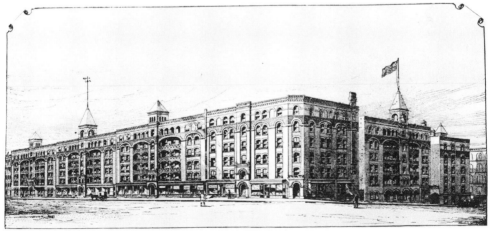

126a. William Field and Sons, "Riverside Apartments" for Alfred T. White and The Improved Dwellings Company, Brooklyn, N.Y., 1890.

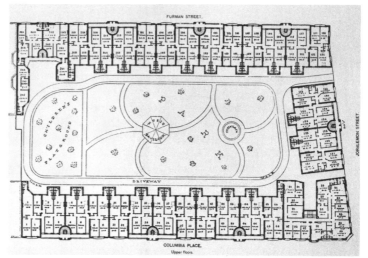

126b. "Riverside Apartments," plan.

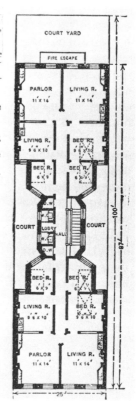

127. James E. Ware, "Dumbbell. Apartment," proposal, 1878.

lem. In December, 1878, the *Sanitary Engineer* announced a competition for the best tenement house design, and out of the 206 entries submitted from across the United States and Europe, the prize was awarded to James E. Ware for his "dumbbell apartment" (Fig. 127), so called because its pinched center provided light and air which even in their limited quantities were luxuries virtually unknown in older tenements. As a result of this public attention to the problem, a number of amendments to the existing Tenement House Law were passed in 1887 in the New York legislature, and in 1895 a new law was enacted. This in turn led to the creation of the City and Suburban Homes Company the following year and another competition for a model tenement apartment based now on the new housing law. This was won by Ernest Flagg and his design was used for the construction of a model tenement at Sixty-eighth Street and Amsterdam Avenue. Following this in 1898–99 another committee was formed which drafted a series of further housing reform ordinances and, in 1900, sponsored an influential Tenement House Exhibition. Its members included Robert W. DeForest, Ernest Flagg, Richard Watson Gilder, George B. Post, and Jacob A. Riis. Following the exhibition another new committee, headed by DeForest, was formed and its efforts led to the passage of a new sweeping tenement house law in 1901; it was the most advanced and well enforced housing legislation in the country.

These later developments fall well past 1885, but it is pertinent to mention them at this point so that the extended influence of Alfred White's model tenements can be gauged. It might appear from this that the whole of New York was transformed by the chain of events set off by the Home, Tower, and Riverside tenements, when in fact the few model apartments built represent a fraction of new construction; moreover, all the old, windowless, unheated, overcrowded buildings remained. Nevertheless, despite the limited initial effect, the work of Alfred T. White and the humanitarian concern it manifested served as an inspiration to several generations of later social humanitarians.

Social concern lay at the very heart of the work of Frederick Law Olmsted. In the 1850s at a time when the country was largely rural, Olmsted had foreseen the relentless development of urban America and the need to develop and preserve areas of natural scenery as a foil to urban density. Yet Olmsted was not a preservationist in the narrow sense of the word; rather he saw husbandry of the natural environment as a corollary and antidote to industrial growth. Olmsted was born in Hartford, Connecticut, and

128a. "Greensward" plan of 1857.

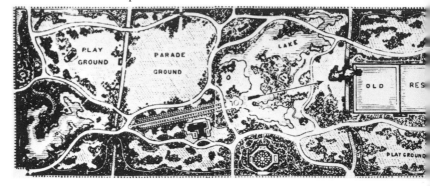

128b. Revised plan of extended park, 1870.

because of illness as a child had a rather intermittent formal education. For a time he studied engineering and surveying, and he attended some lectures at Yale University. His father helped him establish a model farm on Staten Island on which he experimented, learning much that later helped make his parks practical realities. He toured England to study agricultural methods there and inspected Sir Joseph Paxton's Birkenhead Park where he saw open landscaped spaces as part of an urban fabric.

During this same period New York was growing rapidly, and among its more concerned observers, such as the poet William Cullen Bryant, there arose the fear that development would eventually cover the entire island of Manhattan, that piers would line its shores from tip to tip, leaving no open space for its citizens and providing no ready means for workers and their families to reach the outlying countryside. Access to nature was vital to Bryant; for as he had already written in his "Inscription for the Entrance to a Wood" in 1821, the salve for the city's "sorrows, crimes, and cares" could only be found in "the haunts of nature" where the sweet breeze "shall waft a balm to thy sick heart." There was no

128. Frederick Law Olmsted with Calvert Vaux, Central Park, New York, New York, 1857–c.1880.

time to lose in saving what little was left of Manhattan's scenery.

With support from the state legislature, a vast tract was purchased running through the center of the island, and in 1857 a competition was held for designs for developing the land. The plan submitted under the code name "Greensward" was adjudged the winner; it was the entry of Olmsted and his partner Calvert Vaux, an English architect and landscape designer who had originally come to the United States as Downing's prospective partner. Olmsted recognized that eventually the city would surround the park and that circulation between the east side and west side was vital. Consequently, at intervals he placed major crosstown streets running through the park, but depressed below park level so that the heavy traffic would not endanger movement above. Separate paths for carriage drives and pedestrian walkways wound through the park, passing over the crosstown streets on viaducts so that all levels of traffic were kept separate. The true beauty of the park lies in the ordered irregularity of its terrain and its planting (Fig. 128). Where the land was low, Olmsted depressed it still more, installing drainage tiles and creating ponds and low meadows. Natu-

ral outcroppings of schist were emphasized; clumps of trees were planted to contrast with broad meadows. Bisecting the park strip were the Croton aqueduct reservoirs holding the city's water supply. Using this as a dividing element, Olmsted laid out the southern half as a highly developed area, adapted to groups of people and sports activities, while the northern half was developed more as a nature preserve. The success of the park was immediate, and soon led to the design of Prospect Park, 1865–88, in Brooklyn, in which Olmsted and Vaux were able to improve on their work in Central Park. After the war Olmsted was engaged to design more than thirty urban parks outside New York and several more within the city, and these alone would have assured his reputation, but he was equally busy designing the grounds of numerous public buildings, planning campuses, small communities, and estates, and campaigning for conservation areas and national parks beginning with Yosemite Valley in 1864. He began to urge the preservation of the area around Niagara Falls in 1869 at a time when it was just beginning to be despoiled as an industrial slum and tourist trap. Finally in 1880, through Olmsted's unrelenting efforts, the state of New York and the Dominion of Canada purchased large tracts of land above the falls and the islands in the rapids, restoring indigenous plant materials to portions of the preserve that had been stripped for paper mills and other factories. Olmsted's most extensive undertaking was also among his last, for in and around metropolitan Boston Olmsted designed a ring of interconnected parks and landscaped boulevards; completed in 1895, this was an early example of regional planning.

Perhaps with the exception of Central and Prospect Parks, the most prophetic of the designs by Olmsted and Vaux was Riverside, Illinois, planned in 1868 for a group of eastern developers (Fig. 129). The site was a relatively flat area of about seventeen hundred acres lying athwart the Des Plaines River about seven miles southwest of Chicago and connected to the city by the Burlington Railroad; here Olmsted and Vaux planned a romantic landscaped suburban village. Olmsted sketched out a curvilinear web of streets, generally following the slight topographical features, subtly depressing the hard-paved streets so they did not intrude into the landscaped views. Centermost in his thoughts was the preservation of the shores of the river. A low dam was created to raise the level slightly so as to allow greater recreational use, but no lots were laid out at water's edge—the river frontage was turned into a communal park strip. This, plus the boulevard strips and small parks scattered throughout the town, account for

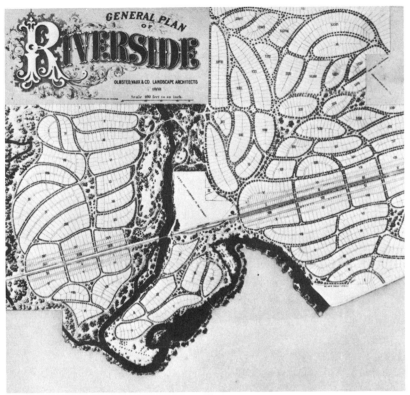

129. Olmsted & Vaux, Plan of Riverside, Illinois, 1868.

about one quarter of the village's land area. Except for the small
blank area shown in the plan, Riverside was laid out as Olmsted
planned it, and development continued according to his pro-
posals. Trees were planted along the parkways, and homeowners
were obliged to keep at least two living trees on the property be-
tween their houses and the sidewalks. Houses, spaced on wide
lots, were set far back along uniform lines. Time has been gentle
with Riverside; it survives virtually intact. Periodic replacement of
the houses has changed the appearance little, and some of the
original buildings by Vaux remain, sheltered under the dense
umbrella of trees which makes this an oasis in the sprawl engulf-
ing it.

Compare the plan of Riverside, with its varied paths, open
spaces, and surprises, with a view of Chicago in 1892 (Fig. 130).
Here is the dense, endless checkerboard which Olmsted's ameni-
ties sought to counteract. Shown in this Currier and Ives print is a
city that twenty-one years earlier had suffered a fire which de-

130. Aerial view of Chicago; lithograph by Currier & Ives, c. 1892.

stroyed nearly the entire foreground area. Not a trace of this destruction remains in this view. While this may be due in some small measure to the artist's license, it accurately reflects the driving business enterprise which, in the pursuit of the ultimate dollar from every square foot, left little open space for recreational enjoyment. Where there had existed a superb opportunity to develop a lake-shore park, the land was sold in 1850 by the city to the Illinois Central Railroad for a token price. So the city lost the entire lake shore south of the mouth of the Chicago River. It was a shrewd business maneuver, for it ensured that Chicago would become a railroad center, and it meant the city would be spared the expense of building a breakwater (the railroad would now do it), but physically it impoverished the southern half of the city, leaving it with no access to the water. Chicago was not unique in this, for thousands of other cities did likewise, selling or giving away their natural legacies to encourage the railroads, economic lifelines, to lay track through their communities. The federal, state, and city governments groveled obsequiously before railroad interests, just as they had done forty and fifty years earlier before canal builders (and as they were to do again in another two generations to placate air transport and automobile interests). While this did indeed nourish industrial growth, the ecological and social costs could not even be imagined.

Domestic building was vigorous after the Civil War, particularly in such rapidly expanding cities as Chicago and in the fast developing suburbs around every major city. There was also a rash of pattern books for architect and builder, and by the mid-1870s the first successful professional journals had been established. Gervase Wheeler's *Homes for the People in Suburb and Country* had first appeared in 1855, and went through six editions by 1868, but this was surpassed by his *Rural Homes* which came out in 1851 and went through nine editions by 1868. In 1857 Calvert Vaux published *Villas and Cottages,* and this was brought out in five more editions up to 1874. Henry Hudson Holly published *Holly's Country Seats* in 1863 and *Modern Dwellings in Town and Country* in 1878. George E. Woodward was especially prolific, publishing nine separate titles, of which *Woodward's Country Homes,* 1865, and *Woodward's National Architect,* 1868, were the most popular, enjoying repeated new editions through the 1870s (Fig. 131). A. J. Bicknell also produced a small library of building manuals (at least ten titles from 1870 to 1886), as did architects Palliser and Palliser (twelve titles from 1876 through 1883).

Essays on architecture had appeared in *The North American Re-*

131. From George E. Woodward, *Woodward's National Architect*, plate 22, 1868.

view since the 1840s, and *Harper's Magazine* (started in 1850) also carried articles on architecture, many of which were illustrated with wood engravings. These succeeded because they were aimed at a broad general readership, but the first professional architectural journals were very short-lived. *Sloan's Architectural Review & Builder's Journal* lasted only three years, 1868–70, but *The American Builder & Journal of Art,* which started the same year, lasted twenty-eight years until 1895, an uncommonly long time. The more prestigious *New York Sketch Book of Architecture* also lasted only three years, 1874–76, but the *American Architect and Building News,* which started in 1876, prospered until 1938 when it finally ceased publication. As a consequence of all this publication the contractor-builder, in the plethora of books, and the professional architect, in the journals, had a wealth of information presented to them.

The house shown in Fig. 131 is typical of the type popularized by G. E. Woodward and his contemporaries, though this example is somewhat restrained in its ornamentation. Other houses, most often those designed by architects for clients with greater means, were more elaborate, and good examples once existed in such suburbs as Brookline outside Boston or Orange, New Jersey, outside of New York City. An example which is relatively small and subdued is one of the several houses designed by J. Lyman Silsbee for developer John L. Cochran and built during 1886–87 in the new suburb of Edgewater about seven and a half miles north of

the center of Chicago on the shore of Lake Michigan (Fig. 132). This little house typifies the kind of Shingle Style which Silsbee brought to Chicago. There seems to be little argument that the most elaborate of all the houses of the period was the William M. Carson house in Eureka, California, built after designs by Samuel and Joseph Newsom in 1884–85 (Fig. 133). The Newsoms drew up highly elaborate designs in general, but the Carson house may have been especially full of detail since, it is said, the house was built by Carson, a lumber producer, to keep his employees busy during the business recession of the mid-1880s.

These houses could be generous in scale not only because of a change in clients' aspirations but also because of advances in heating which had been accumulating since the early part of the century. The important step had been to take Franklin's stove, wrap it in a metal or masonry shell, and conduct the air heated around the stove within this shell to the rooms where it was needed. This appears to have been done in Connecticut during the 1840s, when gravity alone moved the heated air by convection, but by 1860 large fans powered by steam or gas had been added to bulky heating systems to create forced air heating. In the home various gravity systems had begun to be used, and in their epochal book, *The American Woman's Home* of 1869, Catherine E. Beecher and Harriet Beecher Stowe provided plans for an efficient model home in which a warm air furnace in the basement was augmented by small Franklin stoves in each room. Moreover, all plumbing, ductwork, chimney, and stairs were confined to a compact central service core, so that the rooms could be highly adapted to use by means of built-in furniture. The only step that remained was the development of a small power source to run fans to make modern forced air heating possible, and this was accomplished first by Edison with his distribution system for direct current electricity and the direct current motor he developed in 1882 and the even more successful alternating current motor developed by Nikola Tesla in 1888 and in wide use by 1897–1900.

The largest and most innovative of the free-standing private houses were built in the summer social capitals, first in Long Branch and adjacent Elberon, New Jersey, during the early 1870s, and then in Newport, Rhode Island, which began to attract the New York and Boston elite and gained ascendancy as *the* place of summer residence by the close of the 1870s. The clients were the wealthiest and least restrained by building conventions and the architects they engaged the most eminent and inventive. Feigning simplicity, the millionaires called their summer mansions "cottages." Although millions of dollars were expended on houses oc-

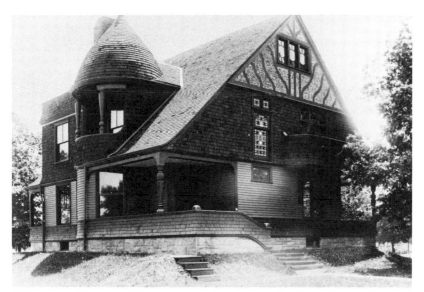

132. James Lyman Silsbee, speculative house for John L. Cochran in Edgewater (now part of Chicago), Illinois, 1886–87.

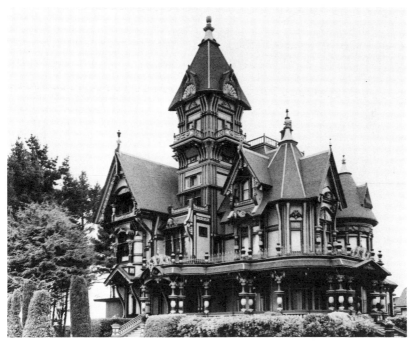

133. Samuel and Joseph Newsom, William M. Carson house, Eureka, California, 1884–85.

cupied only two or three months of the year (and hence, often not equipped with central heating), the freedom given to the architects allowed them to experiment with new methods of plan organization, coordination of masses, and spatial configuration which were later to be taken up by other architects across the country. Silsbee's little house in Edgewater is a good example of the rapid dissemination of the innovations worked out in Newport. Thus, within twenty-five years, by the turn of the century, the form and function of the American home were fundamentally reshaped.

For the most part these fashionable architects of the 1870s and 1880s were concerned not with explicit expression of genuine structure on the exterior, but rather with the organization of the plan to provide large spaces well disposed for the informal, relaxed atmosphere of the suburb or the resort. The result was highly irregular plans, discontinuous asymmetrically massed forms, and the manipulation of surfaces with varied textures. Roofs were high and punctured by many variously shaped dormers, revealing a debt to High Victorian Gothic. Most striking was the treatment of the exterior wall surfaces and the gable ends of the roofs where the architects delighted in breaking up the surface with a basketry of straight stick-like members.

To some extent this exploitation of stick-work came from Downing and also from Upjohn's rural churches such as St. Luke's, but the earliest fully developed expression of the Stick Style, as Vincent Scully has called it, appeared in summer houses by Richard Morris Hunt. His J. N. A. Griswold house, Newport,

134. Richard Morris Hunt, J. N. A. Griswold house, Newport, Rhode Island, 1862.

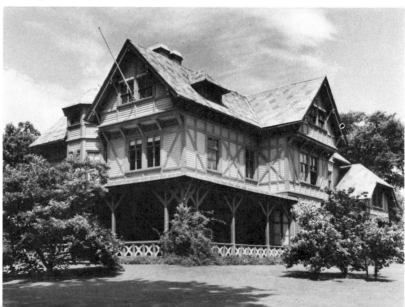

Rhode Island, of 1862 (Fig. 134), is a good illustration of this new type. The house has a rambling asymmetrical shape whose density is partially neutralized by the encircling porch. The relatively steep roofs and projecting gable ends convey a quasi-medieval flavor; so too does the complex frame of sticks which resembles half-timbering. Here, however, it serves to divide the wall surfaces into discreet panels, making the house more visually and structurally comprehensible. So, in a fashion, the Stick Style attempts rationality, reflecting one of its sources in Viollet-le-Duc's drawings of medieval French carpentry. Nevertheless, there is no attempt at strict historicism, and the panels are filled with clapboards in the local tradition. Also indigenous is the expansive porch, where the large knee braces of the frame epitomize the structural expressionism of the Stick Style.

More typical of the Stick Style of the 1870s is the Jacob Cram house, Middletown, Rhode Island, of 1872, attributed to Dudley Newton (Fig. 135). In plan and in appearance the house is a study of discontinuous elements held together by the strongly expressed frame. The plan consists of various parlors and chambers arranged loosely around a pivotal center hall containing the main staircase. On three sides this accumulation of rooms is surrounded by a continuous veranda. Heightening this multiplicity, the roof erupts into a variety of dormers, each with its own roof shape. Everywhere the frame is exploited—in the exposed supports of the porch, in the clapboard-paneled wall, and especially in the attic gable where the roof is pushed out to reveal a truss.

135. Dudley Newton (attributed). Jacob Cram house, Middletown, Rhode Island, 1872.

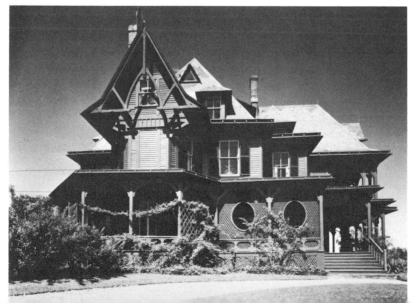

The architects of the period spoke of assertive, masculine architecture, and the Jacob Cram house is a good example of what they meant. While visual attention may be captured by the eccentricities of the exterior, it is important to remember that the form is a reflection of internal functional arrangements.

Such houses, semi-isolated in rural or suburban settings, enjoyed their freedom. When McKim, Mead & White were engaged by James Gordon Bennett, Jr., to design the Newport Casino in 1879, however, they were confronted by a much different situation. Their building was to front on Bellevue Avenue in Newport, in the center of the small business area for the summer colony, next to the long Stick Style commercial Travers block by Hunt. On the inside McKim, Mead & White arranged the tennis courts, verandas, restaurant, club rooms, and clock tower of the Casino in a studied composition of great freedom and controlled irregularity. But on the Bellevue Avenue front (Fig. 136) they arranged the eight shops and upper level of offices in strict bilateral symmetry around the center entrance arch. Each shop front is subtly but separately expressed, and though there are slight projections in the second level and in the multiple gables in the attic, the dominant motif is horizontal continuity. Throughout the entire building the horizontal line is dominant, introducing a new theme in a period when architectural expression was still basically vertical in emphasis. The bilateral formality of the public street front also marked a new direction, and so too did the use of shingles for wall surfaces and roofs. By covering the frame with

136. McKim, Mead & White, Newport Casino, Newport, Rhode Island, 1879–80.

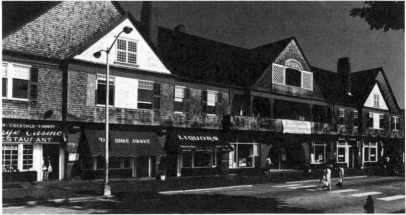

shingles, in figured bands, the horizontal continuity of the wall surfaces was further emphasized.

McKim, Mead & White's Newport Casino marked the beginning of a new phase in domestic architecture, the Shingle Style. This architectural firm, the largest of its time, was one of the leaders in developing this new expression; the other major proponent was Henry Hobson Richardson. His Stoughton house, Cambridge, Massachusetts, 1882–83, is one of the best of the entire period (Fig. 137). The plan is both free-flowing and restrained, with large rooms arranged in an L around a stair hall which protrudes at the corner in a swelling short tower. The porch, instead of standing free against the house, is formed in a recess carved out of the mass of the house so that the basic geometry is not weakened. As his former students, McKim and White, were beginning to do, so Richardson also emphasized the horizontals, but here the continuity of spaces inside and surfaces outside is much more pronounced. Large shingles cover the entire house, from the ridge all the way down to the outward-swelling water table where the house seems to hug the earth. Even at the corners where the flat walls abut the circular stair-tower, the shingles do not form a sharp corner but curve around from wall to tower. The wall surface seems to flow from part to part, concealing the frame but expressing its necessary presence. In its horizontal sweep and continuity, the Stoughton house is the antithesis of the Jacob Cram house of only ten years before.

137. Henry Hobson Richardson, M. F. Stoughton house, Cambridge, Massachusetts, 1882–83.

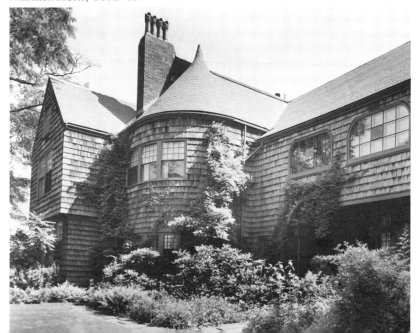

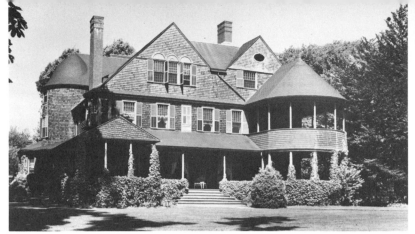

138. McKim, Mead & White, Isaac Bell house, Newport, Rhode Island, 1881–83.

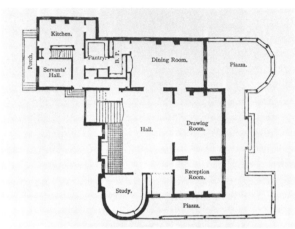

139. Isaac Bell house, plan.

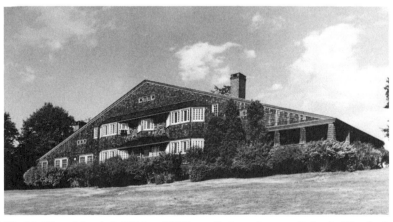

140. McKim, Mead & White, William G. Low house, Bristol, Rhode Island, 1886–87.

In the Isaac Bell house, Newport, of 1881–83, McKim, Mead & White show a more playful approach than Richardson's (Fig. 138). Where Richardson employed a more simple monumentality, McKim, Mead & White (here with White in charge as with the Casino) break up the exterior of the Bell house into separate but carefully coordinated shapes. Window openings are played off against one another, and the tower swelling out from one side is balanced by the two-story semicircular veranda protruding from the other. Everywhere, however, the swelling, shifting surface is of shingles. The first floor plan can almost be said to consist of one vast room, divided into various spaces around a huge central stair hall (Fig. 139). The door openings range from five to ten feet across and can be opened or closed by sliding doors. While the shingles and various minor decorative motifs are derived from colonial precedents (so much on the minds of architects following the Centennial), the plan and the manipulation of space through the use of sliding doors indicate the influence of Japanese architecture. On the porch this appears in the curious posts, lathe-turned to resemble bamboo. Seldom afterward were American architects able to make of such disparate influences so harmonious, playful, and integral an expression; in these Shingle Style houses one finds eclecticism at its best.

From the beginning, however, there was implicit in the Shingle Style a formality that was gradually to grow and reshape it from within. In this development, McKim, Mead & White were the leaders. While the Shingle Style had developed largely as a result of renewed study of colonial building, as it matured a desire for formal discipline began to assert itself. Horizontality and simplified masses had already appeared; bilateral symmetry was next. In the William G. Low house, Bristol, Rhode Island, 1886–87, McKim, Mead & White reached the apogee of formal clarity in the Shingle Style (Fig. 140). The entire house, including the porch, is subsumed within one broad, massive gable. Within the limits of functional practicality, the windows are symmetrically disposed, but bound together by the horizontal hoods which stretch across the shingled surface. Though the shingles are a symbol of the country house and the informality that connotes, the form in its grace and archetypal geometry is classic. It is significant that during the same years, in nearby Newport, McKim, Mead & White built the H. A. C. Taylor house, 1882–86, an oversized but rather archaeological reproduction of an eighteenth century house (it was in fact the first such archaeologically accurate neo-Georgian house). The two designs, one Shingle Style, the

other historically derivative, announced a resurgence of the classical revival.

Behind this surge of residential building was a vigorous business boom. The driving energy of this industrial growth, plus the deepening gulf between architects and engineers, created problems in giving appropriate forms to new building types. The Brooklyn Bridge, though not a building in the traditional sense, illustrates this dichotomy. As the pressure of traffic between Brooklyn and New York taxed ferry capacity, and as it became desirable to connect the two by streetcar, the need for a bridge became clear, but it had to span an unprecedented distance of nearly sixteen hundred feet, at a distance well above the river to allow commercial sailing vessels to pass beneath. Begun in 1869 by John Augustus Roebling, it was completed by his son Washington Augustus Roebling in 1883 (Fig. 141). The huge masonry piers supporting the steel cables are quite plain, with a cornice at the level of the deck and a terminal cornice where the cables rest. The openings are simple Gothic lancet arches, giving the piers historical associations. The cables and deck were determined by structural logic, and incorporate the elder Roebling's perfected technique for spinning high tensile steel cables, radiating stays for aerodynamic stability, and deck-bracing against wind and vibration. Perhaps the piers were intended to convey strength through their mass, but their historicism contrasts with the structural web. An even greater contrast, however, appears between the daring span and the copiously paneled Stick Style-cum-Second Empire Fulton Ferry terminal in the foreground built in 1871.

The same incongruity between associationalism and utility has already been noted in the head house and shed of Snook and Buckhout's Grand Central Station, New York. The needs of the transportation system presented extraordinary challenges to late nineteenth century architects. Trackage, for instance, doubled nearly every twelve years, reaching a peak of 254,037 miles in 1916. The volume of passenger and freight traffic increased at an even greater rate. The same was true for urban mass transit, which began with horse-drawn omnibuses. A major improvement was made by putting the cars on rails in the 1830s, but the greatest improvements came with cable-drawn cars in 1867, steam-powered traction in the 1860s, and electric traction in 1888. Such mass transit was both necessitated by and a stimulus for centralization of services, goods, and people in the urban core. Indeed, the application of motorized power to the horizontal movement of people (elevateds, subways, or trolleys) made the modern city pos-

141. John Augustus and Washington Augustus Roebling, Brooklyn Bridge, Brooklyn, New York, 1869–83.

sible just as mechanical vertical transportation (elevators) made the skyscraper possible; the two systems were symbiotic, for improvements in one system induced improvements in the other. But what appearance these facilities should have was a complicated matter, as suggested by the elaborate interiors of Pullman's Palace Car (introduced in 1864), or the design by landscape painter and amateur architect Jasper Cropsey for the Metropolitan Elevated Railroad stations, New York, about 1878 (Fig. 142). Cropsey's crocketed station is an example of the picturesque application of Victorian decorative effects in iron in the attempt to accommodate the new industrial age.

As mass transit spread, and as population grew, the use of land in the urban core grew ever more intensive, making it mandatory for office buildings to reach higher. In part this desire for ever greater height was also fed by the mystique of the corporate image; the tall building began to be a status symbol. In New York the pressure resulted in the first "skyscrapers" or "elevator build-

142. Jasper Cropsey, design for station, Gilbert Elevated Railroad, New York, New York, c.1878.

ings" designed to exploit the elevator for new heights. In a city in which the average building height was 60 feet, the Equitable Life Assurance Building by Gilman, Kendall and Post, 1868–70, was oustanding with its five floors of 130 feet. Soon it was dwarfed by Post's Western Union Building, New York, 1873–75, rising 230 feet, and even more by Hunt's Tribune Building, New York, 1873–75, containing nine stories and rising 260 feet (Fig. 143). In spite of their height these buildings were constructed in a traditional manner with massive exterior bearing masonry walls and partially iron-framed interiors. Architects had great difficulties in the 1870s trying to handle the expression of this increased height, for they were conditioned to think of Renaissance or Baroque business blocks and thus they had no precedent for a building over three stories. One solution was to pile up successive two- or three-story units as Hunt did in the Tribune Building. Nonetheless, Hunt did attempt to express the bearing nature of the wall by employing certain néo-grec devices such as the broad segmental arches in the stone base, the heavy major piers connected by segmental arches, and the comparatively light curtain wall of the banks of windows. Thus, despite the mansard roof, Hunt did use what was for him a progressive idiom. Furthermore, in the tall tower he introduced a form which continued to shape New York skyscrapers for sixty years.

In one commercial building in New York, George Browne Post (1837–1913) came very close to using true skeletal construction; this was the Produce Exchange, 1881–85 (Fig. 144), a huge rectangular block with a light well in the center. To one side was a tall blocky tower housing mechanical equipment. The entire interior was carried on a frame of cast iron columns and wrought iron

143. Richard Morris Hunt, Tribune Building, New York, New York, 1873–75.

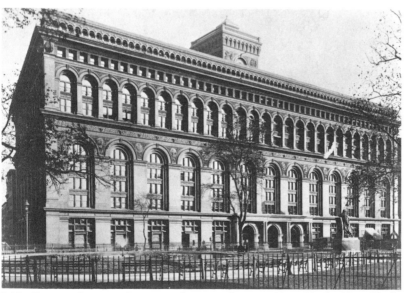

144. George Browne Post, Produce Exchange, New York, New York, 1881–85.

beams and joists. The outermost columns of the frame were embedded in the walls as were spandrel girders for the windows, but the brick wall supported its own weight plus some floor loads. In organizing the exterior Post used Italian Renaissance elements. The arcades correspond to internal arrangements, for above the ground floor was a vast four-story trading room 220 feet by 144 feet, the center of which was covered by an iron and glass skylight. Above the periphery of the room wrought iron trusses carried nearly three hundred offices in the encircling upper floors. Thus the imposing lower four-story arcade indicates the trading room, the cornice is coincident with the ceiling and skylight, and the quickened upper rhythms indicate the cellular offices in the upper floors. Besides the novel iron frame, Post also introduced terra cotta for ornamental sections showing well its potential for finely modeled crisp detail.

Despite his creative innovations, Post exerted little lasting influence; neither did Hunt though he had great prestige as the acknowledged dean of American architects. The greatest figure of this period was without question Henry Hobson Richardson (1838–1886). Born at Priestley Plantation, St. James Parish, Louisiana, to a family of some means, he attended Harvard University and may have been influenced by the austere granite warehouses and residences by Parris in Boston. Since in 1860 there were as yet no schools of architecture in the United States, Richardson went to the École des Beaux-Arts, Paris, where he studied for two years in the atelier of Jules-Louis André, before family support was cut off due to the war. For the next four years he worked in the office of Théodore Labrouste. Thus his academic and office experience gave Richardson the best of French academic discipline. He learned to examine a building's program for the suggestion of a comprehensive solution, to give careful attention to the development of the plan to provide optimum utility, to employ stylistic details sympathetic to the purpose of the building, and to build in the most solid, durable way.

Richardson returned to the United States in 1865, established a practice in New York, and settled on Staten Island near Olmsted with whom he soon began to collaborate. His practice was growing at a moderate rate when two designs propelled him into the center of architectural attention: his competition-winning entry for Trinity Church, Boston, and the summer house for William Watts Sherman in Newport, Rhode Island.

In Trinity Church, 1872–77 (Fig. 145), the general vertical massing and polychromy revealed traces of High Victorian Gothic, but the strong geometric order and the French Roman-

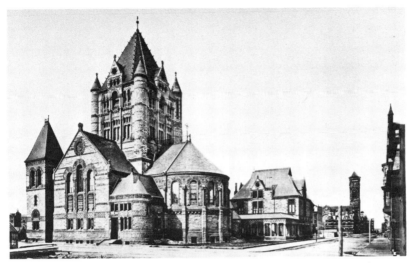

145. Henry Hobson Richardson, Trinity Church, Boston, Massachusetts, 1872–77. In the distance on the right is the tower of Richardson's Brattle Square Church, 1870–72, with its relief sculpture by F.-A. Bartholdi.

esque ornament motifs were new. The tower would have been taller and more inventive, but structural problems due to the spongy soil of Boston's Back Bay necessitated a shorter tower. It was decided to pattern the lantern of the tower after that of the Cathedral of Salamanca, Spain, so that to many observers it seemed that Richardson had added a new style to the repertoire already in use, and that he had made reference to specific historic monuments especially desirable. Such a revivalist assessment, however, completely missed the continuity and unity based on a carefully studied plan that were Richardson's most important contributions.

The Sherman house, 1874–75 (Figs. 146, 147), was designed on a broad expansive plan with rooms clustered about a spacious central stair hall. Just as Trinity Church showed an interest in more continuous integrated form, so too does the Sherman house with its long sweeping roof planes and the large frontal gable (the progenitor of the gable of McKim, Mead & White's Low house). To this organized form was added a new interest in texture, especially evident in the published rendering drawn by Stanford White, who was then in Richardson's office. Above the masonry of the first floor, shingles, small half-timbered panels, and textured stucco are used. Even the diamond-panel windows continue the overall texture. What could have become cacophonous was held superbly in check by grouping windows in horizontal bands so that although this is a tall house, it is the horizontal line which predomi-

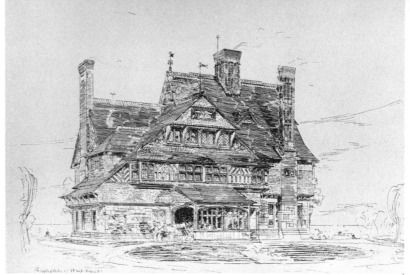

146. Henry Hobson Richardson, William Watts Sherman house, Newport, Rhode Island, 1874–75; Drawing by Stanford White (?)

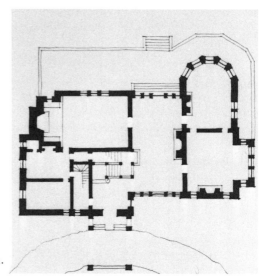

147. Sherman house, plan.

nates. Here, with references to medieval manor houses and the contemporary work of the English architect Richard Norman Shaw, is the beginning of the Shingle Style later carried to maturity by McKim, Mead & White and crystallized by the Stoughton house.

One can appreciate the expansiveness in Richardson's work by looking at the staircase of the Robert Treat Paine house, Waltham, Massachusetts, 1884–86 (Fig. 148). Part of a much

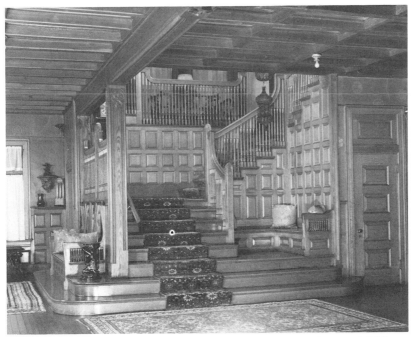

148. Henry Hobson Richardson, Robert Treat Paine house, Waltham, Massachusetts, stairhall, 1884–86.

larger hall, the staircase ascends by easy stages around built-in seats. The structure of stair and ceiling is integrated and openly expressed, ornamented with delicate foliate and geometric clusters. The stairhall also demonstrates the splendid craftsmanship of the Norcross brothers who built not only much of Richardson's work but many of the best known buildings of the next thirty years as well. It was then common practice to leave much to the discretion of the contractor, and the clause in building contracts, "to be finished in a workmanlike manner," expressed what was to builders like the Norcross brothers a sacred duty which they executed with exacting care.

Perhaps Richardson's most representative building is the Crane Memorial Library, Quincy, Massachusetts, 1880–83 (Fig. 149). What the Stoughton house meant for Richardson's Shingle Style, this small library signified for his public, masonry buildings. The general form of the building is simplified to one comprehensive shape with a minimum of elements, each of which articulates a particular interior function: window-wall for reading room to the right, entrance arch, tower for a staircase leading to offices behind the second story gable, and raised windows in the stack room to

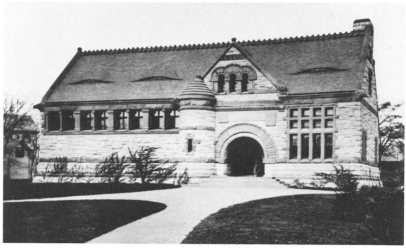

149. Henry Hobson Richardson, Crane Memorial Library, Quincy, Massachusetts, 1880–83.

the left. Horizontal lines and bands of brownstone organize the composition. The ornament, though inspired by French Romanesque and Byzantine sources, is broadly scaled and bold rather than archaeological. The walls are a continuous textured surface of quarry-faced granite and brownstone, creating a visual continuity as do the textured shingles in the houses.

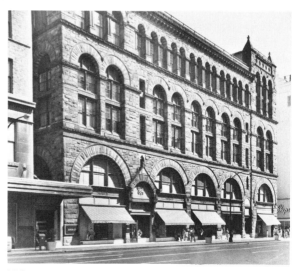

150. Henry Hobson Richardson, Cheney Block, Hartford, Connecticut, 1875–76.

Richardson had an intense interest in all areas of building and devoted considerable thought to utilitarian buildings. An early instance was the Cheney Block, Hartford, Connecticut, 1875–76 (Fig. 150). Thinking perhaps of warehouses of Bristol, England, Richardson used superimposed arcades forming a base, midsection, and terminating story, each successive arcade rhythm quickened. (Post may well have drawn from this for his Produce Exchange.) By 1885, when he was engaged to design the Marshall Field Wholesale Store and Warehouse in Chicago, Richardson had eliminated nearly all specific historical detail, emphasizing mass and proportion. The Field Wholesale Store appeared to be a single huge block (Fig. 151). Since the interior consisted of open loft spaces, Richardson maintained an uninterrupted rhythm of arcades along each side. Instead of historical detail, Richardson used the textured monochromatic surface of the granite and brownstone masonry to provide visual interest, supplemented only by a chamfer at the corners and an enriched terminal cornice. Simple though it appears, the Marshall Field Wholesale Store demonstrated clearly that a large commercial block could be expressed as a single integrated unit of great force and authority. No longer were meretricious historical ornament or a ponderous roof obligatory. Large-scale coherent forms, graced with plain walls, could be effective. Though structurally the Field building was conservative, with bearing walls and cast iron and wooden col-

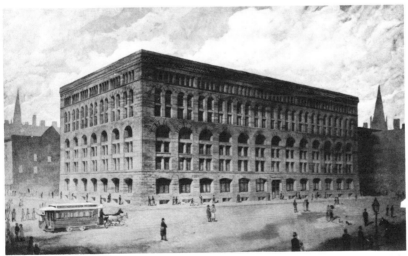

151a. Henry Hobson Richardson, Marshall Field Wholesale Store, Chicago, Illinois, 1885–87.

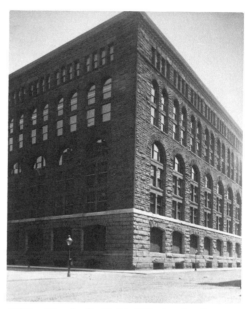

151b. Marshall Field Wholesale Store, view from the street.

umns for internal supports, the visual expression was highly advanced and pointed in a new direction which many critics and architects, both in the United States and Europe, interpreted as being distinctly American.

At the height of his career at the age of forty-eight Richardson died of Bright's disease, but before his death he began construction of the Field Store and his other major work, the Allegheny County Courthouse and Jail, Pittsburgh, Pennsylvania, 1884–88 (Fig. 152). The courthouse and jail are two separate buildings linked by a bridge over the intervening street. In both, the masonry is exploited for maximum expressive effect; some of the individual blocks in the prison wall weigh more than five tons. The courthouse is a large rectangular block with a central light court; externally the great bulk of the building is divided into component elements revealing the organization of the courts and chambers at the principal floors. Because of the significant public function of the building, more attention is given to the details here than in the Field store, as in the capitals of the colonnettes carrying the massive round arches and the dormers of the corner pavilions. Particularly impressive is the tall tower. Yet despite the building's size and many elements, everything works together for

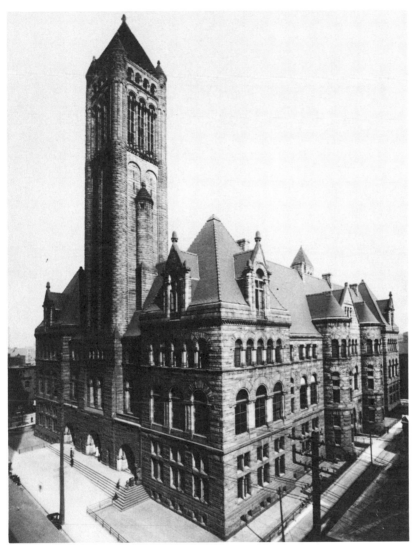

152. Henry Hobson Richardson, Allegheny County Courthouse and Jail, Pittsburgh, Pennsylvania, 1884–88.

the benefit of the whole and no part becomes discordant. This harmony and the lessons that the plan was paramount and that ornament should clarify a building's purpose rather than being an end in itself were Richardson's legacy to his followers in the United States and in England, Scandinavia, and Germany.

6.

Urbanism and the Search for Order: 1885–1915

It is customary in survey histories of American life and economics to discuss the entire period from 1865 to 1915 as a unit, possibly because it falls between two major wars. Yet from the point of view of architectural development, and even economic development, there are two distinct phases: the first, up to about 1884–85, characterized by rampant individualism and fragmented endeavors; and the second, after 1885, characterized by a growing interest in consolidation and in the exercise of a controlling discipline so as to effect maximum harmony and economy of effort.

In industry, after the recession of 1884, there was a decade and a half in which all of the major enterprises were gathered into great conglomerates, the trusts. The major railroads were expanded by acquiring control of smaller branch and parallel lines, particularly by E. H. Harriman and James J. Hill; the need for national standards in business was made especially evident by the example of the railroads which adopted a standard track gauge and then the four national time zones in 1883. The steel industry was consolidated by Andrew Carnegie at Pittsburgh by 1880, and on an even grander scale by the United States Steel Corporation in 1901 at Gary, Indiana. The electrical industries coalesced into two great giants—the General Electric Company and Westinghouse—by the middle of the nineties. The oil-producing and -refining business was emphatically consolidated by John D. Rockefeller, and even the manipulation of money and securities came to be dominated by J. P. Morgan at the end of the century, so much so, in fact, that in 1895 and again in 1907 it was Morgan alone who averted disastrous runs on the nations' banks as the federal government made ineffective gestures. Labor, too, became consoli-

dated in the American Federation of Labor in 1886 under the leadership of Samuel Gompers.

So, it is not difficult to see why several historians, for example Robert Wiebe, have seen a dominant theme in this period to have been a search for order in a culture that was becoming more and more complex. The leaders of industry, in the absence of any help from the federal government, attempted to set up their own standards for business enterprises carried out on a national and even continental scale, and if these efforts sometimes led to excesses, the federal government enacted controls at least on the worst overindulgences of monopoly. And, as we shall see, architects at this same time also sought a clearer sense of order in their work, and looked to find a truly national and modern architecture.

Two forces immediately began to reshape commercial building, one technological and the other architectonic. A flood of technical changes and innovations rendered obsolete the traditional arrangement and structure of commercial buildings, while simultaneous changes in conceptions of how a building should look affected their form and articulation of parts. Steel, which had been available in limited quantities since Bessemer's discoveries in 1856, began to be produced in large quantities by means of the Siemens-Martin open hearth furnace (developed in 1856 and then improved by the Thomas alkali process in 1878), so that by about 1884 the price per ton was low enough to permit entire buildings to be framed with steel members. At the same time businesses quickly adopted the telephone (developed in 1876), the typewriter (1868), mimeograph (1876), and inexpensive reliable incandescent lighting (1879) which for a time had competition in the Welsbach gas lamp mantle introduced in 1885. The synergetic effect of all these innovations was to change radically the nature of business communications and building illumination. Within a few short years these inventions had become basic to American urban culture, and, coupled with the increasing pressure of urban populations and the concomitant intensive use of land, these innovations made the development of the tall, self-contained skyscraper desirable, possible, and perhaps inevitable.

Yet this urgency to build higher and bigger was tempered by a desire to express the structural and functional realities of the building more clearly. The desired clarity and harmony were in some instances achieved through the development of a rigorously analyzed personal idiom, as was done by Sullivan and Wright, but it was more common to return to classic principles of design and,

often, to the literal reuse of classical forms. It was a gradual development growing out of a broad cultural predisposition, for there were no propagandists for this classicism as Downing had been for Gothic or Lafever for Greek a half century before. As the pace of technological and cultural change quickened and intensified, so the need for security through historical associationalism in architecture became more insistent. Thus, in the turbulent years in which modern American society emerged, and in the two decades which followed from 1915 to 1935, there flowered a traditional architecture, both classic and Gothic, that is still unsurpassed in its exploitation of fine building materials, accuracy of historical detail, or ingenuity in planning. This creative eclecticism, the final resurgence of the eclectic spirit of the nineteenth century, was a search for formal and psychological order.

The most rational expression of this search appeared in commercial buildings and in the cumulative efforts to develop a standardized steel frame. George B. Post had come very close to perfecting the free-standing metal skeleton designed to carry all building loads, but the credit for the construction of the first true skyscraper is traditionally given to William Le Baron Jenney (1832–1907) for his Home Insurance Building, Chicago, 1883–85. Jenney had studied engineering at Harvard's Lawrence Scientific School for two years and had then studied for three years in Paris at the École Centrale des Arts et Manufactures. There he was taught building design as a branch of general engineering, not as one of the fine arts, but he did absorb some of the feeling for néogrec structural expressionism, employing this general approach in his Portland Block, Chicago, 1872. In his first Leiter Building, Chicago, 1879, he reduced the internal frame to one of wood girders and cast iron columns, expressed externally by the narrow brick piers enclosing iron columns and by the broad expanses of glass. The ultimate step he took in the Home Insurance Building (Fig. 153), where he developed a complete iron and steel frame for the upper floors, hanging on it the external brick and terra cotta sheathing. As illustrations of the building show, the multitude of elements did not clearly express the radical nature of the structure or internal operations. Though only ten stories high, this skeletal metal-framed building made the potential for height in commercial building seemingly unlimited. Furthermore, the clear logic of Jenney's work attracted young people to his office, and during his career Jenney trained an entire school of Chicago architects including Louis Sullivan, Daniel Burnham, William Holabird, and Martin Roche.

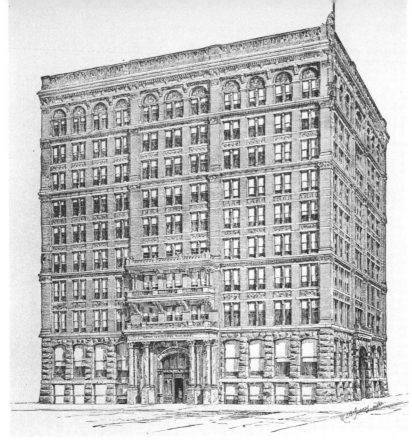

153. William Le Baron Jenney, Home Insurance Building, Chicago, Illinois, 1883–85.

After leaving Jenney's office, Daniel Burnham (1846–1912) worked briefly in the office of Carter, Drake and Wight (the same Peter B. Wight who had earlier designed the National Academy of Design in New York, and who subsequently moved to Chicago). Burnham then formed a partnership with John Wellborn Root (1850–1891) who had been raised in Georgia and who had studied architecture, art, and engineering in England. After the Civil War Root had taken a Bachelor of Science degree in civil engineering at New York University, working for Renwick and Snook in New York City before moving to Wight's office in Chicago and joining with Burnham. In their partnership, Burnham designed, attended business matters and managed the office, while Root functioned as designer and engineer. Root was both rationalist and artist, and had not his career been cut short in 1891 by pneumonia, American architecture would surely have profited by his synthesis of these two seemingly antithetical forces. Among the first fruits of Burnham and Root's collaboration was the simple but exceedingly well-planned and -detailed Montauk Block, Chi-

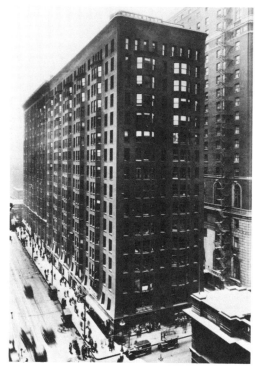

154. Burnham & Root, Monadnock Building, Chicago, Illinois, 1884–85, 1889–92.

cago, 1881–82, for Peter and Shepard Brooks of Boston. This was followed by another Chicago commission for the Brookses, the Rookery, 1884–86, which employed the typical Chicago scheme of a hollow square block around an internal light court. In their Monadnock Building, Chicago, 1884–85 and 1889–92, also for the Brooks brothers, Burnham and Root reduced the building to an elemental statement (Fig. 154). Finished after a hiatus of several years, the building was stipulated by the Brooks brothers to be of traditional bearing wall construction, with an unprecedented height of sixteen stories. Root therefore faced a problem of harmonious expression of this height. His original idea was an ideogram of the Egyptian papyrus column, but over the long period of design he gradually stripped away historical detail, leaving only a massive brick pile with a slightly curved base and outward curving cavetto cornice at the top. No stringcourse or projection breaks the continuity of line so that the tapered mass of the Monadnock Building becomes its own ornament. In spite of Root's

155. Burnham & Root, Reliance Building,
Chicago, Illinois, 1889–91, 1894–95.

artistic achievement in making the tall building a unified, coherent statement, it was structurally traditional, employing cast iron and wrought iron framing only for window spandrels and the internal frame. Consequently the walls at ground level had to be six feet thick to carry the upper floors; this massive bulk then rested on an immense iron and reinforced concrete raft. If tall buildings were to be economical to build and profitable to rent, valuable floor space could no longer be thus given over to bearing walls; the metal frame was the logical alternative.

In a nearly contemporary building, Burnham and Root worked out the quintessential statement of the steel frame. This was the Reliance Building, Chicago, 1889–91, and 1894–95 (Fig. 155). The various dates result from the fact that this building, for William Ellery Hale, was built in two stages: the ground floor with its great banks of plate glass designed entirely by Root was finished first; the upper floors were completed later according to designs by Root's replacement, Charles B. Atwood. Because of the condi-

tions of the site, a steel frame was used to carry the sixteen floors. The upper floors, sheathed in white glazed terra cotta, are opened up through wide expanses of glass forming the characteristic "Chicago window" with one wide fixed pane flanked by narrow double-hung sashes. Nowhere is there the suggestion of a wall; instead the building consists of a transparent skin over the structural skeleton. The terra cotta pieces, protecting the metal from oxidation and fire, are broken down into small elements by the delicate Gothic detailing designed by Atwood (a touch of historicism that Root probably would have avoided), minimizing the sheathing while emphasizing the vertical lines. Typical also of the Chicago skyscraper is the undulating wall with its projecting bays, recalling Holabird and Roche's Tacoma Building of 1887–89. It is also significant that in the upper floors by Atwood, there is a shift away from Root's dark hues toward white.

Burnham & Root were but one of a number of firms then active in Chicago; the best known is certainly Adler & Sullivan. Dankmar Adler (1844–1900), born in Lengsfeld, Germany, immigrated with his parents to Detroit where he worked in the office of engineer E. Willard Smith. After moving to Chicago, Adler enlisted in the Union Army, serving with the engineers; this was the extent of his "formal" training. Beyond this experience, Adler was largely self-taught, and he acquired a vast knowledge of structural techniques, building methods, and acoustics which he made his specialty. Louis Sullivan (1856–1924) was born in Boston; the summers of his youth were spent with grandparents in South Reading, Massachusetts, where Sullivan developed an almost pantheistic adoration of nature. In 1872 he enrolled in the relatively new architectural program at the Massachusetts Institute of Technology, but, chafing under what he thought sterile instruction, he left at the end of the academic year. On the advice of Richard Morris Hunt, Sullivan went to work for Frank Furness in Philadelphia, Hunt's former pupil, but he could be kept on for less than a year due to the poor business conditions of the depression in 1873. Venturing to Chicago, where his family had moved, Sullivan worked in Jenney's office during 1873–74, making many acquaintances which later were important for his career. Nonetheless, recalling Hunt's accounts of his days in Paris and perhaps urged by Furness, Sullivan set out for Paris in the summer of 1874 to complete his education at the École des Beaux-Arts. Ever impatient, however, Sullivan left Paris and the atelier of Émile Vaudremer in 1875, but while at the École he absorbed the basic discipline of academic architecture with its focus on functional

planning, sound construction, and expressive embellishment.

Sullivan's mind was one of the most searching and analytical of his day; he was perhaps the first American architect consciously to explore the relationships between architecture and culture. His theory became one of structural rationalism, based on ideas of the sculptor Horatio Greenough, Ralph Waldo Emerson, and Gottfried Semper. In "Thoughts on Art" written in 1841 Emerson proposed that "whatever is beautiful rests on the foundation of the necessary," an idea concurrently being developed by Greenough who expressed it most succinctly in *The Travels, Observations, and Experience of a Yankee Stonecutter,* New York, 1852: "Beauty is the promise of function." Both agreed too that "all beauty is organic," as Emerson wrote in "Beauty" in 1860; or as Greenough put it in "American Architecture" (published separately in 1843 and then incorporated in *Travels*), beauty "is the consistency and harmony of the parts juxtaposed, the subordination of details to masses, and of masses to the whole." There were also ideas of natural adaptation to purpose drawn from the work of Darwin and Owen Jones, which, coupled with his innate love of nature and plant life and the example of Furness's boldly inventive idiosyncratic ornament, formed the basis for Sullivan's delicate foliate ornament. Infusing everything he did was a penetrating vision of the functional requirements of each building, so that element led to element with a logical inevitability; this he learned from his experience at the École.

This synthesis is only partially apparent in the building which first attracted national attention to the firm of Adler & Sullivan, the Chicago Auditorium, 1886–90 (Fig. 156). What the Auditorium indicated, however, was that a huge building, occupying an entire block, could be harmonized and expressed as one great unit, an idea which Sullivan drew from such examples as Richardson's Marshall Field Wholesale Store and Root's McCormick Offices and Warehouse in Chicago. The Auditorium was built for a syndicate of businessmen to house a large civic opera house; to provide an economic base it was decided to wrap the auditorium with a hotel and office block. Hence Adler & Sullivan had to plan a complex multiple-use building. Fronting on Michigan Avenue, overlooking the lake, was the hotel (now Roosevelt University), while the offices were placed to the west along Wabash Avenue. The entrance to the auditorium is on the south side beneath the tall blocky seventeen-story tower. The rest of the building is a uniform ten stories, organized in the same way as Richardson's Marshall Field Wholesale Store. The interior embellishment, however,

156. Adler & Sullivan, Auditorium Building, Chicago, Illinois, 1886–90.

is wholly Sullivan's, and some of the details, because of their continuous curvilinear foliate motifs, are among the nearest equivalents to European Art Nouveau architecture. Both Adler's and Sullivan's attentions were focused on the auditorium room. The floor slopes up steeply, designed to provide optimum acoustics for every seat in the house, while the dropped plaster ceiling of four broad elliptical arches and cove vaults is proportioned to sustain reverberations while minimizing echoes; it is one of the best concert halls in the world. All of this is enriched by low relief plaster panels of interlacing foliate forms studded with electric light bulbs. Also incorporated in the ornamental patterns are outlets for the ventilation and heating systems designed by Adler which included a rudimentary system for cooling (but not dehumidifying) the air in the summer. Structurally traditional, the Auditorium employed massive masonry bearing walls on the exterior with a complex iron and steel frame supporting the interior and the auditorium balconies and vaults.

The functional promise of the Auditorium was fully realized by Sullivan in the Wainwright Building, St. Louis, Missouri, built 1890–91 (Fig. 157). In this building all the elements of structure and form of the modern skyscraper were developed: the entire building is carried on a steel frame fireproofed by brick and terra cotta sheathing; reinforced concrete raft foundations support the

column loads. All partitions in the office floors are movable since all loads are carried by the steel frame. All these are technical considerations; what is most important is how Sullivan analyzed and gave clear expression to the external elements of this tall office building. At ground level, where shops are located, are wide plate glass windows for display, with a second level mezzanine of broad windows for shop offices. Above all this, in an uninterrupted upward rush of seven stories, are the narrow windows of the office cells, with terra cotta spandrel panels set back from the face of the narrow brick piers so that the vertical emphasis is not compromised. At the top is a foliate frieze of high relief terra cotta, and a bold cornice slab.

The Wainwright Building demonstrates Sullivan's views about the interrelatedness of form and function. He wrote that "if a building is properly designed, one should be able with a little attention to read *through* that building to the *reason* for that building" (*Kindergarten Chats*, 1918). Form, in other words, should follow function. In this Sullivan drew from the ideas of Semper in his essay "Development of Architectural Style," which had just been translated by John Root and published in the *Inland Architect*

157. Adler & Sullivan, Wainwright Building, St. Louis, Missouri, 1890–91.

in 1889. A true style, Semper argued, arose from needs growing out of the conditions of life, a view previously expressed by Greenough in his "American Architecture" in which he said character and expression resulted from an "unflinching adaptation of a building to its position and use." As the proper method of procedure Greenough suggested that "instead of forcing the functions of every sort of building into one general form, . . . let us begin from the heart as a nucleus and work outward." This is exactly what Sullivan did, analyzing simply and cogently the functional activities in the modern commercial high-rise in his essay, "The Tall Office Building Artistically Considered," published in *Lippincott's Magazine* in 1896. The essay summarizes what he had already done in the Wainwright Building where he emphasized and differentiated each of the three major visible sections— ground floor shops, midsection offices, and uppermost mechanical equipment—each with its own separate expression. To augment the verticality of the building, its great distinguishing characteristic, Sullivan doubled the number of vertical piers, giving the bulk of the building a vertical thrust similar to that achieved by fluting on classical columns. In fact, the tripartite division of the building into base, shaft, and capital, is an analog to classical forms and reflects the logic Sullivan absorbed in Paris. Sullivan perfected this basic form in the Guaranty Building, Buffalo, 1895, where the exterior is completely sheathed in terra cotta whose foliate designs increase in relief from the ground floor to the thirteenth-story attic. In this way all parts can be read and understood from the street.

There were other office buildings by Adler & Sullivan, such as the Stock Exchange, Chicago, 1893–94 (in which some of the columns were supported by caisson foundations for the first time), all organized according to the same basic tripartite formula, with a stack of office cells above a ground floor shop area. When Sullivan came to design the Schlesinger and Mayer Store (later Carson, Pirie, Scott and Co.), beginning perhaps as early as 1891, he had to deal with a radically different function. Instead of a stack of undifferentiated office rooms, the department store required broad horizontal open spaces where goods could be displayed; at the ground floor the windows were to be showcases highlighting selected wares. Thus in the finished building, constructed in two phases in 1899 and 1903–4 (Fig. 158), the horizontal line, rather than the vertical, is dominant, with the broad spandrel panels brought up flush with the narrow vertical piers. Nevertheless the tripartite division is present with (a) ground floor windows richly encrusted with cast iron frames by Sullivan and his assistant Elms-

158. Louis Sullivan (with Dankmar Adler?), Carson, Pirie, Scott & Company Store (Schlesinger & Mayer), Chicago, Illinois, 1891?–94, 1899, 1903–04; extension, 1906, D.H. Burnham & Co.

lie, (b) midsection, and (c) the terminating attic and cornice slab. As in Burham and Root's Reliance Building, there is a change in color, away from the reds and browns, to glazed white terra cotta.

The depression of 1893 sharply cut back the commissions of Adler & Sullivan; eventually Adler had to leave the firm to provide support for his family. Alone, Sullivan was given fewer and fewer commissions. Even so some of his finest work is from these last years, especially the banks in small prairie towns. The best of these is the National Farmers' Bank in Owatonna, Minnesota, 1907–8 (Fig. 159). Though much smaller in scale than the earlier skyscrapers, the bank is just as clearly expressed in its parts. The main banking room is a single cubical space enclosed by a box, indicated by the wide stained-glass lunette windows. The base is of red sandstone, with dark red brick walls. Ornamentation is concentrated in panels, of bronze-green terra cotta, with intricate cast iron escutcheons at the corners; the cornice is simply corbeled brick courses. To the rear is a separate block housing offices and shops, a speculative venture by the bank, but clearly related to the bank in materials and design. The other scattered small banks were basically similar, with clearly expressed banking rooms, colorful textured materials, and pockets of dense intricate ornamentation. They were modest works which held fast to the architect's expression of function through form.

Sullivan was both creator and prophet of the modern commer-

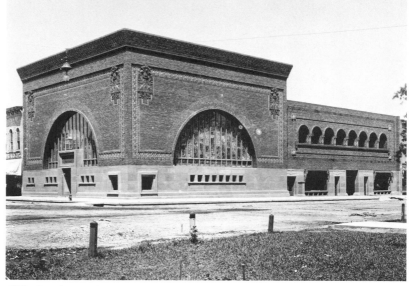

159. Louis Sullivan, National Farmers' Bank, Owatonna, Minnesota, 1907–08.

cial skyscraper, and is rightly lauded as the father of modern architecture. There were other firms at work in Chicago who systematized and perfected the work that Sullivan had begun. Chief among these was the firm of William Holabird and Martin Roche who had met while apprentices in the office of William Le Baron Jenney, and formed their own office in 1881. Their work shows a steady development of building technology with direct external expression of internal function. Their Tacoma Building, Chicago, 1886–89, exploited numerous technical innovations in its foundations and frame and used cantilevered window oriels to express the lightness of the frame. More typical of their later buildings is the Marquette, Chicago, 1893–94 (Fig. 160). Commissioned by Peter and Shepard Brooks, the building benefited from a clear and rational program, the result of the Brookses' many ventures in speculative building. The building is hollow around a light court in the shape of an **E** with the long strokes representing rows of offices and the short center stroke representing the elevator banks. Externally the tripartite organization is clear. It begins with a rusticated base of ground floor and mezzanines. Above this are eleven stories of offices between slightly projected rusticated corner piers; in this middle zone no horizontal lines break the upward movement. An upper intermediate floor, an attic floor, and a heavy cornice terminate the building. This formula, incorporating transitional stages between each of the three zones, became typical of Holabird & Roche's work; so too did the Chicago window which they used repeatedly. And though the Marquette Building uses many classical ornamental features, most notably

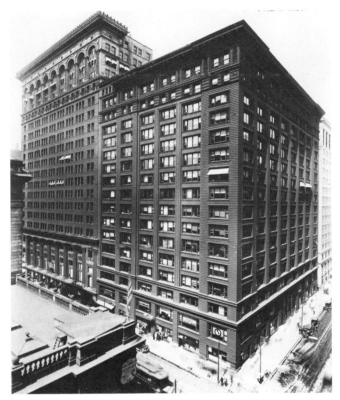

160. Holabird & Roche, Marquette Building, Chicago, Illinois, 1893–94.

the Renaissance cornice, the near-irreducible logic of its straight-forward expression of internal arrangements maximizing comfort and use makes it a paradigm of the Chicago School skyscraper.

There was interest elsewhere in new building materials. On the west coast several extremely interesting buildings appeared which, unfortunately, had virtually little local effect. One was the Bradbury Building in Los Angeles, California, by George Herbert Wyman, 1893 (Fig. 161). The interior of this building is particularly important for it consists of tiers of offices opening on an internal court running the full height. Connecting the circumferential balconies at each floor are open staircases and exposed elevators. Each of the materials—buff brick, iron, and glass—is exploited for maximum expressive and decorative effect, but most important is the expansive interior court and the celebration of vertical movement through that space.

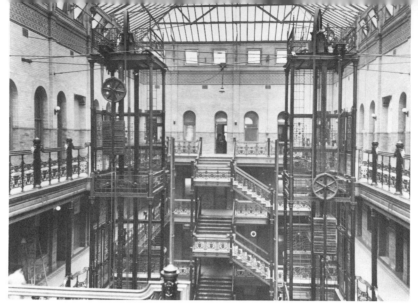

161. George H. Wyman, Bradbury Building, Los Angeles, California, interior, court, 1893.

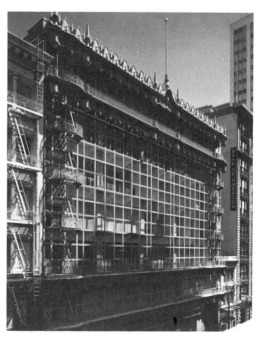

162. Willis Polk, Hallidie Building, San Francisco, California, 1915–17.

Equally progressive was the Hallidie Building, San Francisco, by Willis Polk, 1915–17 (Fig. 162), in which the structural implications of Chicago School skyscrapers were pushed to their logical

conclusion. The wall of glass is held in light steel sash cantilevered in front of, and thus obscuring, the structural columns. In compensation the requisite fire escapes become framing elements at each end of the building. Some historicism remains, however, in the Gothic tracery of the metal embellishments. As with Wyman's Bradbury Building, there was no appreciable influence on local architecture, nor was there any similar expression in Polk's own subsequent work. Despite the parallels to contemporary work by Gropius in Germany, the Hallidie Building was an isolated phenomenon.

In New York City, meanwhile, commercial building flourished in the early years of the twentieth century, and new skyscrapers quickly set height records. Though the basic technology of the steel frame had been worked out in Chicago, New York buildings soon eclipsed those in Chicago in size and conveniences, if not always in direct functional expression. While Chicago architects had focused on frank expression of the frame through banks of broad windows, in New York the emphasis was on expressive height and on the adaptation of contemporary and historic modes to the tall building. To achieve the greatest sense of height, the New York architects employed the local tradition of the tower, introduced in Hunt's Tribune Building, concentrating the upper stories in a slender shaft rising from a solid block, terminated not in a projecting cornice but in a graduated spire; in contrast, in Chicago the skyscraper had become a uniform hollow block, either square or U-shaped, with a continuous terminal cornice. Ernest Flagg's Singer Building, 1906–8 (Fig. 163), is a good example of the New York type. The forty-seven stories far exceed what was being done in Chicago, and the slender proportions of the tower were remarkable. To brace the tower against turbulent New York winds, crossed diagonals were used at the corners, and while this was expressed by the heavy corner wall piers enclosing the glass curtain-walls, it was not so directly expressive of the frame perhaps as were the works of Sullivan, or Holabird & Roche. Flagg, recently returned from the École des Beaux-Arts in Paris, used the fashionable exaggerated French Baroque then current in Paris for the Singer Building, and this suggests a further connection to Hunt's Second Empire Tribune Tower.

Though the historicist and stylish confections used to terminate these spires came under virulent attack during the 1950s and 1960s, they served a very necessary visual function. At a distance of forty to sixty stories from the sidewalk, these overblown, colorful ornaments gave a rich final flourish to the upward movement. If the architect was to carry the observer's eye upward, he then

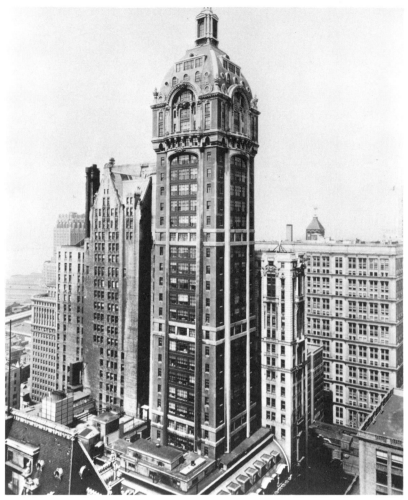

163. Ernest Flagg, Singer Building, New York, New York, 1906–08.

had to provide ample visual reward in the final extravaganza. This is especially true in Cass Gilbert's Woolworth Building, New York, 1911–13 (Fig. 164). Designed to reach the then incredible height of fifty-five stories, it rises just short of 761 feet at the top of the pyramidal spire. As Flagg did, Gilbert has a tower shaft that rises from a supporting block base, but to maximize the expression of height (and to provide associations with other historic tall buildings) Gilbert used Gothic motifs. The piers at the corners of the supporting block and the main tower piers are widened, but nowhere are they stopped by horizontals. At the top the Gothic finials and crockets are vastly overscaled so that they read from the street and provide the proper visual termination to the upward movement. Such an achievement in height, of course, was based on the exploratory work of Jenney, Adler, and Sullivan, but

the monumental impulse was much different from that in Chicago.

The widespread desire to rationalize and standardize commercial building was one facet of a pervasive movement at the turn of the century to bring visual order to the constructed environment. While in commercial architecture this was done in an empirical way, quite different methods were used by other architects and designers. All of them, however, sought to create an environment harmonious in the interrelationship of all its elements.

Bringing order to the constructed environment means designing comprehensively and thinking on a grand scale. These were the characteristics of academic instruction at the École in Paris since the time of Blondel and Boullée. Consequently the few Americans who studied there during the nineteenth century were the first to begin to seek coherence in American building after the Civil War. It is significant that Jenney and Sullivan had both stud-

164. Cass Gilbert, Woolworth Building, New York, New York, 1911–13.

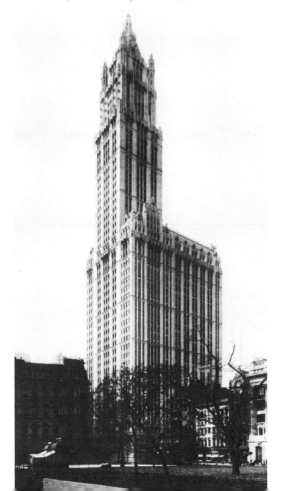

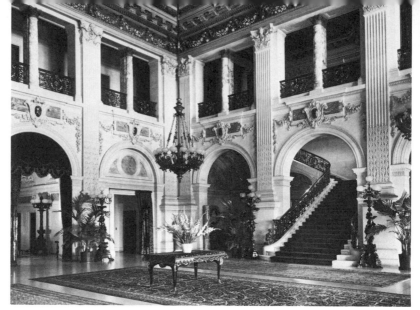

165. Richard Morris Hunt, Cornelius Vanderbilt house, "The Breakers," Newport, Rhode Island, central hall, 1892–95.

ied briefly in Paris and that Post had second-hand instruction from Hunt, the first professional American architect to go to Paris. The great hall at the center of the summer home "The Breakers," designed by Hunt for Cornelius Vanderbilt, Jr., Newport, Rhode Island, 1892–95 (Fig. 165), is a good example of comprehensive design unity. Around this vast hall all the rooms are arranged with a clarity that makes the plan seem inevitable, and the ornamental elements of the hall are so disposed as to create a sense of unity rather than disparity. Even the colors of the materials used in the hall—marbles, onyx, alabaster, bronze, and gilding—are controlled to contribute to the overall harmony.

Perhaps the grandest of Hunt's integrated and controlled designs was the summer house for George Washington Vanderbilt, "Biltmore," near Asheville, North Carolina, 1888–95 (Fig. 166). The house was a vast French château in the manner already used by Hunt for other Vanderbilt projects; including stables it was over a thousand feet in length. Ultimately more important, however, was the estate in which the mansion was placed. Beginning in 1888 under the direction of Frederick Law Olmsted, Vanderbilt acquired 120,000 acres of woodland, with the site for the house at the center. His purpose was to develop an operation that would turn the forest into a productive enterprise. Out of this experiment came the contributions of Gifford Pinchot, chief of the Bureau of Forestry under Presidents McKinley, Roosevelt, and Taft, and father of the National Forest Program, as well as the

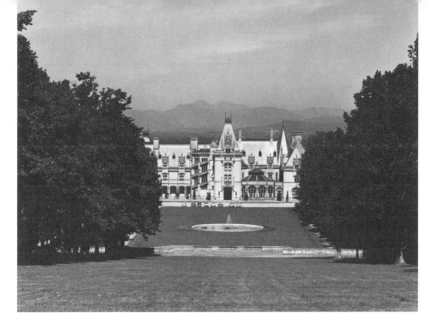

166. Richard Morris Hunt, G. W. Vanderbilt estate, "Biltmore," Asheville, North Carolina, 1888–95.

first American School of Forestry established at "Biltmore" by Carl A. Schenck in 1897.

"Biltmore" is only one example of the collaboration between architects and artists that was prevalent during the closing years of the nineteenth century. Another example is the Adams Memorial in Rock Creek Cemetery, Washington, D.C., 1886–91 (Fig. 167). The historian Henry Adams commissioned Augustus Saint-Gaudens to sculpt a bronze figure as a memorial to his wife. Working with Stanford White, whom he asked to design the base, Saint-Gaudens fashioned a seated figure symbolizing the timelessness of nirvana. While this figure was evolving, White began to sketch out designs for a setting incorporating seating opposite the figure, a polished marble base, a seat for the bronze, and a surrounding bower of holly. It is one of the finest expressions of American sculpture of the period, for it combines great sensitivity to the program, subdued strength and tension in the figure, an architectural setting which enhances those qualities, and landscape elements that set the memorial apart and shelter it.

One way of giving individual buildings a clear sense of order and unity was to employ the classical styles, especially those which emphasized balance, symmetry, and restraint, qualities which had been increasingly absent since the 1850s. In 1880 there began to emerge a return to neoclassicism as a means of making urban buildings more harmonious with one another. Classic Greek forms were usually avoided in favor of Roman and

167. McKim, Mead & White (Stanford White), The Adams Memorial (for Henry Adams), Rock Creek Cemetery, Washington, D.C., 1886–91. Bronze figure by Augustus Saint-Gaudens.

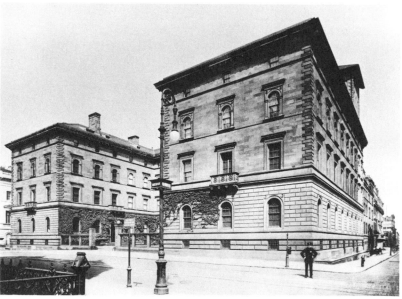

168. McKim, Mead & White, Henry Villard house group, New York, New York, 1882–85.

Renaissance prototypes because they offered greater flexibility of expression in accordance with use. What the architects attempted to do, using the accumulated archaeological knowledge of the previous century, was to design new buildings, accommodating new functions, while using traditional historicist vocabularies. This resurgence of neoclassicism was heralded by a group of six town houses built for railroad entrepreneur Henry Villard in New York in 1882–85 by McKim, Mead & White (Fig. 168). Built in conventional brownstone, the building was closely patterned after Italian Renaissance palaces, most specifically the Cancelleria, Rome. The individual units were so unified that the building, U-shaped around a central courtyard, appears to be one single house. The Villard house group was widely admired, partly because it was so chaste and refined while at the same time being large in scale and grand in conception. The interiors of Villard's own apartments were sumptuously finished with rare marble veneers, mosaic inlay, and delicate low-relief sculpture by Augustus Saint-Gaudens, but little of this enrichment was pompously displayed externally and this civic decorum appealed to a younger generation of architects. Another distinguishing quality was the way in which the sober brownstone block, through its emphatic solidity and horizontal emphasis, gave clear and certain definition to the street.

Because of their success in the Villard house group, McKim, Mead & White were given the coveted commission for the Boston Public Library, 1887–98 (Fig. 169). The functions to be served by the library were several. First, it was to house the largest public circulating collection in the world, something that no one then understood clearly, and therefore the architects were without specific prototypes. Second, it was to symbolize Boston's cultural heritage, and to be, as the trustees specified, "a palace for the people." Third, the library had to visually control the open expanse of Copley Square, bringing together the varied, colorful, Gothic buildings around the square including the new Old South Church and Richardson's Trinity Church on the east side of the square. A horizontal and classical motif seemed to be the answer, and the architects (with McKim in charge) based their design in part on the library of Sainte Geneviève, Paris, by Labrouste, but made it more massive and more imposing in scale, articulated with very carefully designed Renaissance ornament. With its internal reading court inspired by Italian Renaissance palace courtyards, its carefully selected marble paneling, and its commodious public spaces, the library was meant to be as much a sensory experience

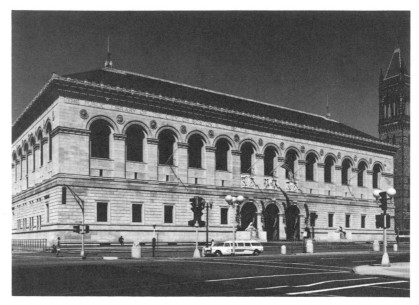

169. McKim, Mead & White, Boston Public Library, Boston, Massachusetts, 1887–98.

as an intellectual one. Especially significant was the collaboration of many artists who provided painting and sculpture embellishing the exterior and interior. Panels above the entrance were by Augustus Saint-Gaudens, the bronze doors were by Daniel Chester French, mosaic work in the vestibule was by Maitland Armstrong, the memorial lions in the stair-hall were by Saint-Gaudens's brother Louis, while the mural painting in the arcaded wall above was by Puvis de Chavannes, the only murals by him for an American building. In addition, in the delivery room was a richly colored mural of the Holy Grail by Edwin Austin Abbey, and in the dimly lit third floor hall was a complex mural sequence depicting the development of religion by John Singer Sargent; this was his finest mural work. Further enrichment throughout the building was provided by other artists. Never before had American architects and artists worked so closely and harmoniously together. It was fitting that this happy collaborative effort should face Trinity Church across Copley Square, for it was there in the joint efforts of Richardson and La Farge that this camaraderie among American artists had been born.

Aside from the impressive integration of allied arts, the Boston Public Library was also significant for its widespread use of thin monolithic shell vaults for its flooring, a technique developed by the Catalan, Rafael Guastavino, who had recently arrived in the United States expressly to perfect his vaulting process. After 1890

Guastavino vaults were widely used to frame the various domical and vaulted forms popular in churches and public buildings before the depression of the 1930s. The exploitation of the Guastavino system indicates that McKim, Mead & White, among other traditionalist architects, used new technological methods to achieve the spaces they desired, but their goal always was to base their designs on popularly understood and accessible traditional prototypes, rather than to develop a literal expression of new structural devices as Sullivan was then doing.

Perhaps this desire for easily accessible form, achieved by using the most current technology, can be seen best in McKim, Mead & White's Pennsylvania Station, New York, designed in 1902–5 and built 1905–11 (Fig. 170). Statistics such as the fact that this was the largest building since the pyramids constructed in one continuous operation obscure an appreciation of the complex overlay of functions served by the building. This was the largest rail station of its day, serving through trains from Chicago and Philadelphia to New York (and eventually to New England), and scores of commuter trains of the Long Island Railroad. All rail lines were nearly forty-five feet below the street in tunnels; hence the building had to be impressive in its own right, for no trains were visible

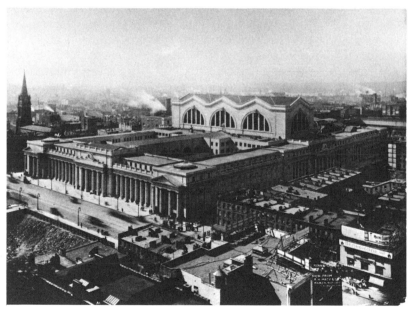

170. McKim, Mead & White, Pennsylvania Station, New York, New York, 1902–10.

from the street. To bring unity to the vast building which covered two city blocks, McKim employed a continuous colonnade around the exterior, and where large spaces were required internally for waiting rooms and for boarding trains, he pushed the ceilings to great heights, opening up great lunette windows which had become the symbol of train stations in Europe and the United States. Like many of his contemporaries, when faced with the problem of articulating such a huge space, McKim turned to the large public meeting places of Rome for solutions; the vast waiting room was patterned after the tepidarium of the Baths of Caracalla in Rome but enlarged by about 25 percent. As originally planned, patterns of traffic for passengers, commuters, baggage, and freight were carefully synchronized through the use of overpasses, ramps, separation of levels, and mechanical carriers. Where movement was swift, spaces were small and low; where movement slowed and stopped, spaces were large and high. Before the station was abused, it functioned, as Lewis Mumford wrote in 1958, with "the effortless inevitability of a gravity-flow system."

Symbolically the strength and position of the railroad were expressed by the seemingly massive masonry of the granite exterior and travertine interior, but all of this was hung on a steel skeleton whose slender columns threaded through the maze of tracks below the station. And while McKim used historicist Roman elements in the waiting room, over the concourse he placed intersecting barrel vaults of glass carried by open steel arches and columns. Utilizing every known technological device, Pennsylvania Station and the new Grand Central Station which followed soon after are significant not only because they were the largest constructions to be undertaken by private capital, but, as Carl Condit notes, because they incorporated so many amenities vital to civic building art. They were superb portals to the city; dignified, integrated despite vast scale, and well ordered.

Both the Boston Public Library and Pennsylvania Station might appear to be pallid and colorless. Nothing could be further from the truth, for architects like McKim, Mead, & White were extremely sensitive to the use of color. These two buildings were constructed of Milford granite which has a delicate warm pink cast; the library has recently been cleaned and returned to its original color. In the case of the library, the greater concentration of color is in the interior, with its murals, the amber, red, green, and black marbles, and the bronze-work and gilding. In urban houses such as the John F. Andrew house, Boston, 1883–86 (Fig. 171), one can see the concern of the architect (in this case McKim)

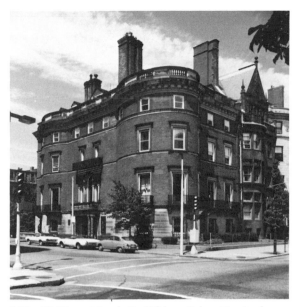

171. McKim, Mead & White, John F. Andrew
house, Boston, Massachusetts, 1883–86.

for color relationships. The base is of finely cut beige sandstone
while the upper stories are of dark reddish brown Roman brick.
Thus the basic color scheme harmonizes with the brick and stone
houses nearby. The color and use of the bowed front also recall
the traditions of Beacon Hill, while the generically Georgian de-
tails reflect the colonial heritage. Individually, the details of the
window frames, moldings, and balustrades are based on Italian
Renaissance sources and so go beyond the colonial prototypes to
their ultimate inspiration; but the overall character of the building
is clearly meant to refer to Boston's building traditions, and this
desire on the part of McKim, Mead & White to reinforce the
uniqueness of place is one of the important positive aspects of this
resurgent neoclassicism.

To a large extent McKim, Mead & White employed machine
prefabrication of details and new structural methods whenever
possible, though there were still important elements of precise as-
sembly and hand finishing in their work as in that of Adler &
Sullivan or Holabird & Roche. In contrast the intricate and com-
plex interiors designed by Louis Comfort Tiffany (1848–1933)
and the furnishings especially fashioned for them required hand-
work down to the smallest detail. Instead of entering and assum-
ing control of the large jewelry business established by his father,
Tiffany formed a workshop where he and his assistants designed

fabrics, lamps, glassware, jewelry, and countless other objects with motifs derived from plant forms. Enhancing the undulating curvilinear forms are the colors: iridescent violets, mauves, ochres, and greens. Though most of his production consisted of *objets d'arts,* Tiffany also designed a number of stained glass windows and several interiors, including the dark and brooding studio for himself (Fig. 172) which occupied the upper stories and roof of a large house in New York built by McKim, Mead & White; on the floors below were separate apartments for Tiffany's father and sister. Yet, as hauntingly beautiful and coherent as Tiffany's work was, it was highly idiosyncratic, expensive, and hence accessible only to a small circle of progressive enthusiasts.

Gustav Stickley (1848–1942) took a different approach, for he wished to see residences for people of moderate means designed as a unified whole, including furniture and fittings, and to make this practicable he simplified elements so as to make his designs suitable for machine-assisted production. Not a practicing architect, Stickley began by designing furniture in 1898 and three years later, in 1901, he started publication of *The Craftsman,* a monthly journal aimed at promulgating the belief, as he wrote in the first issue, "that beauty does not imply elaboration or ornament." His general attitude toward simple, directly revealed craftsmanship owed much to William Morris and the Arts and Crafts movement in England. He reproduced in *The Craftsman* views of houses which epitomized his philosophy (Fig. 173). He also published plans and construction drawings of houses especially designed for the magazine, and readers, on paying a small membership fee, could join a Craftsman's club and receive full working drawings of these houses. Thus, through the influence of the magazine and through the dissemination of drawings, Stickley came to exert a strong influence on the development of the so-called Bungalow Style in domestic architecture. Sadly, he was driven into bankruptcy in 1916 by furniture makers producing counterfeit Craftsman furniture.

To Frank Lloyd Wright as to Louis Sullivan the historicism of such buildings as McKim, Mead & White's Pennsylvania Station seemed to have nothing to do with American culture (at least as they perceived it). Both Sullivan and Wright focused intensely on selected aspects of that culture. Sullivan took on himself the problem of the modern commercial skyscraper, while Wright turned his attention to the free-standing suburban house, reshaping it around the changing social patterns of the American family. Wright's sources were classic, romantic, exotic, eclectic to a high

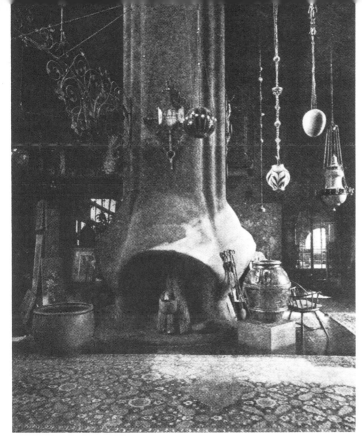

172. Louis Comfort Tiffany, Tiffany studio apartment, New York, New York, 1884–86.

173. "A Craftsman Living Room, Seen From the Hall."

degree, but his goal was an ordered unity which eventually made Queen Anne and Shingle Style houses (his immediate sources) seem like ill-digested aggregations. Thus, in many ways, Wright's search for a more ordered, coherent, integrated architecture paralleled that of the more traditional neoclassicists. Wright, however, set about inventing his own architectural language. As Vincent Scully observed, the neoclassicists relieved the pressure while Wright struck out in new directions.

Frank Lloyd Wright (1867–1959) was born in Richland Center, Wisconsin. His mother was of Welsh extraction, his father was an itinerant preacher. From Richland Center the family moved to New England where young Wright spent his earliest years in Rhode Island and Massachusetts. The family returned to Wisconsin where Wright passed long summers among his mother's family on farms around Spring Green. There grew in him a love of the soil which led, in later life, to his championing Jeffersonian agrarianism.

Many strands wove together to form Wright's architecture. The first and most crucial one was the influence of his mother, who, convinced that her unborn child would be an architect, hung prints of cathedrals in the nursery. Later, when she saw the Froebel kindergarten equipment on display at the Centennial Exposition in Philadelphia, she purchased the "toys" for her son. Much of his characteristic massing and geometric patterning was influenced by early play with the Froebel blocks.

Most pervasive was Wright's love of the land, nurtured during the summers in Spring Green. He came to view architecture as subject to the same rules that govern the organic growth and development of plant life, with each part related to every other part so as to form a functionally complete organism. Like plants, buildings should grow out of the soil and be a part of it. This love of nature led him to the writing of John Ruskin; the Lamp of Truth became Wright's cause also. There could be no sham construction, no artifice, but rather each element was to be exploited to reveal its inherent color, texture, function, and shape. One should build, as he said, "in the nature of materials."

In 1885–86 Wright attended classes at the University of Wisconsin at Madison, studying French and drawing, and though later he had little good to say of the experience, he discovered then the writing of Viollet-le-Duc. The Frenchman's insistence on structural determinism and expression was to affect Wright deeply so that later this was one of the very few sources he acknowledged and recommended to disciples.

Wright knew the Shingle Style, and when he set out on his own in Chicago in 1887, he went directly to the office of J. Lyman Silsbee, a prominent residential architect who used this. Wright may have worked, in fact, on some of the houses designed by Silsbee for Edgewater, north of Chicago (see Fig. 132). Staying with Silsbee only a short time, Wright left to enter the office of Adler & Sullivan in 1888 where his draftsmanship was put to good use completing interiors of the Auditorium. Soon he had gained a responsible position in the office and, because Sullivan wished to concentrate on the larger commercial work, many of the residential commissions were put in Wright's care. A notable example is the Charnley house in Chicago, 1891, designed by Sullivan but supervised by Wright.

Taking an advance on his salary in 1889, Wright built for himself and his bride a house in Oak Park, a Chicago suburb then a haven for intellectuals and reformers (Fig. 174). In this early house Wright showed his debt to the Shingle Style architects, especially to Bruce Price whose houses at Tuxedo Park, New York, served as models. Even so, Wright simplified the forms, reducing the house to a single broad gable on a low base. The entire surface is covered in shingles. In the gable window is the barest hint of the Palladian sources of colonial American houses; inside too are subtle classical details. The innovative character of

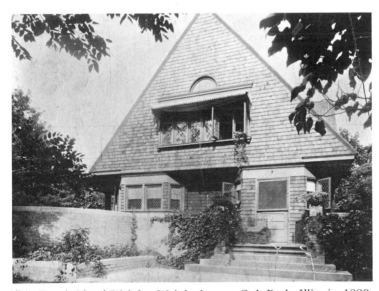

174. Frank Lloyd Wright, Wright house, Oak Park, Illinois, 1889.

the interior, however, comes from the grouping of rooms around the central fireplace. Furthermore the walls are treated as though they are sliding panels giving the impression of a traditional Japanese house. In 1893 Wright was able to see an actual Japanese building firsthand, the Ho-o-den, a half-scale reproduction of the Ho-o-do at Uji, built by the Japanese as their official pavilion at the Columbian Exposition. The crossed axes, stressed horizontals, hovering roofs, and frame construction were to make a lasting impression on Wright.

Wright's growing family, and the resultant proliferating bills, plus his passion for collecting Oriental art led him to take on work outside Sullivan's office, violating his contract. When this moonlighting was discovered Wright was acrimoniously dismissed. Fortunately Wright was well enough established to continue on his own, and one of the first commissions following the break secured his practice. This was the house for William H. Winslow in River Forest, Illinois, 1893–94 (Fig. 175) In this house one can see Wright's flirtation with classical formality and compositional rules he was soon to avoid. Here the house presents two faces, a formal front to the street and an informal face to the rear where the house is shaped to fit the functions of the family. The street façade is bilaterally symmetrical, with carefully studied proportions, but the rear is highly irregular, with recesses and projec-

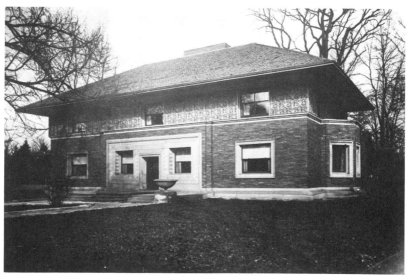

175. Frank Lloyd Wright, William H. Winslow house, River Forest, Illinois, 1893–94. Photograph. c.1910.

tions both horizontally and vertically. The plan is focused on a central chimney mass, perhaps inspired by colonial house plans, and the heavy cantilevered eaves suggest Oriental comparisons. Thus in the Winslow house one can perceive synthesis underway, in the combination of neoclassicism, Sullivan's work, colonial sources, and even a touch perhaps of the Turkish pavilion at the Columbian Exposition in the second-story stucco frieze. Out of all this Wright eventually forged the Prairie Style.

By 1900 this assimilation was complete; the box of the Winslow house was broken and the Prairie house was born. One of the first was the Ward W. Willitts house, Highland Park, Illinois (Figs. 176, 177), designed as early as 1900 perhaps and completed in 1902.

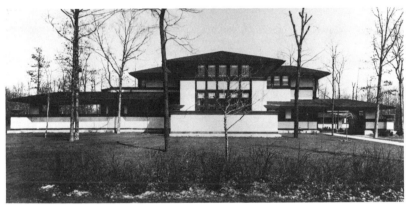

176. Frank Lloyd Wright, Ward W. Willitts house, Highland Park, Illinois, 1900–02.

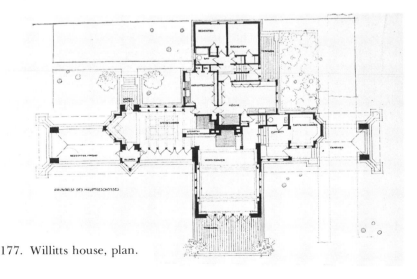

177. Willitts house, plan.

Where the Winslow house was tightly contained, the Willitts house is explosively open, its plan a pinwheel of spaces moving out from the central fireplace mass. Vincent Scully has described the house as embodying both a sense of rootedness and protection with freedom and mobility, for it is pinned to the earth by its clustered chimneys and its ceilings are low and intimate yet they extend far beyond the seried windows under long cantilevered roofs. To Wright the house was no longer a collection of isolated rooms but interwoven spaces, thus the hovering roofs seem to penetrate the block of the house. Everywhere the horizontal line dominates, pulling the house close to the earth, making it seem part of the prairie. This tie is strengthened by the terraces extending from the house which make the transition from interior space to exterior space gradual rather than abrupt as in the Winslow house.

In these frame suburban houses Wright gave expression to the straightforward use of the machine, just as in the irregular interwoven plans he captured the spirit of modern family life. He was able to go beyond this, however, to demonstrate how the principles of "Organic Architecture," as he called it, could reshape the office block and the church. The Larkin Building, Buffalo, New York, 1903 (Fig. 178), contradicted conventional office building norms in much the same way that the Willitts house had done for the typical house. Where the Prairie House opened out to the landscape, however, the Larkin Building was introverted, with circumferential balconies of office space overlooking an internal rectangular court, so arranged in the hopes of fostering a sense of community among the workers. The entire building was a great machine, a near-perfect union of structure, space, and mechanical equipment. In the projecting corner piers, for example, were stairs, and the hollow walls of the towers contained ducts for ventilation. Hollow too were the sphere-topped piers which likewise performed double duty as ventilation shafts. The elaborate built-in ventilation system was necessitated by the location in a heavy industrial area; hence the building was hermetically sealed against soot and fumes. Inspired by Sullivan's office skyscrapers, the Larkin Building is also expressive of its internal function, for each element of the exterior refers to the internal organization.

In a similar way Wright expressed the important interior space in the external massing of his Unity Temple, Oak Park, Illinois, 1904–6 (Fig. 179). Unity Temple consists of two units, the Temple auditorium and the Unity House social hall, with the entrance to the building under a low hood on the side between the two blocks. (One also entered the Larkin building at the side.) Each part of

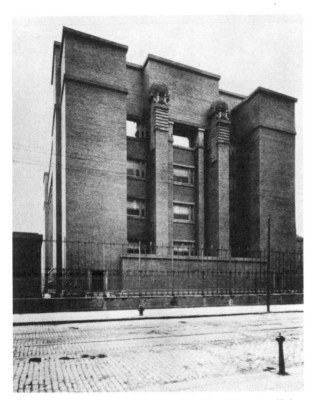

178. Frank Lloyd Wright, Larkin Building, Buffalo, New York, 1903.

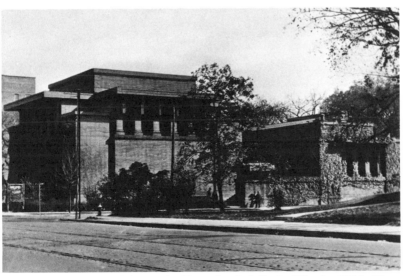

179. Frank Lloyd Wright, Unity Temple, Oak Park, Illinois, 1904–06.

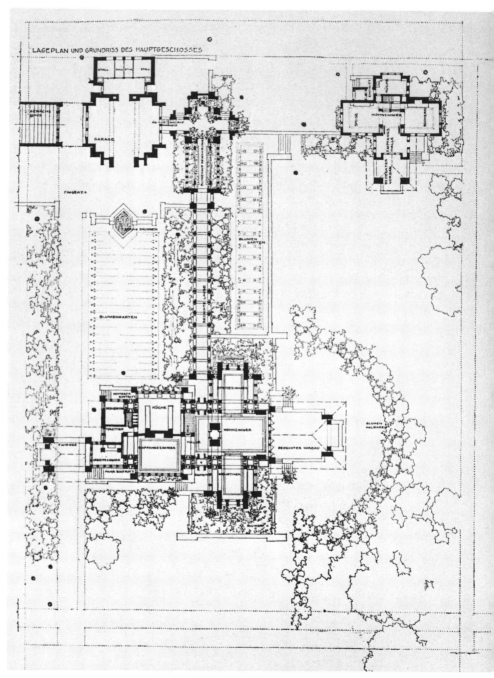

180. Frank Lloyd Wright, Darwin D. Martin house, Buffalo, New York, plan, 1904.

the exterior of Unity Temple discloses an internal function, so that the cubical space of the auditorium is clearly indicated, as are the stairs in the corner piers. The interior is lit by clerestory windows on three sides and by twenty-five square skylights piercing the flat concrete roof slab. To keep within the limits of the budget, Wright used a square plan with identical forms for the poured concrete on three sides of the auditorium block. Care was taken that the pebble aggregate of the concrete be exposed on the exterior, expressing the material and giving the building a distinctive textured surface. This extensive use of poured concrete in Unity Temple as well as its surface treatment were significant innovations.

In the design of these public buildings Wright was moving toward an architecture of spaces articulated by structure and mechanical services alone. The clearest statement of this is in the Darwin D. Martin house, Buffalo, New York, 1904 (Fig. 180). Walls as traditional confining opaque planes virtually disappeared, so that the house became spaces defined by banks of windows and brick piers. Integrated into the clusters of piers which support the house are lighting elements and heating, so that the forms that punctuate the spaces at regular intervals also contain mechanical services (Fig. 181). The living room of the Martin house illustrates well the comprehensive design impulse which shaped every part of the house, including lighting units, built-in

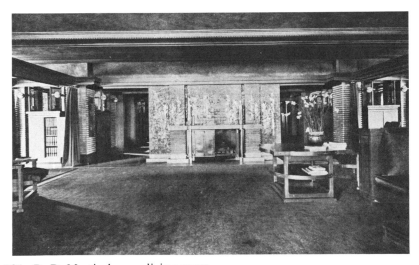

181. D. D. Martin house, living room.

and free-standing furniture, art work (as in the mural over the central fireplace), and rugs and hangings. In this Wright was influenced by William Morris and the English Arts and Crafts movement and perhaps even by Gustav Stickley's *Craftsman* magazine. Such unified interiors also parallel the similar comprehensive design of Tiffany's interiors or even the careful Renaissance classicism of McKim's Boston Public Library.

The Prairie house in its essence embodied a union of nine principles listed by Wright. First, the number of parts of the house were reduced to a minimum to achieve greatest unity. Second, the house was integrated with its site by extending the horizontal planes. Third, the room as a box was eliminated in favor of spaces defined by screens and panels, with little space wasted on structure. Fourth, the damp basement was eliminated by raising the house up off of the ground, placing the major living quarters up one flight with a better view of the landscape. Fifth, windows became banks of "light screens" rather than holes cut in walls. Sixth, the number of materials was reduced to a minimum with ornamentation expressive of the materials and designed for machine production—hence the propensity for straight lines. Seventh, all heating, lighting, plumbing, and mechanical fixtures were incorporated into the fabric of the building and made architectural features. Eighth, all furnishings were made one with the building. And ninth, the "fashionable decorator" was eliminated.

The house in which all of these principles find their fullest realization is that for Frederick C. Robie, designed by Wright in 1906 and built in 1908–9 (Figs. 182, 183, 184). Perhaps because Wright had to contend with a narrow city lot, he was forced to clarify

182. Frank Lloyd Wright, Frederick C. Robie house, Chicago, Illinois, 1906–09.

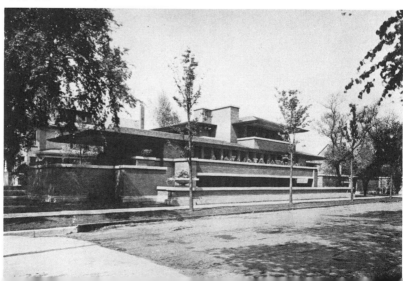

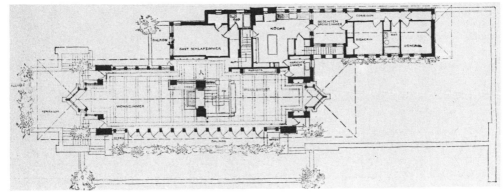

183. Robie house, plan, main (second) floor.

each of the nine points. One enters through a dark, recessed vestibule on the side of the house, and, following a circuitous route, ascends a winding stair to the main level. At the top of the stair is a single room, indicated by the long bank of windows along the south side. The spaces for living room and dining room are defined by the mass of the fireplace which pushes up through the center of the space. Even this, however, is not allowed to interrupt the space completely for at the top it is divided into two piers; through the opening the ceiling and lights of the adjoining room can be seen so that one is constantly aware of the continuity of space. The lights themselves are part of the ceiling and the upstands along which they march enclose steel beams which span the length of the house and carry the incredible cantilevers at each end. Incorporated into the same ceiling upstands are concealed lighting and a ventilation system that carries stale air to the central

184. Robie house, dining room, showing original furniture by Wright.

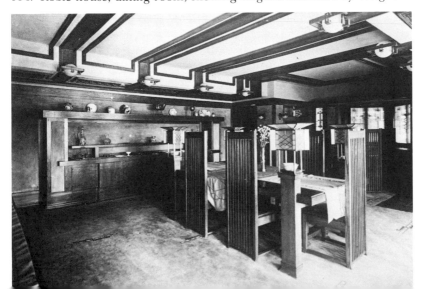

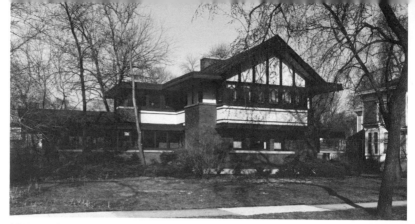

185. Walter Burley Griffin, Frederick B. Carter house, Evanston, Illinois, 1909–10.

chimney and vents it to the exterior through a grill in the chimney brickwork. Externally, the horizontal planes and extended roofs create long shadows which make the masses of the house seem to float. In this, and in the way that every part of the house contributes to the unity of the whole, the Robie house is a synthesis of all that went before it.

In 1910 Wright experienced concurrent domestic and professional crises; his home life and career disintegrated. During the next quarter century Wright's work was overshadowed by that of lesser men. Yet his influence did not abruptly come to an end for during the good years in Oak Park Wright had gathered about him in the studio a group of young men and women who now began to exert an influence of their own. This was the Prairie School. One of them was Walter Burley Griffin (1876–1937) who grew up in Oak Park, had studied architecture at the University of Illinois, and was in Wright's studio in Oak Park from 1901 to 1905. In Griffin's house for Frederick B. Carter, Evanston, Illinois, 1909–10 (Fig. 185), one can see a good example of the impact of Wright's ideas. Though the design is wholly Griffin's—and is marked by his characteristic verticality, open gable ends, and flattened eaves—in the open plan, with rooms clustered around a central fireplace mass, in the horizontal emphasis, and the simple plain surfaces one sees the influence of Wright. In the Carter house Griffin also combined more materials than did Wright, using stone, dark red brick, wood, and stucco, but with the masonry restricted to simple supporting masses at the ground floor.

Other members of the Prairie School were William Gray Purcell and George Grant Elmslie. Purcell also grew up in Oak Park and studied architecture at Cornell before working briefly for Sullivan where he met Elmslie. George G. Elmslie was a native of Scotland

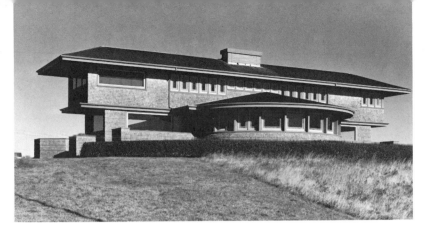

186. Purcell & Elmslie, Harold C. Bradley house, Woods Hole, Massachusetts, 1911–12.

and had little formal training, but he spent nearly twenty years in Sullivan's office as a devoted assistant and collaborator in the Carson Store and the later banks. Of the residences by Purcell & Elmslie, the most striking is the Harold C. Bradley house at Woods Hole, Massachusetts (Fig. 186). In the manner of Wright, the house accentuates a splendid site, a narrow peninsula jutting out into the Atlantic Ocean; it sits on a slight rise, making its greatly cantilevered floors appear to hover like wings. The T-shaped plan has at its core a large fireplace mass, which, like the semicircular dining conservatory, is derived from Wright's work. The boldly projecting floors are distinctive and were even more dramatic before the screening of the ground-floor porches had the effect of making the base appear to be more solid. Particularly important is the shingle covering, for it brings the Shingle Style component in Wright's work back to its original seaboard source.

While Wright and his followers were reshaping residential architecture around Chicago, significant developments were also taking place in California which visually, at least, seem related, but in fact were the fruit of developing local traditions and the growing influence of Oriental building techniques. In Pasadena the brothers Henry M. and Charles S. Greene (1870–1954 and 1868–1957) developed a mature and highly complex expression about 1902–3, which combined elements of the Stick Style, Stickley's influence, the English Arts and Crafts movement, and, especially, Japanese techniques of joinery. One can see in this highly developed carpentry the influence of the brothers' early training in manual arts. The David B. Gamble house, Pasadena, 1907–8 (Fig. 187), is one of their best, with large rooms clustered in seemingly random irregular patterns. The low roofs, carried on elaborate brackets, form a series of parasols shading large parts of the

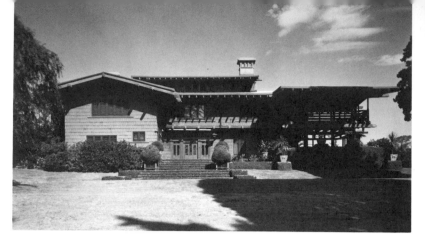

187. Greene & Greene, David B. Gamble house, Pasadena, California, 1907–08.

house. Every part of the frame, while structurally necessary, is lovingly exploited for maximum visual effect, with all corners and edges softly rounded as though worn smooth with time. The Greenes' houses rose slowly, for the architects themselves were often involved in the building, combing local ravines for stones and directing the cutting and fitting of complex joints. This consummate craftsmanship was in part inspired by Stickley through *The Craftsman,* and to a degree it is even more carefully refined in detail than the contemporary work of Wright. Like Wright, who was also influenced by Morris and Stickley, the Greenes designed elegantly simple interiors and pieces of furniture for their houses. While the furniture was basically rectilinear, and incorporated stained glass, leather, and inlays of wood and shell, resembling in a way Wright's furniture, the overall effect was more softly rounded.

The nearby work of Irving Gill (1870–1936) could hardly be more different. Gill was born in Syracuse, New York, the son of a building contractor, and this early experience resulted in Gill's later experiments in simplifying the building process. For a brief time Gill was in Chicago in Sullivan's office during the same period that Wright was there, working principally on the Transportation Building for the Columbian Exposition, but in 1892 Gill had to go to California for his health. He built up a practice centered around San Diego, and his early designs in stucco resemble those of C. F. A. Voysey and Otto Wagner in their severely reduced traditional forms. Gill's house for Walter L. Dodge, Los Angeles, 1914–16, was one of the best examples of his work, revealing a functional asymmetry whose ornament was derived solely from the studied geometry of the sharp openings in the plain walls. The Dodge house was for a well-to-do client, analogous to

Wright's clients, but Gill had a deep concern for practical housing for workers. Using prefabrication techniques developed by the U.S. Army, Gill assembled whole wall segments of reinforced concrete flat on the ground, tilting them upright into place to form the completed building. Such a process, demanding simplified details and sharp edges, was used for the Lewis Courts, Sierra Madre, California, 1910 (Fig. 188). This housing venture consists of eleven units around a court terraced with playing areas and covered walkways. The Lewis Courts, in particular, were quite successful, so much so that the developer raised the rents, infuriating Gill.

Little has been said of new urban planning in the period from 1885 to 1915, since, for the most part, existing cities simply expanded. This was a period of great consolidation combined with vigorous growth around established centers. This boisterous growth, characterized by a drive unequaled until about 1950, caused increasing concern among many architects for it was completely unplanned. Against this background of rampant jerry-building, the carefully organized plan of the Columbian Exposition in Chicago appeared like a dream, its harmonized architecture in sharp contrast to the industrial city of Chicago that produced it. When in 1890 the first report was made by Frederick Law Olmsted to the organizers of the fair, concerning possible sites in Chicago, he urged that a lake site be chosen and that above all that there should be harmony between buildings and grounds. This scheme was quickly taken up by the architects ap-

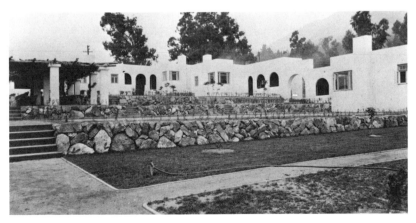

188. Irving Gill, Lewis Courts, Sierra Madre, California, 1910.

pointed by Daniel Burnham to design the various main buildings of the fair. At one of the earliest meetings of the architects, in 1891, it was resolved that there would be unity of expression, and from this it followed that, to achieve this desired unity, it would be necessary to use the classical style since that was the only one all of them knew equally well. It was a modular system of design, one suited to subdivision of detail and to enrichment by means of sculpture and mural painting. Meanwhile the plan of the fair, based on suggestions by Olmsted, was worked out by Olmsted's assistant Henry S. Codman, Burnham, and Root. The site selected, a marshy morass south of Chicago's center, was dredged to create lagoons, and the reclaimed soil was placed behind retaining walls, resulting in the formal character of the southern portion of the fair. Of the several innovations, one was the zoning of activities in four areas: a formal area to the south for the main exhibits, a more informal lagoon in the middle, an irregularly laid-out area to the north for national and state pavilions, and a midway to the west for amusements.

Each of the architects selected the building of his preference in consultation with Burnham who directed the whole operation, designing nothing himself. The architects of the buildings around the Court of Honor to the south were R. M. Hunt, McKim, Mead & White, George B. Post, and Peabody & Stearns, while the buildings in the middle zone were done by Jenney, Sullivan, and other Chicago architects. At the north of the winding lagoon was Charles B. Atwood's Palace of Fine Arts, the most academic of the group; it has been restored and is the only surviving building of the fair.

The Columbian Exposition changed the course of urban building in the United States and, because of its great popular appeal, led to the birth of modern American urban planning. Critics and public alike responded warmly to the planning of the ensemble. The individual buildings, for instance, had been designed to form a harmonized group through the use of a uniform cornice height and arcade module (Fig. 189). Furthermore the spaces between the buildings had been just as carefully planned to facilitate easy movement and to permit viewing the buildings in groups. There was a unity of expression throughout the grounds enhanced by the use of coordinated painting and sculpture. Water was used extensively in lagoons and fountains because of the location on Lake Michigan, making this one of the first large-scale demonstrations in the United States of the public use of water. Especially important too, though largely hidden from view, were the interconnected utilities and services such as the underground electrical

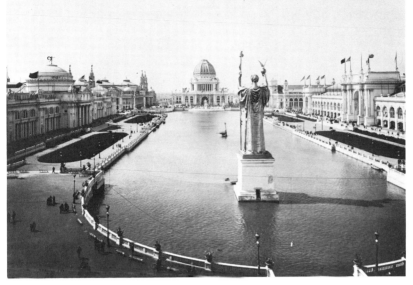

189. Columbian Exposition, Chicago, Illinois, Court of Honor, looking west, 1891–93. In the foreground, left to right: Agriculture Building by McKim, Mead & White; *The Republic* by Daniel Chester French; Manufactures and Liberal Arts Building by George B. Post. In the distance, the Administration Building by Richard Morris Hunt.

and telephone systems, the intermural electric railway, the moving sidewalk on the lake pier, the electric illumination of all the buildings, and the large railroad depot that placed arriving visitors at the strategic centermost point of the fair.

The success of the Chicago Fair spurred the creation of subsequent celebrations, such as those in Buffalo (1900), St. Louis (1904), and especially the Panama-Pacific Exposition in San Francisco in 1915. In the San Francisco Fair the exhibition space was essentially one large rectangular building opened up by several large courtyards; consequently the architects designed the spaces rather than the building proper. At the end of the long main building was a Palace of Fine Arts designed by Bernard Maybeck. It consisted of a round temple next to a reflecting lagoon enclosed in a curving colonnade and gallery where the exhibits were displayed (Fig. 190). Maybeck had been a student at the École in Paris and was an eclectic of the best order. His Palace of Fine Arts, particularly its focal temple, is instructive because it reveals the eclectic's attitude toward design; Maybeck described his intent in designing this frankly Roman ornament, saying that the building was to be a "conveyor of ideas," meant primarily to induce intellectual and emotional associations in the mind of the observer. This the temple certainly did extremely well, to such an extent that it fixed itself in the self-image of San Franciscans and has

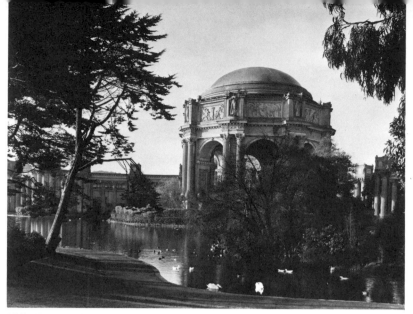

190. Bernard Maybeck. Panama-Pacific Exposition, San Francisco, California, Palace of Fine Arts, 1911–15.

recently been restored. Though Maybeck is perhaps best remembered for his more experimental work in the San Francisco Bay area, such as his houses or the Christian Science Church, Berkeley, 1909–11, this traditional design helps to illustrate the popularity of the classical architecture of these exhibitions.

It was such fairs that brought the City Beautiful movement to thousands of people who delighted in their bright order and the conveyed associations. As a result in scores of cities planning commissions were appointed and hundreds of new classical buildings were begun to house museums, libraries, art galleries, courthouses, and other public institutions. Often these were clustered together in civic or cultural centers forming the terminal elements of grand new monumental boulevards. The civic center of Cleveland, to name just one, was begun in 1903 and completed by stages during the following half century generally following a plan prepared by Burnham.

As a direct result of the Columbian Exposition, in 1901 the United States Senate engaged Burnham, McKim, and Frederick Law Olmsted, Jr., to study the park system of the District of Columbia and to recommend improvements. At least this was the way the legislation read, though the real objective placed before them was to replan the entire city so as to restore the order of L'Enfant's plan. That grand scheme had piecemeal been belittled by insensitive presidents and graft-ridden congresses. The first and most obvious digression had been the placement of the Wash-

ington Monument obelisk well off the crossing of the mall axes at a place where subsoil conditions permitted its construction. This was followed by the construction of Renwick's Smithsonian Institution near the center of the Mall, Downing's romantic landscaping of the White House grounds for President Fillmore, and lastly and most serious, the construction of a railroad station across the middle of the Mall. All this the Senate Park Commission set about to correct. After touring colonial Williamsburg and nearby plantations, the commission left for Europe to inspect the leading capital cities and estates that had served L'Enfant as models. Upon their return, gathering a small army of illustrators and architectural draftsmen, the commission prepared a large exposition clearly demonstrating their proposals. Their extensive models and drawings were shown to Congress and the public when the commission made its report in January 1902.

Drawing upon the lessons of the Columbian Exposition, the Senate Park Commission offered proposals in three general areas: the reclamation of the Mall, the planning of governmental and district office buildings around the White House and Capitol, and the development of an extensive network of interconnected parklands throughout the District. Elaborate drawings were prepared (Fig. 191) to show how the Mall could be redeveloped by slightly rotating the axis so that it bisected the Washington Monument. This would then be further strengthened by new public buildings lining the edges of the Mall and by the construction of a major memorial to Abraham Lincoln on new land reclaimed from the

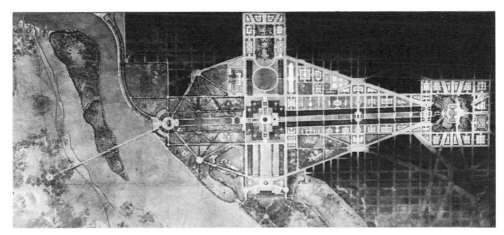

191. Senate Park Commission, plan of proposed changes to Mall, Washington, D.C., 1901–02.

Potomac River. Furthermore, in a gesture of civic munificence, the railroads agreed to build a new station north of the Capitol, abandoning their old right-of-way across the Mall. Thus the open sweep and "reciprocity of sight" which L'Enfant had envisioned could be restored. This work of reclamation and redefinition has been continued according to the spirit of the Senate Park Commission's report, though details have been changed as needs and conditions have varied.

As the new century began Burnham focused his energies increasingly on city planning. His early plan for Cleveland, 1902–3, drawn up with the assistance of Brunner and Carrère, has already been mentioned. In 1905 he drew up plans for Manila and for Baguio, a new summer capital of the Philippines. In 1902 he began preparation of a comprehensive plan for San Francisco which was finished in 1905, but which unfortunately was largely disregarded in the rush to rebuild the city after the earthquake in 1906. Much more successful in the long run was Burnham's plan for Chicago begun in 1906 under the auspices of the Commercial Club. Burnham began by making a comprehensive examination of the region around Chicago extending nearly seventy miles in radius. His goal was to integrate fully the interrelated transportation, industrial, and commercial networks for the greatest efficiency while at the same time to make the city physically and culturally a better place to live. These latter ends he met by urging

192a. Daniel H. Burnham, Plan of Chicago, metropolitan plan showing relationship of traffic arteries, existing recreational facilities, and proposed parkland.

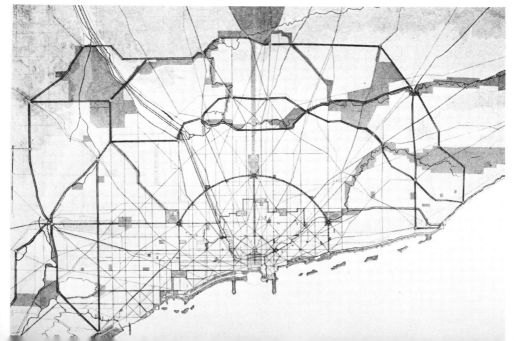

the development of a far-flung system of city and county parks, by reclaiming the entire lake shore as a linear park, and by building a cultural and civic center in a park in the center of the city looking out over Lake Michigan. The report, published in 1909 with many illustrations some of which were in color (Fig. 192), moved from considerations of Chicago in relationship to its supplies of raw materials to such details as specific proposals for the architectural treatment of the Chicago River embankment. Over the next half century many of Burnham's proposals were gradually realized. The lake front was filled out eastward from the Illinois Central tracks to form a new park strip from Grant Park to Jackson Park to the south. In addition to further development of the city's parks, large tracts of land were set aside to form the Cook County Forest Preserve. Portions of the Chicago River were lined with quays, part of this the result of the construction of double-decked

192b. Plan of Chicago. Detail plan showing relationship of proposed civic center, union passenger railroad stations, commercial center, and lakefront cultural center.

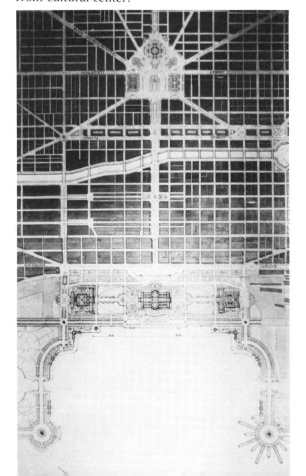

Wacker Drive as proposed by Burnham. And though the civic center with its monstrous domed city hall was never built, the cultural amenities of the city were grouped at the heart of the city in Grant Park on the lake, rather than in an isolated compound.

All of this was important, for it served both the interests of the businessman and the genteel urban dweller, and it is significant that the Columbian Exposition and Burnham's planning appeared at the moment when the urban network and business systems had been completed and attention began to turn toward improving the social and physical environment. Still, in the hearts of the major cities, workers were most often forced to live in overcrowded squalid tenements that rapidly deteriorated into slums. Though entreaties and diatribes against such living conditions had been published for half a century, written language had lost its power to convey the truth accurately and shockingly. In the 1880s police reporter Jacob Riis taught himself the rudiments of photography and began to probe the worst slums of New York, taking flash pictures of the conditions he found. His views, published first as engravings in 1890 in *How the Other Half Lives,* reappeared as half-tone photographic reproductions in the subsequent editions. The stark unflinching photographs told more than had a generation of impassioned writing, and within two years of publication reform movements had started work in New York and numerous other cities.

The effect of Riis's work, and of the passage of new tenement laws in New York, has already been described in the discussion of the long-range influence of Alfred T. White's model tenements in Brooklyn, but parallel to this concern for better urban housing was a marked improvement in the standard of the best company-built towns. The largest of all of the company towns started in this period was certainly Gary, Indiana, begun in 1905 by the United States Steel Company and named for the corporation's lawyer. A choice location at the foot of Lake Michigan was obtained, but nearly all of the shore was set aside for industrial use, with the housing and commercial district to the south in an unmitigated grid. The scale was vast, aimed at an ultimate population of as many as 200,000 people, but the company exercised no comprehensive housing program (an overreaction to the Pullman scandal), and the inevitable result was overcrowded and minimal-quality housing. Gary was representative of one kind of company town in which the company engineer laid out a conventional grid and housing was built by private speculators. A second type, in which the company laid out a grid but in which the buildings were

designed by recognized architects, is exemplified by "Echota" at Niagara Falls, New York, built for the first electric power company there with houses by McKim, Mead & White, 1893–95. A third type, in which a recognized planner laid out the streets but the company or individual workers built the houses, is best represented by Vandergrift, Pennsylvania, planned for the Apollo Steel Company by Frederick Law Olmsted in 1895 (Fig. 193). In this, one sees the curving streets and emphasis on varied prospects which had marked Olmsted's earlier plan for Riverside, Illinois. What was most significant in this period, however, was the emergence of a new tradition in company town construction—the planning of both street and land-use pattern and of housing by recognized and skilled professionals, in some cases all by the same individual or firm. Important examples are the additions to Hopedale planned by Arthur A. Shurtleff with duplex houses by Robert A. Cook in 1910 (Fig. 194); Kohler, Wisconsin, planned by Hegemann & Peets with the Olmsted Brothers, and buildings by Brust & Philipp, 1913; Warren, Arizona, a copper mining town

193. Frederick Law Olmsted, Vandergrift, Pennsylvania, plan for the Apollo Steel Company, 1895.

194. Robert A. Cook, architect; Arthur A. Shurtleff, planner, Lakeside Group, addition to Hopedale, Massachusetts, 1910.

planned by Warren H. Manning with buildings by Applegarth and Elliott, begun in 1906–8; and Tyrone, New Mexico, another copper mining community designed and planned by Bertram Grosvenor Goodhue in 1914.

Tyrone has attracted the interest of students of town planning history because it was done by one of the most prestigious architects of the period, and Goodhue was apparently engaged because the Phelps Dodge Company, developers of the Burro Mountain mine, wanted to construct a model mining community. Just over a mile from the mouth of the mine tunnel, Goodhue placed the central plaza of the town in an arroyo, with the houses for workers and supervisors on the crests of the ridges above (Figs. 195, 196). The public buildings around the plaza, particularly the church, were designed in the colonial Spanish-Mexican Baroque that Goodhue was using at the same time for the theme buildings for the Panama-California Exposition in San Diego, California, but for the residences he studied local adobe structures. The houses of both the Mexican workers and the American supervisors were built of hollow tile blocks, covered with several layers of tinted stucco. The plaza, perhaps somewhat grand in view of the projected population of the town, was to have a full range of facilities—shops and offices, company store, theater, workers' club, hotel, garage, post office, public school, railroad station— and in the hills above was a hospital. Unfortunately less than half of this development was completed for a collapse of the copper market after the First World War and the very low grade of the Burro Mountain ore forced Phelps Dodge to close Tyrone after it had been in operation only three years. Still, though truncated, Tyrone was an important experiment and it was a significant influence in the career of the young assistant in Goodhue's office who supervised the Tyrone drawings—Clarence Stein.

195. Bertram Grosvenor Goodhue, Tyrone, New Mexico, for the Phelps-Dodge Company, 1914–15. View of the village piazza as planned.

196. Plan of Tyrone.

197. Grosvenor Atterbury, "Indian Hill," Worcester, Massachusetts, plan for the Norton Grinding Company, 1915.

Tyrone is the exception in Goodhue's work, which largely came to be concerned with public buildings and commercial structures, but one architect came to prominence during this period almost entirely for his design of worker housing complexes; this was Grosvenor Atterbury. Initially Atterbury, like so many other young architects, was busy with the design of comfortable country houses, but at the same time he lectured on the design of good, commodious, soundly constructed workers' housing. The result was that shortly he was given commissions for such groups, and often acted both as planner and architect. His most attractive industrial village was "Indian Hill" for employees of the Norton Grinding Company, outside Worcester, Massachusetts, begun in 1915. On a gentle hillside adjacent to the factory, Atterbury laid out a system of streets curved to fit the topography, focusing on a square lined with shops and leading to a bridge over the railroad which provided pedestrian access to the factory (Fig. 197). On the 116 acres only fifty-eight free-standing houses were completed, the antithesis of Gary, Indiana. Moreover the frame houses were highly conservative and traditional in expression, basically Dutch Colonial in style with large dormers pushing out of gambrel roofs, but the individual rooms were well disposed for ventilation and were amply proportioned. Indeed, the evidence accumulating in such industrial villages as Hopedale, Ludlow, and Whitinsville in Massachusetts; Willimantic, Connecticut; Leclaire, Illinois; or Erwin, Tennessee (which Atterbury planned and designed in

1916) was that the more traditional in design the buildings, the more successful the enterprise.

Atterbury's reputation as a social progressive rests today on his design of the buildings for the suburban community of Forest Hills Gardens, now part of Queens, New York City. In an effort to improve the practicability of good middle-class housing, the Russell Sage Foundation (established in 1907 for the "improvement of social and living conditions") determined to build a model commuter suburb for people of moderate means, and in 1909 acquired a tract of 142 acres next to a branch of the Long Island Railroad which led to the new Pennsylvania Station on Manhattan, then nearing completion. This was to be the all-important link to the city. Frederick Law Olmsted, Jr., was engaged as planner, and Atterbury as architect. The plan they devised had a fan of winding major streets focused on a plaza and the commuter railroad station (Figs. 198, 199). At the plaza, and framing it, was

198. Grosvenor Atterbury, architect; Frederick Law Olmsted, Jr., planner, Forest Hills Gardens, New York, New York, aerial perspective, 1909–12.

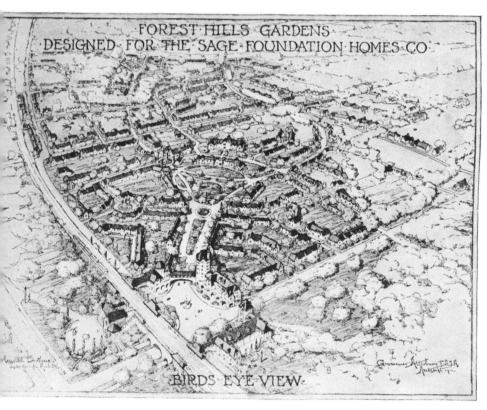

FOREST HILLS GARDENS
DESIGNED FOR THE SAGE FOUNDATION HOMES CO

BIRDS EYE VIEW

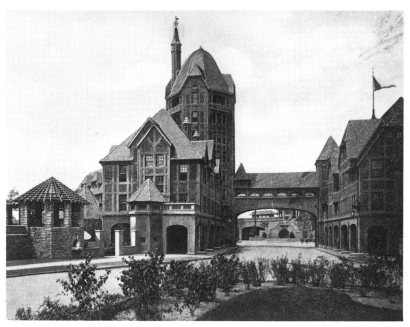

199. Forest Hills Gardens, Station Square.

an apartment tower with lower apartment blocks above arcaded shops; bridges spanned the streets connecting the apartment blocks and the station. Beyond this public square were town house clusters and single family houses, all built of brick and stone with standardized precast concrete elements. The experiment proved a modest success, returning about 3 percent to the foundation funds, but rising construction costs and increased demand for such solidly constructed housing soon made Forest Hills Gardens the enclave of a more affluent group than had been planned for. Still, Forest Hills Gardens marked an important improvement in the standard of community planning and the design of buildings in groups.

The search for order which began in 1885 brought structural logic and formal clarity to the American commercial high-rise by 1895, and concurrently led to a reappraisal of the prevailing view of *laissez-faire* in urban growth, and increasingly toward planned development. At first this meant classicizing civic centers, patterned after the example of the Chicago World's Fair, but gradually the scope of City Beautiful planning expanded to embrace and coordinate entire regions, as in Burnham's Chicago Plan. While this was going on, architects such as Wright and Stickley

sought to rationalize the modern house, attempting to make it more expressive and better adapted to modern living patterns and the influence of the machine. With little fanfare a revolution was effected in modern architecture, resulting in the creation of entirely new commercial and residential building conventions, and in the firm establishment of town planning as a profession. After 1914 the United States gradually became embroiled in the war in Europe, and private construction nearly ceased for the duration. When the war ended there was a pervasive desire to return to the normal order of things, but this could not be, for in the meantime a revolution had occurred in transportation; American cities and American architecture were to be radically reshaped by the private automobile.

7.

Dichotomy: Tradition and Avant Garde: 1915–1940

For a time during 1915 and 1916 Americans fervently hoped that the United States could avoid "foreign entanglements" and not become involved in the war in Europe. Many American manufacturers, however, saw business opportunity in producing war material for the allies, and as they expanded production they enlarged their work forces, creating intense demands for housing in communities which had no surplus of housing units. Several corporations began private programs of building industrial housing villages adjacent to the factories, one example of which was Atterbury's "Indian Hill" outside Worcester for the Norton Grinding Company started in 1915. Tyrone also appeared because of the war, for the demand for copper suddenly made the low grade ores of the Burro Mountains profitable to mine. Among other communities begun to accommodate workers in war-related industries was "Allwood" in Passaic, New Jersey, by the Brighton Mills Company; "Goodyear Heights" in Akron, Ohio, for employees of the Goodyear Company; and the nearby "Firestone Park" for employees of the rival rubber company. One of the largest towns started by private industry was Alcoa, Tennessee, the site of an extensive new aluminum production plant for the Aluminum Company of America. All of these were started in 1916 and many presented the work of the best planners and architects; Warren H. Manning and Mann & MacNeille in "Goodyear Heights," and John Nolen and Murphy & Dana in "Allwood" are representative. One community, "Eclipse Park" in Beloit, Wisconsin, begun late in 1916, is a good example (Fig. 200). On fifty-three acres north of the factory, the Fairbanks-Morse Company hired William Pitkin, Jr., landscape architect, and George B. Post

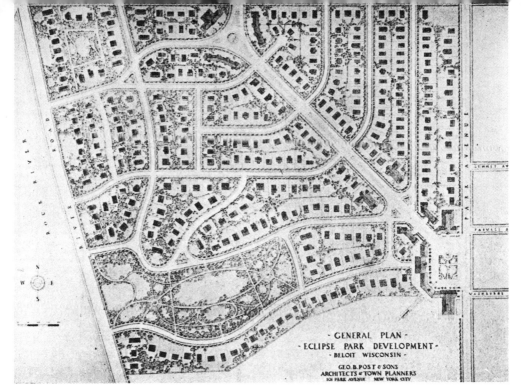

200. George B. Post & Sons, architects; William Pitkin, Jr., planner, "Eclipse Park," Beloit, Wisc., for the Fairbanks-Morse Company, 1916–17.

& Sons, architects, to lay out a workers' village of about 360 free-standing Dutch Colonial houses for the employees added when the plant began to expand production of internal combustion engines for the allies.

When it became clear that the United States would soon become a belligerent, and that industrial production would be further increased, several planners and architects became concerned that proper housing be provided for the numbers of workers about to be concentrated in locations already deficient in good housing. Soon after the United States declared war in April 1917, the American Institute of Architects sent Frederick L. Ackerman to England to inspect the housing construction there. On his return Ackerman suggested that housing boards be formed to develop permanent, well-landscaped and planned villages, rather than have impermanent barracks built. Worker morale would be higher, it was argued, and since the war gave every indication of continuing for several more years, this would prove the most economical solution in the long run. In this Ackerman was supported by Frederick Law Olmsted, Jr., and Otto M. Eidlitz. There was protracted deliberation, for many in Congress feared government intervention in building housing, but by the spring of 1918 three

agencies had numerous projects underway: the Ordnance Department (explosives manufacturing communities), the Emergency Fleet Corporation (shipbuilding), and the U.S. Housing Corporation, an agency of the Department of Labor (miscellaneous manufacturing). Just as their operations got fully underway the armistice was signed, but in the four months of their activity the three agencies were responsible for building more than 33,000 housing units, of putting new roofs over 138,000 people. All together, according to an estimate by Manuel Gottlieb, a total of 169,000 housing units were built in 1918, thus making the war industry housing nearly 20 percent of the total. And although complete and precise figures are difficult to assemble, the number of housing units built through the efforts of the war housing boards appears to have nearly equaled the total of all housing built by industry since 1800. Whatever the precise figure, the achievement of industry, government, and the architectural and planning professions working together was significant.

What makes this work particularly important was the caliber of design and planning, for as in the communities planned during the preceding two years the best talent available was engaged. "Morgan Park" for the United States Steel Corporation was planned by Morell & Nichols and designed by Dean & Dean (and it corrected all the mistakes of the earlier Gary, Indiana); "Hilton," Virginia was planned by H. V. Hubbard with buildings by Francis Y. Joannes; "Perryville," Maryland, was planned and designed by Mann & MacNeille; "Craddock," outside Portsmouth, Virginia, was planned and designed by G. B. Post & Sons; "Yorkship," outside Camden, New Jersey, was planned and designed by Electus D. Litchfield; the small "Union Park Gardens," next to Wilmington, Delaware, was planned by John Nolen with buildings by Ballinger & Perrot; and the immense Nitro, West Virginia, a munitions manufacturing town, was planned and designed by Graham, Anderson, Probst & White, the successor firm to D. H. Burnham & Company (as it was known after Root's death).

Some of these planners and architects, most notably Nolen, continued planning new towns, whether industrial or satellite, after the war, but most quickly turned their attention to commercial urban and residential suburban work, and indeed in the decade after the war the suburb became the focus of intense building activity. Before the war, from 1904 through 1916, approximately 485,000 housing units were built each year (varying from a high of 576,000 in 1909 to a low of 403,000 in 1904); but after 1920, when the number again reached prewar volume, it climbed

quickly, from 767,000 units in 1922 to a high of 1,048,000 units in 1925. Much of this was concentrated in the expanding suburbs.

The years between the wars were marked by strong contrasts, for it was a period of both ingenious invention and looking backward. There developed passions for modernity and nostalgia, and while one strove to establish a new industrial aesthetic, the other produced historicism's finest and final flower. Especially in the suburbs was this nostalgic historicism concentrated, for in the years following the war a great flight to the countryside around the cities began. Initially this urban exodus was led by the well-to-do, but the desire to escape was infused throughout the middle classes. At first the move to the suburbs proceeded along the lines of the commuter railroads and rapid transit, and there sprang up corridors of apartments along these rail lines, with nodes of shops and offices developing at the station points. The apartments were often of the court type, U-shaped blocks framing entrance courtyards, sometimes elaborately landscaped with terraces, trees, shrubbery, and fountains. Some, such as 277 Park Avenue, New York, 1925, by the younger succeeding partners of McKim, Mead & White, were so large as to be towns unto themselves.

Soon, however, the private automobile replaced trains and rapid transit as the most significant mover of people, and subtly but decidedly it began to reshape the city. Mobility had always been the American dream, but for the most part it was the privilege of the rich; now it became a reality for millions. It began in the 1890s with a craze for bicycles which, literally, paved the way for the automobile, for due to lobbying pressure from organized cyclists' groups, roads were graded and given a weatherproof macadamized surface. Had it not been for such all-weather roads the automobile would have been helpless, but ironically in thirty years it had pushed the bicycle off the road.

This revolution in transportation was produced by Henry Ford. Before 1903 the automobile was the expensive toy of the wealthy and Ford began by trying to enter this exclusive and competitive market. Failing in this, he decided to make simpler cheaper vehicles within the reach of a mass market. In 1907 he began production of his Model T, and in 1910 the Ford works moved to a new plant in Highland Park, Michigan, specially designed by Albert Kahn to accommodate Ford's innovative moving assembly line. By exploiting the assembly line and by making every car identical to every other (at a time when most were custom crafted), the price was steadily reduced year after year; in 1908 the cost was $850, in 1914 $490, and in 1926 it reached its lowest figure, $260. In the

meantime other inexpensive automobiles had appeared, and the geometric rise in registrations illustrates the change taking place, for while there had been only 8,000 automobiles on the road in 1900, in 1915 there were 2,332,000, and in 1930 it was ten times that figure. It is a truism, but a fact nonetheless, that Ford put the nation on wheels, and in the process radically altered American culture and its architecture.

The idea of the romantic landscaped suburb had arisen parallel with the emergence of industrialization, and in fact it was the railroad which made such early satellite communities as Llewellyn Park and Riverside possible, linking them with New York and Chicago. But after 1910 the combination of railroad and automobile brought landscaped suburbs to every large city in the United States. Boston had its seaside retreats on the north shore, such as Beverly, Pride's Crossing, and Manchester-by-the-Sea. New York was surrounded by Tuxedo Park to the northwest, Harrison, Rye, Greenwich, and Cos Cob to the northeast, and Glen Head and Roslyn to the east on Long Island. Philadelphia had Chestnut Hill and the string of suburbs along the Pennsylvania Railroad's "Main Line": Merion, Ardmore, Bryn Mawr, and Radnor. East of Cleveland, along Lake Erie, was Bratenahl, while to the southeast was Shaker Heights carefully developed by the Van Sweringen brothers to exploit the wooded landscape and a series of lakes. Stretching northward from Chicago along Lake Michigan ran Evanston, Wilmette, Winnetka, Glencoe, Highland Park, and further north, Lake Forest. While it is true that many of these communities were founded during the nineteenth century, their greatest period of growth was from 1910 to 1940.

That the suburban house was a major concern of the architectural profession can be gauged by the intensive treatment it received in the professional journals. There were frequent issues devoted wholly to the subject, as for instance *The Architectural Record* of October 1919. One could find in such magazines extensive illustration of the latest examples, such as the house in Hartford, Connecticut, by Goodwin, Bullard & Woolsey of New York in the August 1919 issue (Fig. 201). Careful attention was given to the interiors of such houses, and although there was great eclectic freedom in the selection of historic period, the majority tended to combine various Renaissance elements (whether Italian or English) or generically medieval elements (with a preference for the English Tudor style). In these interiors, as in the public buildings of the period, there was strict attention to scale and to the use of the best materials.

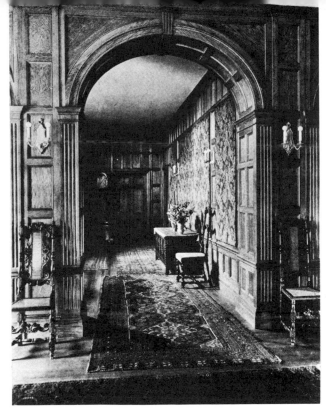

201. Goodwin, Bullard & Woolsey, hallway of a house, Hartford, Connecticut, c. 1918–19.

So pervasive was this romanticism that a few houses begun before the war were completed afterward according to radically changed plans. Perhaps the most striking example is the Arthur E. Newbold house at Laverock, Pennsylvania, a northern suburb of Philadelphia. The original house had been built in 1914 in a modified modern colonial style, but in 1919 architects Mellor, Meigs & Howe began to add to Mr. Newbold's country sheep farm. Further additions followed, beginning with extensive remodeling of the house itself which lasted until 1924, and ending with a Gothic swimming pool in 1928 (Fig. 202). The rambling whole was a "folly" in the best sense of that eighteenth century word, and there were few restraints imposed by budget on the architects' whim or imagination. A blend of English, Spanish, and Norman French medieval sources, it was generally patterned after the Manoir d'Archelles at Arques-la-Bataille near Dieppe. While it was a retreat from the pressures of the modern industrialized city, it was also an example of the influence of French rural architecture on Meigs who had served in the army and of the dulcet spell which it had cast over him. Nonetheless, the Newbold farm was

202. Mellor, Meigs & Howe, Arthur E. Newbold house, Laverock, Pennsylvania, 1919–24.

203. Mellor, Meigs & Howe, C. Heatley Dulles house, Villanova, Pennsylvania, 1916–17.

204. Albert Kahn, architect; Jens Jensen, landscape architect, Edsel Ford house, Grosse Pointe, Michigan, 1927.

functional, perhaps not in the narrow sense that was being defined by Gropius and the Bauhaus, but in a broader psychological way, so as to restore a forgotten "imaginative interpretation of use" in the words of Howe's biographer, Robert A. M. Stern. Actually more representative of the firm's suburban work is the C. Heatley Dulles house, Villanova, Pennsylvania, to the west of Philadelphia, 1916–1917 (Fig. 203). Moreover, what one sees in such work of Mellor, Meigs & Howe in the environs of Philadelphia is a picturesque and romantic eclecticism constructed of the flinty fieldstone that had been a building tradition for so long in this area.

Clearly architects during this period were of many minds. Some, such as Howe, gradually moved from historicism toward a modern geometrically severe expression, felt to be more appropriate to an industrialized culture, while others such as Albert Kahn could produce excellent buildings of both types simultaneously. Albert Kahn can rightly be described as the originator of the modern American factory (a counterpart to Gropius and his Fagus shoe factory), but he also produced some of the most strikingly romantic eclectic public buildings and houses of the period. Particularly well detailed are the several houses he designed for automobile manufacturers in the fashionable northern suburbs of Detroit, such as the H. E. Dodge house in Grosse Pointe, 1915, with its carefully studied Jacobean interiors. Even more elaborate and yet controlled is the Edsel Ford house, also in Grosse Pointe, 1927 (Fig. 204). In his radically innovative designs for factories (such as the Ford plant) Kahn adhered to a bare, gleaming utility,

but in the houses and public buildings commissioned by owners of these factories, Kahn employed a historicism which was unequaled at that time for its archaeological accuracy and careful attention to detail, texture, and subtle color. The Ford house is a rich blend of medieval sources grafted on a basically Tudor base, and much of its charm and comfortable external appearance is due to the landscaping of Jens Jensen, foremost of the landscape architects in the Midwest.

No expense was spared in these expansive suburban houses in the quest for a comfortable environment. The forms employed were the most archly traditional ever in American architecture, all the more appealing perhaps in an era in which technological and financial changes, as in the case of the making and marketing of the Model T, were reshaping the whole of the underlying culture. Such houses were a defense against what is now sometimes called "future shock"; they were safe and secure refuges amidst a culture in flux.

Most of these suburbs, though well planted and spaciously laid out, deviated little from the standard grid of their parent cities. Except for Olmsted's Riverside and Shaker Heights, few made any pretense at augmenting existing landscape features. Lake Forest, Illinois, was one exception. It had actually been established in 1855 by Presbyterians as a site for a new college; the curvilinear streets were planned by David Hotchkiss of St. Louis and generally followed the contours of the lake-shore site. Because of the twenty miles separating it from Chicago, Lake Forest became a retreat for the wealthy of the city, but the rate of growth was modest until about 1890. The decade between 1920 and 1930 was the period of most vigorous growth, and much of this was due to the presence of architect Howard Van Doren Shaw, a highly skilled traditionalist designer who built his own home there in 1897 and thereafter built many generically medieval houses. What makes Lake Forest distinctive among many such elegant early suburbs is the communal focus given it by the market square designed by Shaw in 1913 (Fig. 205). Commissioned by the Lake Forest Improvement Association, the square faces the Chicago and Northwestern Railroad tracks with the station forming the fourth side of the enclosure. The two-story, pitched-roofed arcaded buildings framing the central park are based on Austrian village prototypes, with clock towers rising on each side. At ground level are numerous stores and offices, while the upper floors originally had twenty-five apartments.

In these suburban enclaves, isolated from the bustle of the city,

205. Howard Van Doren Shaw, Market Square, Lake Forest, Illinois, 1913.

life unfolded idyllically, centered on the country club and the polo grounds. In the cities, meanwhile, the romantic proclivities of the architects and the public found full expression in the new theaters and movie palaces which blossomed in the 1920s and early 1930s. Most were floridly Italian and French Renaissance or Baroque in detail, generally in the form of enlarged Baroque opera houses (Capitol Theater, New York, by Thomas W. Lamb, 1919), while others had the form of Italian or Spanish town plazas, the stage being placed in a "building" at one end, with balconied "houses" all around, and the ceiling a smooth vault painted to resemble the night sky with tiny light bulbs twinkling overhead as mock stars (Capitol Theater, Chicago, by John Eberson, 1924–25). The movie palaces exploited exotic expressions to the fullest, and shaped spaces filled with an almost palpable atmosphere, as in one of the lounges of William Lee Woollett's Grauman's Metropolitan Theater, Los Angeles, 1923 (Fig. 206). Loew's 72nd Street Theater, New York, by T. W. Lamb, 1932, was Cambodian Buddhist; Grauman's Chinese Theater, Los Angeles, by Meyer & Holler, 1923, was flamboyantly oriental; and the Aztec Theater, San Antonio, Texas, 1926, was complete with sacrificial altar. The large theaters were truly immense; the Roxy in New York had 6,250 seats while the "smaller" Chicago Theater, Chicago, 1920–21, by Cornelius and George Rapp, accommodated only 3,880. The Chicago Theater was one of the first elaborate movie palaces, and its lush overlay of French Baroque ornament was carefully calculated for effect. The reason for such embellishment was simple, said George Rapp in 1925:

Watch the eyes of a child as it enters the portals of our great theaters and treads the pathway into fairyland. Watch the bright light in the eyes of the tired shopgirl who hurries noiselessly over carpets and sighs with satisfaction as she walks amid furnishings that once delighted the hearts of queens. See the toil-worn father

whose dreams have never come true, and look inside his heart as he finds strength and rest within the theater. There you have the answer to why motion picture theaters are so palatial.

In the theaters and movie palaces the superabundance of ornament was playfulness (or therapy perhaps) on the part of the architects, and at the same time in the Southwest and in Florida there flourished for a brief time regional styles meant as reinterpretations of indigenous local expressions. Mission architecture was revived in California, perhaps nowhere with more playful and yet serious picturesqueness than in William Mooser's Santa Barbara County Courthouse of 1929. The Franciscan Hotel, Albuquerque, 1923, by Trost & Trost, and the Santa Fe Art Museum, Santa Fe, by Rapp & Rapp were among many buildings in New Mexico and the Southwest in a modified Mission or Adobe style, often constructed in solid reinforced concrete. The Biltmore Hotel, Los Angeles, 1923, by Schultze & Weaver, employed Spanish Baroque in its public spaces, while at the opposite corner of

206. William Lee Woollett, Grauman's Metropolitan Theater, Los Angeles, California, 1923.

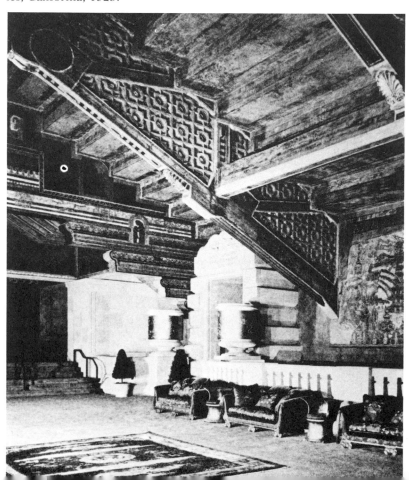

the country in Palm Beach and Boca Raton, Florida, Addison Mizner developed a versatile Spanish Colonial style for the many clubs and houses he built there between 1916 and 1926.

The commercial skyscraper too was embroiled in the struggle between traditional and architectonic ideals. This divergence of view was made very clear in 1922 by the numerous entries submitted in the competition for the design of the Chicago Tribune Tower. The essential requirement, as stated in the competition program, was that it be the world's most beautiful skyscraper. The jury, composed of conservative journalists, city politicians, and a traditionalist architect, selected the design of John Mead Howells and Raymond Hood from among the 259 entries which came from around the world. Built in 1923–25 (Fig. 207), it is a combination of the New York tower form, using Gothic elements similar to Cass Gilbert's Woolworth Building, combined with the tripartite organization of Chicago skyscrapers. It has a four-story base, a soaring midsection shaft, and a setback highly enriched crown.

207. Howells & Hood, Tribune Tower, Chicago, Illinois, 1922–25

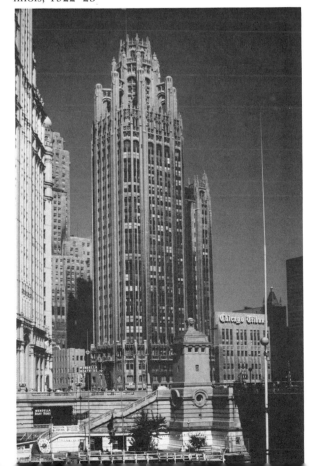

The setback, required by Chicago's zoning law, was given the shape of a diminishing Gothic steeple and was largely based on the Tower of Butter of the Cathedral of Rouen, 1485. At the top the Gothic details, greatly enlarged so as to be readable from the street, are to a large extent gratuitous since the buttresses support nothing, but the Gothic theme allowed for the easy natural emphasis of the vertical piers. The historical exterior veneer hides the elaborate steel frame. In this the Tribune Tower characterizes the ambivalence of the 1920s, for both its planning and its structural frame were among the most sophisticated of the period, while the exterior skin is one of the most sensitively if historically embellished envelopes. As a "traditionalist" skyscraper, however, the Tribune Tower has few equals.

There were other Tribune Tower entries which attempted to express the special nature of a modern office tower. For the most part these came from Europe, and particularly interesting, because of its clear derivation from the work of Sullivan and other Chicago School architects, was that submitted by Walter Gropius. Of all the entries the one most highly regarded by critics including Louis Sullivan was that of the Finnish architect Eliel Saarinen (Fig. 208), which was at once both traditional and yet progressive. Much of the carefully placed ornament came from Gothic precedents, and the emphasis of the vertical piers was likewise Gothic. Yet the gradual gentle setbacks, inspired by Art Deco modernism in Europe, were arranged by Saarinen to effect a gradual diminution of the tower, creating a mass which gave the appearance of having sheer eroded planes making a man-made mountain. Ironically Saarinen's entry, which was awarded second prize, exerted a far greater influence on subsequent skyscraper design than did Howells and Hood's winning design, beginning almost immediately with Hood's American Radiator Building, New York, 1924 (Fig. 209). This, coupled with such books as Hugh Ferriss's *The Metropolis of Tomorrow*, 1929, changed the image of the modern skyscraper from corniced block to tapered, soaring ziggurat.

Another more daring but less celebrated Tribune Tower entry was that of the Dane, Knud Lönberg-Holm (Fig. 210), which combined such elements of the De Stijl movement in the Netherlands as flat planes and primary colors with Constructivist expression of parts according to use rather than structural function. Accordingly the floors are expressed as horizontal trays of continuous space, with bands of ribbon windows. Through the center of the floor tiers runs a vertical shaft, corresponding to the vertical circulation inside, culminating in a series of interlocked cubes at the

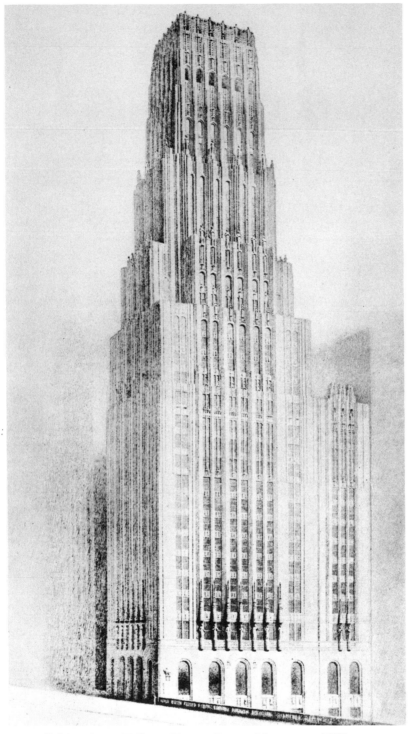

208. Eliel Saarinen, Tribune Tower Competition entry, 1922.

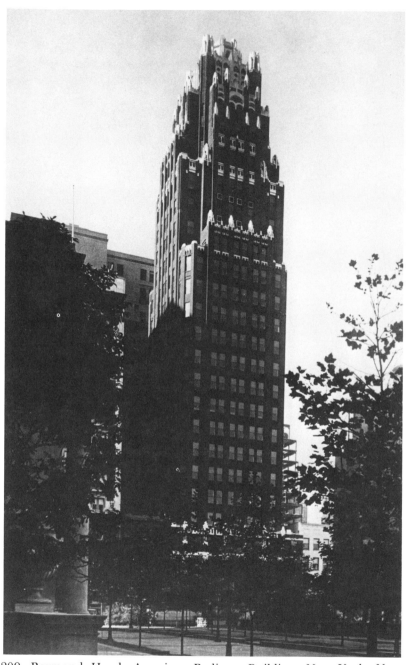

209. Raymond Hood, American Radiator Building, New York, New York, 1924.

top where gigantic letters (prefiguring later "supergraphics") spell out "Tribune." Of all the entries Lönberg-Holm's was most characteristic of the European modern movement, what Hitchcock and Johnson labeled the "International Style" in 1932. It had stark geometry, vivid color, and precisionist minimal detail, but in 1922 it was far from what most Americans considered beautiful and was ignored by the judges. Lönberg-Holm later immigrated to the United States, incorporating in designs of enameled steel plates for gas stations elements of the concern for industrial production and the stark cubical geometries which had distinguished his Tribune Tower design.

The International Style as a force in American commercial building first appeared in the Philadelphia Savings Fund Society, the PSFS, by Howe and Lescaze, 1929–32 (Fig. 211). That the impact of European modernism should have been so delayed is not

210. Knud Lönberg-Holm, Tribune
Tower competition entry, 1922.

211. Howe & Lescaze, Philadelphia Savings Fund Society, Philadelphia, Pennsylvania, 1929–32.

in itself remarkable, for American architects have always been far more interested in such pragmatic matters as the development of a steel frame rather than in the kind of abstract theories of industrial society and an idealized industrial architecture that then so absorbed Gropius, Mies, and other architects allied with the Bauhaus. By the late 1920s, however, American architects and their clients were increasingly persuaded that European modernism was both a visually progressive and a sound building method.

The adoption of European modernism for the PSFS is particularly significant since both the architect and client up to 1929 had been conservative in their views. Howe's early career designing neo-medieval suburban houses around Philadelphia has already been sketched. A house much like them was designed by Howard Van Doren Shaw for James M. Willcox, president of the Philadelphia Savings Fund Society, in Radnor, one of the most staunchly conservative of the "Main Line" communities. Both client and architect, being practical men, approached the problem of designing a new bank and office building pragmatically, and together

they devised a scheme well suited to the activities and needs of the bank. The specifically modern character of the design was clarified by Howe's partner, William Lescaze, a Swiss architect well trained in the severities of the new idiom. At the bottom on the ground floor are small shops since the bank was in a commercial district. The banking room is located on the upper floor, a departure from conventional practice; on the exterior it is indicated by the bank of windows that curves around the corner. A large bank of escalators to one side shuttles customers from the sidewalk to the elevated banking room. A floor of office suites completes the base element. Above this rises the slab of cantilevered rental office floors which terminates in an asymmetrical mass accommodating penthouses, mechanical equipment, and an air conditioning plant. The PSFS Building was the second to offer air conditioning as a standard feature in its rental space (having been preceded in this by the Milam Building in San Antonio, Texas, in 1928). In addition the bank's offices had a dropped ceiling of acoustical tile held in a suspended metal frame. Both of these innovations were to become basic to the office tower of the twentieth century.

While the PSFS Building was the first skyscraper clearly inspired by European modernism, most skyscrapers built in the boom years of the 1920s combined selected International Style elements with the mountainous slab of Saarinen's Tribune Tower design and various traditional elements. One example is William Van Alen's Chrysler Building, New York, 1926–30, whose pierless corners reflect the cantilevers of the International Style and whose richly modeled aluminum spire is the nearest equivalent to European Art Deco (see Fig. 288). Another is the McGraw-Hill Building, New York, 1929–30 (Fig. 212) designed by Raymond Hood. Beginning with the American Radiator Building in New York in 1924, Hood quickly shed the historicism that had so marked his Tribune Tower. Eventually, in his Daily News Building, New York, 1930, he reduced the office tower to a tall, setback slab characterized by slender closely spaced vertical piers which expressed the structural frame. In the McGraw-Hill Building, however, he introduced more variety by devising a central shaft rising from a ziggurat base, with vertical piers juxtaposed with horizontal bands. The vertical piers accord with the vertical circulation shaft at the core, while the horizontal bands and ribbon windows express the tiers of floors. The cladding of the structural columns is recessed and has a black color, making the floors appear to be cantilevered, especially at the corners where the structural column disappears. One can also see in the black and green

212. Raymond Hood, McGraw-Hill Building, New York, New York, 1929–30.

terra cotta sheathing and gold accents of both the McGraw-Hill and American Radiator buildings good examples of the color employed on the skyscrapers of this period. This use of color and the play of vertical and horizontal lines in the McGraw-Hill Building suggest the influence of Lönberg-Holm's Tribune Tower design.

Though not so experimental as the PSFS Building or the McGraw-Hill Building, the huge Empire State Building is certainly the symbol of the period (Fig. 213). Built in 1929–31 from the designs by Shreve, Lamb, and Harmon, and engineer H. G. Balcom, the building climaxed the steady refinement of steel construction begun in Chicago. Its importance lies in the solutions to the hundreds of logistical problems created in raising a building of eighty-five stories reaching a height of 1,239 feet at the tip of its spire. The ziggurat base, the sheer planes of the shaft, the interlocked setbacks of the crown, and the grandly overscaled Art Deco spire are not innovative individually, but they are so well integrated in the great mass of the building that it has a distinction all its own.

Extremely important because of its planned complexity was Rockefeller Center, initiated in 1928 by the Metropolitan Opera

213. Shreve, Lamb & Harmon, Empire State Building, New York, New York, 1929–31.

which desired a new opera house. With the financial assistance of John D. Rockefeller a huge block of land in mid-Manhattan was assembled. The first designs for the complex, calling for a central focal opera house fronted by a plaza and surrounded by office towers, were sketched out by Benjamin Wistar Morris. Subsequently the work was put in the charge of Reinhard & Hofmeister who engaged as design consultants two of the most esteemed architects of the period, Harvey Wiley Corbett and Raymond Hood. With the crash of 1929 the Metropolitan Opera withdrew from the project and its pivotal place was taken by a tall thin office slab for the Radio Corporation of America. Since Rockefeller had become increasingly committtted to the project, it was given his name.

In the final plan of 1930 three adjacent city blocks were bisected by a new cross street, with the centermost half block to the east opened up into a pedestrian mall (Fig. 214). With Fifth Avenue as the front, slab office blocks were placed running east to west, framing the pedestrian approach and focusing attention on the central RCA tower. Along Sixth Avenue slab blocks were turned north to south, forming a backdrop for the entire composition. All of the buildings were fractured slabs with graduated gentle setbacks; the rhythm of the closely spaced limestone vertical wall panels is uniform through the group, and, together with the harmonized Art Deco embellishments, creates a strong sense of unity. This unity in the ensemble, the first to appear since the Columbian Exposition and the City Beautiful civic centers which the exposition inspired, was especially important.

Important too was the complex interrelationship of superimposed levels. Below sidewalk level was laid out a network of pedestrian passageways connecting all parts of the complex; these were lined with small shops and restaurants, making them in effect all-weather streets which connected the office blocks to the subways. Below this concourse was another level of tunnels for deliveries by truck so that this heavy traffic and its attendant congestion were removed from the city streets. Initially, too, there was to have been an elevated pedestrian level, with roof gardens on top of the lower office blocks connected by walkways bridging the spaces between the buildings; these were never executed. One embellishment which was carried out was the sunken ice-skating rink / restaurant terrace at the end of the pedestrian mall at the foot of the RCA Building. This release of potential commercial space to street life, a radical innovation in the American urban landscape, was not so much a harbinger of things to come as a last expression of the Beaux-Arts emphasis on public spaces.

214. Reinhard & Hofmeister with H. W. Corbett and R. Hood, Rockefeller Center, New York, New York, 1927–35.

Architecture between the wars bore the signs of a struggle between historicism and utilitarianism. Buildings were commodiously planned to contain and enhance function and employed the most advanced steel skeletons and mechanical equipment (e.g., air conditioning), yet externally they were clothed in elaborate and carefully detailed historicisms. Of the very few architects who attempted to forge a truly modern expression extrapolated from creative eclecticism, the most promising was Bertram Grosvenor Goodhue, and had he not died at fifty-five he might have more effectively demonstrated how to accomplish this. Goodhue (1869–1924) had little formal education but had served an apprenticeship in Renwick's office, developing an amazing drafting and sketching skill. In 1891 he entered the Boston office of Ralph Adam Cram, rapidly becoming a key member of the firm, and was made a partner in Cram, Goodhue, and Ferguson before the century was out. He was a principal designer in the firm (his work with Cram in St. Thomas's Church, New York, is discussed later on), but in 1914 he established his own practice in New York City. His individual work was less reliant on literal Gothic form and detail; in fact his St. Bartholomew's Church, New York, 1914–23, was a colorful variant of Byzantine architecture, and its round arch motifs accorded well with the Romanesque portal by Stanford White from the old church which was incorporated into Goodhue's new structure. Goodhue's production varied from Spanish Colonial Revival (which he was instrumental in starting in California through his work on the Panama-California Exposition, San Diego, 1915) to a boldly muscular modernized Gothic in the chapel later named in honor of John D. Rockefeller at the University of Chicago, 1924–28. What promised most for the future were his purely secular works, such as his entry in the Tribune Tower competition in 1922 which received an Honorable Mention. It was a sheer tower, devoid of almost all applied historicist ornament, modeled by a series of major and minor sharp angular setbacks at the crown and topped by a square pavilion with a tiled pyramidal roof. It was direct and business-like, yet well modulated, and free of meretricious ornament, but it was not what Colonel McCormick wanted for the Tribune. Nonetheless, in abbreviated form, drawn out horizontally, and rendered in white painted concrete, the basic scheme was realized in the Los Angeles County Public Library, Los Angeles, California, 1924, in which the blue and gold tiles of the tower roof stand out in bright contrast.

Even before these two designs were drawn up, Goodhue started

215. Bertram Grosvenor Goodhue, Nebraska State Capitol, Lincoln, Nebraska, 1919, 1922–32.

what was to be the crowning achievement of his truncated career—the Nebraska State Capitol, won in a celebrated competition of 1919–20 and built 1922–32 (Fig. 215). It was surprising at first to some that Goodhue had won at all, for he eschewed the serene white classicism that was still popular for state capitols in 1919 (as in the Washington State Capitol, Olympia, or the West Virginia Capitol at Charlestown, both of which were then being completed). Goodhue's plan, a square divided into quadrants by crossed central wings, derives from Beaux-Arts plans, but instead of focusing on a central domed rotunda, there rises from the crossing an immense skyscraper tower. It is massively buttressed at the corners, with narrow window ribbons between; the top consists of a setback octagonal stage carrying a further setback dome sheathed in tile. To some extent Goodhue's seried setbacks are based on contemporary work in Europe, especially on that of the Finns Lars Sonck and Eliel Saarinen, but to American eyes Goodhue's design brilliantly combined a greatly stylized classicism, which connoted public building, with the skyscraper, which connoted the modern age.

In such work Goodhue attempted to combine the best of Beaux-Arts composition, symbolism, and expressive detail with modern materials and severity of form, but most architects were more comfortable staying with either one or the other. The contrast can be strikingly illustrated by the Gothic complexities of St. Thomas's Church, New York, 1908–14, by Cram, Goodhue, & Ferguson (Fig. 216), and by the starkly geometric Ford plant at Highland Park, Michigan, by Albert Kahn, 1910, which frankly revealed its reinforced concrete frame. An even better example of

216. Cram, Goodhue & Ferguson, St. Thomas's, New York, New York, 1908–14.

217. Albert Kahn, Dodge Half-Ton Truck Plant, Detroit, Michigan, 1937.

Kahn's industrial work is his later Dodge truck plant of 1937 (Fig. 217); while the date might suggest a marked change in expression during the intervening twenty-seven years, the Dodge plant is not so far removed from Kahn's Packard plant addition of 1911 with its sophisticated saw-tooth glass roof and steel truss-work spanning seventy-two feet.

Albert Kahn (1869–1942) is that most intriguing of architects who was of two seemingly antithetical frames of mind. He rigorously analyzed the problem of modern factory design (he built more than two thousand during his long career) and consid-

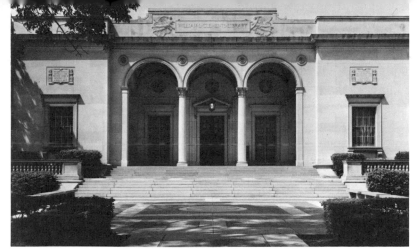

218. Albert Kahn, William L. Clements Library, University of Michigan, Ann Arbor, Michigan, 1923.

ered such work a legitimate province of the trained architect, publishing a book of his industrial work in 1917; yet he was also a dedicated advocate of the university and public buildings done in selected historic modes. Private homes, too, were high on the list, and we have already seen the Edsel Ford house in Grosse Pointe (Fig. 204) which illustrates well Kahn's exacting standards. Kahn's traditionalist emphasis becomes clear when we consider that, of all his work, he said he wished to be remembered by the diminutive William L. Clements Library, Ann Arbor, Michigan, built in 1923 (Fig. 218) and patterned closely on McKim's Renaissance pavilion for the Morgan Library, New York, of 1902. Albert Kahn's work, therefore, is of critical importance in understanding both the end of creative eclecticism in America and the simultaneous rise of utilitarianism.

Both Kahn and Cram made a sharp distinction between an architecture of utility and an architecture of ceremony as symbolized in public buildings. Cram was an ardent latter-day Ruskin, extolling the virtues of Gothic for a Christian society. His marvelously complex, enriched, and balanced Gothic churches were directly inspired by the earlier work of Henry Vaughan who had revitalized the Gothic style as McKim, Mead & White had reinstituted classicism. Cram's best work combined the finest construction (whether traditional solid masonry or with supplemental steel framing), vaults of Guastavino tile construction, excellent carved detail, and stained-glass windows of intense saturated hues by Charles Connick. For nearly thirty years after 1905, with Cram's persuasive support, this neo-Gothic was widely popular for ecclesiastical and collegiate building. In addition to Cram and Goodhue, James Gamble Rogers made excellent use of the Gothic idiom, building quadrangles, towers, and the new library at Yale

University in the period from 1917 until 1930, and similar buildings at Northwestern University, Evanston, Illinois, soon after.

Aside from Kahn's factories and the PSFS Building, progressive architecture seemed to be in eclipse. Frank Lloyd Wright's work fell off sharply after 1910; between the wars he seemed to abandon his own integrated Prairie Style to flirt briefly with a kind of historicism. It was a period of intense introspection and reanalysis, forced on Wright by a public and press that would not forgive him for having deserted his family in Oak Park in 1910 to go to Europe with a client's wife, there to supervise the publication of a folio of drawings by the Wasmuth Verlag in Germany. When this folio and its accompanying smaller volume of photographs appeared in 1910–11, they helped to spur the development of the modern movement among such architects as Gropius, Mies, Richard Neutra, and Rudolph Schindler. Meanwhile, unable to return to his family in Oak Park and his practice in Chicago, Wright withdrew to the forested moraines of central Wisconsin and settled in Spring Green among his mother's family, building a new home, "Taliesin," wrapped around the brow of a low hill. Wright literally dug in, venturing forth to carry out the selected commissions that came his way through devoted clients and friends. In Japan he completed the large Imperial Hotel for the royal family; in California he built a number of residences in which he broke away from the extended horizontals, wooden framing, and elegant glazed brickwork which had come to characterize his "Prairie Style." Wright explored new models based on the architecture of ancient meso-America. He also began to explore new methods of construction which were more truly structurally integrated.

The little house he designed for Mrs. George M. Millard in Pasadena in 1923 (Fig. 219) was one of the first to exploit his new concrete block technique. "La Miniatura" was built of standardized blocks formed in several patterns laid without mortar with strands of steel running horizontally and vertically through the concave joints; grout was then forced into the hollow joints around the steel. When set this became a monolithic mass, interwoven with threads of steel. Because the blocks were knitted together by the metal rods Wright called this "textile construction," and it certainly possessed a structural coherence not possible in the hybrid steel and frame Prairie houses. At the same time Wright introduced vertical motifs which worked better with the square module of the concrete blocks. In fact in "La Miniatura" one sees an almost European cubism; it has three stories with the entrance in the middle level leading to a two-story living room similar to those used by Le Corbusier at the same time. Despite

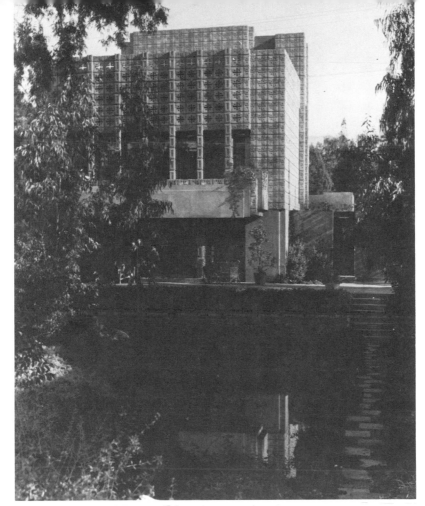

219. Frank Lloyd Wright, Mrs. George M. Millard house, "La Miniatura," Pasadena, California, 1923.

these seeming European influences (which Wright vehemently denied), the Millard house has a very strong relationship to the ground, strengthened by the landscaping by the architect's son, Lloyd Wright.

The reemergence of Wright as a major figure in American architecture was the result of two commissions, the Edgar J. Kaufmann house, "Fallingwater," on Bear Run, Fayette County, Pennsylvania, begun in 1935, and the Johnson Wax Administration Building, Racine, Wisconsin, begun in 1936. Particularly in the Kaufmann house (Fig. 220), it is evident that Wright had in fact not laid aside the principles of Prairie architecture, but had reshaped them, giving this reinvigorated expression a new force and authority. As in the Robie house there is in this weekend retreat a near-perfect integration of space, form, structure, mechan-

ical equipment, and site, forming a coherent unit that seems to have grown out of the rock ledges as if by some process of internal biology. In the plan there are no walls in the conventional sense, but panels of masonry to the rear, enclosing kitchen and work spaces, and screens of glass to the front which open onto a sweeping view of this heavily wooded ravine. There is a sharp contrast between the smooth concrete horizontal balconies which hover over the water and the rough masonry piers laid up of rock found on the site in such a way as to simulate the natural strata. Wright's governing idea was to combine in the house the traditional security of the hearth with the artifices of modern civilization, so the sleek finishes of the ceiling, with its concealed lighting, and the banks of glass are set off against the aggressive masonry of the fireplace which rests on an outcropping of bedrock pushing up through the floor. Although Wright denounced the International Style, in the smooth concrete upstands of the balconies, in the thin steel sash of the windows which open to reveal the absence of a corner post, and in the abstract grouping of planes, one can see the influence of Europe on Wright. It is, in fact, the completion of a cycle, for the freshness and abstract probity of Wright's Wasmuth folio had inspired the European modern movement which in turn then helped to sharpen and clarify "Fallingwater."

Of the several crises that impinged on Wright from 1910 to 1915, one that seems to have deeply affected him was the realization that, while the individual Prairie houses were well integrated in themselves and with their sites, when placed in a group the en-

220. Frank Lloyd Wright, Edgar J. Kaufmann house, "Fallingwater," on Bear Run, Fayette County, Pennsylvania, 1936–37.

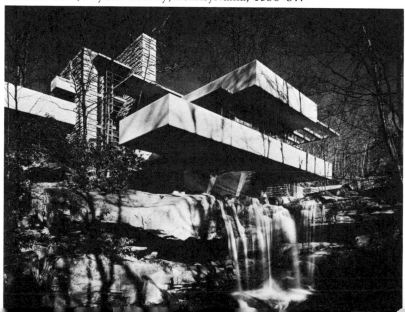

semble did not hold together. This fragmentation was the symbol of a larger problem, for while Wright wished to reshape domestic architecture totally, what he was actually called upon to do was to design scattered homes of wealthy businessmen. During the lean years of the depression Wright set about to devise a new social system in which all citizens lived on the land in model houses that so fully incorporated mechanized prefabrication and maximized the essentials that they could be made available to all. Between 1931 and 1935 this visionary "Broadacre City" took shape. It was a suburb that spread across the land, based on absolute decentralization, with individual houses on one-acre sites, and scattered industries and services made accessible by private automobile transportation (Fig. 221). What Wright succeeded in doing was to fuse the agrarian myth with a growing pervasive desire to escape the city, and, though he had nothing to do with it directly, after the Second World War "Broadacre City" became a sprawling reality around every major urban area.

Crucial to this new social order envisioned by Wright was the Usonian house in which unnecessary elements were eliminated through technical innovation. The basement and garage, for instance, disappeared for furnaces were now clean and compact and automobiles needed little protection from the weather. The first of this new type was the house for Herbert Jacobs, near Madison, Wisconsin, begun in 1936. Turning its back on the street, it had the shape of an L, with the arms enclosing a private yard (Figs. 222, 223). At the pivot were a carport, kitchen, and bath clustered around a utility core. To one side stretched a living room with a

221. Frank Lloyd Wright, Model of Broadacre City, developed between 1931–35.

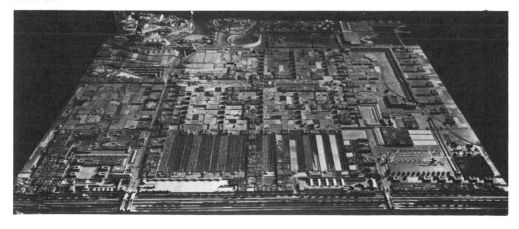

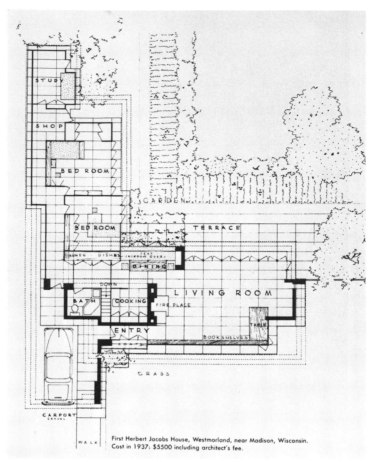

First Herbert Jacobs House, Westmorland, near Madison, Wisconsin.
Cost in 1937: $5500 including architect's fee.

222. Frank Lloyd Wright, first Herbert Jacobs house, Madison, Wisconsin, plan, 1936.

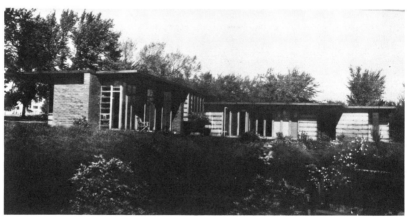

223. First Herbert Jacobs house, view from the rear yard.

dining alcove next to the kitchen; perpendicular to this extended the wing of bedrooms. The house was built on a concrete slab that incorporated pipes providing radiant heat; the walls were formed either of full-length glass doors opening to the yard or of sandwiched panels of plywood whose prefinished inside surfaces eliminated costly and time-consuming wet plaster work (Fig. 224). The only masonry was reserved for the utility core. As the plan indicates, the entire house was designed on a module that tended to reduce special cutting and fitting while giving coherence to the arrangement of parts. The accumulated economies were such that Wright boasted that the Jacobs house cost only $5,500 when completed in 1937, including the architect's fee. By comparison the relatively compact Robie house had cost $35,000 in 1909.

Such houses Wright called "Usonian," a term he coined to express a broad domestic agrarianism. He hoped to build them in groups, though the only group he was actually engaged to design was a development for several instructors at what is now Michigan State University; seven houses were to be built at Okemos, Michigan, spaced in a semicircle around the edge of a bluff, en-

224. First Herbert Jacobs house, living room.

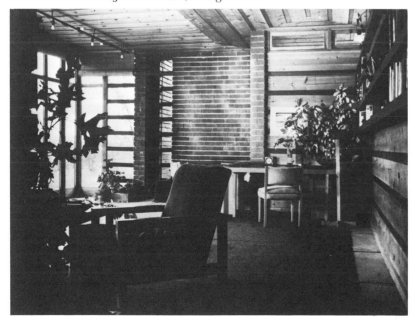

225. Frank Lloyd Wright, Okemos, Michigan, house group, model, 1939.

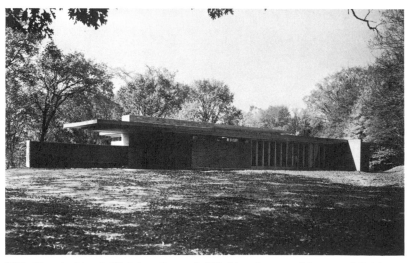

226. Frank Lloyd Wright, Goetsch-Winkler house, Okemos, Michigan, 1939.

closing a communal park (Fig. 225). Though varied in design, the houses were to share common features such as flat roofs, simple massing, and accentuated horizontal lines. Only one of the houses was actually built, for Alma Goetsch and Katherine Winkler, in 1939, and because of its small size and simplicity it well represents the Usonian ideal (Figs. 226, 227). The carport, kitchen, dining "el," expansive living room, and bedrooms form rectangular spaces that slide past one another, achieving great continuity in a simple linear movement. The alcove at one end of the living room exemplifies the Usonian interior with its clerestory windows supplementing the bank of full-length casements to the left. Besides contributing to a more even light distribution, they provide convenient ventilation at the ceiling. The oiled plywood panels of the ceiling and the scored grid of the concrete slab floor are further examples of Wright's desire to eliminate costly interior finishing. Despite its relatively small size, the Goetsch-Winkler house seems large because of the built-in furniture and shelves. Seldom in his larger works, even in his own home, Taliesin West, near Scottsdale, Arizona, begun in 1938, did Wright achieve greater coherence or authority.

For the sake of clarity and economy both the Prairie house and the Usonian house were rectilinear compositions, but increasingly during the 1930s Wright was drawn to the hexagon and circle as planning modules and to the helical ramp as a spatial form. He turned to the circle as the generating element for the S. C. Johnson and Son Administration Building, Racine, Wisconsin,

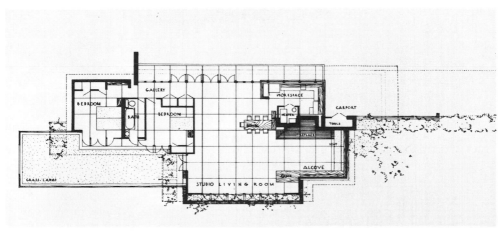

227. Goetsch-Winkler house, plan.

1936–39 (Fig. 228). The requirements were in many ways similar to those of the Larkin Building of 1903, calling for various offices and auxiliary spaces, a large secretarial staff room, and parking facilities. Wright placed the large single room for the secretarial staff to one side of a driveway with the auxiliary services on the other side and offices bridging over the road. One enters by way of the drive into a dark, low space, turns, and comes into a huge room suffused with light. Throughout, the circle dominates; even the office furniture, the desks and chairs (which Wright designed) have rounded tops with circular seats and cushions. For the structural supports Wright devised dendriform (tree-shaped) columns with elongated tapered shafts carrying broad flat disks. Forming the roof of the secretarial staff room is a forest of these columns, three stories high (Fig. 229); looking up at the clustered disks one has the sensation of seeing giant lily pads from below. Identical columns are used throughout the building but with shafts of different lengths so that in the low covered drive the thick stunted columns take on the character of toadstools. In addition to changing the structural norms, Wright also played with the admission of light. In the secretarial staff room skylights fill the spaces between the ceiling disks, and where the ceiling meets the exterior wall there is a curved skylight of bundled glass tubes. This curvilinearity extends to the exterior brick walls which curve and angle inward so as to eliminate sharp corners. Thus every element contributes to a feeling of movement and fluidity which culminates in the expanding volume of the secretarial pool. As in the Larkin Building and Unity Temple Wright internalized the building, focusing the view of the occupants on one another, hoping to generate a greater sense of community. Wright wrote of the Johnson Wax Building: "Organic architecture designed this great building to be as inspiring a place to work in as any cathedral ever was in which to worship." Work would be the liturgy of this communal life.

Though Wright's modernism was particularly his own, it was also much influenced by Europe. Certainly part of this influence was due to two Viennese architects who spent several years in the Taliesin atelier before building their respective careers in California. These were Rudolph Schindler and Richard Neutra. Schindler was somewhat older and had been a student of engineering and architecture under Otto Wagner. In 1914 he came to Chicago in answer to an advertisement for draftsmen for the firm of Ottenheimer, Stern & Reichert. He worked in Chicago for a brief time and then spent five years with Wright, becoming chief

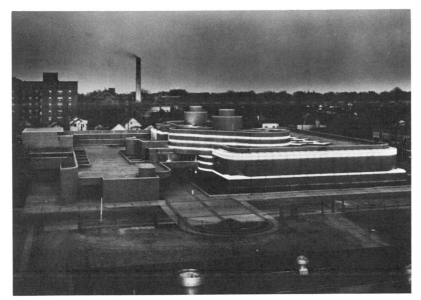

228. Frank Lloyd Wright, Johnson Wax Administration Building, Racine, Wisconsin, 1936–39. Night view, showing light filtering out through glass tube window-strips.

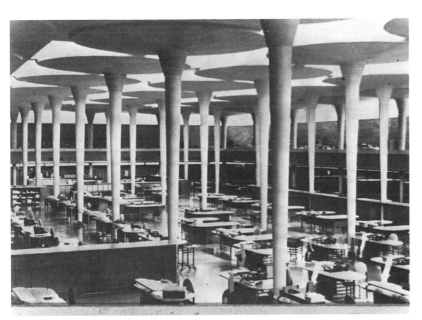

229. Johnson Wax Administration Building, central office.

230. Rudolph Schindler, beach house for Dr. Phillip Lovell, Newport Beach, California, 1925–26.

assistant during the difficult years from 1916 to 1921. Much of this time he spent in California supervising the various Barnsdall commissions while Wright was in Japan at work on the Imperial Hotel. Schindler's original intention had been to return to Vienna but this faded as his practice in Los Angeles grew. Important commissions came to him, such as the beach house for Dr. Phillip Lovell at Newport Beach, California, 1925–26 (Fig. 230), which, though largely overlooked for nearly forty years after its construction, was a landmark in the adapatation of De Stijl and International Style elements in American architecture. The house is basically two rectangular volumes, a large open living space and a smaller cluster of enclosed bedrooms lifted up and nestled under a common roof. Supporting the building, and providing space for a garage underneath the house, are five poured concrete frames. The columns are kept outside of the walls so that the interior spaces are uninterrupted.

In contrast to the beach house, another commission for Dr. Lovell has long been recognized as a masterwork. This is the Lovell home, Los Angeles, 1927, by Richard Neutra (Fig. 231). Neutra had been influenced by Adolf Loos and Wagner, and also, especially, by Wright's Wasmuth portfolio. In 1923 he came to the United States, working for Holabird & Roche in Chicago and then with Wright at Spring Green. In 1926 he went to California and worked in collaboration with Schindler; the most ambitious of their joint works was an entry in the League of Nations competi-

231. Richard Neutra, Dr. Phillip Lovell house, Los Angeles, California, 1927.

tion in 1926. By 1927 Neutra had begun his own practice, starting with the Lovell house. As with Schindler, Neutra's European training had stressed volume and form over structure, but his experience in Chicago and with Wright modified that. In the Lovell house the volumes are clear and crisp, formed by the logic of the structural steel skeleton (it was one of the first private houses framed in steel). Like Wright's "Fallingwater," it has balconies—some of them cantilevered, some of them suspended from the steel hangers fastened to the roof—but unlike "Fallingwater." it is not embedded in the earth but lifted free on slender *pilotis* similar to those used by Le Corbusier. It is not pyramidal as Wright's house was to be, but instead spreads out at the top. Yet with all of its abstract manipulations the Lovell house has a strong relationship to the hillside through the terraces and the assertive diagonal of the staircase. If the smoothly faced balconies of "Fallingwater" show any influence of Neutra on Wright, surely the relationship of the Lovell house to the hillside suggests the reverse.

During the years between the wars steps were taken in city and regional planning that were to have far-reaching consequences. These planning projects grew out of the writing of Ebenezer Howard, an English legal clerk who became fired with the idea of creating the ideal living environment combining the advantages of both city and country. In 1898 he published *Tomorrow, a Peaceful Path to Real Reform* (retitled in subsequent editions *Garden Cities of*

Tomorrow). In this he posited the building of small cities which preserved and enhanced the beauty of nature while providing social opportunity, low housing costs, and high wages. Cities, he reasoned, should be carefully built incorporating much open space and should be kept at their optimum size by controlling speculation in land through communal ownership of land. The buildings on the land would remain private property. Furthermore, such cities should be surrounded by a productive green belt of farms and forests which would act as insulation against encroachment by outside development. With the founding of the Garden City and Townplanning Association, Howard began the realization of his dream in the building of Letchworth outside London in 1902. This was eventually followed by another town, Welwyn, begun in 1919. Through these examples and Howard's writing the garden city ideal came to the attention of American planners and architects. Though there had been a few early excellently planned suburban developments, such as Forest Hills Gardens on Long Island, none of these attempted true economic self-sufficiency as urged by Howard.

Two men particularly responsible for transmitting Howard's ideas to the United States were Henry Wright and Clarence S. Stein, both of whom had been active in the federal projects for housing war industry workers in 1916–18. Wright had been trained as a landscape architect and was both a visionary and a practical technician; Stein was an architect and, as chief designer in the office of Bertram Goodhue, had been in charge of the plan for Tyrone, New Mexico. In the partnership that they formed Wright was the planner while Stein dealt with clients and public officials, demonstrating a great organizational ability. Both were members of the Regional Planning Association of America formed in 1923; though it lasted only a decade the association popularized many of the ideas of regional development and planning that later emerged in the federal projects for garden cities and the Tennessee Valley Authority. In 1924–28 Stein and Wright enlisted the aid of New York financiers to build Sunnyside in the borough of Queens, New York, on a site of seventy acres; this was the first garden city suburb in the United States based on Howard's ideas. Hoping to build a truly self-sufficient community, Stein and Wright next formed a company to build Radburn, New Jersey, in 1928. After acquiring a site of 1,258 acres, they laid out a town for a population of 25,000, adapting Howard's theories to this particular situation (Fig. 232). The prospects were good, for the projected town was close to local industry, had good access to

232. Stein & Wright, Radburn, New Jersey, aerial view, 1928–29.

other nearby cities, and had open land on which to lay out the optimum plan. Unfortunately the depression severely retarded development so that after two years only one of the three neighborhood areas was built up and less than one-tenth of the projected population had been realized. Nevertheless, Radburn exerted profound influence because of its unique character and because of the several radical innovations in planning introduced here. First was the neighborhood planned as a self-generating social group, big enough to provide a base for schools and services yet small enough to be perceived by the individual and to promote self-identity. Second was the superblock concept which disposed living units around the periphery of a large area ringed by major traffic arteries and penetrated only by cul-de-sac streets. In these superblocks the elimination of cross-traffic opened up the interiors for use as communal parks with scattered play facilities for children, landscaping, and meandering footpaths. Third was the clustering of housing in side-by-side duplexes and row houses which freed still more land for recreational space. Though the housing itself had no radically innovative planning or stylistic treatment, it was well designed with a view to function and was solidly built. Fourth was the separation of traffic so that pedestrian and bicycle paths went underneath the major roads carried on overpasses. And fifth was planning for the automobile which made provision for movement but which did not allow it free access to every corner nor allowed it to dictate patterns of human interaction.

Somewhat more successful because of its smaller size was Chatham Village in Pittsburgh, Pennsylvania, planned in 1929 by Stein and Wright in collaboration with architects Ingham and Boyd. Financial backing was provided by a bequest so there were no substantial reversals in this troubled year. The site was an irregular oblong on a hillside overlooking Chatham Wood park. The division of the area into three large superblocks provided access to the projected 197 two-story units while space was preserved for park strips through the center of each block (Fig. 233). The two- and three-bedroom houses were grouped in staggered rows of four to six units, their foundations dropped to follow the contours of the land. At one end was a market building, while at the other, overlooking the park, was a communal clubhouse. Because of the nature of the site it was possible to enclose Chatham Village completely with a green-belt park strip. Of the many projects in which Stein and Wright participated, Chatham Village was one of the most financially successful and aesthetically rewarding.

Still, Radburn and Chatham Village were not truly self-contained garden cities, for both were restricted in size by circumstances. In 1932, because of the serious economic problems, President Roosevelt initiated a program for the design and construction of several satellite cities under federal auspices to help revive the economy. The program was directed by Rexford G. Tugwell, a firm believer in the work of Howard. Only three of the projected cities materialized: Greendale, Wisconsin, about seven miles from Milwaukee; Greenhills, Ohio, five miles outside of Cincinnati; and Greenbelt, Maryland, between Washington,

233. Stein & Wright, planners, with Ingham & Boyd, architects, Chatham Village, Pittsburgh, Pennsylvania, park strip, 1931–35.

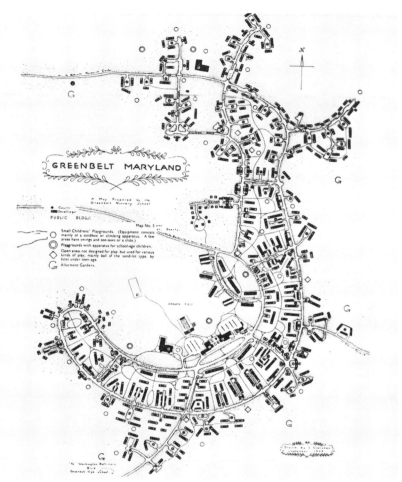

234. Hale Walker, planner, Greenbelt, Maryland, 1935.

D.C., and Baltimore. Greenbelt was begun in 1935 on a site of 3,300 acres of wooded land; the basic plan was worked out by Hale Walker, planner, with Douglas D. Ellington and Reginald J. Wadsworth, architects. Forming the outline of a giant fish-hook or J were six large superblocks enclosed by major roads; at their peripheries were clusters of row houses accessible by cul-de-sac drives (Fig. 234). Through the center of each block were park strips with pedestrian walks (Fig. 235 shows the most densely built-up section of Greenbelt adjacent to the Community Center). Along the residential spine were community buildings, shops, and schools, connected by roads and pedestrian underpasses. With woods on all sides and an artificial lake to the west, the setting was

235. Ellington & Wadsworth, architects, Greenbelt, apartment blocks.

236. Park Avenue, New York, New York, with the focus on the New York Central Building by Warren & Wetmore, 1929.

idyllic, all the more so because no industries were originally incorporated (so much for self-sufficiency). Subsequently, however, several federal agencies—the National Agricultural Research Center and the NASA Goddard Space Flight Center—located nearby, providing a needed employment base.

Stein and Wright's work was visionary and its impact was far out of proportion to its actual physical size; indeed "Greenbelt" became the generic name for all the towns planned in the early thirties based on Howard's ideas. For the most part cities grew along quite traditional lines in this period still secure in its traditions, and, in general, this worked well. Perhaps most important, in city and suburb a sense of scale that had developed since 1890 was maintained. One particularly successful development was the blossoming of Park Avenue north of the New York Central Building in New York City (Fig. 236). The original railroad company had obtained right-of-way down the middle of Fourth Avenue (as it was then called) early in the nineteenth century, but as long as steam locomotives were used to draw the trains into the station, north Fourth Avenue real estate was undesirable because of the steam, smoke, and noise. When electrification of the lines was carried out in 1903 and the open track cut was roofed over, the broad expanse of Park Avenue (as it was renamed) suddenly became choice property. Continuing improvements in foundations and steel frame technology made it possible to erect large office and apartment blocks over the wide subterranean track fan, though here and there an occasional church or club made a dent in the otherwise fairly uniform canyon of the street. Though large, the apartment houses shared a common tripartite facade treatment, giving the street a pedestrian scale at the sidewalk. The relatively uniform height of twelve to sixteen stories was well scaled to the inordinate breadth of the street. Especially important visually was the park strip running down the center of the avenue; originally wider, it was narrowed in 1927 due to increased traffic. Yet even in its truncated form the park serves as a very important buffer. Certainly most important was the focus on the tower of the New York Central Building by Warren and Wetmore finished in 1929 to house the offices of the New York Central. Penetrated at its base by tunnels carrying vehicular traffic through the building to Fourth Avenue, and blessed by a marvelously excessive crown, the tower was tall enough to control the avenue while still suggesting the continuation of the street beyond. As a group, the buildings lining the avenue and the terminal tower were a diverse lot, but they shared an underlying sim-

ilarity of style so that the minor contrasts reinforced the sense of the whole. Ironically the prestige associated with the tenants of these masonry cliffs attracted corporate clients during the 1960s who, anxious to aggrandize themselves with the established image of the place, only succeeded in destroying Park Avenue as they built their endlessly mirroring glass towers.

There were a few attempts to bring the closeness and community of the garden city idea to the urban core in garden apartments built during the 1920s. The large court apartments, such as 277 Park Avenue, were part of this, but the most characteristic were even bigger complexes which covered one or more blocks. "London Terrace Apartments," New York, 1929–30, covered the entire block from Ninth to Tenth Avenue, Twenty-third to Twenty-fourth Street, and contained 1,670 apartments arranged around a central garden. Within the building were a swimming pool, stores, bank, and post office. On the roof terraces were further gardens arranged around water tanks enclosed in belvederes. Even more attractive perhaps was "Tudor City" on New York's East Side, on either side of Forty-second Street at First Avenue. Here twelve apartment towers of varying heights, but all with Tudor Gothic embellishment, were built around two small parks in 1925–28 by the Fred F. French Company. Altogether there were three thousand apartments in the complex, plus stores, restaurants, a church, and a hotel. Even more important than its sheer size and mixture of uses was its circulation plan. Both Forty-first and Forty-third streets are ramped up to meet Tudor Place, a new street forming a bridge over Forty-second Street linking the two halves of Tudor City. The ground level therefore is actually above Forty-second Street which passes underneath uninterrupted, and this separation of traffic corresponds to that developed by Stein and Wright in their scheme for Radburn that same year.

The period between 1915 and 1940 witnessed what was perhaps the most radical change in American architecture. It opened at a point when the structural achievements of the Chicago School were complete and overlaid with a veil of symbolic historicist detail and when tradition exerted an authority that seemed unquestionable. It was a period of pluralities in which good planning and sound construction were graced with a genuine concern for visual delight and variety. But it was also a period in which John Dewey's philosophical pragmatism gradually became architectural pragmatism, making such visual enrichment suspect. A commer-

cial culture which applied cost accounting, empiricism, and time-motion studies throughout industry and business came to want an architecture of empiricism, stripped of seeming superfluities. With the example of a few venturesome architects and their buildings, the new vocabulary was introduced, and in countless shops, diners, and restaurants, the gleam of aluminum and stainless steel came to be customary, so that gradually the machine aesthetic became a part of a broad mass culture. Yet by 1940, when this contemporary radical purist architecture might have begun to assert itself, the Second World War intervened, bringing nonmilitary building to a halt. The war imposed an absolute hiatus in building unlike anything experienced during previous conflicts; because of the urgency, and the dearth of material and skilled labor, the modernists were put to work designing war industry housing developments and training camps, and such conditions forced the maximum utilization of material and the elimination of ornament. Perhaps this is why, when the economy returned to civilian production after the war, the masterworks of modernism appeared so quickly, for they had been in gestation a long time.

8.

Pure Function, Pure Form: 1940–1970

Just as when the United States entered the First World War, so too, in 1941, as the nation increased production of war material for the European allies, the need for housing for the workers newly clustered at industrial sites became paramount. This time, however, the designers were not traditionalists or eclectics, unlike those who in 1917 attempted to use historic styles to foster a sense of communal and regional identity, but leaders of the avant garde movement. "Channel Heights," for shipyard workers at San Pedro, Los Angeles, California, 1943, was one of the largest war housing groups. The 600 apartments, designed by Richard Neutra, had flat roofs, and were arranged in tidy, seried rows on the irregular terrain. Better known, perhaps, and certainly better disposed on the rolling landscape, were the apartments at New Kensington, outside Pittsburgh, Pennsylvania, 1941, by Gropius and Breuer (Fig. 237). These too had flat roofs, and in the buildings wood was used extensively as the war caused restrictions on more permanent materials. For the FPHA housing complex, "McLoughlin Heights," in Vancouver, Washington, 1942, Pietro Belluschi designed a shopping center. Square, compact, gable-roofed units were designed by young Hugh Stebbins for Windsor Locks, Connecticut, 1942. The larger Carver Court in Coatesville, Pennsylvania, 1944, by George Howe, Oscar Stonorov, and Louis Kahn, was especially severe, partly because of increased stringencies imposed by the war, but also because this was housing for black workers and their families. A generation later federal laws and judicial decrees were to make determined attempts at preventing such ghettos but in 1944 segregation was still the practice, and the irony was that here it was sanctioned by the government.

237. Gropius & Breuer, New Kensington, near Pittsburgh, Pennsylvania, 1941.

By far the most extensive of the war towns was Oak Ridge, Tennessee, designed by the office of Skidmore, Owings, & Merrill, and of this more will be said later when attention is given to the rise of this large and influential firm.

Economic readjustment after the Second World War was relatively quick. Industry boomed in an effort to meet soaring demands for consumer goods. There opened an era of unparalleled prosperity creating what John Kenneth Galbraith called in 1958 the "affluent society." The United States became a nation of consumers, firm believers in annual obsolescence. The ensuing abundance of consumer goods designed to encourage the small nuclear family bred a callousness to larger social urban issues. Private splendor was mirrored by public squalor. Expediency was given the force of comprehensive planning in the marketplace and in civic chambers.

Cities became the dominant force in American life; by 1960 seven out of ten people lived in urban areas. Yet these were increasingly divided cities, their centers left to growing populations of blacks and Latinos by Caucasians who fled in search of idyllic free-standing houses in the suburbs. The refugees settled into their crabgrass havens and tried to ignore the fact that the new suburbs were often minimally planned and built. In the most jerry-built there were no schools and the sewers balked. The only links to the urban core, the economic base, were the freeway and the automobile, but it seemed that no matter how many expressways were opened into and through the growing megalopolises, there were always more cars to clog them. In the green ghettos were deposited the women and the young who seldom saw the heart of the city.

Increasingly during the 1960s, while the nation enjoyed its abundance and its foreign adventures, determined to have both

"guns and butter," the economy became a Gordian knot of government and business ties. Vast near-sovereign corporate states became dependent on federal financial support, so that by 1970 the whole structure was laced through with props inspired by English economist John Maynard Keynes. The nation mortgaged itself to ram concrete arteries through the fragile tissue of its cities, flinging multilane roads coast to coast. The conquest of time and space seemed complete in 1969 when American astronauts ambled on the surface of the moon; but meanwhile, one after another, public transit systems failed, cities went bankrupt, and municipal services dimmed, sputtered, or even collapsed altogether.

The immediate postwar period held great promise as the average private disposable income increased and leisure time lengthened. Yet the worker and even his salaried counterpart were unprepared to enjoy this newly won time. They could not stop to enjoy diminishing urban amenities for the ingrained work ethic rendered them unable to do so without feeling guilt. They should be doing something; typically their free time was spent grooming their possessions so they would retain their resale value, and replacements were similarly groomed ad infinitum. Thus the private environment gleamed, while the public environment—city halls, libraries, railroad stations, museums—became tarnished, disused, and decayed.

There also emerged after the war, however, a new concern, among the former leaders of the modern movement, for symbolic qualities in public architecture and for a renewed awareness of monumental qualities that went beyond mere utility. Most eloquent of these proselytizers was Lewis Mumford who, in 1958, called attention to the abuse of the marvelously excessive space of Pennsylvania Station, and who also began to criticize the mania for freeway building. The prevailing views among most planners and developers during the 1950s and 1960s, however, were that bigger was better (and the corollary that unit costs had to be minimal to allow for more extensive construction) and that people's needs were pretty much the same everywhere (a philosophy formerly advanced by Gropius and Le Corbusier). During the late 1950s and 1960s this too came under scrutiny, particularly in the impassioned writing of Jane Jacobs, especially her *Death and Life of Great American Cities,* New York, 1961. Diversity was the great advantage of urban life, she argued, and the street as an enclosed spatial social environment was important to a sense of identity in the city. Tall apartment towers set in open sterile expanses of sacrosanct grass were antithetical to human social interaction, she

urged, but, even as her book was read and discussed, housing "developments" went up in every major city. Too late to provide thousands an environment more humane, her theories proved themselves correct, and perhaps the most dramatic vindication was the dynamiting of the Pruitt-Igoe complex in St. Louis by city officials in 1972 when it was clear beyond any doubt that the apartment complex was destroying the spirit and character of those who had no choice but to live in it. When it had been designed by Minoru Yamasaki in 1952–55, Pruitt-Igoe was a model of efficiency in housing, but within ten years it had become a behavioral sink, a death trap.

This realization came much later, however, for the years immediately after the war were not characterized by disillusionment but rather by a confident and enthusiastic desire to get on with the business of progress. The ideals of the International Style were still very potent, and as the economy returned to civilian production in 1948–49 there was an optimistic building boom.

Part of this dynamism was due to the fragmented complexity of modern social, economic, and governmental institutions, yet this pluralism in the social sphere was countered by a singularity in architecture that became particularly rigid during the 1950s and the early 1960s. Pragmatic utilitarianism became the driving force in the United States, but since this compulsive utility had no coherent body of theory behind it as in Europe, the architectural forms it generated carried the mannerist stamp of individual architects or particular decades.

Commercial architecture furthermore became an increasingly important form of public relations. Following the war corporate clients sought to fix their public images through building and in the process gave architects like Mies, Johnson, and Skidmore, Owings & Merrill opportunities to realize the normative, universal, and technically pure architecture they had been advancing for twenty years. In the hands of Mies and his colleagues, this became an exercise in abstract beauty, but when attempted by others it often turned pallid. Architecture became a package in which the ambiguities and complexities of modern institutions were ruthlessly wrapped in sleek, monotonous continuities. It became reductive and exclusive, eliminating untidy functions to conform to a vision of society as the architects thought it *ought* to be, rather than according to the way it was. This arrogant heroicism continued through the 1960s when, under the influence of a new generation of architects, it simply exchanged its bland uniformities for more sculptural forms.

The first of these corporate images in New York was Lever House, built in 1951–52 (Fig. 238), the product of an office that quickly became a leading force in American architecture, Skidmore, Owings & Merrill. The project was supervised by Gordon Bunshaft, and his design made use of a recent change in New York's zoning laws that permitted construction of an unbroken rectangular slab provided that a certain percentage of the ground area was either occupied by a low unit or left open altogether. Bunshaft did both, enclosing an open court with a one-story base element raised on free-standing columns. At the north end he placed the vertical slab, sheathed in green glass and vitreous spandrel panels set in narrow metal mullions. The structural columns supporting this curtain wall are entirely hidden so that the wall is a nonsupporting skin, just the reverse of the traditional heavy bearing wall of McKim, Mead & White's Racquet Club, 1916–19 (in the foreground, Fig. 238). Bunshaft turned his back on Park Avenue, so carefully defined by the older traditional buildings, carving out a hole in the wall of the street. By itself, in the early 1950s, this was a pleasant accent, but when every new

238. Skidmore, Owings & Merrill, Lever House, New York, New York, 1951–52. In the foreground, the New York Racquet and Tennis Club by McKim, Mead & White, 1916–19.

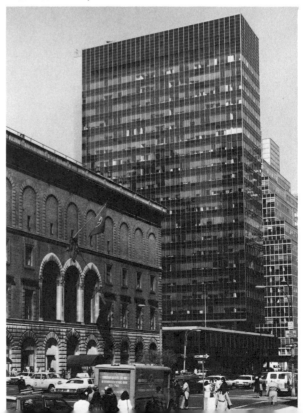

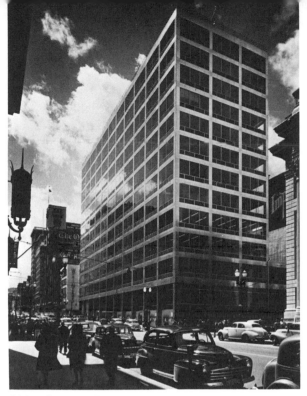

239. Pietro Belluschi, Equitable Savings and Loan
Association Building, Portland, Oregon, 1944–48.

successive office tower stood in a similar wind-swept plaza, the
street as a defined space slipped away.

At the other end of the continent, in Portland, Oregon, a sec-
ond glass box rose in 1948, the Equitable Savings and Loan Asso-
ciation by Pietro Belluschi. Born in Italy in 1899 and initially
trained there, Belluschi emigrated in 1923 to study at Cornell and
within two years had settled in the Pacific Northwest where he
joined the office of Albert E. Doyle in Portland. During the late
1930s and after the war in the late 1940s Belluschi designed a
number of simple but highly sophisticated suburban and country
houses in the region around Portland (about which more later)
which represented a synthesis of international modern and
regional indigenous elements. It was after the war that Belluschi
came to prominence, particularly with his Equitable Building (Fig.
239), for it is a pure green glass box, divided into window bays by
the slenderest of mullions. It appears smooth since the mullions
project only seven-eighths of an inch from the glass. It too is
raised on exposed columns, but it hugs the sidewalk and main-
tains the corridor of the street.

Lever House, though not the first, was the most famous of the
new breed, a direct descendant of the pioneering designs pro-
jected by Ludwig Mies van der Rohe in Germany during the

1920s. The son of a master mason, Mies from his youth was concerned with the precise assembly of building materials. This concern was intensified during Mies's apprenticeship with Peter Behrens and his careful study of the work of German neoclassicist Karl Friedrich Schinkel encouraged by Behrens. Through Behrens Mies was introduced to the Deutscher Werkbund and its dream of a functional purist architecture derived from the industrial process. Out of his participation in the Werkbund and the idealist *Novembergruppe* came Mies's prophetic glass tower projects in 1919–20. This radiant idealism, continued through the 1920s, found its fullest expression perhaps in the Weissenhof housing exhibition in Stuttgart in 1927, and was reduced to its essence in Mies's jewel-like German pavilion at the Barcelona International Exposition of 1929. Hoping to realize the dream of a new social order through the universal application of technology in architecture and design, he became associated with the Bauhaus. As opposition from the Nazis grew, Gropius left for England, placing the school under the direction of Mies in 1930. Within three years Mies had to close the school; there was no place for Mies or his architecture in the Third Reich.

Mies came to the United States in 1937 through the assistance of Philip Johnson, long an ardent admirer and champion of his work, who secured for Mies a commission for the Resor house at Jackson Hole, Wyoming, which went unbuilt. In 1938 Mies was appointed director of the Architecture Department of the Illinois Institute of Technology in Chicago and the following year he began planning a new campus for the school on the city's south side. Since the plan would include many buildings, Mies began by laying out a comprehensive modular system across the entire site that would organize not only the buildings but also the spaces between them (Fig. 240). The three-dimensional module was twenty-four feet by twenty-four feet by twelve feet high. The projected individual buildings of the ensemble were likewise rationally ordered using a modularly determined black steel frame with the bays filled with glass, buff glazed brick, or a combination of the two (Fig. 241 shows a view of the Metallurgy and Chemical Engineering buildings built 1942–46). Each aspect of the wall system was carefully studied so the industrial sash would fit precisely in the structural bays and so the brick panels would be separated from the frame by a narrow reveal; as Mies observed, "God is in the details." This careful articulation, especially at the corners, is analogous to the treatment of the classical corner piers in Schinkel's Old Museum in Berlin, but Mies transposed the composition

240. Ludwig Mies van der Rohe, plan, Illinois Institute of Technology, Chicago, Illinois, 1939–42. Buildings in black denote those completed by 1965, following the original plan. Cross-hatching indicates those projected but not yet built.

241. Mies van der Rohe. Metallurgy and Chemical Engineering Building, Illinois Institute of Technology, 1942–46.

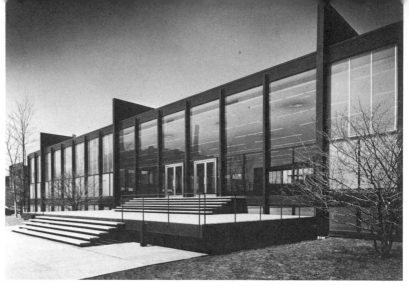

242. Mies van der Rohe, Crown Hall, Illinois Institute of Technology, 1950–56.

to use a series of carefully composed standard rolled steel sections to turn the corner. From the comprehensive plan down to the smallest detail, a pervasive abstract technological ideal governs all.

This extension of the machine was more intellectually rigorous and complete than anything by Albert Kahn, for Mies saw it pervading all of society. As for the anonymity of this architecture, Mies felt that this paralleled modern life. Since the use of a building changed so frequently it was impossible to draw up a finite program and design for a specific function. Modern architecture, Mies felt, should be adaptable to a broad range of functions; it must be universally functional. The ideal would be a single huge enclosed volume that could be subdivided by movable impermanent screens as patterns of use changed. An example is Crown Hall built in 1956 (Figs. 242, 243), in which the single space contrasts to the earlier compartmentalized campus buildings. Crown Hall is one large room, 120 by 220 feet, covered by a roof suspended from four immense transverse plate girders which bear on eight major structural columns. Between roof and floor is a wall of glass. Two pipe chases break up the space of the room (these were necessary for flues and downspouts); aside from these and the small partitioned areas for offices and the two stairs leading to the basement classrooms, the space is uninterrupted.

As did Wright, Mies wished to encourage a sense of community among the users of a building, but Mies did this by removing physical barriers altogether. His motto "less is more," meant that through this simplification a better architecture would be created, one more realistically adapted to modern society and building methods.

The campus of the Illinois Institute of Technology summarized

243. Crown Hall, interior.

well Mies's *Weltanschauung,* but his tremendous impact on American architecture was not so much due to his I.I.T. campus as to his apartments at 860–880 Lake Shore Drive, Chicago, 1948–51 (Fig. 244). Given a trapezoidal lot, Mies maintained geometric purity by using duplicate rectangular slabs placed perpendicularly to one another. The basic module is the bay of twenty-one feet, with each tower being three by five bays (nearly the golden section); each bay is further subdivided into four windows by intermediate mullions. At first it appears that one sees the actual structure, but it is in fact encased by concrete inside this veneer of steel. The external plates actually formed part of the forms for the concrete. To this veneer I-beams were welded both to brace the skin and to give the surface a third dimension, creating a play of light and shadow. What one sees, then, is symbolic structure.

244. Mies van der Rohe, Lakeshore Drive Apartments, 860–880 Lakeshore Drive, Chicago, Illinois, 1948–51. This photograph, taken about 1951–52, shows well the impact of the glass tower in its original setting.

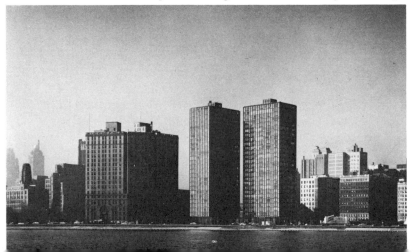

Idealism pervades the complex. Each tower is raised on free-standing columns, with a small glass-enclosed lobby at the center of the ground floor, thereby deftly eliminating the variety of small shops accommodated in the bases of apartment blocks in previous decades which had come to be viewed as clutter. While radiant slab heating was used with supplemental perimeter units, the psychological chill of winter was not lessened, and in the summer the apartments became hothouses since air conditioning had not been included. Furthermore, lest residents break the perfectly symmetrical surface of the buildings, restrictions prohibited individual air conditioning units which protruded from the wall. To maintain uniformity standard gray draperies were hung at each window; behind these, should they care to, the residents might hang their own. Originally Mies had planned large open spaces for the apartments—residential "universal spaces"—but was eventually persuaded by the developers to put in more conventional walls, subdividing the apartments into the usual rooms. This modification was unimportant, wrote William Drexler in a preface to the catalogue *Built in the USA, Post-War Architecture,* New York, 1952, for "an appraisal of 860 Lake Shore Drive, if it is to be relevant, should be concerned primarily with those abstractions of the building process which have preoccupied the architect." Finally, despite the varying orientations of the walls, and the widely differing thermal heat gains on the east, south, and west sides, there is absolutely no variation in the design of the faces of the towers. They are fully interchangeable; these towers might be anything, anywhere.

The Lake Shore apartments became the paradigm of aloof, anonymous glass boxes that began to appear in every American city, beginning with Bunshaft's Lever House. Yet these derivatives seldom carried Mies's social concern, the best example of which is an extension of the I.I.T. plan—Lafayette Park in Detroit, designed by Mies in 1955 and built over the next eight years. It combines a few multistory towers and many two-story town houses with shops and schools, all scattered in ordered irregularity over seventy-eight acres with a landscaped nineteen-acre mall through the center designed by Ludwig Hilberseimer. Few such commissions came to Mies, but this single example helps to mitigate the exceptionally cold image presented by much of Mies's work.

Frigid hauteur, of course, was exactly what was wanted by corporate clients, and the glass box became the symbol of American business. Mies's Seagram Building, New York (Fig. 245), is the classic example. Designed in 1954, in collaboration with Philip

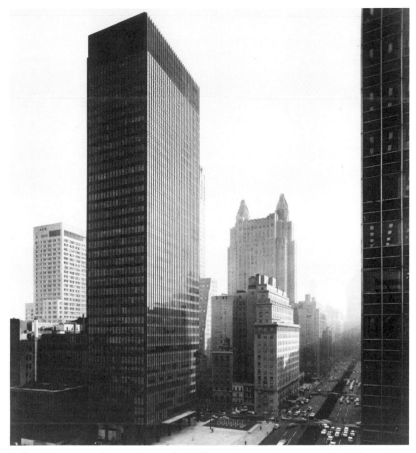

245. Mies van der Rohe and Philip Johnson, Seagram Building, New York, New York, 1954–58.

Johnson, it was finished in 1958. Basically it is similar to the Lake Shore apartments, but with several important differences. Though it is raised on columns and has a glass-enclosed lobby, the need for additional space required a large service block to the rear. This extends upward along the back of the building to form a utility spine containing stairs, elevators, and washrooms. Consequently the upper floors have a plan in the shape of a stubby T, but from the front there is no hint of this; one is given the impression of a pure rectangular shaft. Attention is focused on the svelte tower, made all the more sheer by hanging the glass wall in front of the structural columns so that there is none of the subtle rhythm of the Chicago towers. The elegantly uniform fenestration is of dark amber glass in mullions of oiled bronze extrusions so that the building has a dense, opaque appearance during the day

but turns into a golden crystal at night. To be allowed absolute geometric purity within New York zoning regulations, Mies pushed the tower far back from Park Avenue, opening up a large granite-paved terrace with twin fountains. In this way he satisfied municipal regulations, lost a few rentable square feet, and achieved an unmatched regal image. It is significant that in its exacting attention to structure, color, and sensual delight, the Seagram Building manifests a highly focused artistic energy that previously had been employed for buildings of the church or government.

Of the countless architects who took up the Miesian idiom, perhaps none were more energetic or more inventive than Louis Skidmore, Nathaniel Owings, and John Merrill. Their partnership had begun in 1936 and their early designs showed technological inventiveness and purity in advance of Mies's coming to Chicago. For example, in the Main Reception Building, Great Lakes Naval Training Station, Great Lakes, Illinois, 1942, Skidmore, Owings & Merrill used inverted laminated wood trusses on narrow steel columns to support a broad shed roof. To this was added a marked organizational ability which enabled SOM to plan and build Oak Ridge, Tennessee, between 1942 and 1946, accommodating a population that went from zero to seventy-five thousand people in those four years. The SOM office staff grew steadily; by 1970 the firm comprised one thousand architects, twenty-one general partners, forty-five associate partners in offices in Chicago, New York, San Francisco, Portland, Oregon, and Washington, D.C. National recognition came to the firm in 1952 with the completion of Lever House, and one of the firm's major contributions during the ensuing fifteen years was the creation of a generic glass tower type for corporate headquarters, examples of which are the Crown Zellerbach Building in San Francisco, 1957–59, the Chase Manhattan Bank in New York, 1957–61, and the Union Carbide Building, New York, 1957–60; the last example is, in its externals, the 860–880 apartments on an expanded scale (Fig. 246). Often, however, their smaller Miesian buildings are more hospitable and engaging. Particularly successful is their Manufacturers Hanover Trust, New York, 1953–54 (Fig. 247). It is only four stories tall, its top marked by a balcony and a visible penthouse structure. The lower two floors house the banking space while the shorter upper floors house offices. To connect the two banking floors visually, the mezzanine floor is held well back from the glass curtain wall so that from the street, as well as from within, one senses the single space divided by the insertion of the

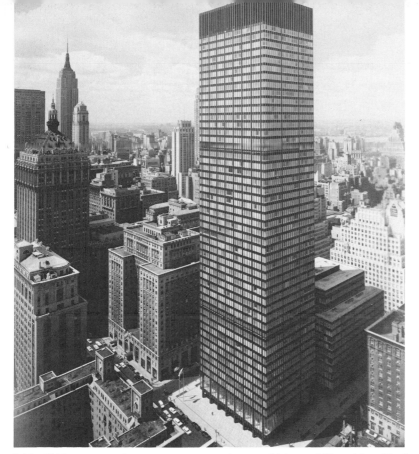

246. Skidmore, Owings & Merrill, Union Carbide Building, New York, New York, 1957–60.

247. Skidmore, Owings & Merrill, Manufacturers Hanover Bank, New York, New York, 1953–54.

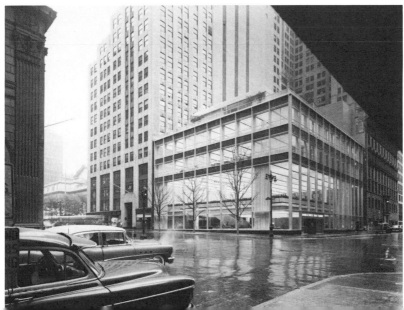

mezzanine tray. From the street, too, one can see the escalators connecting the two levels and the massive vault door so positioned as to be highly visible from Fifth Avenue. Total visual accessibility is the theme, for the image of the bank had changed from that of a strongbox keeping cash reserves inviolate to that of a merchandising center where credit is sold in a competitive market. The mid–twentieth century bank became a transparent lure, an advertisement.

During the late 1960s the nature of urban economics changed. The twenty-one stories of Lever House became dwarfed as new buildings commonly reached heights of fifty to sixty stories in an effort to keep ahead of soaring costs and taxes. Nearly all were variants of Mies's deceptively simple-looking towers; most were mediocrities bereft of any sense of pleasure in their creation and providing no reward for their inspection. Amidst this miasma there appeared several giant towers by SOM, one of which did possess at least some measure of aesthetic sensibility, John Hancock Center, Chicago, 1965–70 (Fig. 248). William E. Hartman was the partner in charge, Bruce Graham was the designer, Fazlur Khan was the structural engineer, and the many other principals involved indicate the complexity of these immense structures. The project began as a complex of business and residential facilities on a relatively small lot on Chicago's north side. When problems arose in fitting all of the services on the lot it was decided simply to stack one atop the other, creating a single shaft of one hundred stories, 1,107 feet tall. Beginning at the plaza level, which contains a restaurant, skating rink, and miscellaneous shops, the building has five commercial floors for a large department store and a bank, seven floors for parking, twenty floors of office space, two mechanical floors, a double-level "skylobby" with shops and a swimming pool, forty-eight floors of apartments ranging from efficiencies to four-bedroom units, an observatory at the ninety-fourth floor, a double-level restaurant and bar, and four mechanical floors at the top. Such height, given the slender proportions of the tower and the treacherous winds off Lake Michigan, precluded traditionally braced steel frame construction because the necessarily large amounts of steel would have consumed too much space and drastically increased the total weight and cost. Graham and Khan decided to view the tower not as a braced frame but as a rigid tube securely fastened at its base, a form of vertical cantilever. Hence the X-braced tapered sides, its members so fastened together that they carry all of the gravity and wind loads and thus free the interior of any structural ele-

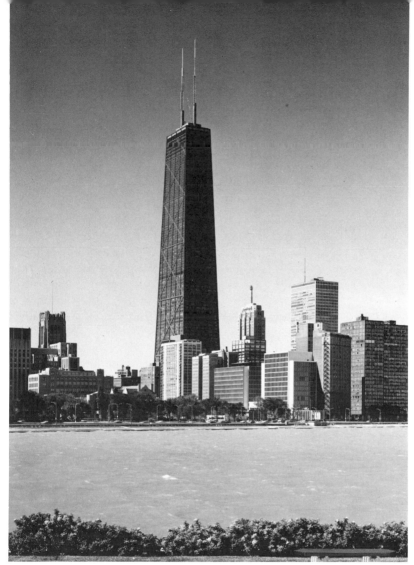

248. Skidmore, Owings & Merrill, John Hancock Center, Chicago, Illinois, 1965–1970. Here are seen three generations of skyscrapers, for to the right of the Hancock tower is the dwarfed set-back top of the Palmolive Building by Holabird & Root, 1928–29, and far to the right are the Lakeshore Apartments by Mies van der Rohe, 1948–51.

ments except utility core and elevator shaft—Mies's universal spaces piled nearly a quarter of a mile into the air. Happily, however, this megastructure is divided into comparatively easily perceived visual units by the cross braces, and the tapered silhouette gives the prism a distinct individual grace.

The same, unfortunately, is not true of the Sears Tower, Chi-

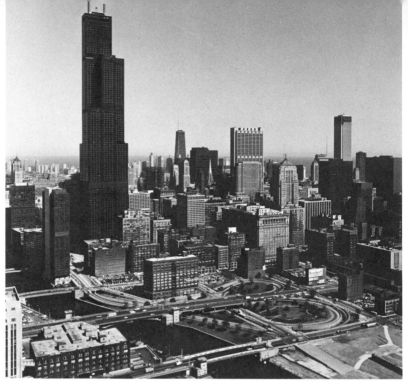

249. Skidmore, Owings & Merrill, Sears Tower, Chicago, Illinois, 1970–74.

cago, also by SOM, 1970–74 (Fig. 249). Save for the ingenuity of using nine clustered rigid tubes, each approximately seventy-five feet square, to achieve column-free interior spaces, this building suffers in nearly every respect in comparison with the Hancock Tower. Instead of combining many uses, so as to distribute traffic patterns and to minimize periodic congestion, the Sears Tower is wholly devoted to office space, nearly 4¹/₂ million square feet, enough room for sixteen thousand workers including the seven thousand Sears employees. The original proposals prepared by the Sears company called for 104 stories but under corporate pressure to surpass the Hancock tower the architects redesigned the upper portion, trimming away some area and piling it up to gain another six stories for a total height of 1,454 feet. The only apparent criterion was that this be the tallest building in the world, not necessarily the best or the most beautiful as had been the case with the Tribune Tower in 1922. To minimize maintenance the building was sheathed in black aluminum which, with the smoked glass, gives the building an ominous appearance. Structural and architectonic articulation was kept to a minimum, making this one of those unique buildings which gets distinctly

less interesting the closer one comes to it. It would not be necessary to speak of it at all at such length were it not that, given economic conditions in most cities, this seemed to be the only kind of new building which appeared economically feasible for a time.

What had caused this megalomania in part was the geometric increase in urban land taxes required by growing demands for municipal services; taxes in turn were exacerbated by the diminishing tax base as more and more land in the urban core was converted to public use. An example is the Civic Center in Chicago, containing the city and Cook County courts, to provide space for which an entire city block was cleared. Architecturally, however, it is a splendid building, the aesthetic and structural apogee of the Miesian idiom (Fig. 250). Jacques Brownson of C. F. Murphy Associates was in charge, working in collaboration with SOM and Loebl, Schlossman & Bennett. The initial studies were made in 1959, the final design prepared in 1962, and the building finished in 1965. The program was unlike that of the typical office building for it was to contain hearing rooms, conference rooms, judicial chambers, and 120 courtrooms, some of which were to be two stories high. Because of these requirements the building has only thirty-one stories but they rise 648 feet, with a floor-to-floor height of eighteen feet. To maximize flexibility the bay width was fixed at an unprecedented forty-nine feet by eighty-seven feet, requiring a floor structure nearly six feet deep. Accordingly the cruciform columns carry great weight, indicated visually by the increase in cross-section at three points along their length. Happily the architects selected for the external members a newly developed steel which forms a tenacious oxide coat similar to aluminum; its color gradually changes from rust to a deep bluish-brown. This color scheme is complemented by amber-tinted glass. In addition in the sweeping plaza south of the building there was placed a large sculpture in steel designed by Picasso, an enigmatic image that has made the otherwise barren plaza an urban place.

The pristine Miesian glass-clad rectilinear tower thus became the symbol of the postwar period, its mythical functionalism applied indiscriminately. Though the architectural ideal of Mies's youth was realized, the reformed society did not follow. What had been originally intended by Mies were isolated glass monoliths reflecting neighboring older buildings and glimpses of the surrounding landscape; what had been envisioned as an alternative became a cliché. In postwar cities, as more and more traditional brick and stone buildings were replaced, the vacuous glass boxes

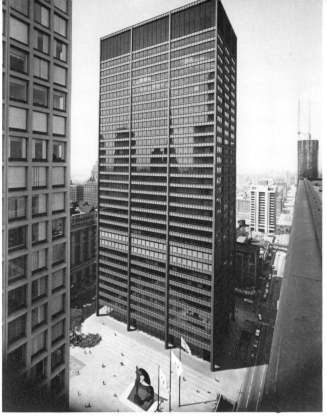

250. C. F. Murphy Associates with Skidmore, Owings & Merrill and Loebl, Schlossman & Bennett, Civic Center, Chicago, Illinois, 1959–65.

stared at each other blankly, reflecting themselves endlessly.

While Mies had been perfecting the technology of the steel frame, Wright had probed the mysteries of the helix. In 1925 he had designed the Gordon Strong Automobile Objective and Planetarium in which two spiral ramps wound around a hemispherical concrete dome. In that project the helical ramp was on the exterior, but in the V. C. Morris Gift Shop built in San Francisco, California, 1948, Wright used a helical ramp to wrap and define an internal space. This experimentation culminated in 1943–45 in the first design for the Solomon R. Guggenheim Museum in New York. During the next nine years the design was restudied and refined; construction began in 1956 and the building was dedicated in October 1959, six months after Wright's death (Figs. 251, 252). In this Wright used a helix which expanded as it rose, forming a pedestrian ramp in which the gallery became a single continuous experience. Instead of traditional closed gallery rooms, Wright devised a single space which one glimpses from the bot-

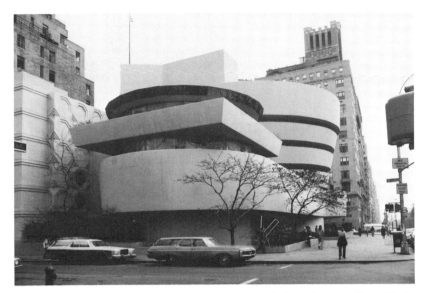

251. Frank Lloyd Wright, Solomon R. Guggenheim Museum, New York, New York, 1943–45, 1956–59.

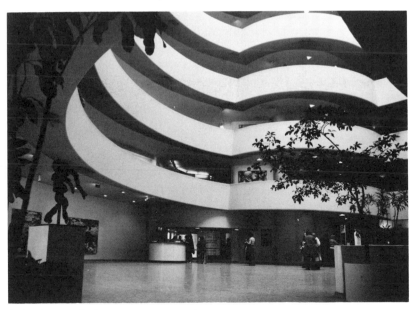

252. Guggenheim Museum, interior.

tom on entering but which is not fully revealed until one takes the elevator to the top of the spiral and begins the journey down the ramp. Unlike Wright's Prairie houses which stretch out into the landscape, the Guggenheim Museum seems turned in upon itself, having little relationship with Central Park or Fifth Avenue, yet the idea grew out of earlier inverted designs, such as the Larkin Building, 1903; Unity Temple, 1904; the project for the Spaulding Print Gallery, Boston, of 1919; the Johnson Wax Administration Building, 1936; and the Morris Gift Shop. As in each of these buildings, in the Guggenheim Museum Wright sought to make of the disparate inhabitants a "family" who viewed themselves across the room as they moved down the ramp. In choosing the spiral ramp, however, Wright introduced numerous problems. The reinforced concrete shell he wanted poured in one operation was unlike the structure of any building ever built before, and at every turn it seemed he violated some provision of the conservative New York building code. It was largely for these reasons that the design had to be carefully studied and revised during the period from 1945 to 1956. Wright was determined to see this built as was his contractor George N. Cohen who suggested many modifications to satisfy code requirements. Also important in solving the numerous problems were Professor Mendel Glickman and Wright's assistant William Wesley Peters. One of the problems they faced was an inability to build complex rounded forms with smooth intersections; the result was awkward junctures. Wright had originally hoped to use exposed marble aggregate but this had to be changed to smooth painted surfaces whose irregularities were consequently exaggerated. Furthermore, the necessity of using flat plate glass in faceted curves conflicted with the otherwise smooth circular continuities of the concrete elements. Perhaps it is too easy to cite its faults; the Guggenheim Museum is a masterwork, a dream realized of unified space and purpose, an assertion of continuous movement and quest, and the visible record of human perseverance in the face of seemingly insurmountable obstacles. As a refutation of virtually every convention of museum design and of a building industry increasingly hidebound by the rectilinear grid, the Guggenheim Museum was a fitting end to Wright's long individualistic career.

What Wright suggested in the Guggenheim Museum was that architecture was a potent vehicle for conveying expression and a powerful psychological force, functions that the adherents of Miesian purism disavowed and largely ignored. In restoring to mid–twentieth century architecture something of its traditional

mystical and psychological symbolism, Wright was joined by Eero
Saarinen (1910–1961). Saarinen, the son of the second place win-
ner in the Tribune Tower competition, was born in Finland; at
the age of thirteen he came to the United States when his father
reestablished his family in Michigan. Eero grew up in a home
devoted to architectural design in its broadest interpretation, for
his mother was a weaver and designer and collaborated closely
with his father. Eero took an architectural degree at Yale in
1930–34 at a time when it was still a stronghold of Beaux-Arts
academicism. From this combination of familial and academic in-
fluences came a desire for an architecture that was both total in
scope and consummately crafted, that simultaneously celebrated
both utility and symbolic function. Saarinen's was a heroic, monu-
mental architecture but one freed of the literary and archaeo-
logical conceits of the previous two centuries. This monumental
concern surfaced quickly in his work in the Jefferson Memorial
competition which he won in 1948 with his huge parabolic arch
built in St. Louis only much later. It can be seen as well, in a subtle
but revealing way, in his otherwise purely Miesian complex of
glass boxes (inspired by the I.I.T. campus) for the General Motors
Technical Center, 1948–56. The dynamometer building is a recti-
linear, flat-roofed box, with revealed steel frame and glass and
brick walls, but close to the exterior wall is a series of thick black
columnar exhaust pipes which through their size and their care-
fully studied spacing become invested with a sculptural power. It
appeared also in his Kresge Auditorium, at the Massachusetts In-
stitute of Technology, 1952–56, where he experimented with
clean geometries in reinforced concrete. This monumentalism
reached maturity in his design for the Ingalls Hockey Rink, Yale
University, 1956–58, which combined a soaring parabolic concrete
arch carrying a roof on suspended steel cables. From this point
onward Saarinen took an increasingly anti-Miesian stance, for he
believed that each building was unique in its internal require-
ments and in its relationship to its site; hence there could be no
prototypical solution for potential application anywhere. Each
part of a specific building was designed as a part of that building,
just as the building in turn was designed as part of its environ-
ment. Each form, in other words, was designed in relationship to
its next larger context.

Perhaps Saarinen's most expressive work is the Trans World
Airlines Terminal at Kennedy (Idlewild) Airport, New York,
1956–62 (Figs. 253, 254). The design began with a study of the
entire airport and its projected growth, including a projection of

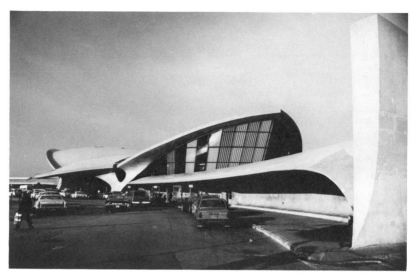

253. Eero Saarinen, TWA Terminal, Kennedy Airport, New York, New York, 1956–62.

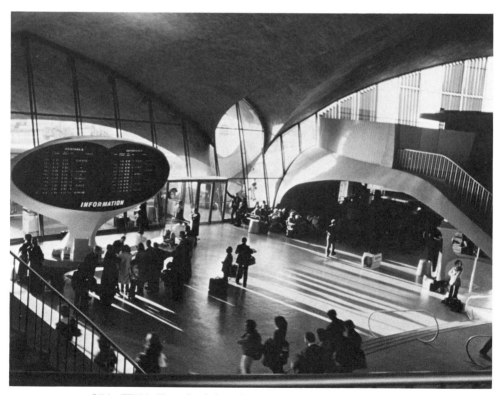

254. TWA Terminal, interior.

the probable development of aircraft and changes in patterns of air travel. Once this was done Saarinen developed a design based on a theme of motion and the excitement inherent in air travel. The initial scheme provided for two great soaring concrete shells, but these were split down the middle and slightly rotated so as to give the design a curved outline that fit the corner site. To make the terminal "one thing," totally resolved in all its parts, as he observed Wright's Guggenheim Museum was not, Saarinen closely supervised numerous studies with large-scale models. The result was a complex environment giving the appearance of a great clam shell, visually indeterminant (Fig. 254). The several changes in level are made gentle and easy, as all lines curve and weave together. As Wright had done, Saarinen confounded every convention of the construction industry, and he worked closely with engineers Ammann and Whitney to ensure full integration of structure and sculptural form. Even mechanical equipment such as signboards and ventilation ducts were made sculptural accents. In the affluent 1960s the airplane (along with the automobile) was the cynosure of public transit, a symbol of power and mobility. Thus the TWA terminal was for the 1960s what Pennsylvania Station had been at the turn of the century. It was a monument in which function was accommodated with form; it was, moreover, a good demonstration of what architect Matthew Nowicki meant when he asserted that "form follows form."

Following Saarinen's early death in 1961, his office, under the direction of Kevin Roche and John Dinkeloo, continued in the monumental spirit already began. Perhaps the most successful of this genre is their Ford Foundation Building, New York, 1967 (Fig. 255). The building faces the northerly small vest-pocket park created as part of the Tudor City complex. The working part of the building with its tiers of offices is in the form of an L along the west side and rear; the remainder of the building is a vast glass-enclosed space with a terraced garden descending from the higher level of Forty-first Street to the lower level of Forty-second Street. This internal park is therefore a perpetually green extension of the Tudor City park. In this way nearly 30 percent of the volume of the building is given over to being a greenhouse, where tamed nature blooms year-round. Though the building, at least the garden terrace, is open to the public, the Ford Foundation is nonetheless a private world, a secular cloister protected from the dirt and disorder of the external world.

As the Ford Foundation Building suggests, this new monumentalism tended to become as exclusive as the earlier Miesian

255. Roche & Dinkeloo, Ford Foundation Building, New York, New York, 1967.

purism. Both rejected messy realities, reducing programs and tightening buildings to fit a priori judgments; both favored simplistic, prototypical solutions. Mies's work certainly fits this description, as does that of Roche, Paul Rudolph, and Philip Johnson, at least to about 1965. To some extent this description also applies to Louis Kahn, but not entirely, for his work transcended these concerns in favor of an architecture in search of what it "wanted to be," designed for beings of spirit as well as corporeality. Kahn believed that human experience is made up equally of the measurable and the immeasurable, that man is always greater than his works.

Born in Estonia, Louis I. Kahn (1901–1974) was brought to the United States at the age of four and early demonstrated a marked artistic ability. After obtaining his architecture degree from the University of Pennsylvania in 1924, Kahn first worked in the office of the Philadelphia city architect where he was particularly concerned with housing design, and then in the office of Paul Cret, where his university-nurtured Beaux-Arts formalism was strengthened. Yet Kahn moved far beyond pure formal concerns; during the depression he devoted much of his energy to WPA housing projects in the Philadelphia area and during the war he

worked on housing complexes; his collaboration with Howe and Stonorov in Carver Court has already been noted. Kahn's mature work appeared quite late; after a long period in which he absorbed and sifted each of the major theoretical movements of the day, he gradually shaped a theory of of his own. This process was focused by his teaching at the Yale School of Architecture from 1947 to 1957. It was during this time that he designed the Yale University Art Gallery.

In approaching a design, Kahn first probed the nature of the activities to be physically accommodated as well as the concepts implied by each activity; he endeavored to find what the building wanted to be. "How to do it," the design, was a matter of finding the space appropriate for each component activity, a space that not only was simply big enough, but that also evoked its particular use. The end result of such study would be that the building's spaces would be naturally harmonious and would also have psychical, symbolic truth. Finally came the harmonious integration of all the necessary systems, always with a clear view of the distinction between the "served" spaces for human activity, the primary-use areas, and the "servant" spaces providing mechanical and support systems—stairs, bathrooms, storage, and other nonprimary functions.

This process is vividly demonstrated in Kahn's Alfred Newton Richards Medical Research Building at the University of Pennsylvania, Philadelphia, 1957–61 (Fig. 256). The commission was to provide research facilities on a very constricted narrow site. This suggested to Kahn some sort of vertical stacking to meet the requirements, but instead of using the typical loft spaces filled with tangles of piping and flues, Kahn set about analyzing the basic humanist function. His solution was three towers of superimposed, glass-enclosed research studios clustered around a central fourth mechanical tower. The governing idea was that each scientist be isolated and yet be able to see his colleagues at work, to be alone with his own thoughts and yet united in the communal experience; the human beings come first and the apparatus second. Perhaps this is most fittingly illustrated by the way in which the towers are placed to look over the lush garden to the south, so that the scientists are constantly presented with a view of the feral world in all its complexity and flux.

In each tower the constituent elements are vigorously articulated. The central service tower (on the far right side in Fig. 256) contains elevators, stairs, major plumbing, storage rooms for experimental animals, and, along the rear wall, four large projecting

256. Louis I. Kahn, Alfred Newton Richards Medical Research Laboratories, University of Pennsylvania, Philadelphia, Pennsylvania, 1957–61. The towers to the left with the cantilevered office cubicles at the top are the Biological Research Building addition, 1961–64.

flues for air intake. Each of the studio lab towers, with their glazed cantilevered corners, has large external flues for fume exhaust and stair towers which terminate in tall fin walls to differentiate them from the exhaust ducts. As a result, through the intensive study of the physical and empirical realities of the program, each of the elements expresses its own nature and function. Similarly each part is constructed in the way best suited to its form and function; the towers and air ducts are of monolithic poured concrete using slip forms and covered with a brick veneer so as to blend with older neighboring buildings by such architects as Cope & Stewardson, while the studio lab towers are constructed of precast and post-tensioned concrete members interlaced Chinese-puzzle-fashion and left exposed as a record of the construction process. This pioneering structure, combining elements of the Vierendeel truss and the space frame, was worked out by Kahn and Dr. August E. Komendant of the University of Pennsylvania. Its assembly pointed out to Kahn the importance that the derrick would come to play increasingly in the future as whole sections of buildings could be lifted into place so that weight would no longer be an obstacle to the use of large prefabricated assemblies.

The Richards Medical Research Building, later enlarged by a biology addition (on the left in Fig. 256), in fact did become quickly overcrowded as research programs expanded; its assertive boldness was even disconcerting to some scientists conditioned to working in minimal architectural environments. Yet it demonstrated the power of an architecture fully expressive of its use, whose primal forms had no pretense of fashion. With a simpler more stable program the results approached poetry, as Kahn

257. Louis I. Kahn, First Unitarian Church, Rochester, New York, 1959–64.

proved in the First Unitarian Church, Rochester, New York, 1962–64 (Fig. 257). Here the quintessential experience was the meeting, so at the center of the plan Kahn placed a large severe rectangular room, covered by four light-catching monitors. Around it he grouped rooms of various configurations—classrooms, committee rooms, minister's office, women's workroom, a library with a projecting reading nook, and an entrance lobby. Each element is distinct, sharp-edged, molded by recesses that catch the light and bounce it into the rooms, for there is no architecture, Kahn asserted, without natural light.

As Kahn's geometry became increasingly more assertive, his work assumed a timeless monumentality and authority. Certainly his was among the best work of the 1960s, and perhaps of the century; expecially good were his Residence Hall at Bryn Mawr College, 1960–65, his governmental buildings at Dacca, 1962–66; and particularly the Salk Institute at La Jolla, California, 1959–65. In the Salk Institute, Kahn had a much larger site, so he was able to separate and more sharply define each of the three basic components—the housing of the scientists, the research facility, and a community center (Fig. 258). The three elements form a U, with the housing and community center on projecting cliff bluffs overlooking the Pacific, and the laboratories behind them at the base of the U. Indeed, the laboratories themselves are arranged in a U-shaped block, opening out onto the ocean. Instead of using towers and threading the utilities through the exposed structure, Kahn used a sandwich of floors, with mechanized floors alternated with research floors, so that changes in the supply of utilities can be made for any given lab area without interfering with other experiments. Even more important, in the courtyard on the alternating floors are projecting studies or private offices for researchers,

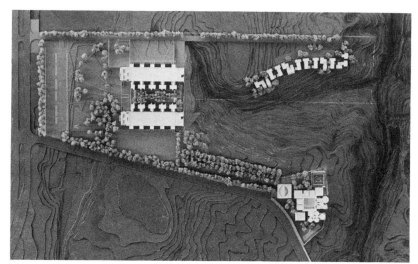

258. Louis I. Kahn, Jonas Salk Institute for Biological Studies, La Jolla, California, 1959–65. Vertical view of study model, c.1963, showing three zones of activity: living quarters; laboratories and studies; and community center, or the "Meeting House."

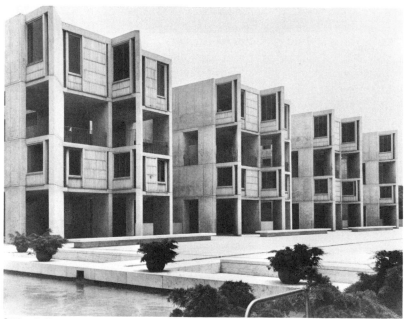

259. Salk Institute, laboratory building, view of the central court and individual studies.

each with a view of the ocean (Fig. 259). Whereas the building is of carefully detailed reinforced concrete, the studies are fitted with naturally finished wood. The work area is thus divided into two parts—one for active investigation and one for contemplative analysis of the work in hand, one for scientist and one for the human being. Perhaps nowhere else has Kahn's concern for the whole of the human experience been so carefully and patiently realized.

If Kahn represented the more rational and intellectual side of heroic expressionism during the 1960s, then Paul Rudolph represented the more aggressively flamboyant aspect of the decade. Paul Rudolph (born 1918) studied at the Alabama Polytechnic Institute and then took his professional degree under Walter Gropius at Harvard over a period interrupted by the war. His early work with Ralph Twitchell in Florida was marked by a precision of form and structure that spoke well of his training under Gropius. Indeed, in the Healy Guest House, Siesta Key, Sarasota, 1949, there is a severity worthy of Mies. The entire house is treated as a small pavilion and consists of one space subdivided into functional sub-spaces. During the next decade, however, Rudolph turned increasingly to expressive forms and idealized programs. In 1958 he was appointed chairman of the Yale School of Architecture and within the year he began studies for a new art and architecture building. Completed in 1964 (Fig. 260), it seemed to bear small formal relationship to his beginning work, for in it Rudolph seemed driven to experiment with plastic sensation, as Vincent Scully has observed. Drawing inspiration from Wright's Larkin Building (with its internalized spaces) and Le Corbusier's monastery at La Tourette (with its grandly elevated masses), Rudolph wrapped balconies around central two-story rooms and piled layer upon layer, creating more than thirty floor levels. The painting studios are raised aloft on the massive corner piers. Some of the piers house stairs in the manner of Wright, while others contain seminar rooms and offices. While in general there seems to be a loose relationship between specific function and form, the paramount interest clearly is in formal, visual qualities intensified by the rough texture obtained by hammering the ridged concrete surface. On its corner site, forming the culminating element in a row of Yale buildings along Chapel Street, it is certainly splendid. Yet there is a self-consciousness about its boldness and a presumptive willingness to manipulate the program for the sake of form that is disturbing. It suggested that architecture should be heroic act and that art should be an uplifting,

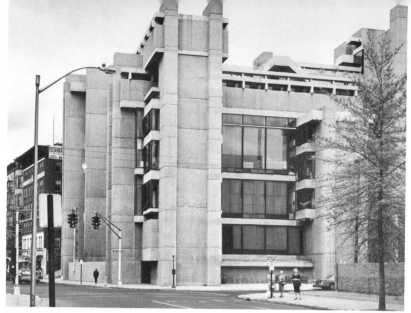

260. Paul Rudolph, Art and Architecture Building, Yale University, New Haven, Connecticut, 1958–64.

enhancing experience even at the expense of rational function. This building, for example, was seemingly designed more to reflect these ideals than to express how architecture, painting, or sculpture was actually taught or experienced, as Vincent Scully has noted. The same was true of Rudolph's Crawford Manor, New Haven, an apartment tower for the elderly, which also has ruggedly manipulated forms, corrugated surfaces, and a prominently placed library where older citizens were expected to enlighten their minds.

Of the several architects in the "exclusivist" camp in the 1960s, perhaps the most reductivist were Skidmore, Owings & Merrill. One of the clearest instances in which they forced the program into a preconceived envelope is their Beinecke Rare Book Library, Yale University, 1960–63 (Fig. 261). Since climatic control was crucial to preservation of the books, Gordon Bunshaft, partner in charge, designed a shell of marble slabs filtering sunlight into a large room about one-quarter of which was occupied by a second smaller glass box enclosing the stacks of leather-bound volumes—a jewel box inside a jewel box. The catalog, delivery desk, offices, study rooms, and other functional facilities were tucked away below ground beneath the marble paved terrace. Only one-fourth of the collection is housed in the visible glass box; the remainder is kept in storage in basements. Bunshaft formed the self-supporting walls of the outer box of welded steel Vierendeel trusses filled with translucent marble slab panels. The frame was then covered by carved marble sections externally and precast marble-concrete

sections internally, so that the masonry wall is counterfeit. The four recessed corner piers contribute to this paradox for they do lie on the planes of the forces of the walls but have the loads shifted to them by means of heavy diagonal girders all of which are hidden from view. Consequently the Beinecke Library is far more devious about its purpose and its structure than any of the older buildings that surround it, and in comparison with its neighbors it suffers doubly because of its scalelessness. This lack of human scale was mockingly and humorously exaggerated in 1969 when a giant lipstick by sculptor Claes Oldenburg was placed in the courtyard facing the library. Neither the immaculate construction, the semiprecious materials, nor the marble sculpture by Isamu Noguchi in the sunken courtyard can quite counter the feeling that the building was conceived primarily as the optimum showcase for selected incunabula and that its human use was subordinate. In few other instances have the implications of the site or the needs for meaningful perceptual relationships been so blatantly disregarded in the quest of heroicism.

261. Skidmore, Owings, & Merrill, Beinecke Rare Book Library, Yale University, New Haven, Connecticut, 1960–63.

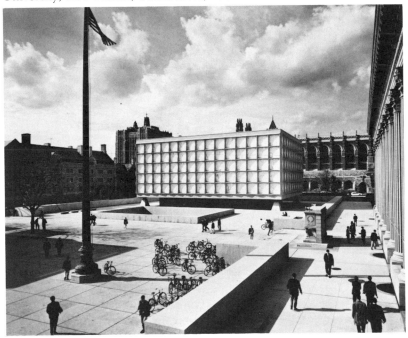

During the 1940s and 1950s the arch-advocate of Miesian purism was Philip Johnson (born 1906). He had been an admirer of Mies since the 1920s, had visited him in Germany during the next decade, and had obtained for him the crucial Resor commission that brought Mies to the United States. In 1932, in collaboration with Henry-Russell Hitchcock, Johnson wrote the catalogue *The International Style,* which focused on the work of Mies and the other modernists, and subsequently Johnson was appointed to the Department of Architecture and Design of the Museum of Modern Art, New York, eventually becoming its director. While at the museum in 1947 he published one of the first monographs on Mies. Yet Johnson's true interest remained the practice of architecture, so in 1943 he took the professional degree at Harvard studying with Gropius. While in Cambridge he built for himself a small house featuring a wall entirely of glass, an idea he expanded in his famous "Glass House" in New Canaan, Connecticut, 1949, which marked the beginning of his career. This was soon followed by equally purist designs such as the Rockefeller guest house, New York, 1950; the Robert Leonhardt house on Long Island, 1956; and the geometrically severe public buildings such as the Munson-Williams-Procter Institute, Utica, New York, 1957–60; or the Sheldon Art Gallery, University of Nebraska, 1960–63. In 1960, however, a new direction appeared in his work in the small shrine for the Blaffer Trust, New Harmony, Indiana (Fig. 262). For this he used a small strongly evocative shingled form which showed a new concern for monumentalism. The Blaffer commission called for a "Roofless Church," in which the body of the church enclosure was defined by a high wall, the space open to the sky. The "narthex" was covered by a canopy of trees, as was the side entrance, but the "altar" marked by a sculpture by Jacques Lipchitz was covered by a shrine consisting of a convoluted shingle roof carried by six laminated wooden arches resting on marble pier blocks. The shrine roof seems to pay homage to the continuities of surface of the Shingle Style and its rich historical lineage, while at the same time asserting the evocative power of pure form. Architectural form, it indicated, comprises a visual language which has long been undervalued.

As this interest in the language of architectural form developed in Johnson's architecture, it was at the same time consistently tempered with a concern for symbolic expression of function and place. These qualities are well illustrated by the Kline Biology Tower, Yale University, 1962–66 (Fig. 263), done in collaboration with Richard Foster. The functional requirements were compara-

262. Philip Johnson, "Roofless Church" for the Blaffer Trust, New Harmony, Indiana, 1960.

263. Philip Johnson with Richard Foster, Kline Biology Tower, Yale University, New Haven, Connecticut, 1962–66.

ble to those of Kahn's Richards Medical Research Building at the University of Pennsylvania, and the restrictions of the site were also similar. Yet aside from their common verticality—the Kline Tower is fourteen stories tall—Johnson's solution is far different in expressive intent. The Kline Biology Tower is decidedly simple and monumental, with its exterior walls formed of many closely set cylindrical columns. One of the tower's prime purposes according to Johnson was to be a symbol of biological research at Yale, that is, a monument in the purest sense, marking a special place, calling attention to a unique activity, generating pride of place among those associated with the building's use. Kahn chose to express the heroic qualities of the building as apparatus, hence his sharp delineation of the service elements. Johnson, however, chose to use formal aesthetics alone and his dense sculptural columns (which are actually only semicircular in plan) have only indirect relationship to the service elements. Johnson was correct in pursuing this course, for his tower became one of the tallest elements in the landscape, calling attention to the pursuits of the university just as James Gamble Roger's Gothic Harkness Tower had done for the previous generation. Johnson was also extremely sensitive in his use of color, selecting dark brown salt-glazed brick and brownstone in deference to the surrounding science buildings of the Pierson-Sage square dating from 1913 to 1924. Through its sheer verticality the tower became the focus of the group, yet it reads as a part of the group because of its materials. The Kline Biology Tower served as a fitting memorial too to Yale president A. Whitney Griswold whose perspicacity had been responsible for engaging so many important architects for university buildings during the 1950s and 1960s making the campus a veritable museum of modern architecture.

Johnson's monumentalism, moreover, was flexible, for he was especially sensitive to the irrational psychic human needs architecture must meet. For the most part such needs were not satisfied, he said in 1954 in an address to Yale architecture students, because modern architecture relied largely on seven crutches (in a parody of Ruskin's seven lamps). These included: history, pretty drawing, utility as an end in itself, comfort, cheapness, client-serving, and structure. While Johnson was not the first to ridicule these clichés, his attack was unusually broad and good-humored for he admitted to having used some of these himself from time to time. His analysis of the seven crutches helped in the development of a new more inclusive architecture that matured in the next six years.

The example of one architect in particular assisted in this reassessment; this was Alvar Aalto (1898–1976), who during the war taught at the Massachusetts Institute of Technology. While there he designed Baker House, a dormitory along the Charles River, 1946–48 (Fig. 264). Aalto's buildings combined the rational purism of the International Style, which he had helped to introduce in Finland, with such intuited forms as the undulating wooden ceiling of the Viipuri public library, 1927. In Baker House one of Aalto's major tasks was to provide the maximum number of rooms with an engaging oblique view of the river. This he achieved by bending the building in the form of a giant S so that very few rooms actually face the river frontally while the great majority look up or down the expanse of water. The back of the building is even more irregular for it contains larger suites of rooms and lounges. In addition, climbing the wall are stairs that branch out from the base of the building; cantilevered from the wall, they form a stark irregular zigzag. The walls are of rough deep-red brick laid with randomly spaced misshapen clinkers whose protrusions give the surfaces a rich tweedy texture. What Aalto showed in Baker House was that form should follow the irregularities of actual use and that this expression of complexity could be enhanced by the use of warm colors and tactile surfaces.

264. Alvar Aalto, Baker House, Massachusetts Institute of Technology, Cambridge, Massachusetts, 1946–48.

Such ideas were to lie fallow for nearly a decade before American architects took them up, but Aalto developed them beautifully in his town center for Säynatsälo, Finland, after his return to his native country.

By the early 1960s a few architects began to effect a shift toward a more complex, inclusive architecture, one that tended to view neighboring buildings more sympathetically and that accepted the messy and seeming chaotic quality of human activity. This new view was pluralistic, and accordingly encountered stiff resistance from those still in the exclusivist camp. Especially persuasive among this new generation, through their writing as much as through their building, were Charles W. Moore and Robert Venturi. Moore studied architecture at Princeton where he absorbed some of the Beaux-Arts formalism of Jean Labatut, but to this he added a strong feeling for the environmental role of architecture. Crystallized during his years of practice in Berkeley and San Francisco and then as chairman of the Department of Architecture at Yale, Moore's image of the architect came to be one who acts to particularize and reinforce a sense of place, thereby letting people know, he wrote, "where they are—in space, in time and in the order of things." Thus to reinforce the nature of a particular place, one must accept what is already there constituting the place. Moore delights in contrast and idiosyncrasy. A good example of his work can be seen in the addition to the Citizen's Federal Savings and Loan Association, San Francisco, which he did in collaboration with Clark and Beuttler in 1962. In this the Beaux-Arts motif of the original building is restated in contemporary terms, in the large base element and especially in the modified mansard roof, so that the new building deals successfully with the awkward corner site, augments the original building, and still asserts its own contemporaneity. The result is a combination that strengthens the character of the place. In a rustic landscape the character is far different, requiring a much different response; so in Moore's Sea Ranch housing, 1965–66, north of San Francisco, one finds a cluster of angular rough units (Fig. 265). Moore collaborated with Lyndon, Turnbull, Whitaker, and developer Alfred Boeke of Oceanic Properties, designing this condominium group so that it would have both unity and privacy. This same idea was carried out in later extensions to Sea Ranch by Joseph Esherick and landscape architect Lawrence Halprin. Groups of shed-roofed pavilions, sheathed in rough siding left to weather, enclose small spaces, and in their overall craggy silhouette echo the rugged coastal cliff. Sea Ranch enhances the nature of the

265. Moore, Lyndon, Turnbull & Whitaker, architects; Lawrence Halprin & Associates, planners, Sea Ranch, north of San Francisco, California, 1965–72.

place, but its nestled boxes reveal something even more important—a unity of many individualities, or what architect and critic Robert A.M. Stern calls "the willingness of many to give up something for the community."

Robert Venturi is perhaps the best-known embattled advocate of this new pluralism. He too was a student of Labatut at Princeton, and from that exposure to formalism he, like Kahn, learned "what it is like actually to look at things," as Donlyn Lyndon put it. And, like Kahn, Venturi resided at the American Academy in Rome, learning there the primacy of environmental relationships. When many architects were rushing to advance Miesian purism, in 1953, Venturi wrote that "the architect has a responsibility toward the landscape, which he can subtly enhance or impair, for we see in perceptual wholes and the introduction of any new building will change the character of all the other elements in a scheme." This emerged from a careful study of Michelangelo's Campidoglio and is illustrative of Venturi's analysis of the past. In addition, like Kahn, Venturi has been forced to test his theory in the classroom at Princeton and at Yale. In his first book, *Complexity and Contradiction in Architecture*, 1967, he attacked the pretentiousness of the exclusivists, arguing for accommodation and multiplicity. "Less is a bore," he retorted. Venturi accepts mundane grubbiness, the limitations of budgets, and imperfect human nature, admitting that "main street is almost all right," in *Learning from Las Vegas*, 1972. It may not be perfect, but neither is it ripe for preemptory bulldozing.

Venturi's own designs show this complexity and contradiction.

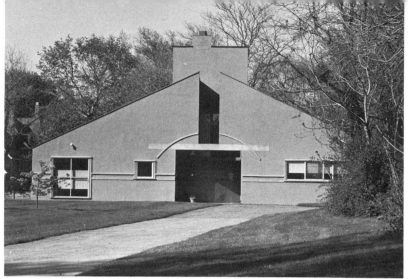

266. Robert Venturi, Venturi house, Chestnut Hill, Philadelphia, Pennsylvania, 1962.

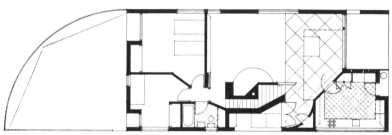

267. Venturi house, plan.

His own house in Chestnut Hill, outside Philadelphia, 1962 (Figs. 266, 267), contains an irregular cluster of rooms all trying to be in the same place at the same time. The way in which the rooms focus on a central fireplace recalls Wright and New England, but the way in which the rooms seem to collide, the unexpected angles of walls, the jostling of spaces into mutual accommodation, is quite unlike the neat geometries of Wright. On the exterior the windows change shape and size according to the function within— a high horizontal band over the kitchen counters to the right, a small porthole in the bathroom to the left, and a large window in the bedroom far to the left—but all are tied together with thin belt course "strips." These along with the abstracted broken gable and arc seem to refer to a formal classical Philadelphia heritage. Certainly Venturi's whimsy and irony are joyfully exhibited, revealing the architect as *homo ludens,* man at play, and it is this whimsy that so infuriated critics who believed that all architecture, public and private, is a serious battle of purist beauty versus ugli-

ness. In Philadelphia, in the shadow of Furness, Venturi found in the contradictions of studied ugliness a powerful imaginative resource.

Whimsy, irony, and realism define Venturi's larger public buildings of which his apartment building for the elderly, Guild House, Philadelphia, 1960–65 (Fig. 268), is one of the earliest and best. It is a very plain building, making no pretense to being any better or grander than the surrounding vernacular buildings. Standard industrial elements are used throughout for windows, balconies, brickwork, and finishes. Nevertheless Venturi avoids foursquare boxiness by stepping the building forward in stages and by employing complexly interlocked floor-plans which, as Charles Moore observed, recall apartments of the 1920s. The wall planes are punctuated by openings of varied sizes, proportioned to changing internal functions. The street façade is made a frontispiece by using glazed subway tile at the entrance to form a base element. Above the door are supergraphics, and at the top is a large segmental window, forming something of a pedimented crown. This window lights a large communal lounge for television viewing, for, unlike Rudolph in his library of Crawford Manor, Venturi did not moralize about what the elderly should do. He celebrated what they actually do by placing a giant gold-plated antenna at the top of the building. In fact this is purely symbolic,

268. Venturi & Rauch, Cope & Lippincott, associated architects, Guild House, Philadelphia, Pennsylvania, 1960–65.

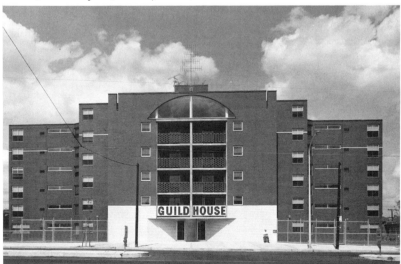

since the real antenna was mounted elsewhere. Functional activities, structure, and external environment are all reconciled to one another, with touches of humor in the "misalignment" of the entrance recess and its bisecting column, the arch of the frontispiece, the slits in the parapet wall, and the razor-sharp line of the white tile marking an "attic story" which passes through every window at the top and aligns with none. If purists should ask why he does things like this, Venturi, observing the complexity of High Victorian Gothic examples, particularly those of Furness, might well reply with every justification, "Why not?"

Paralleling thriving commercial building at the urban core during the 1950s and 1960s was an intense focus on suburban development and the free-standing single family house. Indeed, suburb-building was almost a mania after the war, as every major city became surrounded by proliferating satellite communities. Park Forest, south of Chicago, was one early example, and Levittown, outside Philadelphia, was not so much a specific development as a concept; it became a symbol describing hundreds of places. William Whyte's "Organization Man" could be transferred across the country, moving from one suburb into another that was virtually indistinguishable.

Wright's Usonian house developed before the war became a kind of conceptual model for much of the residential building after 1945. His influence was particularly marked in California for several reasons. The local traditions of Maybeck and the Greene brothers formed a good base and the climate was ideal for Wright's open, expansive plans. The parallels to Wright's work can be easily seen in the Ralph Johnson house, Los Angeles, 1949–51, by Harwell Hamilton Harris (Fig. 269). Harris was a na-

269. Harwell Hamilton Harris, Ralph Johnson house, Los Angeles, California, 1949–51.

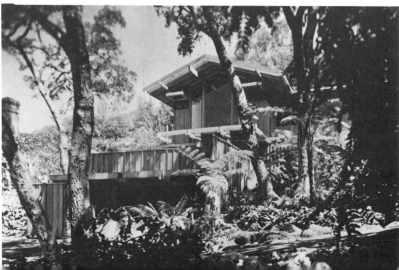

tive of California, had grown up in Redlands, and knew the work of the Greenes and Wright's Barnsdall house. His early experience was in the office of Richard Neutra in Los Angeles. Given a challenging sloping site for the Johnson house, Harris stepped the three levels of the house using the garage as terrace for the living room. This and the interlocking pinwheel plan recall the flexibility of Wright, as does the three-foot grid. The exposed timber frame, the highly articulated roof structure, and the natural finishes, however, acknowledge a debt to the Gamble house and to the Orientalism of the California coast.

Perhaps the houses most sensitive to materials and site were those designed by Pietro Belluschi in the region around Portland, Oregon. In the office of Albert E. Doyle he quickly became the principal assistant, and though Doyle died in 1928, Belluschi retained the original name of the office until 1943 when he began to practice under his own name. The houses which he began to design in the late 1930s, continuing until he was appointed dean of the School of Architecture at M.I.T. in 1951, are among the most refined and sensitive of the period. They seem to combine the direct expression of wood with natural finishes, the clarity of Oriental architecture, and the simplicity and directness of form of Oregon barns, so that they are free of the preciousness that sometimes appears in the work of Wright or the Greene brothers. An early example was the Jennings Sutor house, Portland, 1938, while the even simpler Peter Kerr house outside Portland, 1941 (Fig. 270), incorporates a sun-bleached tree trunk as a porch column, seeming to make a reference to Arthur Little's shingled James L. Little house, Swampscott, Massachusetts, of 1882. Belluschi's treatment of materials in these early houses is in the best

270. Pietro Belluschi, Peter Kerr house, Gearhart, Oregon, 1941.

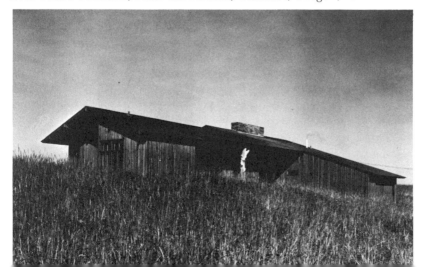

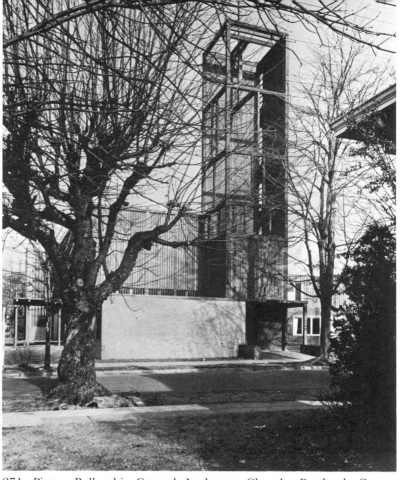

271. Pietro Belluschi, Central Lutheran Church, Portland, Oregon, 1950–51.

tradition of Wright, and is contemporary with a similar attention to natural color and finish in the work of Aalto when he returned to Finland after the war. Indeed, Belluschi's Central Lutheran Church, Portland, of 1951 (Fig. 271), because of its use of brick and wood, might be fittingly compared to Aalto's civic center for Säynatsälo built in 1950–52.

To the south in California Richard Neutra continued to build houses which extended the application of International Style principles to the private house. The best examples are the "Desert House" for Edgar Kaufmann, near Palm Springs, 1945; the Moore house at Ojai, 1952; the Perkins house, Pasadena, 1955; and the Singleton house, Los Angeles, 1960. All of these show a remarkable adaptation to desert and arid climatic conditions; all incorporate pools of water for swimming, for cooling air, and for its psychological effect; and though all manifest the sharp planar geometries of the International Style, each is specially developed

to fit its unique site so that there is no suggestion of the mass-production that pervades Mies's work.

After about 1960 Neutra, Gropius, and Marcel Breuer all began to concentrate on larger commercial buildings which increasingly lacked the distinction that had marked their domestic designs of the preceding two decades, obscuring perhaps the sharp geometries, restrained elegance, and good use and expression of materials in those houses. It was later evident that each of them was better adapted to the design of small works. Both Gropius and Breuer had emigrated from Germany early in the 1930s, passing first through England. Gropius arrived in the United States first, in 1937, and assumed the position of professor of architecture at Harvard where he helped to shape an entire generation of American architects (Philip Johnson and Paul Rudolph, for example, studied there during the 1940s). He invited Breuer to join him on the faculty, for since the 1920s they had been colleagues, first at the Bauhaus and then in London. They complemented each other in many ways, for Breuer's intense study of detail and construction techniques balanced Gropius's more sweeping approach. At first Gropius and Breuer maintained a partnership but eventually Breuer withdrew to establish his own practice in New York. Prior to this, however, the two had collaborated in the design of the New Kensington housing project during the war and on the exquisitely but simply articulated weekend house for Henry G. Chamberlain, at Wayland, Massachusetts, in 1940. To this theme Breuer returned in 1947 when he built for himself a weekend home in New Canaan, Connecticut (Fig. 272). The house has the simple cubical clarity of Breuer's early work combined with a new

272. Marcel Breuer, Breuer house, New Canaan, Connecticut, 1947.

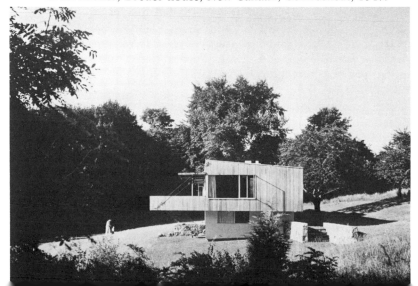

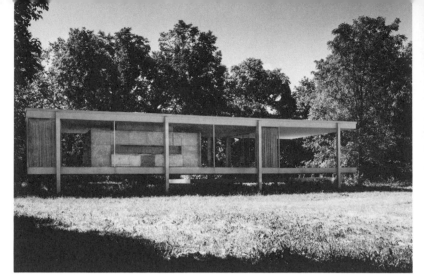

273. Ludwig Mies van der Rohe, Dr. Edith Farnsworth house, Plano, Illinois, 1945–51.

expression of materials. It is basically a box of wood, roof slightly sloped, with a boldly projecting terrace; it is lifted free of the earth on a masonry pedestal. Each element is defined as crisply as possible; the siding is turned on the diagonal to indicate its function as bracing and the frankly revealed diagonal cable supporting the terrace accentuates the rectilinearity of the house. As with his furniture of the 1920s, this house showed Breuer to be a master of design on a small scale.

While Mies was most concerned with commissions for larger buildings, he did design several small houses. Essentially they were derivatives of his Barcelona Pavilion of 1929, each one more simple and abstract, each a demonstration of "less is more." The culmination of this process was the weekend house for Dr. Edith Farnsworth at Plano, Illinois, designed in 1945 but not built until 1950–51 (Fig. 273). Here the universal space is condensed and modified to domestic scale. Since the site was large and screened from view by trees, Mies could use walls entirely of glass, and since the Fox River was subject to spring floods, the house had to be raised off the ground. Basically the house consists of two rectangular slabs parallel to the ground, 29 feet by 77 feet. They are supported by eight columns, four to a side; each bay is 22 feet wide, leaving about 5½ feet cantilevered at each end, a very efficient structural arrangement. One bay at the end is an open veranda; the other bays are enclosed by great sheets of glass. Within this glass box is a single room interrupted by a single rectangular utility core which houses a kitchen counter, bathrooms, flues, and a fireplace. By placing it off center toward one corner Mies divided the large room into unequal areas that serve as bedroom,

kitchen, dining area and living room. What characterizes the house in particular is the exacting refinement of the design and the equally precise construction. Each of the eight columns was welded to the face of the horizontal beam, the weld seams ground down to a perfect fillet, and the whole frame primed, painted, repainted, and polished so that no trace remains of its assembly. The floor is laid in travertine panels, measuring two feet one inch by two feet nine inches, making the basic modular grid. The locations of the glass walls, the utility core, even the position of the pieces of furniture, are dictated by this grid. The materials are commensurately elegant; besides the travertine flooring the utility core is paneled in light yellow primavera, and the curtains are of raw silk. The house hovers in the air, seeming to disdain the ground; its purity and abstraction contrast sharply to the irregularity and unpredictability of the landscape. In many ways it is not designed to be a home at all but the realization of an architectural ideal, existing somewhere between the world of things and the world of dreams.

Compared to the Farnsworth house from which it was derived, the Philip Johnson house in New Canaan reveals how Mies's purism was modified by an American architect. Johnson had contemplated building a house of glass since seeing Mies's Resor house project and, as has been noted, had actually built a small version with one wall entirely of glass in 1942 while living in Cambridge. After Mies showed him the designs for the Farnsworth house in 1945, Johnson began making definitive plans for his own house. It was completed in 1949, two years before the Farnsworth house (Fig. 274). Aside from the clear similarities

274. Philip Johnson, Johnson house, "Glass House," New Canaan, Connecticut, 1945–49.

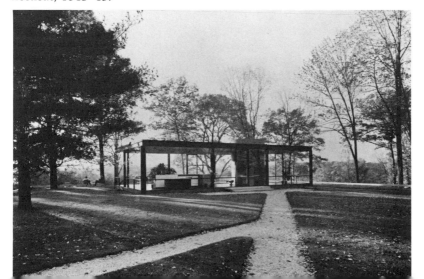

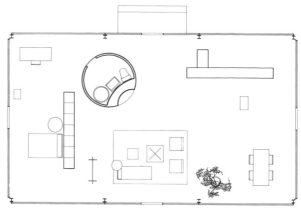

275. Johnson "Glass House," plan.

there are a number of highly significant differences. Instead of being free of the ground, the Johnson house is placed directly on the ground on a low brick base in the center of a polygon-shaped terrace at the edge of a gentle hill. Doors on each of the four sides give access to the tree-shaded lawn, where Mies had only one door and one movable pane for ventilation. The Farnsworth house is determined by a modular grid to which everything is compulsively tied, but Johnson's approach was much more intuitive. He began with a simple rectangle with a width to length ratio of 1:1.66 (nearly the golden section) (Fig. 275). The floor of this rectangle is of brick laid in a herringbone pattern so that there is no grid but rather a nondirectional, nonproportional field on which anything can be arranged (he does in fact change the furnishings from time to time; Fig. 276). Instead of a precisely aligned rectangular core, Johnson employed a brick cylinder to house the fireplace and bathroom; its placement is intuitive not mathematical. Where Mies placed the structural columns outside the glass envelope, using thin symmetrical mullions at the corners, Johnson made the supports both columns and mullions, resulting in a complex asymmetrical corner articulation (Fig. 277). If Mies represents High Renaissance precision then Johnson represents mannerist variation.

The cylindrical core, in particular, illustrates two marked departures from Mies's astringent purism. First, Johnson introduced a circle into a rectilinear scheme, a fillip Mies avoided since he said he had not yet perfected the straight line. Even more significant is the huge fireplace for it throws into sharp relief one of the seven crutches Johnson liked to ridicule—comfort. Johnson said that modern architects let ventilation engineers dictate the architectural environment as though a constant temperature of sev-

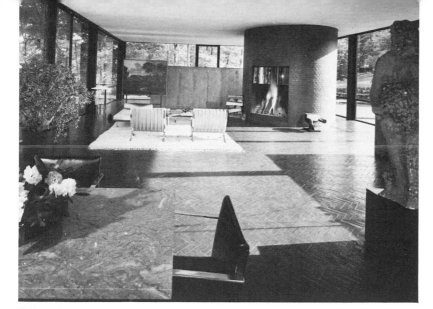

276. Johnson "Glass House," interior

8" H column

277. Johnson "Glass House," corner detail.

enty-two degrees were sacrosanct. To them fireplaces are anathema because they throw thermostats off. Johnson said he preferred the beauty of the fireplace; he preferred to light a great fire, turn the thermostat down, and move back and forth to control his warmth. "Now that's not controlled environment," he admitted. "I control the environment. It's a lot more fun." Mies was obliged to introduce curtains to curb sunlight in his Farnsworth house (see Fig. 273), whereas Johnson was able to avoid their use

by the much more simple but natural device of exploiting the large broad-leaf trees around his house as sun screens. In the summer, especially in the afternoon, these prevent sunlight from penetrating the glass box (thus turning it into a hothouse), but on winter afternoons the light filters through the bare branches and warms the house.

A further departure from the implied axiality of the Farnsworth house was the arrangement of the main house and the nearby guest house to force an oblique approach creating a processional element which Johnson came to stress more and more. One might compare to this, for instance, the angled approach up the hill to the Kline Biology Tower (see Fig. 263). Still, for all its mannerist nuances, the Johnson house represents an exclusivist position, even if somewhat more liberal than Mies's Farnsworth house. The counterpart to this purism we have already seen in the residential work of Moore and Venturi.

Until about 1960 the deeper urban problems were either ignored or considered superficially, for few architects had been trained to deal with broad cultural problems. One of the very few who did try to reshape his society was Richard Buckminster Fuller who consistently acted according to a vision so apocalyptic, and devised forms so radical, that his influence has been only minimal. Fuller grappled with the totality of the contemporary social and technological environment, inventing a system of construction which requires minimal material used to maximum efficiency, what he calls a "minimal dimensional energy system." Many of his ideas were already present in his Dymaxion house of 1927 which consisted of a prefabricated hexangular module suspended from a central utility mast. This was followed by the streamlined Dymaxion car in 1933, a total living environment on wheels. In 1946 he developed a second Dymaxion house with a stressed aluminum skin, yet none of these proved popular enough to warrant tooling up for the mass production that would have made them economical. Fuller then turned these defeats around, developing a new structure using small standard elements which he called the "geodesic dome." It is a regular polyhedron of any size which can be erected with a minimum of on-site labor. Perhaps his best known dome was that built for the United States pavilion at the Montreal Expo, 1967 (Fig. 278), which was 250 feet in diameter and stood 200 feet high. The basic unit was a hexahedron of steel tubing, glazed with gray-tinted plastic acrylic panels which were graduated from clear at the bottom to the darkest at the top. Inside the dome was an openwork of escalators and platforms holding the exhibits. Thermal control of the bubble was provided by con-

278. R. Buckminster Fuller, U.S. Pavilion, Montreal Expo, Montreal, Quebec, Canada, 1967.

trolled vents at the top and by a complex system of blinds on rollers which formed part of the hexahedronal frames and which were unrolled by motors controlled by a punched-tape computer program designed to follow the movement of the sun during the course of a day. Fuller's view was cosmic, and although his writing has suggested ways in which man, the machine, and the environment may exist together in harmony, Fuller's buildings have so far had only limited applications.

While architects after the war theorized about the ideal prototypical solution, the cities died. New York, said critic Ada Louise Huxtable, definitely seemed to have a death wish. When politicians and business interests realized how the cities' life blood was ebbing away, their response was urban renewal which, despite its cataclysmic sweep, was usually more cosmetic than substantive. The isolated apartment towers, the vast open areas, and the new freeways that connected these oases, were based on proposals made by Le Corbusier thirty-five years before and had little to do with the facts of American urban sociology. Typical of such autocratic presumptive planning was Lincoln Center in New York, built in 1962–68 (Fig. 279). Here, in the company of the New York State Theater and Philharmonic Hall, the Metropolitan

279. Wallace K. Harrison, Director of Board of Architects, Lincoln Center for the Performing Arts, New York, New York, 1962–68. Buildings, clockwise from left foreground: New York State Theater, Johnson & Foster, 1962–64; Guggenheim Band Shell; Metropolitan Opera House, W. K. Harrison, 1962–66; Vivian Beaumont Theater, E. Saarinen & Associates, 1965; Juilliard School of Music, P. Belluschi et al., 1968; Philharmonic Hall, M. Abramovitz, 1962.

Opera found its long desired new home (see the previous discussion of Rockefeller Center). Instead of being integrated into an established cultural environment, where it could have benefited from and have enhanced existing activity, Lincoln Center was placed by Robert Moses in the midst of a blighted upper west side where it is isolated from the life of the city. The buildings huddle close to one another, each of them hidebound in symbolic neoclassicism, enclosing a rather sterile plaza.

In actuality the plaza was little used when the Center first opened, for those attending performances entered the buildings from the sides. Indeed plazas by their very nature have been anomalies in American cities for, as places of leisure, they are an embarrassment to a culture still governed by the Protestant work ethic. Plazas have been carved out nonetheless because they were regarded as good for people and, more important, as good for public relations. Similar to Lincoln Center in some respects, though benefiting from better architecture and more variety in landscaping, is Constitution Plaza in Hartford, Connecticut, begun in 1960 (Fig. 280). Here, too, in a blighted urban area, whole blocks of useful though dilapidated buildings were cleared and replaced by a two-level terrace on which were placed eye-catching office blocks in studied irregularity. The most striking is the green glass, almond-shaped Phoenix Life Insurance Company Building by Harrison and Abramovitz. Nevertheless, despite the

way in which coordinating architect Charles DuBose, and design-
ers Sasaki, Dawson, DeMay Associates manipulated the levels,
stairs, planting boxes, and fountains, the fact remains that the
complex was only minimally integrated with the business center of
Hartford; it generated little traffic of its own and was cut off from
existing sources of activity. It is a good example of what most such
plazas were planned to be—sparkling lures to draw the suburban
shopper into the city. As a consequence they are found next to
freeway arteries, just as this one lies next to Interstate 95. The
pity is that the highway runs along the Connecticut River and cuts
Constitution Plaza off from the water which could have been its
natural focal point.

There were more intelligent alternatives in bringing life back to
the city center, and one good example is Marina City, Chicago,
begun in 1959 and completed in 1964 (Fig. 281). The site was
very restricted—a small area of air rights over railroad tracks run-
ning on the north side of the Chicago River—forcing architect
Bertram Goldberg to be compact. His solution, drawn up in 1960,
proposed a multilevel platform along the river, surmounted by a

280. Charles DuBose, coordinating architect; Sasaki, Dawson, DeMay As-
sociates, designers, Constitution Plaza, Hartford, Connecticut, 1960.

281. Bertram Goldberg Associates, Marina City, Chicago, Illinois, 1959–64, 1965–67.

number of small auxiliary blocks and twin cylindrical apartment towers of reinforced concrete. Each tower would be sixty stories high, containing 448 units. Goldberg made the automobile an integral part of the design but instead of giving up large horizontal spaces he coiled a parking ramp around the bottom eighteen stories of each apartment tower. Above this are two stories of mechanical equipment and forty stories of apartments. Goldberg used the cylinder to concentrate the services in a small central circular core, and he then expressed the cellular apartment units by the petal-like balconies. Marina City is significant because it is not solely a residential development but a complex mixture of many activities. The lower level of the platform houses a boat marina, while the upper levels house shops, a restaurant, a bar, beauty and barber shops, florist, bookstore, newsstand, skating rink, and an observation terrace. In the separate buildings on the upper terrace are a bank, health club, swimming pool and bowl-

ing alley, while the distinctive hyperbolic-paraboloid houses a theater. Unlike Constitution Plaza which ignored its water frontage, Marina City celebrated its setting on the river, marking a new assertive belief in the positive qualities of urban life and an easing of the exodus of the middle class to the suburbs.

Another indicator of this shift in attitudes was Habitat by Moshe Safdie. This housing complex, built as part of Expo 67 in Montreal, was essentially a realization of Safdie's thesis project as an architectural student at McGill University. Though architects before him had projected large residential clusters, including Kevin Lynch and Kenzo Tange, to young Safdie belongs the credit of seeing a prototype built and inhabited. Safdie was born in Israel and spent summers on a kibbutz, and this experience in communal living was important to the creation of Habitat. Safdie studied with Louis Kahn and at McGill University, Montreal, where he settled. When plans for Expo were announced in 1964, Safdie persuaded city authorities of the advantages in building a permanent housing exhibit based on his designs. The project was trimmed from the original 900 units for 5,000 people first to 354 and then to 158 units for 700 people; it was built in this reduced version. It consists of three hollow clusters of stacked prefabricated concrete boxes attached to a concrete frame providing elevated streets at every fourth floor (Fig. 282). Each of the units is seventeen feet six inches by thirty-eight feet by ten feet high and weighs ninety tons. They were lifted into place by special cranes, a

282. Moshe Safdie, David Barott, and Boulva, Habitat, Montreal Expo, Montreal, Quebec, Canada, 1964–67.

technique foreshadowed by Kahn. Safdie's arrangement of the units stepping back and zigzagging along the structural spine creates individual terraces for each apartment unit and semi-enclosed courts underneath. Each of the clusters and each apartment have separate identities through the varied massing of the blocks; the anonymous character of the filing-cabinet tower was avoided. There were problems, it is true, in routing the plumbing through the maze of stacked boxes, and in the enormous expense of construction, caused in part by the building of special cranes whose cost could not be offset by mass production since the size of the project had been so curtailed. Nevertheless the basic scheme was promising.

An even grander project, though unrealized, was that by Paul Rudolph in 1967 for the Graphic Arts Center complex in midtown New York comprising nearly fifty stories of four thousand modular housing units attached to twenty-six vertical utility cores. Rudolph's scheme was more suited to conventional technology and used light prefabricated units, moved to the site by truck, and raised into place by more conventional cranes. These units, to be made by a mobile home manufacturer, combined ease of transport, in contrast to the ponderous weight of the Habitat units, with the economics of mass production and quality control at the factory. Yet until outdated municipal building codes can be brought up to date and recalcitrant building trade unions can be persuaded, such enterprising solutions to the housing problem seem confined to the drawing board.

The creations of Goldberg, Safdie, and Rudolph are partial solutions; the ideal would be to build wholly new satellite towns outside the major metropolitan areas. While this was done with initial success in England and Sweden after the Second World War, few comparable attempts were made in the United States. Only four towns were started during the 1960s on what was a true urban scale—Columbia, Maryland; Reston, Virginia; Jonathan, Minnesota, outside Minneapolis; and Irvine, California, the largest of them all but the most slowly developed. By the close of the 1960s Columbia and Reston had been carried furthest. Columbia, the larger of the two, is situated midway between Baltimore and Washington, D.C.; it was begun in 1963 with a projected population of 100,000 people, on a site of 14,000 acres. Reston was begun in 1961 by Robert E. Simon, whose initials suggested the town's name. On a site of nearly 7,400 acres about eighteen miles west of Washington, D.C., it was planned for a population of 75,000 people. The village center on Lake Anne (Fig. 283), was

283. Reston, Fairfax County, Virginia, 1961. Master plan by William J. Conklin, Julian H. Whittlesey, and James S. Rossant. Lake Anne Complex, 1963–67, by Conklin & Rossant, Cloethiel W. Smith, and Charles M. Goodman.

designed by William J. Conklin and Julian H. Whittlesey who had once worked for Stein and Wright. In this new town Simon had several objectives: well-developed recreational facilities, a broad range of housing types seen in the town houses, tower apartments, and semidetached houses, attention to individuals through varied landscape and architecture, and the integration of residences and work in the same area. Yet for all its variation, color, and artifice, Reston is a picturesque romantic escape to a preindustrial village. It is not a real city.

In spite of the wealth of examples of urban architecture in older cities, both in Europe and in the United States, answers to current problems have come slowly. The first reaction after the war was to bulldoze and build bright new towers and efficient roadways, but these solutions did not respond to people. By the close of the 1960s it became more common to deal gently with the existing urban fabric and to insert new buildings in such a way as to complement the physical and social environment; in other cases valued buildings have been rehabilitated and returned to economic productivity. A particularly striking example is the rehabilitation of Ghirardelli Square, San Francisco, begun in 1964 (Fig. 284). This hillside mélange of nineteenth century commercial buildings, clustered around a chocolate plant and its ornate Second Empire tower, was purchased in 1962 by William Roth to forestall wholesale development of the waterfront as a district of high rent apartment towers several of which had already been started. Under the direction of planners Lawrence Halprin and Associates, the architects Wurster, Bernardi, and Emmons retained nearly all of the nineteenth century buildings, refurbished them, and added a low arcade on the waterside to enclose a courtyard. There are several levels, dotted with kiosks and fountains, which offer varied prospects of San Francisco Bay. Perhaps most telling is the preservation of the huge Ghirardelli sign as an important landmark; it is such improbable, irrational, and cherished idiosyncracies which give cities identity and character.

Foliage and water are being increasingly used to enliven urban spaces, but instead of large park projects, the natural element is now employed more in smaller concentrated compositions, perhaps more easily perceived and enjoyed. The recessed plaza and fountain of the First National Bank in Chicago are an example, but perhaps the best of these urban spaces is the fountain in the forecourt of the Portland Civic Auditorium, built 1966–70 (Fig. 285), designed by Lawrence Halprin with Angela Tzvetin and Satoru Nishita. It is a complicated series of pools and cascades rival-

284. Lawrence Halprin, planner; W. Wurster, and Bernardi & Emmons, architects, Ghirardelli Square, San Francisco, California, 1964. Original Ghirardelli chocolate factory building by William Mooser, c. 1893–1914.

285. Lawrence Halprin & Associates, planners and designers, Fountain, Civic Auditorium Forecourt, Portland, Oregon, 1966–70. The environment of the fountain is now even more enriched because the plantings have begun to approach maturity.

ing in its exuberance the great fountains of Baroque Rome, and like them it has become a focus of activity. It is no copy but an evocation of the tumbling streams in the nearby Cascade Mountains. The largest of the falls is twenty feet high and one hundred feet across; the rush of thirteen thousand gallons per minute plunging down this precipice blots out the noise of the city. More important than the statistics, however, is the way in which the fountain is designed. Halprin depressed the lowest pool ten feet below the sidewalk so that the overflowing basins can be viewed by the passersby. Halprin said he wished this to be a people's park, a place designed for adult play, where spatial and sensory experiences and human movement would be encouraged. It has become exactly that; the turning on of the water has become an event celebrated by expectant crowds. In a period which might be characterized by a desperate search for personal peace in a frenetic world, Halprin's Portland fountain reasserts the basic joy of human experience and the necessity of such pleasure in our cities. He reminds those who think of the city only as an economic machine that it is, in fact, a human community. The city is the people. At the fountain's dedication, to make that message clear, after saying a few words, Halprin kicked off his shoes, rolled up his trousers, and went wading—the shallow pools of the fountain have been full of waders of all ages ever since.

The years from 1940 to 1970 witnessed a dramatic shift in attitude among American architects, first toward maximum utility and pure function, and then, after about 1964, away from these toward optimum utility united with increasingly emphasized form. The early years are characterized by Mies's embodiment of Sullivan's dictum "form follows function," which in actual practice came to mean "form follows structural imperative." In later years there was increasing agreement with the proposal made by architect Matthew Nowicki in an article published in 1951 that "form follows form." At least there was evidence of this in nearly every area of building *except* the design of speculative commercial office buildings where an insistence on wrenching the maximum dollar of profit resulted in some of the most banal and insipid architecture ever conceived. Perhaps one of the most important changes in this period was the enlargement of scope of the architect's domain, away from the rarefied subtleties of module and structure as represented by the Lever House toward the complexity of Habitat and the playfulness of the Portland Auditorium Forecourt Fountain.

Epilogue: Pluralism in the 1970s

To sketch the "history" of the recent past is to attempt to correct for distortions in perspective caused by nearness in time and place, for what seems important at the moment may well, in a short time, fall into relative obscurity. Yet a series of economic and aesthetic developments in the 1970s seems certain to shape American architecture for a generation if not longer.

The superimposed economic reverses of the early 1970s tended to compound each other. Ever-expanding American military activity in Southeast Asia during the preceding decade had spurred inflation at home to such an extent that in 1971 federal wage and price controls were imposed. The result by 1974 (when the controls were lifted) was an *increase* in prices of 20 percent. Thereafter the annual rate of inflation rose to a high of 12 percent in 1975 and then eased to about 6 percent in 1976 where it remained relatively steady despite attempts to lower it. The result was a serious business recession early in the 1970s that closed many small architectural offices and significantly impinged even on the larger firms. The depths of the recession also coincided, unfortunately, with an embargo on oil exports by Arab petroleum producers when the United States supported Israel in the Arab-Israeli War of 1973. The price of fuel had been climbing even before the embargo, from $2.80 a barrel in 1971 to $4.40 a barrel in 1973, but when the embargo ended and deliveries of imported oil resumed, the price had been fixed at nearly $12, and this high price was maintained and gradually raised further. Very quickly the implications of importing more than a third of the nation's oil became painfully apparent. The era of cheap energy was rapidly drawing to an end and the search began for alternative sources, with special attention to solar and wind energy.

One immediate response was the use of reflective glass in the Miesian glass box so as to reduce the solar heat gain, and while this was partially successful during the summer months (discounting the fact that the light and heat were bounced onto some adjacent building), it required even more heat in the winter when the limited heat gain from the sun was dearly wanted. Glass which changed its opacity according to the amount of ultraviolet light present was also developed, but the necessary radical rethinking of the implications of the glass box did not come quickly. A new vocabulary emerged and advocates argued in favor of "passive" solar heat systems (which have no moving or motorized elements) as opposed to more sophisticated "active" systems (which use heat pumps, motorized louvers, heat transfer fluids, heat storage masses, and motorized controls). And serious research was directed at the ways in which aboriginal buildings had shed or conserved heat.

The high and increasingly rising costs of materials, and of building construction which by this time was extensively implemented by gasoline-driven appliances, forced a new appraisal of rehabilitation of existing buildings as opposed to the wholesale destruction of neighborhoods as had been prevalent in the preceding two decades. Entire issues of major architectural periodicals in the mid-1970s were devoted to preservation and adaptive reuse, "recycling" of old buildings. This new interest was even more sharply focused by the approaching bicentennial celebration of 1976; though a sternly pragmatic view shared by the public and Congress disallowed sponsoring a great exhibition as had been done in 1876, the monies which might have been so expended were disbursed to local governments and agencies to be used for projects of historical significance to each community. The effects of this are not yet apparent (and it should be noted parenthetically that the colonial revival initiated by the Centennial did not get underway until 1879), but many buildings were preserved, restored, or adapted to new uses. Highly indicative of this change in attitude is the renovation of Furness's Pennsylvania Academy of Fine Arts carried out in 1973–76 by Hyman Myers and Marc-Antoine Lombardini, in which the inimitable interiors were returned to their once strident splendor, so that just as the original building was the symbol of the bold energies of 1876, the restored building is indicative of a growing artistic maturity among Americans who can finally admit to loving its conscious ugliness.

The Bicentennial seems not to have reinvigorated the study of

colonial architecture as in 1876, but rather to have sparked a critical examination of the dogma of modernism as it was formulated a half-century ago. The exhibition of the immense project drawings from the École des Beaux-Arts at the Museum of Modern Art in the fall of 1975 served to give this critical examination a running start, for it made dramatically evident that Beaux-Arts architects were not intrinsically ignorant of modern materials or functions, but that they consistently manipulated whatever materials seemed most satisfactory to shape sequences of public spaces; they were more behavioral architects than functional architects as "function" was then understood by modernists. Modern International Style purism, which had at one time been assumed to hold the answers to all building needs, was now seen as supplying only a limited range of solutions for very specific functions. The attack on modernism was made public in two books—Brent Brolin's *The Failure of Modern Architecture,* New York, 1976; and Peter Blake's *Form Follows Fiasco: Why Modern Architecture Hasn't Worked,* Boston, 1977. Brolin took issue with Le Corbusier's ideal of "one single building for all nations and climates," illustrating how "modern" buildings erected in Third World countries for which they had never been intended quickly began to self-destroy. Traditional methods of planning and building, he insisted, were better adjusted to local climate and social systems than were the abstractions of International Style purism. Blake's book has something of the character of Johnson's essay on the "Seven Crutches," but without the sardonic humor. As if to emphasize the greater complexity of the contemporary problem he cites eleven fantasies that have shaped modern purism (four more than the conventional Ruskinian seven), the unblinking pursuit of which has led so many architects astray—function, the open plan, purity, technology, the skyscraper-ideal, the ideal city, mobility, zoning, housing, ideal form, and the mystic religion of architecture itself. The most popular form of this attack appeared in films which presented the horrors of fire in skyscrapers too tall to evacuate (*The Towering Inferno,* 1975), or of towers shattered by earthquake and transformed into showers of glass daggers raining on hapless pedestrians below (*Earthquake,* 1975). In Boston this came true as window after window was sucked from I. M. Pei's soaring John Hancock Building near Copley Square. The agent in this case was wind not quake, but the public square and streets below became a no-man's-land, and Richardson's Trinity Church was wrapped by a girdle of plywood-covered walks to protect the faithful from

286. Paul Rudolph, Earl Brydges Memorial Library, Niagara Falls, New York, 1970–75.

falling shards of glass. What had been intended as a great crystalline tower was patched with sheets of plywood as year after year teams of engineers attempted to solve the riddle.

The most emphatic symbol of the failure of modernism lay in the rubble of the Pruitt-Igoe housing complex which was dynamited by the city of St. Louis in 1972, but a more subtle example of the conflicting aims and realities of modern abstractionism is seen in the Earl Brydges Memorial Public Library, Niagara Falls, New York, 1970–75 (Fig. 286). In an effort to raise the quality of the Niagara Falls environment as a way of enticing tourist and convention business away from the more pleasant Canadian side, the city engaged prominent architects for new public buildings—Philip Johnson for the Convention Center and Paul Rudolph for the library. Using the device of stacked corbeled rooms over a central nave which he had already employed in the Burroughs Wellcome Building of Durham, North Carolina, 1969–71, Rudolph now conceived an even more complex plan with the superimposed corbeled elements angled so as to shape entrance funnels on each side of the extended block. The walls defining the bays of the building extend out in spurs, forming sheltered recesses which proved to be ideal lairs for night-time muggers, for the library had been placed in a deteriorated section of town in an effort to "elevate" it. Inside, the central nave which contains the main reading room is defined by the converging balconies devoted to special and regional collections. It is an awe-inspiring space, library-reading as religious experience, yet to use the library collections is to ferret for books under plastic sheets, for the

complicated roof, window, and wall intersections proved impossible to seal, and throughout the building the shelves are covered with plastic tarpaulins draining into an army of strategically placed buckets and pails. It is undeniably a beautiful and visually engaging building, but one put in the wrong place and subjected to the wrong climate.

Such errors in judgment and design have proven expensive in the correcting, perhaps none more so than the acoustics of Philharmonic Hall in Lincoln Center, New York. From the moment the hall had been opened in 1962, the acoustics had been widely decried as miserable and antithetical to music. The architect, Max Abramovitz, and his acoustical consultants, the eminent Bolt, Beranek & Newman, had incorporated the latest innovations and improvements in auditorium design, but the sound of the orchestra was partially absorbed by the light wooden ceiling, reflected off the concrete floor, and unevenly distributed. Moreover, reverberations did not decay at an even rate. In 1974 Cyril M. Harris, who had become well known for his highly successful acoustics in the Kennedy Center concert halls, Washington, D.C., and for other auditoria he designed in Champaign, Illinois, and Minneapolis, was asked by Lincoln Center trustees if he could provide a remedy. After studying the original plans he reported he could if: (1) everything inside the hall down to the steel frame was removed, (2) an entirely new interior was fitted into the remaining shell, and (3) he was authorized to undertake the work in collaboration with Philip Johnson. Johnson and Harris were subsequently instructed to prepare plans and quickly they settled on a purely rectangular hall with a megaphone-shaped concert stage. They employed a great deal of wood in a heavier, more acoustically reflective flat ceiling, and in the walls and floor. On the ceiling and walls they devised elaborate relief patterns to disperse the sound. The final result, unveiled in October, 1976 (after the expenditure of nearly $4.5 million provided by Avery Fisher for whom the new hall was named), proved to be a contemporary variation of the acclaimed model, Boston Symphony Hall by McKim, Mead & White, 1892–1901, which was itself patterned after the Neues Gewandhaus, Leipzig, built in 1884. The deeply figured walls and ceiling break up the sound and, it was now abundantly clear, do indeed serve a very real acoustical function as do the rich classic architectural embellishment and sculpture of the models. For such purposes "more was more," but it had proven to be a very expensive lesson.

Such experiences suggest that architecture performs best when

287. Roche & Dinkeloo, The College Life Insurance Company of America, Indianapolis, Indiana, 1972.

it allows for the suitability of many modes, when it is pluralistic rather than purist. This became especially true for public buildings during the decade, but even commercial buildings began to lose the foursquare severity of supposed utility. An early example was the tall Bank of America World Headquarters building, San Francisco, by Wurster, Bernardi & Emmons with Skidmore, Owings & Merrill and Pietro Belluschi, consultant, 1969–70. The external envelope consists of narrow angled bays derived from Saarinen's CBS Building, New York, 1960–64, but instead of ending them all at the same point, the narrow window bays terminate at different floors, creating a series of gradual setbacks that recall the Art Deco complexities of the Barclay-Vesey Building, New York, finished in 1926. Saarinen's interest in the expressive power of form was continued by Roche & Dinkeloo, his successors, as had been noted in the Ford Foundation Building, but it became even more pronounced in the series of six pyramid-like blocks of concrete and glass that they designed for the College Life Insurance Company of America in Indianapolis, of which the first three were built in 1972 (Fig. 287). For the final design of the glass towers for One United Nations Plaza, New York, 1969–76, they modified the pure geometry of Mies by chamfering the edges, creating overhangs and setbacks, so that the towers have something like the ordered irregularity of quartz crystals which have slight imperfections in their molecular lattices (Fig. 288). Philip Johnson and his partner John Burgee have provided perhaps the most exciting new skyscrapers, particularly their Post Oak Central Building, Houston, Texas, with its two large staggered setbacks and, even more, the strong banding of glass and spandrel panels which curve around the corners, reflecting the linear continuities of the 1930s and Hood's McGraw-Hill Building. Their IDS (Investors' Diversified Service) Building in Minneapolis, 1969–73, combined one immense tower with three low buildings filling a downtown block, but the corners of each are formed of many small reentrant angles, denying the sharp

288. Roche & Dinkeloo, One United Nations Plaza, New York, New York, 1969–76. In the foreground is the United Nations Headquarters, Wallace K. Harrison et al., 1947–53. To the left of One U.N. Plaza, in the distance, is the Chrysler Building, William Van Alen, 1926–30; and to the right is the Pan Am Building placed atop Grand Central Station, Emery Roth and Sons with Gropius and Belluschi, 1961–63.

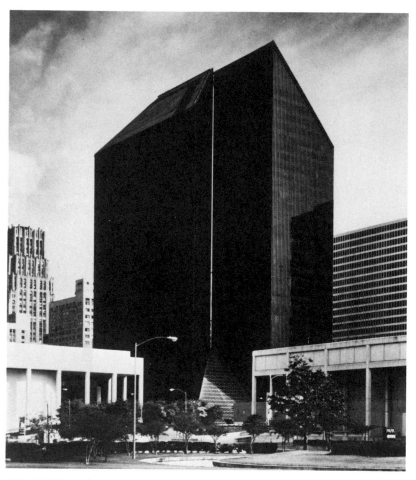

289. Phillip Johnson and John Burgee, Pennzoil Place, Houston, Texas,
1972–76.

grid of the Miesian box. At the base the irregular space between
the four units is covered with a glass roof supported by a steel
space frame, so that a great covered court is formed. This has sev-
eral levels, and the upper floors are connected by second-story
enclosed walkways bridging the streets to neighboring buildings.
Perhaps most impressive in form and enclosed space is their Penn-
zoil Place, Houston, 1972–76, which consists of two trapezoidal
towers, seemingly one rectangle cut on the bias with the sections
then pulled apart, with sharp shed roofs at conflicting angles (Fig.
289). The remaining open spaces of the square block are covered
by two angled glass roofs which slope up from sidewalk level to
meet the diagonal walls of the twin towers. All of these commer-

cial buildings rise from the ground, but even this convention was broken in Hugh Stubbin's Citicorp Center, New York, 1973–78, in which the forty-six floors of the tower are lifted on four massive stilts 127 feet into the air (Fig. 290). At the top of the building is an unfenestrated crown cut at a sharp angle facing south. Originally solar collectors were to have been installed there to augment the building's energy needs, and although these were not put in, the total demand for heating and cooling was reduced by using strip windows with wide spandrel panels of brushed aluminum to reflect light without causing intense glare. The space at the base was kept open for public use, a tall court covered by the building itself, and at one of the corners is a new strikingly angular St. Peter's Church also by Stubbins (Fig. 291). Perhaps more than any of the other soaring new skyscrapers, Citycorp Center illustrates

290. Hugh Stubbins and Associates, Citicorp Center, New York, New York, 1973–78.

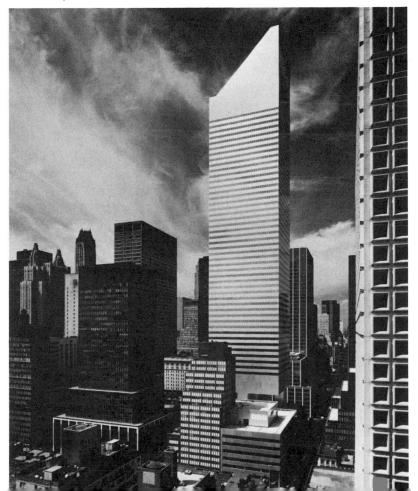

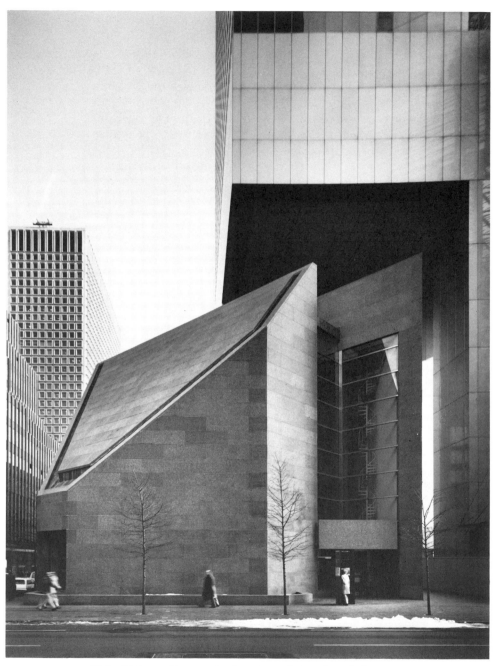

291. Citicorp Center, St. Peter's and the plaza below.

one way in which sophisticated structure, technical excellence, and perfection of detail can both serve business interests and yet preserve and enhance the life of the city street.

This new group of commercial skyscrapers makes it clear that there is no longer a single way to build office towers, no prototypical solution, yet all are related in their necessary exploitation of technology. The fading promise of purism and the rise of pluralism, while it certainly made these towers possible, has been like the Reformation in that it allows for the existence simultaneously of many points of view, each of which claims legitimacy. The conflict has been most pronounced between the so-called Whites and Grays, young architects whose work has largely been residential and who assert, respectively, that architecture is a complex formal language unrelated to any exterior reference and, conversely, that architecture is a formal expression which works best when it acknowledges its context, when it incorporates allusions to the past, even when those references are humorous and ironic. Both groups stem from Louis Kahn, but one has moved in the direction of Le Corbusier in the 1920s while the other has followed the trail blazed by Robert Venturi (indeed, Venturi is one of its advocates). Both factions, however, recognize the expressive power of architecture as a nonverbal language (no matter whether the end is conceptual or literal), and both use structure as a means to their respective ends rather than an end in itself. Both too have returned to the position that architecture is simply architecture and not the instrument through which to reform society.

The major White architects are Peter Eisenman, Richard Meier, and Michael Graves. Eisenman is perhaps the most intellectually penetrating of the group, and he has focused on houses in which he has developed multiple autonomous structural and visual systems, which he terms bi-valent, heightening and complicating the tensions between two conceptual relationships. Like abstract painters he tends to avoid names for his houses and identifies them as House I, House II, or House III. The first two (the Barenholtz pavilion at Princeton, New Jersey, 1967–68; and the Falk house, Hardwick, Vermont, 1969–70, Fig. 292), are based on parallel rectilinear grid systems that are played off against each other, while the third (the Robert Miller house, Lakeville, Connecticut, 1971) has two grids turned at forty-five degrees to each other. Richard Meier avoids these cerebral exercises in favor of more easily perceived relationships between solids and voids, but he too tends toward monochrome compositions in white which stand in sharp contrast to their environment. His early houses,

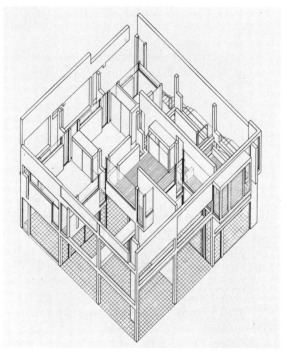

292. Peter Eisenman, House II (the Falk house, Hardwick, Vermont) 1969–70.

such as the Smith house, Darien, Connecticut, 1965–67, and the Saltzman house, East Hampton, New York, 1967–69, lead to what is perhaps his masterpiece to date, the Douglass house on the bluff above Lake Michigan at Harbor Springs, Michigan, 1971–73 (Fig. 293). The brilliantly white house sits high on a tall base on a steep incline, amidst dense conifers, looking out over the water. It celebrates human artifice in contrast to nature; it combines sculptural abstraction and machine-like clarity; even its railings of shaped steel tubing recall the steam liners Le Corbusier so much admired. Michael Graves is comparatively more relaxed in his approach, as indicated by his use of bright primary colors to isolate selected structural elements, as in his Benacerraf house, Princeton, New Jersey, 1969. Perhaps more consistent in its visual complications is his Snyderman house, Fort Wayne, Indiana, 1972, in which color was used extensively on the walls, so that selected portions of the conceptual grid in white are in contrast to planes of pale violet, pink, and rose.

Venturi, in partnership with John Rauch, continues to champion the cause of the "ugly and ordinary," exploring the ways in

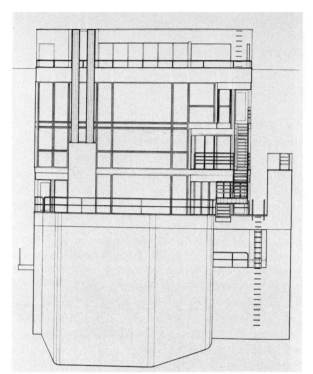

293. Richard Meier, Douglass house, Harbor Springs, Michigan, 1971–73.
 293a. Front elevation.

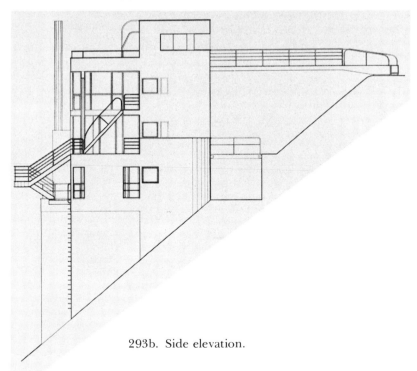

293b. Side elevation.

which architecture can be made more real by being less preten-
tious. The Dixwell Fire Station, New Haven, 1973, is a "decorated
shed" in the tradition of Guild House. The rectangular building is
set at an angle to its curved corner site, and the front wall at the
right bends back in a logarithmic curve that extends beyond the
edge of the side wall so that the spur becomes a billboard carrying
in supergraphics the name of the station. In fact the desire to
create "ordinary" buildings results in designs so strongly under-
stated as to acquire assertiveness. This is evident in the proposal
submitted by Venturi & Rauch in the competition for the Yale
Mathematics Building, 1969, which, in a field of 468 entries, was
awarded first prize (Fig. 294). The program called for an addition
to Leet Oliver Hall, a small Gothic structure on Hillhouse Avenue,
on a restricted trapezoidal site bisected diagonally by a railroad
cut below grade, and facing a splendid Italian villa house built for
Professor James Dwight Dana by Henry Austin in 1849 which is
both a New Haven Preservation Trust Landmark and a National
Historic Landmark. In the face of two such singular neighbors,
Venturi made his design as plain as possible (thereby giving it its
own distinction), and on the boards of the final competition draw-
ings he wrote, *"The Image is Ordinary:* a working, institutional
building enhancing rather than upstaging the buildings around
it."

Robert Stern, the most articulate of the Grays, has suggested
that the Whites represent the last phase of modernism introduced

294. Venturi & Rauch, Yale Mathematics Building, Yale University, New
Haven, Connecticut, 1969.

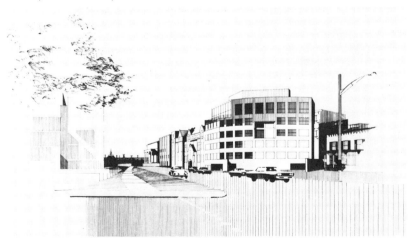

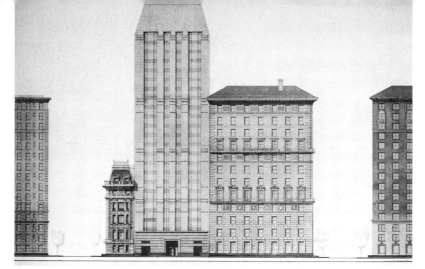

295. Johnson & Burgee, 1001 Fifth Avenue, New York, New York, 1976. To the right is 998 Fifth Avenue by McKim, Mead & White, 1910–15.

by Mies and Le Corbusier (and in fact much of their work derives from Le Corbusier), while the Grays, he proposes, have moved beyond the strictures of modernism to a new post-modernist phase. What concerns post-modernists, he declares, is not an abstract formal architectural language which exists outside of any reference to the outside world and normal experience, but an architecture that is primarily dependent on its surroundings. Post-modern architecture is rooted in its context, makes allusions to the past, and employs applied ornament.

Contextualism, as Stern terms it, was used by Moore as early as 1962 in the addition to the Citizen's Federal Savings and Loan in the continuation of the Beaux-Arts composition of the original building. More abstract is Philip Johnson's addition to the rear of McKim, Mead & White's Boston Public Library, designed in 1964–67 and built 1969–73. Johnson carefully maintained the overall scale of the original block, enlarging the arcade module, but using the same Milford granite of the original, and extending the roof line so that both sections read as related components of a unified whole. Working in New York Johnson became particularly aware of the careful articulation of building elements in the work of McKim, Mead & White, so omnipresent in that city. When, in 1976, he was engaged to redesign the façade of a new apartment skyscraper at 1001 Fifth Avenue, he found himself working next to the large luxury apartment block at 998 Fifth Avenue by the office of McKim, Mead & White, 1910–15 (William Symmes Richardson in charge). That twelve-story block was in the form of an immense Renaissance palazzo with three tall sections set apart by strong moldings and crowned by a bold cornice (Fig. 295). The

296. Venturi & Rauch, addition to the Allen Memorial Art Museum, Oberlin College, Oberlin, Ohio, 1973–76. To the left is the original museum building by Cass Gilbert, 1915–17.

more Johnson studied this distinguished neighbor, the more he saw the logic of its ornamental moldings, for they helped to subdivide the bulk of the building. So in his new façade he carried over the lines of the moldings, and topped the twenty-three stories with a tall mock-mansard roof.

In some instances respect for the context results in a building or an addition which carefully continues the character of the existing buildings, and a particularly good example is the addition to the University Museum at the University of Pennsylvania, Philadelphia, by Mitchell-Giurgola, 1971. The original Lombard Renaissance portion of the museum, started by Wilson Eyre, was extended in a brick wing of nearly equal dimensions. Both Johnson in his library addition and Mitchell-Giurgola in their museum extension pay homage to the older buildings, and indeed Johnson discreetly separated his addition from McKim's building by a "hyphen" link. This deference Venturi feels demans the modern architect, and so, when he added a new gallery and school wing to the Allen Memorial Art Museum at Oberlin College in 1973–76, he collided his new block into the Renaissance palazzo designed by Cass Gilbert in 1915–17 (Fig. 296). Aside from a narrow strip of black marble at the joining, there is no gentle or genteel transition, but the general scale of the new gallery continues that of Gilbert's museum, and Venturi specified the same red and beige sandstone Gilbert had used, though not in delicately framed panels but in a boldly assertive checkerboard. As a result, the ad-

297. Allen Memorial Art Museum, Ionic column detail, at connection between original building and the new gallery.

dition refers to the original building but strictly on its own and Venturi's terms.

Allusion to the past is a principal part of post-modernism, as indicated by Johnson's 1001 Fifth Avenue apartment building. Reference to the past can be made, however, even in the absence of a specific context, and such allusionism has been most evident in suburban and resort domestic architecture which in its material alone clearly refers to the shingled houses of the late nineteenth century. An early example is the Wiseman house, Montauk, Long Island, New York, 1966–67, by Robert A. M. Stern and John S. Hagman. The shallow depth of the house, its broad extended gable, and the comprehensive shingle covering all recall McKim, Mead & White's Low house which was then being celebrated by Vincent Scully, but Stern may also have been recalling the simpler shingled cottages built by McKim, Mead & White at Montauk Point in 1881–82 for a group of New York businessmen. In the larger more box-like but visually complex Saft house, East Hampton, New York, 1973, Stern & Hagman seem to acknowledge Arthur Little's "Shingleside," at Swampscott, Massachusetts, 1881. Perhaps unconsciously but even more suggestive of the Montauk

Point complex by McKim, Mead & White are the Wislocki and Trubeck houses on Nantucket Island by Venturi & Rauch, 1972 (Fig. 298). Like the Montauk cottages, the two cubic gable-roofed shingled Nantucket houses sit in studied irregularity amidst scrubby dune vegetation overlooking the ocean. It is no coincidence that these houses all recall the Shingle Style, for all were by architects close to Vincent Scully who were paying particular attention to his researches; in fact in a lecture at Columbia University in 1973 Scully spoke on "The Shingle Style Today, or the Historian's Revenge."

While reference to the past can be made through form or material alone, the strongest way is through applied ornament, and post-modern architecture has once again taken up ornament. As we have seen, Johnson did just this in his moldings at 1001 Fifth Avenue, and this sense of decoration can be seen in a somewhat more generic way in the finishing and details of the Brant-Johnson house, Vail, Colorado, 1975–76, by Venturi & Rauch. At the inside corner where the new Yale Mathematics Building connects with Gothic Leet Oliver Hall, Venturi used large overscaled Gothic tracery in front of a window as a way of making a transition to the older building. In the addition to the Allen Memorial Art Museum at Oberlin a similar situation arose, and at the rear corner where the new gallery comes up against the old Renaissance building. Venturi cut away the corner at the ground floor (easing circulation), placing an angled window there so that one can see from inside the tall clerestory-lit gallery to the old building alongside (Fig. 297). The corner above is carried by a steel column and this then was enclosed by a stylized Ionic column, vastly overscaled, built up of tongue-and-groove wood. In its manifest construction and because it touches neither floor nor ceiling above, the column is clearly applied ornament, but it introduces a deliciously whimsical touch while making transition to the Gilbert building. Another example is the Lang house, Washington, Connecticut, 1973–74, by Stern & Hagman in which the formal, symmetrical entrance façade contrasts with the rear where the exigencies of internal functions assert themselves in playful geometries (Fig. 299). Among shingled prototypes, one might compare this combination of formal entrance and informal interior to McKim, Mead & White's Newport Casino with its symmetrical Bellevue Avenue façade and its more playful court façade. What makes the Lang façade so striking, in addition to its bright yellow ocher color, is the classical molding which runs over the windows and which forms a hood over the door. Avoiding the pitfall of explicit historicism, Stern acknowledges such diverse sources as American

Georgian houses, the classical Edwardian country houses of Sir Edwin Lutyens, the Beaux-Arts classicism of McKim, Mead & White, and even Mediterranean Baroque. In their abstract form, and through their simplified whimsical ornament, the Trubeck and Lang houses manage the difficult task of combining the discoveries of two centuries—expressive ornament and logical structure. Such post-modernist work brings together again humor, traditional references, and contemporaneity in material and structure.

Pluralism, diversity of design, and the resultant diversity of form, which were presaged by Alvar Aalto in Baker House at M.I.T., are present too in the last building Aalto designed in the United States, the Mount Angel Abbey Library, Mount Angel, Oregon. The first proposals for this small library were begun in 1967 but the building was not completed until 1971. The service facilities are tucked to the back, against the hillside, while the reading rooms spread out in a fan of unequally shaped wedges, looking out over the green Willamette Valley.

Adherence to the Miesian structural grid lessened, too, in governmental buildings, and perhaps most dramatically in the Federal Reserve Bank of Minneapolis by Gunnar Birkerts & Associates, 1971–73. Because of a need to have as much column-free space as possible to permit armored trucks access to the underground vaults, the decision was made to suspend the building from cables thus requiring only two supports (Fig. 300). The towers carrying the cables were placed 275 feet apart, with a bridge girder at the top to prevent the tops from being pulled together. On either side of the sixty-foot-wide slab are then hung rigid façade frames attached to the cables, so that the ground floor beneath is completely free of supports. To express the struc-

298. Venturi & Rauch, Wislocki (left) and Trubeck houses, Nantucket, Massachusetts, 1971–72.

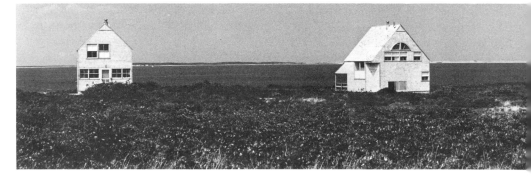

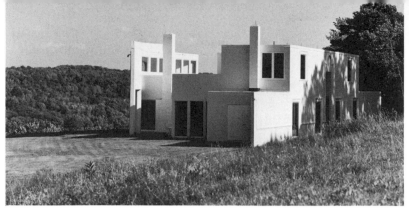

299. Stern & Hagman, Lang house, Washington, Connecticut, 1973–74.

tural action, the catenary curve of the cable is marked by an emphatic change in the mirror-glass sidewalls, and the supporting end towers and bridge girder at the top are solidly clad. Certainly it is a tour-de-force and yet it shows clearly that there are alternatives to the ubiquitous steel frame.

It is curiously significant that, just when the spatial richness of Beaux-Arts architecture again began to be studied seriously, architects also began to explore more seriously the manipulation of space in their own work. Lawrence Halprin & Associates had already started this in the various public fountains they had done, such as the Portland Auditorium Forecourt Fountain. In 1974–75 they went beyond that in the Manhattan Square Park Fountain in Rochester, New York, in which Timothy Wilson was the designing partner. A bit more compact, the fountain offers similar cascading sheets of water from a densely interlocked cubic mass of concrete, all pouring into a ground-level wading pool. In this case, however, there is an additional steel tower and cat walk, enabling one to climb up the better to see the fountain, so that the pleasure of feeling and playing in the water is enhanced by the bird's-eye view showing one how it all works.

Interior spaces too have become more opulent, especially so in Water Tower Place on North Michigan Avenue, Chicago, 1969–76. The enterprise is a mixture of uses, with a variety of shops grouped together around several large department store branches in the lower floors, the Ritz Carlton Hotel above them, and a slender tower of condominium apartments above that. Externally the boxy building by Loebl, Schlossman, Bennett & Dart with C. F. Murphy is monotonously severe, its polished gray marble veneer (in flush panels so as to "reveal" the reinforced concrete skeletal frame) tending to merge with gray winter skies. But inside is a dazzling series of spaces, one ascending in stages from the Michigan Avenue entrance, its landings forested with potted

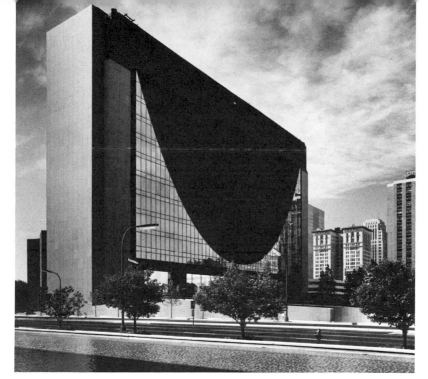

300. Gunnar Birkerts and Associates, Federal Reserve Bank of Minneapolis, Minneapolis, Minnesota, 1971–73.

trees and its escalators running parallel to cascading fountains, and the other a vast well of eight stories ringed with balconies linked by a single column of glass-walled elevators. The interiors by Warren Platner & Associates make shopping simply an adjunct to being there. The materials are sumptuous—travertine and glass, mainly—and though the hotel above precludes a skylight, the vast space sparkles with light glinting off glass and the chromium steel clamps that hold the glass panels. It is the kind of space that one comes to not necessarily for any specific purpose but just to savor its public excess.

One architect who more than any other individual effected a change in attitudes toward public space has been John Portman, and though many critics claim his work has a certain kitsch quality, it is nonetheless true that he has shaped more actively used and commercially productive public spaces than any other single architect. Since the mid-1960s he has served as the "court architect" for the Hyatt hotel chain, starting with the Regency Hyatt Hotel in Atlanta, 1964–67. As this was being completed he started work on the larger, more complex, and grander Hyatt Regency in San Francisco, finished in 1973. An irregular polygon in plan because of its site, it has 840 rooms arranged on more than four-

teen stories which are corbeled out over a soaring interior court
that is 300 feet long and 170 feet high. As a consequence, a major
part of the volume of the building is given over to this immense
fourteen-story room on whose floor are arranged the lounges and
restaurants. More hotels followed, including another in Atlanta
and one in Chicago, the Bonaventure Hotel in Los Angeles,
1975–77, and Renaissance Center in downtown Detroit, 1973–78
(Fig. 301). During the decade after 1964 Portman's buildings,
many of them incorporating round cylinder towers sheathed in
mirror glass, became symbols of commercial success, so that when
a new building was proposed as a way of regenerating downtown
Detroit the selection of Portman as architect was both an act of
faith and a statement of the efficacy of his work as a symbol of
business and civic prosperity. Both the hotel in Los Angeles and
Renaissance Center employ a central high tower enclosed by four
lower towers. In the Bonaventure Hotel the center tower is square
and the outer towers are circular, all sheathed in mirror glass,
while the Renaissance Center has at the center the tall round De-
troit Plaza Hotel flanked by four square office towers in which
large amounts of space have been occupied by the Ford Motor
Company, General Motors, and Manufacturers National Bank.

301. John Portman, Renaissance Center, Detroit, Michigan, 1973–78.

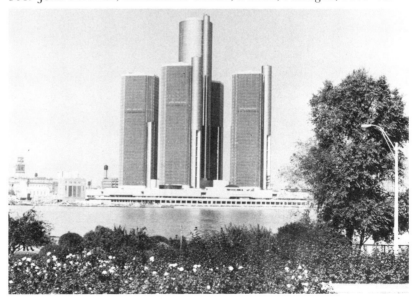

For Detroit and for many other cities whose centers have suc-
cumbed to a kind of urban rot, rebuilding whole sections in this
way, shimmering and glistening with hope for the future, may
well be the only solution. But far more pressing will be the need
to make additions or alterations to existing environments in ways
that do not destroy the kind of street life or cultural ambiance
which may have developed there. Increasingly, too, as much of
what Jane Jacobs wrote proves accurate, we will need to provide
for mixed uses; in social and economic systems as in ecosystems,
the more complex the more stable and self-regenerating. The best
buildings will be those which are both self-possessed and yet gen-
tle with their neighbors. How this might be accomplished is re-
vealed in Louis Kahn's last work, his Yale Center for British Art,
New Haven, designed in 1969–72 and built 1972–77, for in this
Kahn was obliged to incorporate mixed uses and to enhance the
physical and social environment of Chapel Street (Fig. 302). As
did so many urban colleges during the late 1960s, Yale suffered
from increasingly limited space on which to build and a love-hate
relationship with its host city, made particularly difficult because
acquiring additional property ate away at the municipal tax base.
When it became known that the block on Chapel Street across

302. Louis I. Kahn, Yale Center for British Art, Yale University, New
Haven, Connecticut, 1969–72, 1972–77.

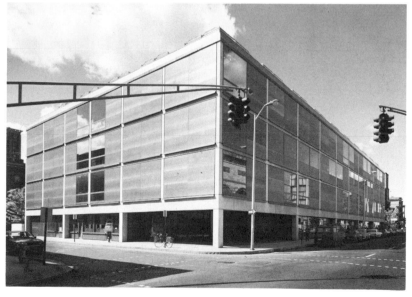

from the Yale Art Gallery had been acquired by Paul Mellon for the purpose of building a new art gallery to be presented to Yale, a conflict ensued involving city officials who envisioned yet more choice commercial property passing into Yale's hands, students (many of whom lived above the stores then on Chapel Street) who saw the elimination of a significant part of the city's street life at the edge of the university, and the faculty who generally wanted the new gallery. Not only did the students see the loss of inexpensive housing adjacent to the campus, but they feared the creation of a *cordon sanitaire* separating Yale from the profane city.

When Kahn was then appointed architect a solution was reached in which the ground area of the building would be used for commercial purposes and taxed accordingly, but the gallery above would not be subject to taxes. Such a mixture of uses, each with conflicting needs and circulation patterns, was not to Kahn's liking for it seemed to preclude the clear compelling geometries he shaped so well. Kahn's solution, after a period of study, was to develop a broadly scaled reinforced concrete frame, to place the shops around the periphery of the block within this grid, to reserve the corner as an entry to the gallery, and to place all the exhibition spaces, library, museum offices, and auxiliary spaces in the floors above. Of the total floor area, commercial use accounts for 16 percent. In the upper floors the bays of the frame are filled with panels of gray glass and specially finished stainless steel with a mat finish, pewter-like in color. Bays differ widely in the proportions of glass and pewter steel they contain, depending on the size of the room inside and its need for light. The overall expression is greatly restrained, and indeed from the exterior the building looks rather plain (perhaps even slightly "ordinary" in Venturi's sense), but inside the gallery is splendidly spacious with open courts rising through the four floors and intimate exhibition rooms opening onto the courts. Here natural white oak paneling, linen wall panels, and a natural wool carpet soften and complement in color the gray-beige of the exposed concrete frame. It is at the same time both bold and gentle, structurally hard and sensuously soft, heroic and soaring where the huge George Stubbs animal paintings hang and quietly intimate where the small watercolors hang. And it is suffused everywhere with a soft enveloping light that filters down into the galleries from skylights that form the entire roof and is bounced off external stainless steel louvers and refracted and re-refracted through Plexiglas domes. In the Yale Center for British Arts, Kahn made an important, and, as it turned out, a parting statement about preserving and enhancing

the quality of life in this area where the university and the city meet; he died before the building was completed and the work was taken up by his former associates, Pellecchia & Meyers. Both university and city are necessary for the well-being of each other, and symbolically in this building they exist in fruitful symbiosis.

The decade of the 1970s has been difficult for American architecture for the old certainties of theory and practice have vanished with seemingly little left behind to suggest a new path. Postmodernism may be one way, but so far it has been advanced only by a handful of architects. The dilemma is evident in the subtitle of the book, edited by Charles Moore and Nicholas Pyle in 1974, presenting the entries to the Yale Mathematics Building competition: "Architecture for a Time of Questioning." Reassuring is I. M. Pei's East Building addition to Pope's National Gallery of Art (1938–41), studies for which began in 1968 and which was constructed 1971–78 (Fig. 303). This museum, like the original building, was a Mellon gift; Paul Mellon, who endowed the addition, stipulated that pink marble be used from the same Tennessee quarries that had supplied the material for Pope's building. Pei had a most difficult and restricted trapezoidal site on Pennsylvania Avenue close to the Capitol; taking his cue unconsciously from L'Enfant, Pei crossed the trapezoid with a diagonal reflect-

303. I. M. Pei & Partners, East Building, addition to the National Gallery, Washington, D.C., 1968–78.

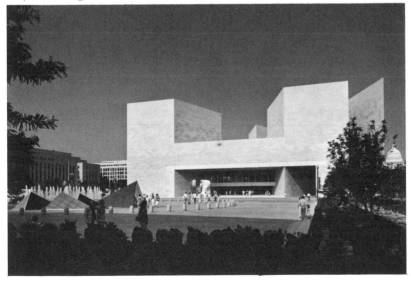

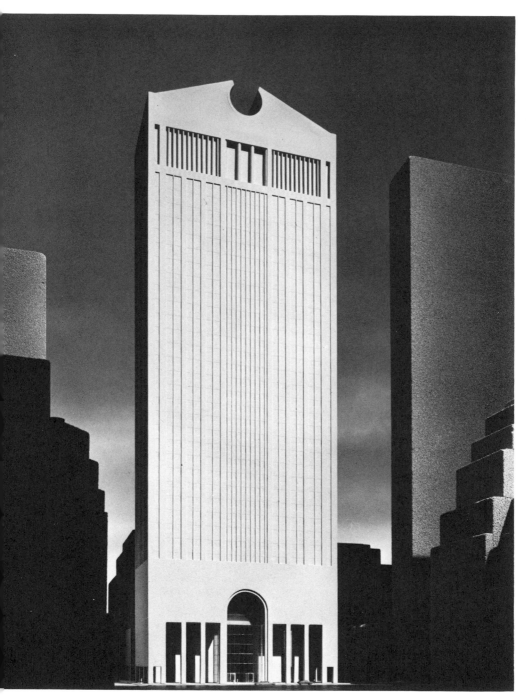

304. Johnson & Burgee with Simmons Architects, American Telephone and Telegraph Corporate Headquarters project, New York, New York, 1978.

ing that of Pennsylvania Avenue, dividing the plan into a long isosceles triangle and a right-angle triangle. Once this was done a logical system of related triangles was developed which gives the plan individual character and a clear sense of order, so that the building is classically simple and universal while at the same time being particular and special. The ends of the sharp isosceles triangle rise in tall lozenge-shaped piers cradling a triangular skylight over a court which fills the center of the building, so that here too light plays and shifts across the walls, and an expansive and dominant central space is countered by intimate surrounding galleries.

As the 1970s draw to a close Philip Johnson's work manifests a strong if whimsical classicism, most vigorously expressed in the 660-foot-tall office tower for American Telephone and Telegraph Company designed in 1978 (Fig. 304). At its base is an eight-story arch which recalls the archways at the base of the New York Central office tower by Warren & Wetmore, but even more surprising, at the top is a thirty-foot-high broken pediment. What Johnson may be suggesting is that whatever shape the architecture of the next generation may take, it must not again fall into the trap of the comfortable formula, of perfecting a system and then repeating it ad nauseum. The only absolute, Johnson has said, is that there are no longer any rules, and if this results in a measure of chaos, it also opens up possibilities for inventiveness, just as High Victorian Gothic came as a breath of fresh air after the archaeological correctness of the Gothic revival. "I believe," Johnson says, "we are standing at the edge of a mighty watershed between the past half-century of modern architecture and a new uncertain, unclear, but clearly fascinating future."

Style Chronology

Any attempt to show the development and interrelationship of styles is certain to incorporate generalizations and simplifications that do not express adequately the complexities of historical fact. Nonetheless this chronology is presented in the hope that it may dramatize the many options that have existed for American architects since the early seventeenth century.

The style entries for the seventeenth and eighteenth centuries describe ethnic and regional developments whereas those for the nineteenth and twentieth centuries are not geographical in organization since the rapid dispersal of architectural ideas increasingly erased regional distinctions. It should be remembered that virtually all building in the seventeenth century was vernacular in expression and relatively unselfconscious, while designers thereafter were increasingly selfconscious. The style entries of the nineteenth and twentieth centuries show those modes employed by architects, but they indicate little of the far larger volume of important vernacular building.

The dates at which a style emerges or later passes from use are often difficult to pinpoint, for although it is sometimes known when the first of a type appeared, vernacular variations on a style or expression often continued in outlying areas well after its use had subsided in the area of origin. The dates shown here, therefore, should be considered approximate not absolute.

SEVENTEENTH-CENTURY REGIONALISM

Provincial Spanish Baroque
(Southwest and Florida)
c.1600–1840
Provincial Jacobean
(Virginia, Carolinas)
1607–1695
Late English Gothic Vernacular
(New England)
1620–c.1700

Provincial Dutch Renaissance
(New Netherlands)
1624–c.1750
Swedish Vernacular
(Delaware, Pa.)
c.1638–1665
English Vernacular
(New York)
1664–c.1700

English Vernacular
(Delaware, Pa.)
1664–c.1700

EIGHTEENTH-CENTURY GEORGIAN

Early Georgian (in the middle 1680s isolated early Georgian buildings appeared in Boston and Philadelphia)

French Colonial
(Mississippi Valley)
c.1700–c.1805
Provincial Spanish Baroque
1768 c. 1840

Georgian
(Maryland, Virginia, Carolinas)
1695–c.1775
Georgian
(Middle Colonies)
1703–c.1775
Georgian
(New England)
1706–c.1775
Gibbsian Georgian
(New England)
1754–c.1790
Gibbsian Georgian
(Maryland, Virginia, Carolinas)
1756–c.1799
Gibbsian Georgian
(Middle Colonies)
1760–c.1795

ASSOCIATIONAL ECLEC- TICISM: 1770–c.1820

Jeffersonian Classicism
1770–c.1820
"Gothick"
1799–c.1830

SYNTHETIC ECLECTICISM: 1790–c.1825

Adamesque Federalist
1787–c.1820
Federalist
1790–c.1820

ECLECTIC REVIVALS: 1818–c.1860

Greek
1818–c.1850
Early Medieval
1821–c.1850
Gothic
1839–c.1870
Egyptian
1834–c.1850
Renaissance, Italianate and Italian Villa
1837–1860
Romanesque
1845–1875

Downing Davis Cottage
1842–1890
The Octagon Mode
1848–c.1860

CREATIVE ECLECTICISM I: c.1860–c.1885

Second Empire Baroque
1855–1880
High Victorian Gothic
1860–1880

Stick Style
1862–c.1880
Eastlake
1872–c.1885
Queen Anne
1875–c.1890
Shingle Style
1879–c.1900

Richardson Romanesque
1880–1895
François 1er
1880–1900
Chicago Commercial
(Chicago School)
1880–1915

CREATIVE ECLECTICISM II: c.1885–c.1930

Renaissance
1887–1930

Beaux-Arts
1890–1920
Gothic
1885–1930

TWENTIETH - CENTURY PLURALISM

Craftsman Bungalow
1895–1940
Bay Area Group
(San Francisco)
1900–1915
Prairie School
1900–1920
Northwest Regionalism
1935–1950
Suburban & Regional Eclecticism
1910–1940

Art Deco
1925–1940
Early Modern
(International Style)
1929–1940
International Style
(Mies and the Second Chicago School)
1940–c.1970
Formalism
1957–
Expressionism
1957–
Brutalism
1959–
Post-Modernism
(Creative Eclecticism III)
1964–

Glossary

For terms that cannot be included in this brief selection, please consult the two compact dictionaries: John Fleming, Hugh Honour, and Nikolaus Pevsner, *The Penguin Dictionary of Architecture*, 2nd ed., Baltimore, 1972, and Henry H. Saylor, *Dictionary of Architecture*, New York, 1952. More extensive definitions may be found in two large works both by Cyril M. Harris, *Dictionary of Architecture and Construction*, New York, 1975, and *Historic Architecture Sourcebook*, New York, 1977. For brief biographies of important architects see J. M. Richards, ed., *Who's Who in Architecture, From 1400 to the Present*, London and New York, 1977.

adobe　From Spanish *adobe* which comes from Arabic *al-ṭōba*, "the brick." A brick of sun-dried mud, grass, and straw, and by extension, buildings made of such brick.

arcade　Literally, a series of arches supported on columns or square or rectangular piers; or a covered passageway whose sides are open arcades; and by extension a covered way lined with shops even if no arches are used.

architrave　From Old French and Old Italian *arch* + *trabs*, "chief beam." Specifically, the lowest element in the *entablatures* of the Ionic and Corinthian columnar orders (see *order*), with two or three stepped-back faces; but by extension the frame around windows, doors, and arches in Renaissance architecture (see Fig. 171).

ashlar　A dressed or squared stone and the masonry built of such hewn stone. It may be coursed, with continuous horizontal joints (see Fig. 151b), or random, with discontinuous joints (see Fig. 149).

astylar　From Greek *a* + *stylos*, "without column." Term used to denote a building which, though embodying classical features, has none of the traditional orders or pilasters (see *order* and *pilaster*) (see Fig. 88).

axis　An imaginary line about which parts of a building, or individual buildings in a group, are disposed, usually with careful attention to bilateral symmetry.

baluster　From French and Italian derivatives of Greek, *balaustion*, the flower of the pomegranate, because of the shape of the post. An upright vase-shaped post used to support a rail.

balustrade　A series of balusters supporting a rail (see Fig. 171).

bargeboard　A trim element running along the lower edge of a gable

roof, originally a carved board with foliate Gothic ornamental devices, but later translated into flat scroll-sawn patterns (see Fig. 102). Also called *vergeboards.*

barrel vault A masonry vault resting on two parallel walls and having the form of a half cylinder; sometimes called *tunnel vault;* also, by extension, a nonstructural wooden ceiling of the same form.

batten From French, *bâton;* and from Latin, *bastum,* "stick." A narrow strip of wood used to cover and seal a joint or crack (see *board and batten*).

batter The downward and outward slope of the lower section of a masonry wall (see Fig. 149).

bay A basic unit or module of a building defined by repeated columns or pilasters or similar framing members.

belt course (or *stringcourse*) A projecting horizontal course of masonry, of the same or dissimilar material, used to throw rain water off a wall; usually coincides with the level of an interior floor.

blind arch An arch within a wall that contains a recessed flat wall rather than framing an opening; used to enliven an otherwise unrelieved expanse of masonry or to decrease the dead weight.

board and batten A form of sheathing for frame buildings consisting of wide boards (usually placed vertically) whose joints are covered by battens.

bracket A projecting support used under cornices, eaves, balconies, or windows to provide structural or purely visual support (see Fig. 107).

brickwork Three types of brickwork or bonding are common in eighteenth-century architecture. The simplest is common bond in which the bricks are all laid lengthwise to the plane of the wall. More complex is English bond in which the brick are laid in alternating courses, one course lengthwise (stretchers) and the other endwise (headers). Flemish bond is even more intricate with each course consisting of stretchers and headers (see illustration).

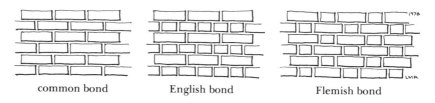

common bond English bond Flemish bond

cantilever A beam, or a part of a building supported by such beams, which is supported at one end only, the other end hovering in the air (see Fig. 220).

capital The top-most part of a column (see *order*), above the shaft, which carries the entablature.

casement A window pivoted at the side, like the page of a book, and usually taller than it is wide. (See the contrasting *double-hung window*) (see Fig. 20).

castellated Having battlements (parapet walls with notched openings) and turrets like those of a medieval castle (see Fig. 105).

chamfer From French *chanfrein,* "a bevel." To remove the edge or corner; also, the flat surface left after the corner is cut away.

clapboard From Dutch, *clappen,* "to split," + board. A thin board, origi-

nally riven or split, thinner at one edge than the other (later sawn with this profile), laid horizontally and with edges overlapping on a wooden-framed building (see Fig. 9).

clerestory From Middle English, *clere*, "lighted," + story. Originally the upper section of the nave of a Gothic cathedral with its banks of large windows, hence any elevated series of windows for light and ventilation.

coffer From Middle English, *coffre*, "box;" and Latin *cophinus*, "basket." A recessed box-like panel in a ceiling or vault; usually square but sometimes octagonal or lozenge-shaped (see Fig. 63).

colonnette A diminutive column or a greatly elongated column, most often used for visual effect rather than for structural support.

common bond See *brickwork.*

console From Latin, *consolator*, "one who consoles," hence a support. See *bracket.*

corbel From Middle English, *corp;* and Latin, *corvus*, "raven." A block of masonry projecting from the plane of the wall used to support an upper element (cornice, battlements, upper wall).

Corinthian Order See *order.*

cornice From Greek, *koronos*, "curved," referring to the curved profile. Specifically, the uppermost and projecting section of the entablature; hence, the uppermost projecting molding or combination of brackets and moldings used to crown a building or to define the meeting of wall and ceiling (see *order*).

crocket From Old French, *crochet*, "hook." In Gothic architecture, a carved, ornamental foliate hook-like projection used along the edges of roofs, spires, towers, and other upper elements.

crowstep gable A masonry gable extended above the roof line with a series of setbacks; often found in Northern European medieval architecture, especially Dutch architecture (see Fig. 16). See the related *Flemish gable.*

cupola From Late Latin, *cupula,* diminutive form of "tub." A rounded tower-like device rising from the roof of Northern Renaissance and Baroque buildings, usually terminating in a miniature dome (see Fig. 44).

dentil From Latin, *dens*, "tooth." A small rectangular block used in a series below the cornice in the *Corinthian Order;* any such block used to form a molding below a cornice.

dependency An outbuilding or other subordinate structure that serves as an adjunct to a central dominant building.

Doric Order See *order*

dormer From Old French, *dormeor*, "bedroom window." A vertical window and its projected housing that rises from a sloping roof (see Figs. 32, 135).

double hung window A window of two (or more) sash, or glazed frames, set in vertically grooved frames and capable of being raised or lowered independently of each other; widely in use in the American English colonies after c. 1700.

eave The lower edge, often overhanging, of a roof.

engaged column A column that is attached to and appears to emerge from the wall; in plan it consists of a half to three-quarters of a fully round column. It may be purely decorative or it may serve as a buttress-like thickening of the wall.

English bond See *brickwork.*

entablature The horizontal beam-like member supported by a classical column (see *order*). Although the details and proportions of the entablatures of the Doric, Ionic, and Corinthian orders vary, each has three component parts: the lower *architrave,* the middle *frieze,* and the crowning *cornice.*

eyebrow dormer A dormer formed by bowing upward a section of the roof and inserting a narrow segmental window beneath (see Fig. 149).

fanlight A circular or elliptical window over a door, often with elaborately contrived and interwoven *mullions;* used extensively c. 1700 to c. 1820.

fenestration From Latin, *fenestra,* "window." A general term used to denote the pattern or arrangement of windows.

finial From Latin, *finis,* "end." In Gothic architecture, an ornament, usually foliate, used at the end or peak of a gable, tower, or spire.

Flemish bond see *brickwork.*

Flemish gable A masonry gable extended above the roof with setback stages that may have stepped or curved profiles in any of a variety of combinations (see Fig. 21). Related to the *crowstep gable.*

foliate From Latin, *foliatus,* "bearing leaves." Having a two-dimensional or carved three-dimensional pattern based on leaves or plants; often stylized.

frame A structural support composed of separate members joined together to form a cage, as contrasted to solid masonry construction. Traditionally a wooden frame was composed of large, hewn hardwood members fastened by complex interlocking joints (see *mortise and tenon*). The frame of the Gleason house is a good example.

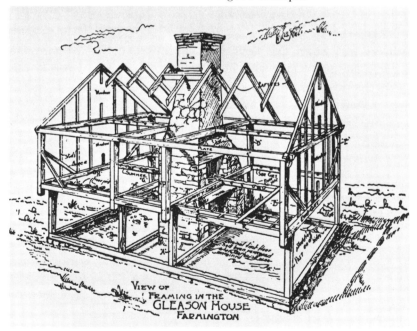

Frame of the Gleason house, Farmington, Connecticut, c. 1660.

About 1830 a radically new method was introduced that employed mass-produced softwood lumber in a frame that could be much more speedily raised (see Fig. 111 and the discussion of the balloon frame).

frieze From Latin use of the name *Phrygia,* a city known for its elaborate embroidery. Specifically the flat, horizontal panel in the *entablature* of the Ionic order, between the lower *architrave* and the crowning cornice, ornamented with low relief sculpture (because of its resemblance to elaborate embroidery). Hence, by extension, the center panel or section of all entablatures, even in the much different Doric order which has grooved stylized beam ends (triglyphs) with the spaces between filled with panels of low relief sculpture (metopes); see *order.* By further extension any elevated horizontal decorative band or panel.

gable The triangularly shaped area enclosed by the two sloped surfaces of a *gable roof* and the wall below; a generic term distinct from *pediment* which refers to a portion of a classical facade.

gable roof A simple roof composed of two flat surfaces meeting to form a straight ridge (see Fig. 9).

gambrel roof From Old North French, *gamberel;* from Late Latin, *gamba,* "leg," referring to the bent or crooked stick used by butchers to suspend carcasses. A roof, similar to a *gable roof,* but with two slopes on each side, a steeper pitch to the lower outer portion of the roof, and a gentler pitch to the upper center portion of the roof. In the colonies used by Dutch, Swedish, and English settlers, though in each area the profile differed. For a typically Dutch or Walloon gambrel roof, see Fig. 17; for an example derived from Swedish influences, see Fig. 28.

golden section A proportional ratio devised by the Greeks that expresses the ideal relationship of unequal parts. Capable of being demonstrated by Euclidian geometry, it can also be stated thus: a is to b as b is to a + b, or

$$\frac{a}{b} = \frac{b}{a+b}$$

If this is rewritten as a quadratic equation, the value 1 assigned to a, and solved for b, the value of b is 1.618034. Thus, the golden section is 1:1.618.

half timbering Frame construction in wood in which the framing members are left exposed on both exterior and interior, with the spaces between the framing members filled with brick nogging (random brickwork) or *wattle and daub.* Practiced in medieval France and England and briefly in the English colonies, it was revived as a purely decorative motif early in the twentieth century by using applied "half timbering," which is not structural.

hipped roof A roof of four sloped surfaces that meet in a point (with a square plan) or a sharp ridge line (rectangular plan) (see Figs. 32, 175).

hood molding A large projected molding over a window used to throw rain water away from the window; sometimes supported by brackets.

in antis Used to described columns set between projecting walls (*antae*).

Ionic order See *order.*

lancet Used to describe extremely narrow sharply pointed Gothic windows (hence the name) (see Fig. 91).

lantern In architecture, a small square or round glazed structure built atop a larger structure to admit light (see Figs. 60, 83).

leaded glass Small glass panes, most of them clear but often colored too, forming a geometric or foliate pattern, held in place by channels of lead soldered together.

lintel From Middle English and Old French, *lintel;* from Latin, *limen,* "threshold." A beam or support used to carry a load over an opening or to span between two columns.

loggia Italian, from French, *loge,* "small house, hut." A covered but open gallery, often in the upper part of a building; also, a covered passageway, often with an open trellis roof, connecting two buildings.

Mansard roof From François Mansart, French architect, 1598–1666, who employed this roof form extensively. A roof with two slopes on each of its four sides—a steep and nearly vertical slope on the outside and a gentle nearly flat slope on the top (see Figs. 115, 118). The outer roof slope may often be convex or concave in profile.

modillion From French and Italian, *modiglione;* from Latin, *mutulus,* from an Etruscan root meaning "to stand out." A small curved and ornamented bracket used to support the upper part of the cornice in the Corinthian order; any such small curved ornamented bracket used in series.

molding Any carved or modeled band integral to the fabric of a wall or applied to it.

monitor A form of *lantern,* but wider and usually square in plan.

mortise and tenon One of the basic wood joining methods. One member is cut with a rectangular or square hole (*mortise*) to receive the other member cut with a rectangular or square tongue (*tenon*).

mouse tooth gable (*muisetanden gable*) Dutch term referring to the infilling in the steps of a crowstep gable. Brick is laid at an angle perpendicular to the slope of the gable within the steps, and the gable is finished off with a smooth brick or stone coping or sill; an adaptation widely used in New Netherlands and Virginia.

mullion From Middle English, *moniel;* from Latin *medianus,* "median." Originally the large vertical stone divider in medieval windows; later the vertical supports in glazed windows; often now any support strip, vertical or horizontal, in a glazed window.

nogging Brick or miscellaneous masonry material used to fill the spaces between the wooden supports in a half-timber frame.

obelisk From Old French, *obelisque;* from Greek, *obeliskos,* "spit or pointed pillar." A tall narrow square shaft, tapering and ending in a pyramidal point.

order From Old French *ordre;* from Latin, *ordo,* "line or row;" possibly from Greek, *arariskein,* "to fit together." Any of the several types of classical columns, including pedestal bases and *entablatures.* The Greeks developed three orders, the Doric, Ionic, and Corinthian, of which the Romans adopted the latter two and added Tuscan Doric and the Composite (a combination of the features of Ionic and Corinthian).

 1. The Greek Doric, developed in the western Dorian region of Greece, is the heaviest and most massive of the orders. It rises from the *stylobate* without any base; it is from 4 to 6¹/₂ times as tall as its diameter; it has twenty broad flutes. The capital consists simply of a banded necking swelling out into a smooth echinus which carries a flat square

peristyle From Greek, *peri,* "around," + *stylos,* "column." Noun, refer-ring to a free-standing colonnade running completely around a build-ing (see Fig. 82).

pilaster From Old French, *pilastre;* from Medieval Latin, *pilastrum,* "pil-lar." A buttress-like projection from a wall in the form of one of the classical *orders,* and like them, having base, fluted or unfluted shaft, and capital, carrying an entablature or cornice.

plinth From French, *plinthe;* from Greek, *plinthos,* "square stone block." Specifically, a square flat block used as the base under a column, but by extension any block-like podium beneath a building.

polychromy From Greek *polukhromos,* from *polus,* "many," + *khroma,* "color." The use of many colors, and particularly in nineteenth century architecture the employment of many building materials with contrast-ing natural colors (see Fig. 122).

porte cochère From French, "coach door." A covered area, attached to a house, providing shelter for those alighting from carriages (see Figs. 176, 177).

portico From Latin, *porticus,* "porch." A porch, with a roof usually car-ried by columns, protecting the main entrance to a building (see Fig. 51).

post and lintel A structural term used to describe a generic type in which upright columns support horizontal beams. The structure may be stone, wood, or iron and steel.

quatrefoil From Latin, "four leaves." An ornamental pattern of four circular or pointed lobes.

quoin From Old French, *coing,* "wedge." Originally the structural use of large masonry blocks to reinforce the corner of a brick or other ma-sonry wall (see Fig. 45); but often used as a decorative embellishment in non-load-bearing materials (see applied wooden quoins, Fig. 26).

rinceau From Middle French, *rainsel,* "branch." Ornamental work, often low relief sculpture, consisting of curvilinear intertwining leaves and branches.

rosette Stylized circular floral ornament in the form of a fully open rose.

rustication From Latin, *rusticus,* "of the country, rude, coarse." The treatment of stone masonry with the joints between the blocks deeply cut back. The surfaces of the blocks may be smoothly dressed (as in Fig. 168), textured (as in Fig. 122), or extremely rough, or quarry-faced (as in Fig. 151b).

saddleback roof Traditionally a roof with two gables and one ridge, but also a roof (gable or hipped) with two slopes on each side, the outer portion gentler in slope, the inner portion steeper (see Fig. 46).

saltbox Term used to describe the typical seventeenth-century New En-gland house with a short gable roof to the front and a long gable roof to the rear (see Fig. 13).

sash From French, *châssis,* "frame." Frame in which glass window panes are set.

setback A recessed upper section of a building; used in New York and Chicago skyscrapers of the 1920s as a way of admitting more light and air to the streets below (see Figs. 207, 209).

shed roof The simplest roof consisting of a single inclined plane; used widely in domestic architecture, 1965–1975 (see Fig. 265).

skeleton frame See *skyscraper construction.*

skyscraper construction The method of construction developed in Chicago in which all building loads are transmitted to a ferrous metal skeleton, so that any external masonry is simply a protective cladding.

spandrel From Old French, *espandre,* "to spread out." In a wall system of arches, the area between the architraves of the arches and the entablature above (as in Fig. 144); in a skeletal frame building, the panels between the columns and the windows of each story (see Figs. 157, 238).

stereobate From Greek, *sterebates,* "solid base." The total substructure or base of a classical building; in a columnar building, the uppermost level is the *stylobate.*

stringcourse See *belt course.*

stylobate From Greek, *stylobates,* "column foundation or base." The upper layer of the *stereobate* upon which the columns rest.

terra cotta From Latin, "cooked earth." A ceramic material made from clay slip poured into molds and fired; capable of assuming many forms; widely used, 1875–1930, as a sheathing material—particularly when glazed.

trabeated structure From Latin, *trabs,* "beam." Used in place of *post and lintel.*

truss From Middle English, *trusse;* from Old French, *trousser,* "to secure tightly." In architecture, a frame assembled of small members (of wood or metal) in triangular sections in such a way that the whole is rigid and cannot be deflected without deforming one of the members; used to span large distances (see Fig. 117).

turret, tourelle From Old French, *tourete,* diminutive for tower. A small tower, sometimes corbeled out from the corner of a building.

vault From Middle English, *vaute;* from Latin, *volvere,* "to turn." An arched ceiling of masonry; if circular or oval in plan, a dome.

veranda, verandah From Hindi, *varanda,* which is partly from Portuguese, *varanda,* akin to Spanish, *baranda,* "railing." An extensive open gallery or porch.

verge board See *barge board.*

Vierendeel truss From M. A. Vierendeel, Belgian engineer, who developed it in 1896. A lattice frame with members at right angles that derives its strength from the rigidity built into its joints; it has no diagonal members as in a typical truss.

volute From Latin, *voluta,* "scroll," from *volvere,* "to turn." A spiral curve; the curled top of the Ionic capital.

voussoir From Old French, *vossoir,* derived perhaps from Latin, *volvere,* "to turn." Any of the wedge-shaped blocks used to form an arch, the center one of which is the keystone.

water table A molded course of masonry forming a transition between the foundation wall and the upper wall, designed to throw rain water away from the wall.

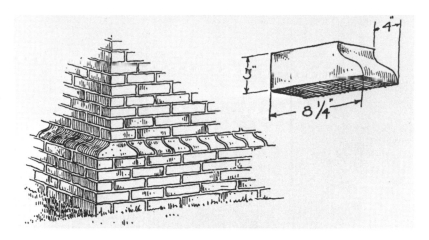

Molded brick course.

wattle and daub A rough form of construction in which a woven basket-work of twigs is coated with mud plaster; employed to fill the spaces between framing members in *half timber* construction.

ziggurat From Assyrian *zigguratu,* "summit, mountain top." A temple-tower of multiple stepped-back stages built by the Babylonians and Assyrians.

Bibliography

Specific items have not been footnoted in the text for the sake of the continuity of the narrative, though authors have been credited. Cited here is a selected bibliography, including the many sources consulted. For brevity, however, the many pattern books, journals, and other books discussed in the text are not relisted here.

General Surveys, American Art and Architecture

Brown, Milton W. *American Art to 1900*. New York, 1977.

Green, Samuel M. *American Art: A Historical Survey*. New York, 1966.

Hunter, Sam, and John Jacobus. *American Art of the Twentieth Century*. Englewood Cliffs, 1974.

Jarves, James Jackson. *The Art-Idea: Sculpture, Painting and Architecture in America*. New York, 1864.

Larkin, Oliver. *Art and Life in America*, rev. ed. New York, 1960.

McLanathan, Richard. *The American Tradition in the Arts*. New York, 1968.

———. *Art in America: A Brief History*. New York, 1973.

Wright, Louis B., George B. Tatum, John W. McCoubrey, and Robert C. Smith. *The Arts In America: The Colonial Period*. New York, 1966.

Architecture and Planning Surveys

Andrews, Wayne. *American Gothic: Its Origins, Its Trials, Its Triumphs*. New York, 1975.

———. *Architecture, Ambition, and Americans*. New York, 1964.

———. *Architecture in America: A Photographic History from the Colonial Period to the Present*. New York, 1960.

———. *Architecture in Chicago and Mid-America: A Photographic History*. New York, 1968.

———. *Architecture in Michigan: A Photographic History*. Detroit, 1967.

———. *Architecture in New England: A Photographic History*. Brattleboro, Vermont, 1973.

———. *Architecture in New York: A Photographic History*. New York, 1969.

Burchard, John, and Albert Bush-Brown. *The Architecture of Amer-*

ica: A Social and Cultural History. Boston, 1961.

Cheney, S. *The New World Architecture.* New York, 1930.

Coles, William A., and Henry Hope Reed, Jr., eds. *Architecture in America: A Battle of Styles.* New York, 1961.

Collins, Peter. *Changing Ideals in Modern Architecture.* London, 1965.

Condit, Carl W. *American Building.* Chicago, 1968.

Edgell, G. H. *The American Architecture of Today.* New York, 1928.

Fitch, James M. *American Building: The Historical Forces That Shaped It,* 2nd ed. Boston, 1966.

———. *American Building: The Environmental Forces That Shape It.* Boston, 1966.

———. *Architecture and the Aesthetics of Plenty.* New York, 1961.

Gebhard, David, and Deborah Nevins. *200 Years of American Architectural Drawing.* New York, 1977.

Giedion, Siegfried. *Mechanization Takes Command: A Contribution to Anonymous History.* New York, 1948.

———. *Space, Time, and Architecture,* 5th ed. Cambridge, Massachusetts, 1967.

Gifford, Don, ed. *The Literature of Architecture: The Evolution of Architectural Theory and Practice in Nineteenth-Century America.* New York, 1966.

Gowans, Alan. *Images of American Living: Four Centuries of Architecture and Furniture as Cultural Expression.* Philadelphia, 1964.

Glaab, Charles N., and A. Theodore Brown. *A History of Urban America.* New York, 1967.

Green, Constance McLaughlin. *American Cities in the Growth of the Nation.* London and Tuckahoe, New York, 1957.

———. *The Rise of Urban America.* New York, 1965.

Greiff, Constance M. *Lost America, From the Atlantic to the Mississippi.* Princeton, 1971.

———. *Lost America, From the Mississippi to the Pacific.* Princeton, 1972.

Hamlin, Talbot. *The American Spirit in Architecture.* New Haven, 1926.

Hammett, Ralph W. *Architecture in the United States: A Survey of Architectural Styles Since 1776.* New York, 1976.

Heckscher, August. *Open Spaces: The Life of American Cities.* New York, 1977.

Hitchcock, Henry-Russell. *American Architectural Books: A List of Books, Portfolios, and Pamphlets on Architecture and Related Subjects Published in America Before 1895,* 3rd ed. Minneapolis, 1946.

———. *Architecture: Nineteenth and Twentieth Centuries,* 3rd ed. Baltimore, 1968 (rev. ed., paper, 1977). (The Pelican History of Art).

———, and William Seale. *Temples of Democracy: The State Capitols of the USA.* New York, 1976.

Jordy, William H. *American Buildings and Their Architects, III: Progressive and Academic Ideals at the Turn of the Twentieth Century.* Garden City, New York, 1972.

———. *American Buildings and Their Architects, IV: The Impact of European Modernism in the Mid-Twentieth Century.* Garden City, New York, 1972.

Kidder-Smith, G. E. *A Pictorial History of Architecture in America.* New York, 1976.

Kimball, S. Fiske. *American Architecture.* Indianapolis, 1928.

Kostof, Spiro, ed. *The Architect: Chapters in the History of the Profession.* New York, 1977.

McCallum, I. R. M. *Architecture, U.S.A.* New York, 1959.

Meeks, Carroll L. V. *The Railroad Station*. New Haven, 1955.

Miller, Zane L. *The Urbanization of Modern America: A Brief History*. New York, 1973.

Moore, Charles, Gerald Allen, and Donlyn Lyndon. *The Place of Houses*. New York, 1974.

Mumford, Lewis. *From the Ground Up*. New York, 1956.

——. *The Highway and the City*. New York, 1963.

——. *Roots of Contemporary American Architecture*. New York, 1952.

——. *Sticks and Stones*, 2nd rev. ed. New York, 1955.

Newton, Norman. *Design on the Land: The Development of Landscape Architecture*. Cambridge, Massachusetts, 1971.

Pierson, William H., Jr. *American Buildings and Their Architects, I: The Colonial and Neoclassical Styles*. Garden City, New York, 1970.

——. *American Buildings and Their Architects, II: Technology and the Picturesque, The Corporate and the Early Gothic Styles*. Garden City, New York, 1978.

Reps, John W. *The Making of Urban America: A History of City Planning in the United States*. Princeton, 1965.

——. *Monumental Washington: The Planning and Development of the Capitol Center*. Princeton, 1967.

Roos, Frank J., Jr. *Bibliography of Early American Architecture. Writings on Architecture Constructed Before 1860 in Eastern and Central United States*, rev. ed. Urbana, Illinois, 1968.

Scott, Mel. *American City Planning Since 1890*. Berkeley, 1969.

Scully, Vincent. *American Architecture and Urbanism*. New York, 1969.

——. *Modern Architecture: The Architecture of Democracy, c. 1789–1960*. New York, 1961 (rev. ed., 1974).

Singer, Nathan. *Lost New York*. Boston, 1967.

Sky, Alison, and Michelle Stone. *Unbuilt America*. New York, 1976.

Still, Bayrd. *Urban America: A History with Documents*. Boston, 1974.

Tallmadge, Thomas E. *The Story of Architecture in America*. New York, 1927.

Tunnard, Christopher. *The City of Man*, 2nd ed. New York, 1970.

——. *The Modern American City*. New York, 1968.

——, and Henry Hope Reed. *American Skyline*. Boston, 1955.

Warner, Sam Bass. *The Urban Wilderness: A History of the American City*. New York, 1972.

Weimer, David R., ed. *City and Country in America*. New York, 1962.

Whiffen, Marcus. *American Architecture Since 1780: A Guide to the Styles*. Cambridge, Massachusetts, 1969.

Wrenn, Tony P., and Elizabeth D. Mulloy. *America's Forgotten Architecture*, by the National Trust for Historic Preservation. New York, 1976.

Indian Building

Bushnell, David I. *Native Villages and Village Sites East of the Mississippi*. Bureau of American Ethnology, Bulletin 69, 1919.

——. *Villages of the Algonquian, Siouan, and Caddoan Tribes West of the Mississippi*. Bureau of American Ethnology, Bulletin 77, 1922.

Driver, Harold E. *Indians of North America*, 2nd ed. Chicago, 1969.

——, and William C. Massey. *Comparative Studies of the North American Indians*. Transactions of the American Philosophical Society, 47 (1957), 165–456.

Hewett, Edgar L. *The Canyon and Its Monuments*. Albuquerque, New Mexico, 1936.

Jennings, Jesse D. *Prehistory of North America*. New York, 1968.

———, and Edward Norbeck. *Prehistoric Man in the New World*. Chicago, 1964.

Laubin, Reginald and Gladys. *The Indian Tipi, Its History, Construction, and Use*. Norman, Oklahoma, 1957.

Morgan, Lewis H. *Houses and House-Life of the American Aborigines*, new ed. Chicago, 1956. (Originally published, Washington, D.C., 1881).

Scully, Vincent. *Pueblo: Mountain, Village, Dance*. New York, 1975.

Waterman, T. T, "North American Indian Dwellings," *Geographical Review* 14 (1924), 1–25.

Willey, Gordon R. *An Introduction to American Archaeology, v. 1, North and Middle America*. Englewood Cliffs, New Jersey, 1966.

———, and Jeremy A. Sabloff. *A History of American Archaeology*. London, 1974.

Seventeenth and Eighteenth Centuries

Bridenbaugh, Carl. *Peter Harrison*. Chapel Hill, North Carolina, 1949.

Briggs, Martin S. *The Homes of the Pilgrim Fathers in England and America (1620–1685)*. London, 1932.

Donnelly, Marian Card. *The New England Meetinghouses of the Seventeenth Century*. Middletown, Connecticut, 1968.

Downing, Antoinette F., and Vincent Scully. *The Architectural Heritage of Newport, Rhode Island, 1640–1915*, 2nd ed. New York, 1970.

Eberlein, Harold, and Cortland Hubbard. *American Georgian Architecture*. Bloomington, Indiana, 1952.

Frary, I. T. *Thomas Jefferson, Architect and Builder*. Richmond, Virginia, 1931.

Garvan, Anthony. *Architecture and Town Planning in Colonial Connecticut*. New Haven, 1951.

Howells, John M. *Lost Examples of Colonial Architecture*. New York, 1931.

Jackson, Joseph. *American Colonial Architecture*. Philadelphia, 1924.

Kimball, Fiske. *Domestic Architecture of the American Colonies and of the Early Republic*. New York, 1922.

———. *Mr. Samuel McIntire, The Architect of Salem*. Portland, Maine, 1940.

———. *Thomas Jefferson, Architect*. Boston, 1916.

Kubler, George. *The Religious Architecture of New Mexico*. Colorado Springs, Colorado, 1940.

Morrison, Hugh. *Early American Architecture, from the First Colonial Settlements to the National Period*. New York, 1952.

Newcomb, Rexford. *Spanish Colonial Architecture in the United States*. New York, 1937.

Place, Charles A. *Charles Bulfinch, Architect and Citizen*. Boston, 1925.

Reynolds, Helen W. *Dutch Houses in the Hudson Valley before 1776*. New York, 1929.

Summerson, John. *Architecture in Britain, 1530–1830*, 5th ed. Baltimore, 1969. (The Pelican History of Art).

Waterman, Thomas T. *Domestic Colonial Architecture of Tidewater Virginia*. New York, 1932.

———. *The Dwellings of Colonial America*. Chapel Hill, North Carolina, 1950.

———. *Mansions of Virginia, 1706–1776*. Chapel Hill, North Carolina, 1951.

The Nineteenth Century, to 1860

Bunting, Bainbridge. *Houses of Bos-*

ton's *Back Bay: An Architectural History, 1840–1917*. Cambridge, Massachusetts, 1967.

Coolidge, John. *Mill and Mansion: A Study of Architecture and Society in Lowell, Massachusetts, 1820–1865*. New York, 1942.

Davies, Jane B. "Llewellyn Park in West Orange, New Jersey," *Antiques* 107 (January, 1975), 142–58.

Early, James. *Romanticism and American Architecture*. New York, 1965.

Gallagher, Helen. *Robert Mills, Architect of the Washington Monument, 1781–1855*. New York, 1935.

Gilchrest, Agnes A. *William Strickland, Architect and Engineer, 1788–1854*. Philadelphia, 1950.

Greenough, Horatio. *Form and Function: Remarks on Art*. Berkeley, 1949.

Hamlin, Talbot. *Benjamin Henry Latrobe*. New York, 1955.

———. *Greek Revival Architecture in America*. New York, 1944.

Hitchcock, Henry-Russell. *Rhode Island Architecture*, 2nd ed. New York, 1968.

Kilham, Walter H. *Boston after Bulfinch: An Account of Its Architecture 1800–1900*. Cambridge, Massachusetts, 1946.

Landy, Jacob. *The Architecture of Minard Lafever*. New York, 1970.

Loth, Calder, and Julius T. Sadler, Jr. *The Only Proper Style: Gothic Architecture in America*. Boston, 1975.

Meeks, Carroll L. V. "Romanesque Before Richardson in the United States," *Art Bulletin* 35 (March, 1953), 17–33.

Newcomb, Rexford. *Architecture of the Old Northwest Territory*. Chicago, 1950.

Newton, Roger H. *Town and Davis, Architects; Pioneers in American Revivalist Architecture, 1812–70*. New York, 1962.

Smith, J. Frazer. *White Pillars: Early Life and Architecture of the Lower Mississippi Valley Country*. New York, 1941.

Stanton, Phoebe B. *The Gothic Revival and American Church Architecture: An Episode in Taste, 1840–1856*. Baltimore, 1968.

Upjohn, Everard M. *Richard Upjohn, Architect and Churchman*. New York, 1939.

The Nineteenth Century, After 1860

Barlow, Elizabeth. *Frederick Law Olmsted's New York*. New York, 1972.

Buder, Stanley, *Pullman: An Experiment in Industrial and Community Planning, 1880–1930*. New York, 1967.

Bush-Brown, Albert. *Louis Sullivan*. New York, 1960.

Condit, Carl W. *American Building Art: The Nineteenth Century*. New York, 1960.

———. *The Chicago School of Architecture: A History of Commercial and Public Building in the Chicago Area, 1875–1925*. Chicago, 1964.

———. *The Rise of the Skyscraper*. Chicago, 1952.

Eaton, Leonard K. *American Architecture Comes of Age: European Reaction to H. H. Richardson and Louis Sullivan*. Cambridge, Massachusetts, 1972.

English, Maurice, ed. *The Testament of Stone: Themes of Idealism and Indignation from the Writings of Louis Sullivan*. Evanston, Illinois, 1963.

Fabos, Julius G., Gordon T. Milde, and V. Michael Weinmayr. *Frederick Law Olmsted, Sr., Founder of Landscape Architecture in America*. Amherst, Massachusetts, 1968.

Fein, Albert. *Frederick Law Olmsted and the American Environmental Tradition*. New York, 1972.

Hitchcock, Henry-Russell. *The Architecture of H. H. Richardson and His Times*, rev. ed. Cambridge, Massachusetts, 1966. (Original ed., New York, 1936).

Hoffman, Donald. *The Architecture of John Wellborn Root.* Baltimore, 1973.

Jackson, John B. *American Space: The Centennial Years, 1865–1876.* New York, 1972.

Kaufmann, Edgar, Jr., ed. *The Rise of an American Architecture.* New York, 1970.

Kidney, Walter C. *The Architecture of Choice: Eclecticism in America, 1880–1930.* New York, 1974.

Lancaster, Clay. *The Japanese Influence in America.* New York, 1963.

————. "Oriental Forms in American Architecture, 1800–1870," *Art Bulletin* 29 (September, 1947), 83–93.

McKelvey, Blake. *The Urbanization of America, 1860–1915.* New Brunswick, New Jersey, 1963.

Meeks, Carroll L. V. "Creative Eclecticism," *Journal, Society of Architectural Historians* 11 (December, 1953), 15–18.

————. "Picturesque Eclecticism," *Art Bulletin* 32 (September, 1950), 226–235.

Morrison, Hugh. *Louis Sullivan, Prophet of Modern Architecture.* New York, 1935.

Mumford, Lewis. *The Brown Decades,* 2nd ed. New York, 1955. (Original ed., New York, 1931).

O'Gorman, James F. *The Architecture of Frank Furness.* Philadelphia, 1973.

————. *Henry Hobson Richardson and His Office: Selected Drawings.* Boston, 1975.

————. "The Marshall Field Wholesale Store: Materials Toward a Monograph," *Journal, Society of Architectural Historians* 37 (October, 1978), 175–194.

Rifkind, Carole. *Main Street: The Face of Urban America.* New York, 1977.

Roper, Laura Wood. *FLO: A Biography of Frederick Law Olmsted.* Baltimore, 1973.

Roth, Leland M. *The Architecture of*

McKim, Mead & White, 1870–1920, A Building List.* New York, 1978.

————, ed. *A Monograph of the Work of McKim, Mead & White, 1879–1915,* with an introductory essay, "McKim, Mead & White Reappraised," and notes on the plates. New York, 1974. (Original ed., New York, 1915–1920).

Schuyler, Montgomery. *American Architecture and Other Writings,* 2 vols. (William H. Jordy and Ralph Coe, eds.). Cambridge, Massachusetts, 1961.

Scully, Vincent. "Romantic Rationalism and the Expression of Structure in Wood: Downing, Wheeler, Gardner, and the 'Stick Style,' 1840–1876," *Art Bulletin* 35 (June, 1953), 121–142.

————. *The Shingle Style.* New Haven, 1955. (Rev. ed., New Haven, 1971, includes "Stick Style" article reprinted from *Art Bulletin*).

Sullivan, Louis. *The Autobiography of an Idea.* New York, 1924.

————. *Kindergarten Chats and Other Writings* (Isabella Athey, ed.). New York, 1947.

Sutton, S. B. *Civilizing American Cities: A Selection of Frederick Law Olmsted's Writings on City Landscapes.* Cambridge, Massachusetts, 1971.

The Twentieth Century

Baldwin, Charles C. *Stanford White.* New York, 1930.

Banham, Reyner. *The Architecture of the Well-Tempered Environment.* London, 1969.

————. *Los Angeles: The Architecture of Four Ecologies.* Harmondsworth, 1971.

————. *The New Brutalism, Ethic or Aesthetic?* New York, 1966.

Blake, Peter. *The Master Builders.* New York, 1960.

(Each of the three sections on

Frank Lloyd Wright, Le Corbusier, and Mies van der Rohe published separately, New York, 1964).

Brooks, H. Allen. *The Prairie School.* Toronto, 1972.

Cohen, Stuart E. *Chicago Architects.* Chicago, 1976.

Cook, John W., and Heinrich Klotz, eds. *Conversations with Architects.* New York, 1973.

Comey, Arthur C., and Max S. Wehrly. *Planned Communities. Supplementary Report of the Urbanism Committee, National Resources Committee.* Washington, D.C., 1939.

Condit, Carl W. *American Building Art: The Twentieth Century.* New York, 1961.

———. *Chicago, 1910–29, Building, Planning, and Urban Technology.* Chicago, 1973.

———. *Chicago, 1930–70, Building, Planning, and Urban Technology.* Chicago, 1974.

Cram, Ralph Adams. *My Life in Architecture.* Boston, 1936.

Drexler, Arthur. *Ludwig Mies van der Rohe.* New York, 1960.

Eisenman, Peter, et al. *Five Architects.* New York, 1972.

———, and Robert A. M. Stern, eds. "White and Gray," *Architecture and Urbanism* 52 (April, 1975), 3–180.

Gebhard, David. *Schindler.* London, 1971.

Goldberger, Paul. "The New Age of Philip Johnson," *The New York Times Magazine,* Sunday, May 14, 1978, 26–27, 65–73.

Grief, Martin. *Depression Modern: The Thirties Style in America.* New York, 1975.

Heyer, Paul. *Architects on Architecture: New Directions in Architecture.* New York, 1966.

Hildebrand, Grant. *Designing for Industry: The Architecture of Albert Kahn.* Cambridge, Massachusetts, 1974.

Hines, Thomas S. *Burnham of Chicago, Architect and Planner.* New York, 1974

Hitchcock, Henry-Russell. *In the Nature of Materials: The Building of Frank Lloyd Wright, 1887–1941.* New York, 1942.

———, and Arthur Drexler, eds. *Built in USA; Post-War Architecture.* New York, 1952.

———, and Philip Johnson. *The International Style: Architecture Since 1922.* New York, 1932.

Huxtable, Ada Louise. *Kicked a Building Lately?* New York, 1976.

———. *Will They Ever Finish Bruckner Boulevard?* New York, 1970.

Jacobs, Jane. *The Death and Life of Great American Cities.* New York, 1961.

Jacobus, John M. *Philip Johnson.* New York, 1962.

———. *Twentieth-Century Architecture: The Middle Years, 1940–1965.* New York, 1965.

Jencks, Charles A. *The Language of Post-Modern Architecture.* New York, 1977.

———. *Modern Movements in Architecture.* Garden City, New York, 1973.

Johnson, Philip. *Mies van der Rohe.* New York, 1947.

Kaufmann, Edgar, Jr., and Ben Raeburn, eds. *Frank Lloyd Wright; Writings and Buildings.* Cleveland, 1960.

Kilham, Walter H., Jr. *Raymond Hood, Architect; Form Through Function in the American Skyscraper.* New York, 1973.

Krinsky, Carol H. *Rockefeller Center.* New York, 1978.

Lyndon, Donlyn. "Philology of American Architecture," *Casabella* no. 281 (November, 1963), viii–x, 8–42.

McCoy, Esther. *Five California Architects.* New York, 1960.

———. *Richard Neutra.* New York, 1960.

Maginnis, C. D. *The Work of Cram and Ferguson, Architects.* New

York, 1929.

Meier, Richard. *Richard Meier, Architect.* New York, 1976.

Mock, Elizabeth, ed. *Built in USA Since 1932.* New York, 1945.

Moore, Charles. *Daniel H. Burnham, Architect, Planner of Cities,* 2 vols. Boston, 1920.

———. *The Life and Times of Charles Follen McKim.* Boston, 1929.

Moore, Charles W. "Plug It In, Rameses, and See If It Lights Up, Because We Aren't Going to Keep It Unless It Works," *Perspecta* 11 (1967), 32–43.

———. "You Have to Pay for the Public Life," *Perspecta* 9/10 (1965), 57 106.

Mujica, Francisco. *History of the Skyscraper.* Paris, 1929 (New York, 1930).

Newcomb, Rexford. *Mediterranean Domestic Architecture in the United States.* Cleveland, 1928.

———. *The Spanish House for America: Its Design, Furnishing, and Garden.* Philadelphia, 1927.

North, Arthur T. *Raymond M. Hood.* New York, 1931.

Onderdonk, F. S. *The Ferro-Concrete Style.* New York, 1928.

Peisch, Mark L. *The Chicago School of Architecture: Early Followers of Sullivan and Wright.* New York, 1964.

Robinson, Cerwin, and Rosemarie Haag Bletter. *Skyscraper Style: Art Deco New York.* New York, 1975.

Saarinen, Aline B., ed. *Eero Saarinen on His Work.* New Haven, 1962.

Saylor, Henry H. *Bungalows: Their Design, Construction, and Furnishing.* New York, 1917.

Schwab, Gerhard. *The Architecture of Paul Rudolph.* New York, 1970.

Scully, Vincent. *Frank Lloyd Wright.* New York, 1960.

———. *Louis I. Kahn.* New York, 1962.

———. *The Shingle Style Today, or The Historian's Revenge.* New York, 1974.

Stern, Robert A. M. *George Howe: Toward a Modern American Architecture.* New Haven, 1975.

———. *New Directions in American Architecture,* rev. ed. New York, 1977.

Temko, Allan. *Eero Saarinen.* New York, 1962.

Tucci, Douglass S. *Ralph Adams Cram, American Medievalist.* Boston, 1975.

Twombly, Robert C. *Frank Lloyd Wright, An Interpretive Biography.* New York, 1973.

Venturi, Robert. *Complexity and Contradiction in Architecture.* New York, 1967.

———, Denise Scott Brown, and Steven Izenour. *Learning From Las Vegas.* New York, 1972.

Witaker, C.H., ed. *Bertram Grosvenor Goodhue—Architect and Master of Many Arts.* New York, 1925.

White, Theo B. *Paul Philippe Cret, Architect and Teacher.* Philadelphia, 1973.

Wright, Frank Lloyd. *An American Architecture.* New York, 1955.

———. *Ausgeführte Bauten und Entwürfe von Frank Lloyd Wright.* Berlin, 1910.

———. *Autobiography.* New York, 1932.

———. *Frank Lloyd Wright: Ausgeführte Bauten.* Berlin, 1911.

———. *In the Cause of Architecture* (F. Gutheim, ed.). New York, 1975.

———. *The Living City.* New York, 1958.

———. *Modern Architecture.* Princeton, 1931.

———. *On Architecture* (F. Gutheim, ed.). New York, 1941.

———. *An Organic Architecture: The Architecture of Democracy.* London, 1939.

———. *The Natural House.* New York, 1954.

———. *A Testament.* New York, 1957.

Index

Page numbers in italic refer to illustrations.

Icon Editions